# Photojournalism

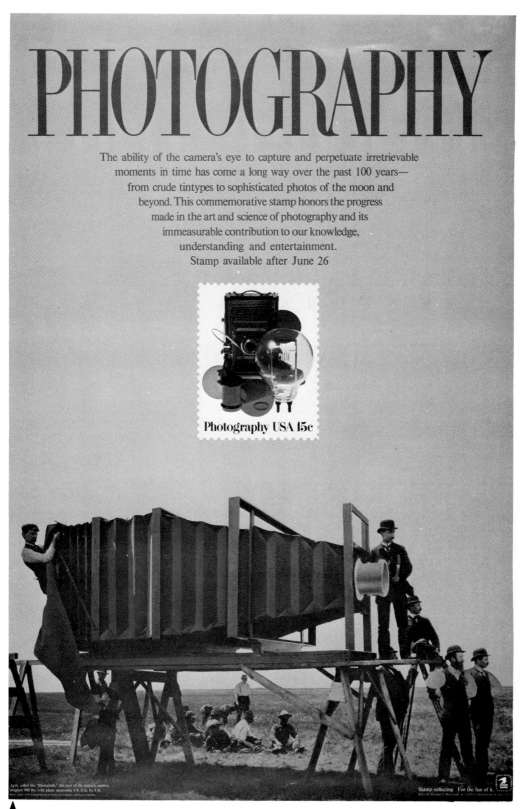

# Photojournalism

## Principles and Practices
### Second Edition

**Clifton C. Edom**

*Professor Emeritus, School of Journalism*
*University of Missouri, Columbia*

wcb

Wm. C. Brown Company Publishers
Dubuque, Iowa

Cover photo by Bob Coyle

Consulting Editor
Curtis MacDougall
Northwestern University

*Dedicated to Vi*

# Contents

# Preface

When the first edition of *Photojournalism, Principles and Practices* was begun in 1975, the aim, then as it is now, was to provide a text which would add to and complement the material found in many excellent books.

Purpose of this book, was and is, to give direction and information about photojournalism philosophy, photojournalism principles, and practices.

This volume was created for those who know about lenses, film, filters, and the mechanics of a camera. Presumably young people will continue to grow in technical knowledge, but I hope, too, they will realize the need to broaden their photojournalism education, and sharpen their focus on other than technical aspects. With advanced photography in mind let them probe inquiringly and honestly into the very heart and soul of photocommunication.

Because the book was different and because it offered much material not previously available in book form, *Photojournalism, Principles and Practices* was well received. Photojournalism is a living, changing thing, however, and any appreciable lapse of time requires that texts be revised. It has been only a few years since our first edition was published, but changes in the field dictate that a revision is now in order.

This revised edition is far more than an updating; far more than a face-lifting. The new *Photojournalism, Principles and Practices* has undergone a major operation. It contains more information, is more interesting, and easier to read than ever before.

As far as organization is concerned, the book begins with a brief treatment of photography and photojournalism which takes us from the days of woodcuts through to the well printed, well illustrated publications of today. After this, we listen to experts in research; we also learn the latest about "legal aspects." Young people who have achieved success tell us how they learned to get along in this highly competitive field and—we have a good look at the future.

The book contains twenty-three inspiring chapters, all of which guide the learning process through interesting discussions and pertinent questions designed to stimulate "student participation."

The text provides an up-to-date bibliography for special readings, and for those who want to build their own helpful library. In the appendix one finds a detailed explanation of what Q-sort is all about; there, too, one can refer to a helpful listing of photojournalism organizations, as well as a list of photo competitions in this country.

Like its predecessor, the new edition is the work of a number of writers. Among new names in the book is that of Dr. John Merrill, who gives his views on ethics, and Bill Eppridge, the young man who became a *Life* staffer and photographed, among other tragic news events, the assassination of Robert Kennedy. In the new edition, too, H. Michael Sell tells how he went into the weekly newspaper publishing business when photographic jobs were not available. And James Holland, a young Boston freelancer, explains how and why he got into the business of producing photographic books.

*Photojournalism, Principles and Practices,* is a collection of comments by experts. Rather than "pick their brains" and translate their messages, I stood aside to let their words come directly to you. Thus, we have avoided dilution and have increased the value of this book.

Contributors are friends, former co-workers, former students in the School of Journalism, or the Missouri Photo Workshop. I am happy to share my platform with this hard-working, dedicated group. If thinking of me as "editor" rather than as "author" will add to the stature of those who have written articles, loaned pictures, or in any other way have contributed to this volume, please do so. They have given me information which I sought for my students during my 30-year teaching career. What budding photojournalists read in this book will, I hope, help direct them to a successful career.

Roy Stryker once told me that photography students should have access to dozens and dozens of fine pictures. Put them on a table—let your students learn to know them as friends. That's what we've done with this book. We've given you a great collection of photographs. Learn to read them. If you familiarize yourself with the photographs and the captions in this book, you will have an idea of what has happened, as well as an idea of what will happen, in the future of photojournalism.

Clifton C. Edom

ix

# Acknowledgments

Grateful acknowledgment is made for the guidance, encouragement, and help given by the following persons: J. Bruce Baumann, Photo Director, the *Mercury-News*, San Jose, California; Hal G. Buell, Executive Newsphoto Editor, The Associated Press; Howard Chapnick, President, Black Star Publishing Company; Rich Clarkson, Photo Director, *Topeka Capital-Journal*; Joany and Randy Cox, Coffeyville, Kansas, *Journal*; Bill Eppridge, Sports Illustrated; W.E. (Bill) Garrett, Associate Editor, *National Geographic* magazine; Robert E. Gilka, Director of Photography, *National Geographic* magazine; Special thanks to Gilbert M. Grosvenor, Editor of *National Geographic* magazine, who gave so much cooperation and who was very generous in permitting use of *National Geographic* photos; Gifford D. Hampshire, Director of Documerica; Wayne V. Harsha, Executive Editor of the *Inland Printer*, and *American Lithographer*; Herb Hemming, Associated Press; James R. Holland, freelance, Boston, Mass.; Jack Kenward, Farmland Industries, Inc.; H. Edward Kim, Layout and Production, *National Geographic* magazine; Bill Kuykendall, freelance and editor of a mining magazine, with headquarters in Keyser, W. Va.; Brian Lanker, formerly with photo department, *Topeka Capital-Journal*, now photo director, The Eugene, Ore., *Register-Guard*; David Lipman, Assistant Managing Editor, *St. Louis Post-Dispatch*; Giorgio Lotti, *Epoca Magazine*, Milan, Italy; F.W. Lyon, Vice President for Newspictures, United Press International; Prof. Angus McDougall, Director, Photojournalism, School of Journalism, University of Missouri, Columbia; Dr. John C. Merrill, Distinguished Professor, University of Maryland; Dr. Keith P. Sanders, Professor, Communication Research, School of Journalism, University of Missouri, Columbia; H. Michael Sell, The *Monroe City News* (Mo.); Verna Mae Edom Smith, Teacher, Researcher, and Consultant in Sociology, Northern Virginia Community College, Alexandria; Dale R. Spencer, Professor of Journalism, University of Missouri, Columbia; Dr. William Stephenson, Distinguished Research Professor, Emeritus, School of Journalism, University of Missouri, Columbia; William H. (Bill) Strode, III, formerly assistant director of photography, The *Courier-Journal* and *Times*, Louisville, Ky., and now William H. Strode, Associates; Jerry Umehara, Foreign Picture Editor, United Press International; Arthur L. Witman, St. Louis. A special thanks is due all former students, co-workers, and friends who gave permission to use their photographs in this book.

# Introduction

In 1951 a book titled *Picture Editing,* directed to photojournalism students, free-lance photographers, and newspaper and magazine workers—to all concerned with pictures as a communications tool—was published. The principles set forth in the foreword, written by the late Frank Luther Mott, Dean of the Missouri University School of Journalism, are as applicable today as they were a quarter of a century ago. Dr. Mott wrote:

Photojournalism is growing up. It seems only yesterday that the news photographer was looked upon as a queer fellow—half artist and more than half roughneck—and his product was referred to as the "embellishment" of a story or feature. But now, having had an opportunity to observe pictures supplied in rich profusion, and having studied the function of pictures in a world full of them, we who are concerned with producing newspapers and magazines have been forced to take a different attitude. To put it colloquially, we've got a different slant on the whole business. We know that pictures are just as definitely reporting as the written story is. Whether pictures are better reporting than words depends on many factors in individual cases, and is a purely academic question anyway. The point is that they are a necessary part of reporting today.

And if they are reporting, they must lend themselves to the requirements of reporting—timeliness, accuracy, honesty, and so on. Further, they must submit to the techniques of editing just as news stories and features must. Pictures are today an extremely important part of journalism, and we must increasingly regard them as integral with all of journalism. They are, indeed, integral with all of modern communication, not only in newspapers and magazines, but in books, in motion pictures, in television, in advertising, in education. . . .

The authors of this book *[Picture Editing]* are committed to this principle of integration. They are striving to apply to pictures the best editing techniques that have been developed in the wide field of communications. . . .

The literature of photography is growing: and that is an especially good sign because it indicates that photographers are thinking about their craft. Too long the camera has been a plaything and a gadget. It will always have something of that appeal, but serious cameramen are now realizing that their craft has some of the elements of a profession: it has to be studied, and its use brings responsibilities. There should be a reason for every picture. We have only begun to explore the possibilities of *significance* in photography. It takes thinkers and scholars to lead us in this direction, and books and serious articles and professional associations and schools and seminars. These phenomena of an expanding field and a new profession we are now witnessing. . . .

Present-day leaders must be more versatile, must know a great deal about many things. Today the job market is tougher. Competition is keener. If one makes good in photojournalism today and in the future, he must have greater all-around knowledge than was necessary twenty-five to fifty years ago.

To make sure that all of us are on the same wavelength, let's define the term *photojournalism.*

In either the print or electronic media, persons who record a news event with a camera are photo reporters, photo communicators, photojournalists, if you will. But in either television or newspapers, trade journals, and magazines, the photographer is not one whit more a photojournalist than is the picture editor or photo director who sends him on assignment. After the cameraman has returned, the editor must select the picture or pictures which are to appear before the public, and may also do the picture layouts and plan how they are to be presented.

Some modern newspapers have gone beyond this. To ensure the best use of pictures, words, and type, they employ an art director or a director of graphics. The workers who fill these positions work in the field of photojournalism and are, therefore, photojournalists. They, like photographers, are specialists.

Wilson Hicks emphasized the belief that photojournalism is a partnership affair. Among Mr. Hicks' important conclusions, gleaned from many sources are the following:

"An *idea* can come from copy or art. No difference. They both deal with images, either words or pictures . . . copy and art ought to fall in love with each other."

"A clear, concise presentation of the principles of creative advertising [should be] based on the premise that copy, layout, and typography must combine to achieve a simple effect."

"What holds for advertising holds for nonadvertising matter. . . . Layout and graphic display play an important part in joining visual images. Typography, when used in the spirit of the story, can become a transitional element uniting words and pictures."

# 1

# In the Beginning

Ours is a visual age. Pictures are important whether we see them on television, in books, in newspapers, or in magazines. The camera stops a bullet in flight . . . permits us to see man's first step on the moon . . . even lets us examine the miracle of life itself.

To better realize this age of pictures and to savor more fully the "visuality of our time," let us glimpse into the past. Nearly a hundred years ago, Mason Jackson, a perceptive and observant Englishman, wrote:

> The inherent love of pictorial representation in all races of men and in every age is manifest by the frequent attempts made to depict natural objects, under the most unfavourable circumstances and with the slenderest means. The rude drawing scratched on the smooth bone of an animal by the cave-dweller of prehistoric times, the painted rocks of the Mexican forests, and the cave paintings of the Bushmen, are all evidences of this deeply-rooted passion. The child of civilized life looks with delight on his picture book long before he can make out the letters of the alphabet, and the untutored Esquimaux treasures up the stray number of an illustrated newspaper left in his hut by the crew of some whaling ship, though he cannot understand one word of the printed page. But the pictures speak a universal language, which requires no teaching to comprehend.[1]

Predating the alphabet by thousands of years are the paintings and carvings on the walls of the caves of ancient man. In remote areas of Spain, France, Italy, and India remain crude "pictographic records." Hunts, battles and skirmishes, births, deaths—events which took place centuries ago—are, thanks to the fact that they were recorded, subject to visual review.

The story of the illustrated press is long. The illuminated manuscripts of ancient Egypt are thought by some authorities to be the first chapter of that story, and the second chapter, which followed closely, in the minds of these experts, was the use of woodblocks in the manufacture of playing cards. Soon after came newssheets—one-page, one-shot illustrated publications which recorded the story of a flood, war, famine, or other disaster.

In the hazardous journey from the early crude engravings to the fine woodcuts of Thomas Bewick (1753–1828) wood engraving as an art form many times stumbled and fell, even after reaching its peak. The illustrations that appeared in the early press made this fact abundantly apparent. However, once the quality of wood engraving had stabilized and the form had become an

**Recording history with pictures began thousands of years ago on the cave walls of ancient man.**

---

1. Mason Jackson, *The Pictorial Press: Its Origin and Progress* (London: Hurst and Blackett, Publishers, 1885).

◄The sketch artist in the mid-1800s followed a genteel profession. Dressed in top hat and frock coat, John W. Barber, well-known sketch artist-historian, made many trips throughout the nation prior to the Civil War. This engraving from a photograph appeared in the book *A Panorama and Encyclopaedia of the U.S.* by John W. Barber and Henry Howe.

accepted commodity, illustrated publications gained an important rung on the ladder of mass communications. The wedding of words and pictures, a wedding which is recognized even today, did much to enhance the printed page.

Although both the camera and an embryonic form of photographic reporting were known in the 1840s and 1850s, illustrations then and for many years afterward were, for the most part, the work of sketch artists. True, in 1855 photographs of the Crimean War by Roger

Fenton appeared as woodcuts in the *London Illustrated News,* and photographs of the Civil War by Mathew Brady and his staff appeared in the same manner in United States publications. Nevertheless, the main source of illustrations remained the sketch artists who with pad and pencil recorded the scenes before them. Although they were not entirely honest in their portrayals, the sketch artists could stop the action of war—something the cameramen of the 1850s and 1860s could not do.

Even so, the outbreak of the Civil War in the United States was propitious for the publishing industry and served as a stimulant, especially to the growth of the illustrated press. In the June 1, 1861 *Leslie's Illustrated Newspaper,* we find the following words:

OUR ARTISTS IN THE FIELD: Long before the commencement of hostilities, we made arrangements for thoroughly illustrating every event that might arise out of the national difficulties.

We enjoyed the services of first class artists and photographers in all cities and towns within the circle of probable hostilities. We also sent out several artists at a very heavy cost on special missions to the South and West. . . .

From these gentlemen we receive 20 to 40 sketches per day. . . . From this immense mass of authentic matter we select the most striking, and transferring them to our columns, present them in *Frank Leslie's Illustrated Newspaper,* the only correct and authentic illustrations of the war.[2]

Equally enthusiastic were spokesmen for *Harper's Weekly.* In an advertisement in the March 15, 1862 issue, we read:

The crisis which the war has reached imparts fresh interest to the war pictures which are appearing in every number of *Harper's Weekly.* We have now regular Artist Correspondents, to wit: Mr. A.R. Waud, with the army of the Potomac; Mr. Alexander Simplot, with Gen. Grant's army; Mr. Henry Mosler, with Gen. Buell's army; Mr. Theo. R. Davis, with Gen. Sherman's army; Mr. Angelo Wiser, with Gen. Burnside's army, besides a large number of occasional and volunteer correspondents in the Army and Navy at various points. These gentlemen will furnish us faithful sketches of every battle which

takes place, and every other event of interest, which will be reproduced in our pages in the best style. People who do not see *Harper's Weekly* will have but a limited comprehension of the momentous events which are occurring.[3]

Photographic histories (see Bibliography pages 315–17), have been written many times and have been done far better than this writer could ever hope to do. Interesting as they are, therefore, we do not propose to devote time or space in this book to retelling the story of photography. Even so, we believe it is fitting and proper to pay brief tribute to some of the greats whose lives were dedicated to the invention and advancement of photography.

To begin, let us go back to Euclid 300 B.C., and to Leonardo da Vinci in the 15th century. Both understood the principles of photography and Da Vinci, through experiments with the camera obscura, made profound contributions to our visual age.

Among other patron saints of today's photojournalism, we find the names of Louis Jacques Mandé Daguerre, often referred to as the father of photography, and to Daguerre's renowned partner, William Fox Talbot. Then, of course, there was Joseph Nicephore Niepce (pronounced Knee-eps), Thomas Wedgewood and others.

Pioneers in the continuing story of photojournalism, too, were Samuel F.B. Morse, Mathew Brady, and many, many others.

Who, for example, would want to forget the great work of Frederic Eugene Ives and Stephen Horgan in the field of halftone reproduction? Who would want to forget Thomas Edison, Alexander Graham Bell, Marconi, DeForest, and thousands of others whose combined contributions have added the miracle of modern audiovisual communication?

By 1870, film and photographic equipment had improved, but even then "slow" film, lenses, and inadequate shutter mechanisms were unable to stop appreciable amounts of action. Just as important to publishers was the fact that the halftone was in an experimental

2. *Frank Leslie's Illustrated Newspaper,* 1 June, 1861.

3. *Harper's Weekly,* March 15, 1862.

# THE

# Philadelphia Photographer.

## EDITED BY EDWARD L. WILSON.

| Vol. XVIII. | JUNE, 1881. | No. 210. |

## THE DEATH OF M. ADAM SALOMON.

IT is with most profound sorrow that we announce the death of Mons. Adam Salomon, the famed sculptor, the master photographer, and our beloved friend, whose name and fame are well known to our readers. He died last month at his home in Paris, near the Bois de Boulogne.

Further details may be found in our French correspondence.

In our next issue we shall give a sketch of his life and work, and "Our Picture" will be a "mosaic" made up of some of his best works, and include a portrait of our lamented teacher also.

## FOX TALBOT.

THE *Photographic News*, of March 11th, was accompanied by a photo-engraving of the distinguished photo-scientist, Mr. Fox Talbot, which we have caused to be reproduced and present below, that our readers may become familiar with the features of one to whom they owe so much. Mr. Talbot was born in 1800 and died in 1877. He began in 1839, with Daguerre, to publish his discoveries to the world, and we are in-

debted to him for the paper-printing process substantially as used now; the development-printing process; the albumen-porce-

lain process; an instantaneous negative process, and a fifth invention was a method of photo-engraving. The process by which the above picture was made, belongs to this last family, and may be appropriately used here to help keep alive the memory of one who has done so much towards the growth of our art.

11

◄The June, 1881 issue of the *Philadelphia Photographer* paid tribute to the memory of William Fox Talbot.

stage. It was impossible to reproduce the tonal range of a painting or a photograph. These accomplishments would come later.

In deference to the profession of photography which it represented and to its desire for good illustration, *The Philadelphia Photographer*, a monthly magazine, used actual photographs as frontispieces. The quantity naturally was limited. Mass production of photographs was slow and expensive. Such operations were restricted to small circulation publications. Illustrative material for the total press—for books, magazines, and newspapers—required thousands of sketches and wood engravings, with a sizable number of steel engravings and lithographs for good measure.

▲
*Above,* A self-portrait showing sketch artist Mr. W. Waud appeared in *Frank Leslie's Illustrated Newspaper,* May 31, 1862. With shells exploding all around him, Waud nonchalantly goes about the business of sketching the battle.

# Student Participation

Predating the alphabet by thousands of years, cave paintings are among the earliest records left by man. Illuminated manuscripts were next, and were followed by the use of crude woodcuts and the beginning of the illustrated press.

For many years sketch artists were the source of book, magazine, and newspaper illustrations. Human beings have always been interested in "visuals," and the United States citizen of the 1860s learned much about the Civil War by perusing woodcuts in *Leslie's Illustrated Newspaper*, *Harper's Weekly*, and other similar publications.

1. It has been said that ours is a visual age. Do you agree or disagree? Give reasons for your thinking.
2. Use an encyclopedia as a reference and prepare a brief report on early cave paintings.
3. Why was it impossible for Roger Fenton (Crimean War) and Mathew Brady (Civil War), using the cameras of their time, to stop appreciable amounts of action?

4. Judging from the pictures you have seen, would you agree with some authorities that Brady's photographic coverage of the Civil War was "the best" until David Douglas Duncan's pictures of the Korean War?
5. Brady used wet plates and cumbersome equipment. Compare his pictures with the informality of those made by Duncan with his fast film, fast lenses, and miniature equipment.

# 2

# Price of Progress

Technological changes, while important to progress, exact a toll. When the typesetting machine was invented, for example, it increased production of printed matter beyond the fondest dream. Even so, at some levels the change caused dissension and brought on genuine hardship. One mechanical typesetter could do the work of dozens of hand compositors—could do it much faster, easier, and at considerable saving. Describing the "encroachment," a Canadian newspaper publisher in 1950 told his readers:

> In the early '90s, people knew very little of the practical application of electricity; nothing of airplanes; nothing of automobiles or of motor boats. The telephone had been in practical use only a few years and was but little used, and the electric light was still a novelty. . . .
>
> Editions of daily newspapers consisted of 8, 12, and 16 pages, and up to 100 hand compositors were quite frequently employed to get out big Sunday editions. The largest and fastest presses of the time could not print in a day as many copies as a modern press can turn out in a half-hour. Five of the fastest hand compositors in the world could not then produce as much type as a typesetting operator of equal comparative ability can produce today.

The Linotype[1] came into practical use in daily newspaper offices when I was a small boy, but I can remember its advent caused a feeling of uneasiness, almost a feeling of consternation, among hand compositors of the day. At the time (1896), three or four of the straight-matter hand compositors employed by my father in the production of a small-city daily newspaper in the middle West made a visit to a nearby larger city to see the new Linotypes which had just been installed. . . . One of them was so discouraged with the future prospects of the hand compositor in the printing business that he quit his work as a printer, and took up another occupation. In fact, the feeling was somewhat general among printers throughout the world that the day of the hand compositor was fast drawing to a close.[2]

**Progress, although of benefit to the masses, usually extracts a penalty from a few.**

1. Trade name for the typesetting machine produced by the Mergenthaler Company. Intertype and Linograph were trade names for other typesetting machines soon on the market.

2. Frank M. Sherman, ed. and compiler. *The Genesis of Machine Typesetting* (Chicago: M & L Typesetting & Electroplating Company, publisher, 1950).

# Genesis of the Illustrated Press

The genesis experienced by the picture portion of the illustrated press was just as painful. Like the hand compositors whose jobs were nearly obliterated by the typesetting machine, many sketch artists and wood engravers were adversely affected by the arrival of photoengraving. One example was the artist-engraver W.J. Linton who waged a bitter war against the publishers of his time. Battle lines were drawn in 1879 when *Century Magazine* made the claim that "from the moment our magazine began to avail itself of the art of photographing pictures upon the wood (in preparation for the engraver) a great development took place."

Linton, a fine artist and an excellent wood engraver, challenged the statement in his book *Wood Engraving, A Manual of Instruction*. In that little volume, Linton wrote:

Photographing on wood will save the time of the draughtsman, when a reduction of a drawing or a picture is wanted. If you must have the lines of the larger facsimile drawing, you can only get them by photography. . . . Use it then! . . . But, if you would have the best copy of a picture, do not be content with a photograph! The "correctness" of photography is a mistake. It is never correct. It always alters colours, and more or less disturbs effect. . . . The artist-copier translates the painting into black and white, so making a truer copy than the photographer's; and he puts on the block only what he knows can be engraved, helping the engraver by saving him the unpleasant and dangerous task of leaving out. Let the draughtsman economical of time have the picture—especially a portrait—photographed on the block, and then draw his translation over that. The engraver will be grateful to him.

It may not be uninteresting to give account of the origin and occasion of this photographic usage, which was certainly not invented for the benefit of engravers. . . . It was invented by or for artists who could not draw on wood. . . . From newspaper work, the new system spread to book-work; and following a long, cheap system of careless facsimile—fairly exemplified in early numbers of *Punch* . . . gave the death-blow to engraving as an art. . . .

For the mechanic-engraver, the days of engraving are numbered. Only the artist-engraver, while he upholds the dignity, can assure the future of engraving. Beware of photography![3]

In agreement was Linton's fellow countryman Mason Jackson of Britain who believed "Sir John Gilbert was the very foremost" in establishing the pictorial press. In his book, *Pictorial Press*, Jackson pointed out:

Other Royal academicians and eminent painters have drawn on wood for the illustrated press, but Gilbert stands out preeminently the great popular illustrator of the Victorian age. He it was who first gave a distinctive character to the illustration of news. He seemed to possess an inborn knowledge of the essentials of newspaper art, and could express by a few freely drawn lines and touches the hurried movement of street crowds or the state and dignity of Court ceremonies. Whether Gilbert had to draw a knight in armour or a gentleman in paletot, he did it in a way exactly suited to rapid engraving and printing.[4]

In March 1880, the same month and year in which a halftone engraving appeared in the daily press, *Scribner's Monthly* had a rather caustic report on Linton and his book:

The main difference between the old and the new schools, as they have been called, concerns the limits and the function of wood engraving. Here Mr. Linton's conservatism is apparent. He would have nothing called wood-engraving that is not done mainly in "pure line." And would permit no progressiveness. The new school, on the contrary, is intent upon experiments with new methods of a less conventional kind. Between the two, this

---

3. W.J. Linton, *Wood Engraving, A Manual of Instruction* (London: George Bell and Sons, 1884).

4. Mason Jackson, *The Pictorial Press, Its Origin and Progress* (London: Hurst and Blackett, Publishers, 1885).

◄ Soldiers of the Civil War (and many soldiers earlier) often complained that sketch artists were not truthful. Examples were cited where a battle was shown with the participants in full dress. The steel engraving of a painting by Alonza Chappel of Horatio Gates is an example of over-romanticizing. It remained for photojournalism, nearly a century later, to give the true story of combat.

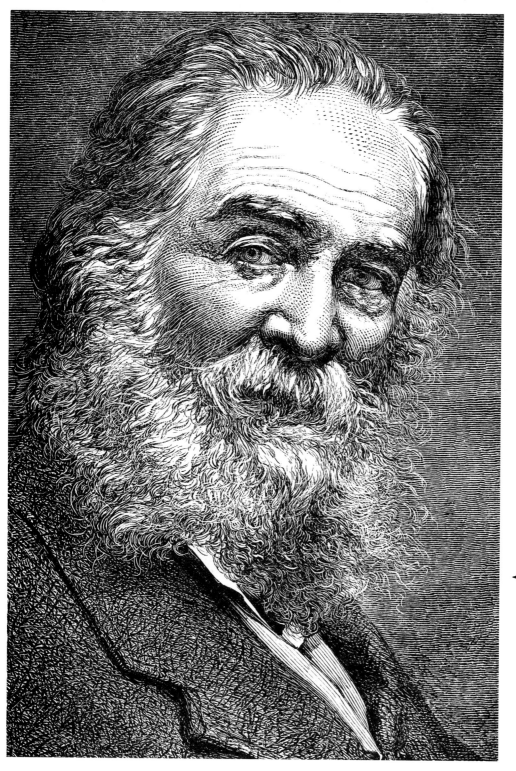

◄This excellent illustration of Walt Whitman *(left)* is a fine example of what a "good engraver" could do. To produce this portrait, W.J. Linton drew it from a photograph and transferred the sketch, without the aid of photography, to a wood block. The image was then engraved. In his book *Wood-Engraving, a Manual of Instruction* printed in London in 1884, Mr. Linton used this portrait as an example of the type of work which would outdo those engravers who had come to depend so much on photography.

magazine, though it originated the experiments, has never discriminated. It has never said "we will have no pure line," or "we will have nothing but pure line," but has left the engraver free from dictation, and has tried to judge his work on its merits. Where we have liked the new style, it has not been because of the technique, but of the results. . . . The very men whose experiments Mr. Linton decries may yet prove that, even with his methods, better results are obtainable than his school has yet produced.

This difference of opinion, as to the limits of wood engraving, finds its battleground chiefly on the question on the use of photography—a question quite apart from the intrinsic value of the photograph as a work of art. The artists, and most of the engravers, prefer the results of its use while Mr. Linton will have none of it, and declines to engrave pictures so transferred to the block. . . .[5]

Five years later the question was still unsettled. In a "Word About Our Pictures," W. Lewis Fraser of *Century Magazine* wrote in the January 1885 issue:

5. *Scribner's Monthly*, editorial, March, 1880.

Something more than twenty years ago, drawings were made on the wood block, and cut on the drawn surface. The designer of that period was happy if he saw given back to him the dry bones of his design with such alterations of light and shade as best suited the method of the particular engraving. Then came, fostered and encouraged and developed by this magazine, the new school of American wood engravers mainly induced by the return from Europe of many promising young artists who in foreign schools had learned new methods of art expression, and who the management of the magazine thought should have a hearing. Marvelous reproductions of these men's work were made by the engravers of this new school—notably by Timothy Cole and the late Frederick Juengling; but the fault of the school, with some individual exceptions, lay in the too slavish imitation of surfaces and textures, and the artists, who at first were delighted after a while complained that their forms, the expression of their faces, and their artistic intention, were not satisfactorily reproduced. Then

In his war against photography as a tool for the wood engraver, Mr. Linton singled out Timothy Cole of *Scribners* and later of *Century Magazine*. Cole made a trip to Europe where he learned a new style of engraving utilizing the photograph. The portrait of Abraham Lincoln which, engraved from a portrait done by Wyatt Eaton, shows Cole's earlier style. The portrait of Paul Potter *(above, right)* done for *Century Magazine* in the 1890s shows the new style of engraving done by Timothy Cole after he began to use photography.

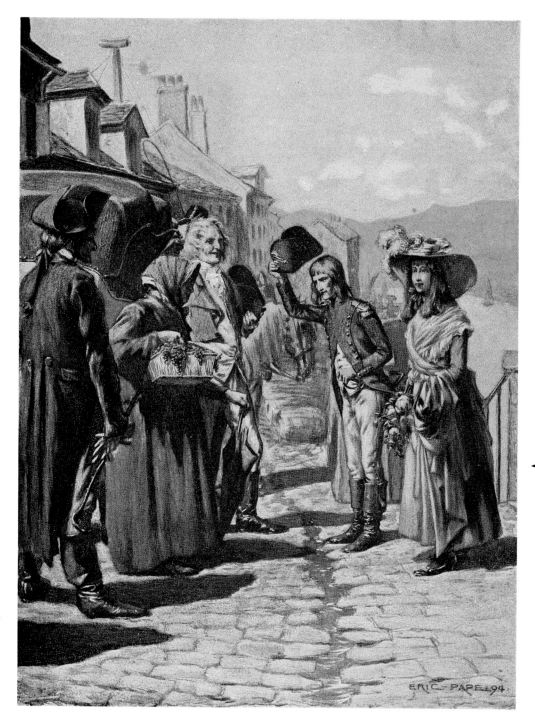

In the continuing battle of wood engraving versus halftone, *Century Magazine* in January 1895 conceded that the ultimate in illustration would probably be a combination of photoengraving and hand engraving. As an example editors cited the illustration *(left)* showing Napoleon on his way to Corsica with his sister Elsie. The drawing by Mr. Pape was first made into a halftone plate. Using his engraving tools, Mr. Pape then dropped out several of the highlight areas to add contrast and snap to the halftone. *Century* editors liked the combination very much and predicted that if any type of illustration was to replace the wood engraving this probably was it.

came the half-tone process, which claimed to be able to reproduce the work of the artist by mechanical means, and without the intervention of the engraver. It was hailed with delight by the most serious of the artists because it was supposed, being a mechanical process, to be faithful to the original. But it was true, and still remains true, that this new process is largely what its name implies—a *half-tone;* that is, as the deepest darks cannot be rendered by it, nor the highest lights, only the middle of the scale of the drawing can be reproduced. . . .

A year or two ago it seemed as though the noble art of wood engraving would be, through the popularity of half-tones, lost to the world. But the American engravers, realizing the situation, resolved, if they must die, to die game. Learning its deficiencies as perhaps they never could have done, had their art remained as pop-

ular as it was at one time, they have set themselves heroically at work to make the deficiencies good; and they are today, as may be seen from the wood engravings in this number of *The Century*, making a good fight. They have emancipated themselves largely from the slavish adherence to texture and meaningless detail and are engraving with definite reference to the artistic intention of their originals. This is evident in a more or less degree in all the engravings printed in this number from the work of the veteran Timothy Cole to that of the youngest acquisition to the ranks of first class engravers.

Working in this manner, and with this impulse, there is little danger of the death of their beautiful art unless it should be brought about by the last movement shown in the reproduction of the drawing by Eric Pape. . . . This is an entirely new development—a half-tone plate originally worked over by the wood engraver until about one-half of its surface has felt the touch of the engraver. Those portions of the reproduction where the mechanical process has been adequate have been left

untouched; where the mechanical process failed to produce the effect of the original, the engraver has not merely supplemented it, but in many places replaced it entirely. For some time it has been the practice for engravers to retouch process plates by reentering the lines, in order to lighten the tones, and by burnishing, to deepen the darks, but this new reproduction not only does that, but takes the bull by the horns, and frankly substitutes engraving where the mechanical process fails. . . . First-class wood engraving is ten times dearer than good half-tone; engraved half-tone costs three or four times as much as unengraved or ordinary half-tones. *The Century* uses these various methods solely with reference to the fidelity with which they reproduce the difficult-to-be reproduced drawings of today.[6]

But in spite of all of the arguments, the photograph was destined to replace the sketch, and the halftone, because of its ability to reproduce a photograph "direct from nature," sooner or later was to replace the wood engraving.

For many years it was impossible to stop action with a camera. Then sketch artists such as Frederic Remington really came to the forefront. The Remington drawing shown here, used by *Century Magazine* in 1891 in the story of "Custer's last stand," shows a tremendous amount of realism and fidelity. Remington, unlike his contemporaries and many of the sketch artists who preceded him, did not romanticize his subjects. Perhaps that's the reason a few years later William Randolph Hearst gave him an assignment to sketch the Spanish-American War in Cuba.

6. W. Lewis Fraser, "A Word About Our Pictures," *Century Magazine*, January, 1885.

# Appletons' Journal

### OF LITERATURE  SCIENCE  AND ART.

Entered, according to Act of Congress, in the year 1869, by D. APPLETON & CO., in the Clerk's Office of the District Court of the United States for the Southern District of New York.

No. 17.—With Supplement.]　　SATURDAY, JULY 24, 1869.　　[Price Ten Cents.

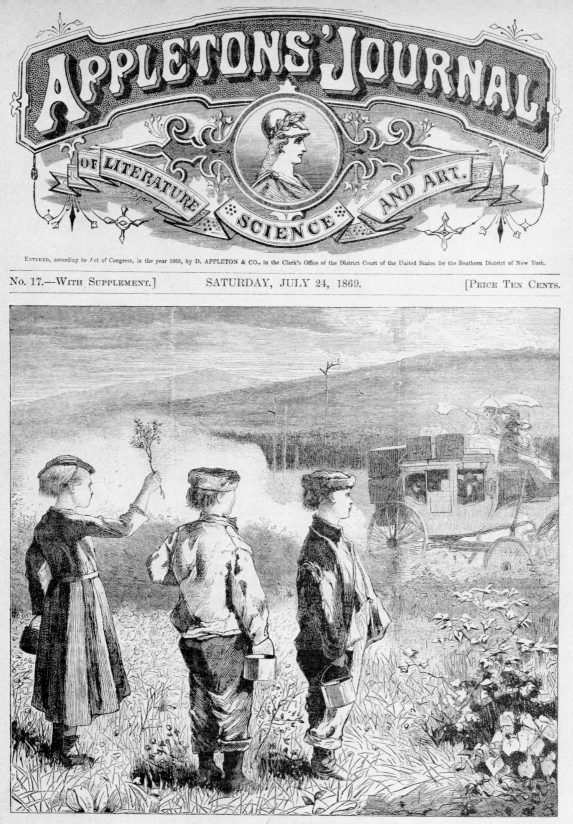

ON THE ROAD TO LAKE GEORGE. By Winslow Homer.

Sketches by young Winslow Homer were often featured in *Appletons Journal of Literature, Science and Art* and in other contemporary publications. In this illustration for the cover of the July 24, 1869, issue we see the sensitivity and skill which before many years were to produce Winslow Homer the great painter of seascapes—a man whose paintings remain feature attractions in nationally known art museums.

14/Price of Progress

# Some Sketch Artists

Incidental to the transition, let us briefly follow the careers of a few artists. Alfred A. Waud of *Harper's Weekly* was among the better-known Civil War sketchers. In 1866, two years after the war had ended, the *Harper's* management sent Mr. Waud on an extended tour of the South "to illustrate the rising of a new world from chaos."

Another increasingly famous artist was Thomas Nast. He first achieved prominence during the rough and tumble times of the Civil War and continued to grow in stature long after the struggle had ended. Nast is better remembered today as a caricaturist and satirist than as a combat artist, especially for introducing the donkey as the symbol of the Democratic party, the elephant as the symbol of the Republican party, and the tiger to symbolize Tammany Hall. Nast's caricatures, more than any other factor, were credited with breaking up the William M. (Boss) Tweed Ring.[7]

Winslow Homer was another Civil War artist who gained prestige after the end of the war. His skill and sensitivity as a young artist on the battlefield foretold the honors he later won as a painter of seascapes.[8]

Others, notably Frederic Remington and Charles Russell, "artists of the Old West," helped bridge the gap between sketch artist and photoreporter. Remington, who did many illustrations for publications of the 1870s and 1880s, was hired by the Hearst publications as a sketch artist during the Spanish American War in 1898.[9]

# Student Participation

Illustrations for magazines, books, and newspapers during the period 1850–1890 were for the most part produced by sketch artists and wood engravers.

1. Name three factors which prevented development of "an earlier photojournalism."
2. Why in newspapers, magazines, and books were the photographers destined to replace the sketch artists? Why was the halftone photoengraving (zinc and/or copper) destined to replace the woodcut?

---

7. Frank Luther Mott, *American Journalism—A History of Newspapers in the United States Through 250 Years—1690–1940* (New York: Macmillan Co., 1942). (Hereafter cited as Mott: *American Journalism—A History of Newspapers.*)

8. Lloyd Goodrich, *Winslow Homer* (New York: Macmillan Co., 1944; published for the Whitney Museum of American Art).

9. Mott, *American Journalism—A History of Newspapers.*

# 3

# The Halftone Takes Over

The ability to reproduce photographs through the printing process was so important to the development of photojournalism that it is well for us to probe the beginnings of photoengraving and the use of halftones.

The first halftone, A Scene in Shantytown, New York, "direct from nature," appeared March 4, 1880, in the New York *Daily Graphic.*

## The Halftone—Its Invention and Use

To share in this interesting historical event, and to put it in proper perspective, we turn to the booklet *The Beginnings of Halftone* by Lida Rose McCabe. Based on material in the notebook of Stephen H. Horgan, "Dean of Photo-Engravers," the story was originally written for *The Inland Printer*, also the publisher of Miss McCabe's *The Beginnings of Halftone*. In her foreword, Miss McCabe announced:

Through the courtesy of the editor of *The Inland Printer* the writer has been permitted to revise the following important bit of history. This was first printed in *The Inland Printer* for March and April, 1924.[1]

Here are excerpts from Miss McCabe's *Inland Printer* articles and her booklet which followed:

March 4, 1880, the day the New York *Daily Graphic* printed its first halftone [reproduction] of a picture (photograph) entitled 'Shantytown' marked the beginning of a new era in engraving and printing circles. It was on that day that photoengraving, [The first halftone reproduction, Horgan says, was in the March 4, 1880 *Daily Graphic,* and was produced using the lithographic, not letterpress, process.] as it is now known, first came into commercial use, and on that day and date were born the present revolution and evolution of the printing industry and the business world itself. In an illuminating article on "Photoengraving, The Mainspring of Progress in the Graphic Arts," Louis Flader [for many years Secretary of the Photo-Engravers Union and editor of the Photoengravers Bulletin] fixes the date of this epoch-making event. This comprehensive tribute to the importance of photoengraving appeared in the fortieth

▲
Halftone of the Late Seventies The screen used was made from perforated cardboard. The negative and screen are preserved among Mr. Horgan's notes.
From the booklet *The Beginnings of Halftone* by Lida Rose McCabe. (Courtesy of *The Inland Printer.*)

---

1. Lida Rose McCabe,*The Beginnings of Halftone* (Chicago: The Inland Printer, 1924) Foreword.

anniversary number of *The Inland Printer*, October, 1923. First reprinted in the *Photoengravers Bulletin*, October, 1923, the article since has been reprinted frequently both at home and abroad.

Mr. Flader's article substantiates not only the date of the first halftone printed, but dispels much misinformation on this vital subject. For a long time it has been the wont of writers and lecturers to attribute the invention of halftone to Meisenbach in 1882. Mr. Flader's statement that the New York *Daily Graphic* began the making of halftones two years before that date is amply verified. This first illustrated daily newspaper began publication on March 4, 1873, and for eighteen years, from 1873 to 1891 it did much to promote photo mechanical methods of illustration. For the first time in the history of the graphic arts, it proved that photography could be depended upon to produce illustrations with certainty, printing a newspaper daily through photography's aid.[2]

Years ago, while studying the history of halftone engraving, the writer visited Beaumont Newhall at the George Eastman House in Rochester, New York. Later, Mr. Newhall sent me a copy (see below) of an annotation by John A. Tennant of the passage on the alleged "first halftone" by Horgan of "Shantytown" in Newhall's book *The History of Photography:*

The first halftone engravings (Leggo, 1871—in Canada; Leggo 1873 and Horgan 1880 in N.Y. *Daily Graphic*) were *not* "relief blocks" as we understand the term today—capable of being printed with or without type in a typographic press.

Horgan's 1880 "Shantytown," the first halftone reproduction of a continuous *tone* original (photo) *made through a screen* was transferred to a lithoplate or stone and *printed on a lithographic press*. Today we would call it a half tone lithograph. The *Daily Graphic* was a demonstration house organ of the Graphic Co.—leading photolitho house of U.S. and all their work was printed lithographically on a litho press—not on a *typographic* press.

Halftone photoengraving in the form of "relief blocks" for printing in an ordinary typographic press began with Ives, Moss, Mumler and others (1878–1885) by various stereotype methods—gelatine relief casts, etc. But halftone engraving through a screen began with Ives (1883–1885)

◄ Stephen H. Horgan, the man credited with using the first lithographic halftone in a daily newspaper—the *Daily Graphic*, March 4, 1880. (Courtesy of *The Inland Printer*.)

although some say Meisenbach (1883), Petit (Paris 1875). These were all relief *blocks*—i.e. mounted type high on a wood or metal base for printing in a typographic press.

The *point* in Horgan's invention with the *Tribune* was a method of handling a halftone plate so that it could be printed from the *curved stereotype plate in a web perfecting press.*[3]

Miss McCabe's article, however, goes on to say:

The success of the *Daily Graphic* heartened capital and quickened experimenters throughout the world. Scientists, photographers, and experimenters in photomechanical methods at home and abroad subscribed to the *Graphic*, and studied its methods with the hope of improving them. . . .

Born in February, 1854, among the slaves of a Norfolk, Virginia plantation, Stephen H. Horgan showed throughout his school days a bent for drawing and a love of pictures. It was quite natural, he asserts with a humorous twinkle, that his life work should begin at the age of 16 years with photography learned from a Methodist minister at Nyack on the Hudson, New York. Young Horgan, on the sudden death of the minister, bought the photograph gallery from the widow and at 18 was proprietor of a studio. The panic of 1873 put him out of business. A year later he was in the employ of Abraham Bogardus, described in the October 1871

2. McCabe, *The Beginnings of Halftone*, p. 1.

3. Beaumont Newhall, *The History of Photography* (New York: Museum of Modern Art, 1949), pp. 222–23.

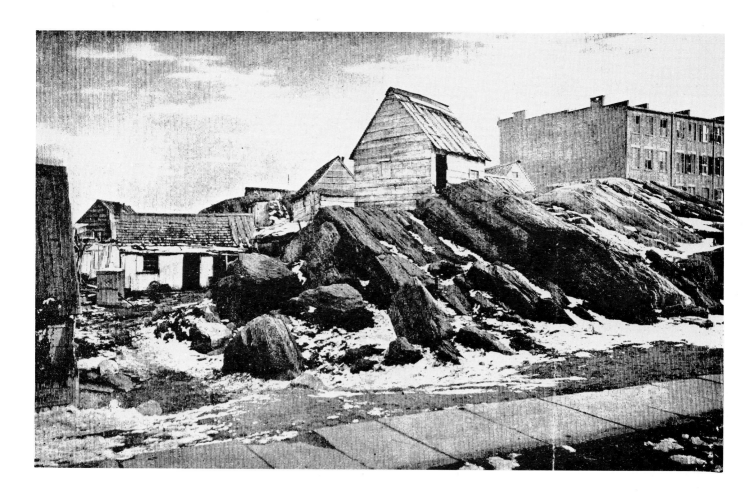

issue of the *Philadelphia Photographer* as "one of nature's generous and genial noblemen, as a photographer—none started higher."

Shortly after, the New York *Daily Graphic* advertised for a photographer. Horgan applied for the position and got it. . . . Out of nearly thirty applicants he was selected and put under a $5,000 bond not to reveal the *Graphic's* methods. Within three years, Mr. Horgan invented an improvement of the *Graphic's* processes and was given charge of the department, which at that time included the largest photomechanical equipment on the American continent. This was a tremendous responsibility for so young a man, but not too great for his tireless energy. . . .

The notebook of the young Horgan of this period reveals that as early as 1875 he was formulating (mentally) a method by which the gradations in opacity and transparency in an ordinary photographic negative might be translated into lines after the manner of wood engravers. He contemplated a line screen with gradations

from opacity to transparency, since called an "optical V," which screen inserted between the negative and the sensitized surface would by light action break the shadows in the negative into lines and dots. The only way to obtain such a screen . . . was to have a large drawing made of graded lines and photograph this drawing. The idea was carried out on October 25, 1876. . . .[4]

Mr. O.G. Mason, secretary of the American Institute, explained March 2, 1880, before the photographic section of that august body how Stephen H. Horgan made the first halftone ever to appear in a newspaper. Mason in a report which appeared in Anthony's Photographic Bulletin said:

I have here a print which might be called an advance copy of a supplement of the *New York Daily Graphic,* which will be issued two or three days hence. Knowing that I have taken a good deal of interest in the various printing processes which

▲
According to Stephen H. Horgan, who thus defined it in the January 1924 *Inland Printer,* the term *halftone* includes all pictures in which the lights and shades are defined by lines and dots of different surface areas made through a mechanically lined screen. The first halftone ever to appear in print was titled "A Scene in Shantytown, New York." Reproduced "direct from nature" *(see above),* only a single-line screen was used, not the crossline screen later made famous by Levy.

4. McCabe, *The Beginnings of Halftone,* pp. 1–2.

Following is the caption which appeared with the cover illustration in the March 4, 1880 *Daily Graphic:* "The reproduction of the front page of the New York *Daily Graphic* of March 4, 1880, shows what is now called a combination plate, a pen-and-ink drawing with a halftone inserted. The pictures on the easel are a reproduction in halftones of the double page in that issue. The woman's right hand covers the now famous halftone of 'Shantytown.' Pressmen of that day believed it impossible to print halftones made with a crossed line screen on a 'steam press,' consequently Mr. Horgan was compelled to make halftones with a single-line screen."

were founded on photography, the publishers, and Mr. Horgan, who has charge of the photographic work, took pains to send me this sheet. It is particularly interesting to *us* from the fact that it has in it a picture (Shantytown) made and printed in the power press directly from a negative by our chairman (Henry J. Newton). It is issued on this advance sheet and will be printed in the paper by the thousands, without the slightest touch of the hand on photographic work. The method of producing it may be described as follows:

A negative is made from a series of fine rulings slightly out of focus. The film of that negative is transferred by the use of collodian—or rather taken off and placed between the negative from nature and the bichromated gelatine film—a print made and treated as the ordinary photo lithographic prints are treated, the effect is to produce detail in the shadow parts, and where there is a light portion the ruling shows very slightly. . . .[5]

The important part of this report, and a point which Horgan, himself many times emphasized (and reiterated in the note sent me by Beaumont Newhall—see page 17), was that the print *was made and "treated as ordinary photo lithographic prints are treated."*

In a booklet titled "More About the Beginnings of Halftone" addressed to members of the American Institute of Graphic Arts, Horgan, in reply to a pamphlet by Frederick Eugene Ives,[6] July 1925, said in part:

Mr. Ives is peeved because the writer was honored "by the medal of a pretentious American society. . . ." Mr. Ives thinks this award was due to articles on "The Beginnings of Halftone" by Miss Lida Rose McCabe, published in the *Inland Printer* for March and April 1924 . . . Mr. Ives is mistaken. The valued medal has engraved on it: "Presented to Stephen H. Horgan for photo mechanical achievements, 1874–1924."

This portrait of Edward L. Wilson, editor, *Philadelphia Photographer*, appeared in the June, 1881 issue of that magazine (see footnote 6, below.) In another part of the publication, Mr. Wilson stated: "Cross Cup & West furnish for this number of the *Photographer* a portrait of the editor, engraved from life by the improved process." This process, patented by Ives, was used to make a halftone for letter press (not lithographic) printing.

Some of these achievements were enumerated by Edmund G. Gross in the presentation address, and included: "His experiments of 1877 and his making of a single-line screen halftone in 1880; his making of the first halftone printed on a stereotyping web perfecting press; his invention in 1881 of a method of photo-intaglio engraving; his part in the introduction of pictures in country newspapers and the great metropolitan dailies; his part during the present year in the sending of a color photograph by telegraph, and his books and other contributions to the literature of photoengraving."—*American Printer*, December 5, 1924.[7]

---

5. O.G. Mason, "Report of the Photographic Section of the American Institute," *Anthony's Photographic Bulletin*, March 2, 1880. Reprinted in McCabe, *The Beginnings of Halftone*, p. 3.

6. Frederick Eugene Ives, then at Cornell University, like Horgan, had done much experimenting with the halftone. Robert S. Kahan, University of Wisconsin, in a paper delivered at the AEJ convention in 1964, pointed out that magazines lagged behind in the use of photo-engravings but that the first magazine to use an Ives halftone was the *Philadelphia Photographer* in the June, 1881 issue. For more credit to Mr. Ives, as "inventor of the halftone" see W.E. (Bill) Garrett's article on the National Geographic magazine, pages 222–246.

7. Stephen H. Horgan, "More About the Beginnings of Halftone" (Speech delivered before The American Institute of Graphic Arts, July, 1925).

# The Photoengraving Process

Once the photoengraving process had been accepted, use of woodcuts was on the wane, and halftone engravings began to grow in stature. At the research session of the photojournalism division at the 1969 convention of the Association for Education in Journalism, Robert S. Kahan pointed out:

> Just how the halftone played an important role in the history of magazines is exemplified in the emergence of *Cosmopolitan, Munsey's,* and *McClure's.* These three magazines were harbingers of a new style in establishing themselves as major publications between 1890 and 1895. In taking their place, they also helped to establish photojournalism as a means of mass communication.[8]

The big problem with the application of photography to platemaking was not in reproducing the lines of a black-and-white drawing, but in reproducing the actual tones of a painting, a wash drawing, and more important at this juncture the tones of a photograph.

To capture the tonal range of a photograph and to transfer that gradation to the page of a newspaper or magazine, most of those experimenting with the photoengraving process in the 1870s realized that some sort of screen system was essential.

Preliminary to publishing the "Scene in Shantytown," Stephen Horgan evolved the theory that a negative made from a line drawing would show gradations "from opacity to transparency," and would, thus, break up the original pictures into different sized and shaped dots which on the printed page would give the illusion of highlights, middletones, and shadows.

The highlight dot in a relief printing plate (after etching) looks like a tiny toadstool; middletone dots vary in shapes and sizes. Shadow dots are tiny pinholes etched into the darkest portion of the plate. The tiny dots suggest a tone, which solid metal does not. The pinholes also add to the printability of the engraving.

When he first began experimenting with halftone, Horgan used a perforated cardboard as a screen. (See page 16).

Newspaper halftones made with a glass crosshatched screen and zinc engravings were very popular for many years. The Levy Brothers perfected manufacture of the glass screen and in the early 1900s sold thousands of them to publications which had "gone in" for pictures.

---

8. Robert S. Kahan, unpublished paper given at the 1969 AEJ convention, Berkeley, California.

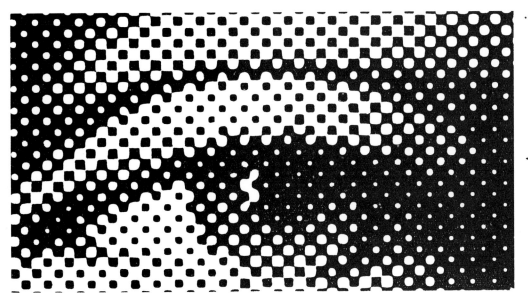

◄A magnified portion of a reproduction made through a cross-line halftone screen—an eye—is an optical illusion. Highlight, middletone, and shadow dots are used to interpret the lighter and darker portions of the original and the tones in between. Look at this illustration from a foot away, then examine it from across the room. At the latter distance it is quickly recognized.

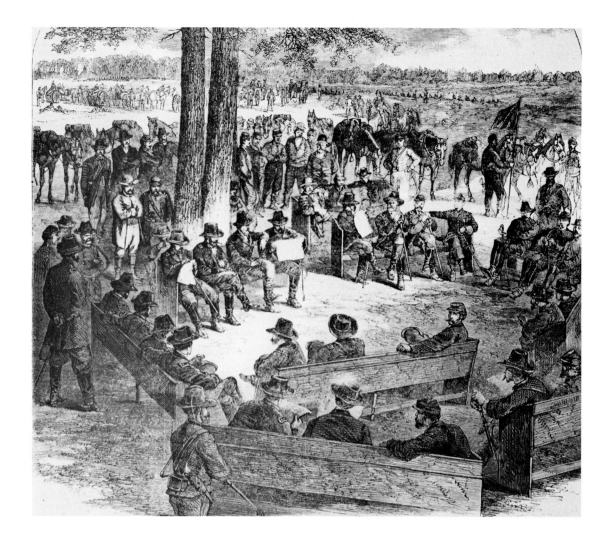

Letterpress, offset, and gravure are the three types of printing in use today. The development and perfection of each has greatly influenced the growth of photojournalism.

The photogravure plate, the exact opposite in appearance to the plate (or cast) used in letterpress printing, was described as follows by Herbert Denison in 1892:

. . . The gravure plate is one of metal, preferably of copper, which bears on its surface in intaglio an etched representation of the subject to be reproduced. In other words, the portions of the plate representing the shadows and halftones of the subject are sunk, instead of being the highest points—as in the case of half-tone and other blocks intended for use in ordinary letterpress printing—and the portions representing the highlights of the subject still retain the original level and surface of the plate.

. . . The mechanical nature of photogravure is distinctly in its favour for reproductive purposes; there is no opportunity for the individuality of the engraver to leave an impress on the print antagonistic to that of the painter. It is the work of the painter in its entirety that the reproduction should portray—not a portion only of his work contaminated with the style of another. . . .[9]

To better understand the gravure process, let us examine the old method used in making "engraved" (intaglio) calling cards. A metal plate (copper) is engraved, using acid or a cutting tool. The proper amount of ink is rolled onto the plate, after which the surface is rubbed clean, usually with the palm of the hand. During this phase, the engraved portion is undisturbed. Under pressure, ink from below the surface of the plate is forced onto the card. The

▲ ►
*Above,* a Civil War woodcut from a photograph by Alexander Gardner (then working for Brady) as it appeared in the July 16, 1864 *Frank Leslie's Illustrated Newspaper. Right,* the retouched photograph from a 1907 book published by Edward Baily Eaton, who owned a large collection of Brady photographs. Note how the photograph was "doctored" in the Eaton book, and how the illustration was drawn on the block before it appeared in *Leslie's.* The event was a council of war at Massaponax church in Virginia. Both the line cut and the halftone are examples of letterpress printing.

9. Herbert Denison, *A Treatise on Photogravure* (London: Iliffe and Son, 1892).

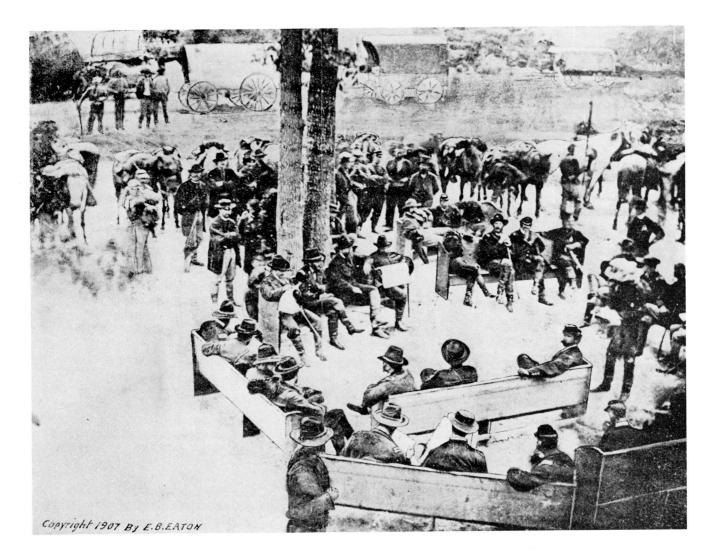

Copyright 1907 By E.B. EATON

deeper, wider portions yield the darker objects; the shallower, narrower portions of the engraving, on the other hand, transfer what appear to be the lighter portions of the symbol to the calling card.

No screen is needed in gravure printing, although a copper mesh (not halftone screen) covers the printing cylinder to hold the ink in place until pressure is applied. The squeeze of the press during the instant the cylinder comes in contact with the paper forces ink through the mesh. Dots thus formed are so fine that they hardly show in the finished product.

From the foregoing it would seem gravure has greater fidelity than do letterpress and offset printing. Generally speaking, this is true and this fact explains why many of the finest photographic books today are done by sheet-fed gravure.

In 1914, realizing the great potential of gravure printing, Adolph Ochs of the *New York Times* imported craftsmen and gravure printing equipment from Germany. Welcomed as the most faithful of reproductive mediums, the *Times* "roto supplements capitalized on this fidelity to give its readers fine reproductions of the world's greatest art pieces."[10]

Stimulated by the demand for pictures from faraway lands, camera reporting and gravure picture sections took on added importance during World War I. Photojournalism, then in its infancy, abandoned its swaddling clothes and began to grow up.

---

10. Stanley E. Kalish and Clifton C. Edom, *Picture Editing* (New York: Rinehart & Co., Inc., 1951).

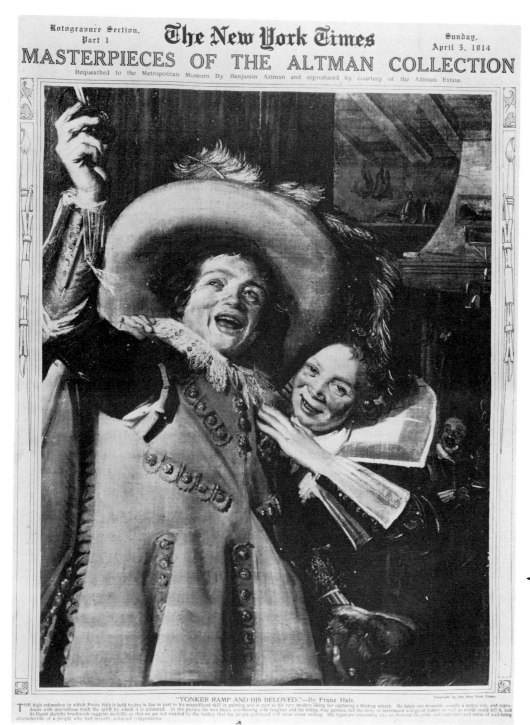

Rotogravure Section.
Part 1

# The New York Times

Sunday,
April 5, 1914

# MASTERPIECES OF THE ALTMAN COLLECTION

Bequeathed to the Metropolitan Museum By Benjamin Altman and reproduced by courtesy of the Altman Estate.

"YONKER RAMP AND HIS BELOVED."—By Franz Hals.

THE high estimation in which Franz Hals is held to-day is due in part to his magnificent skill in painting and in part to his very modern liking for capturing a fleeting aspect. He takes one moment, usually a merry one, and reproduces with marvellous truth the spirit by which it is animated. In this picture the two faces, overflowing with laughter and the blithe, free gesture, tell the story of merriment and good humor as well as words could tell it, and its fluent sketchy brushwork suggests mobility so that we are not wearied by the feeling that the people portrayed will never cease smiling. His types are interesting also as showing the pride and eagerness and sense of well-being characteristic of a people who had recently achieved independence.

◄First Sunday rotogravure section in this country appeared April 3, 1914 in the *New York Times*. A year earlier Adolph Ochs had brought equipment and workmen to this country from Germany. Originally intended as a means of "presenting masterpieces of art" to his readers, the Sunday roto section has become a magazine in every sense of the word. Most Sunday roto magazines today appear as tabloids, and good color reproduction is commonplace.

# Student Participation

In spite of the battle between the sketch artist and the wood engraver, the camera and the halftone were destined to take over by the turn of the century.

1. The three types of printing now in use are: Letterpress, photogravure, and photo-offset.
   a. Describe the characteristics of each.
   b. Which gives the most faithful reproduction of a photograph or painting?
2. Bring to class three examples of letterpress printing, of lithographic printing, and of photogravure printing. Use an encyclopedia or other source to learn the approximate date each came into use.
3. The key to invention of the typesetting machine was the spaceband. What was the key to development of the halftone photoengraving?

# 4

# Photo-offset Newspapers

Because of the increasing demand for more and better pictures in magazines and newspapers, each year since invention of the halftone screen the search for better methods of reproduction has continued.

Cold type, now widely used by newspapers throughout the country, probably came into national focus in December 1947 concurrently with the compositors' strike at the *Chicago Daily Tribune*. *The Tribune* explained to its readers:

For the last two weeks *The Tribune* has been published without the aid of printers. From a somewhat uncertain start, and utilizing makeshift methods, employes who remained at work since the strike of the typographical union have progressed steadily toward their goal: Production of a newspaper that affords the same news coverage, advertising, and public service as the prestrike editions.

Great strides already have been made, with present issues carrying more than double the news of earlier ones, legibility is much improved, and the speed of production increased. . . .

. . . The new type reproduction process required that virtually every bit of news matter and part of the advertising had to pass through the newspaper's photo-engraving department, adding greatly to its regular work. . . .

. . . In the linotype process, copy, either news or advertising, is sent to the composing room after it is written by reporters or copywriters. The linotype operator reproduces the words and letters in metal cast automatically by operating the keyboard of the machine which somewhat resembles that of a typewriter. . . .

In the photo-engraving process, the copy prepared in the editorial and advertising departments must be typewritten twice before it goes to the composing room. The first time it is written on typewriters in column form with a notation at the end of each line telling how many spaces have been taken in the line.

This copy goes to Varitype operators who adjust their machines according to the notations made by the pretypers so that each line in the column of the finally typed product is "justified," i.e., comes out even on the right hand margin. Thus these pretypists and Varitypists serve the purpose of a composing room in the new process.

The finished copy from the Varitypers, together with the original written material supplied by writers and reporters, is passed along to a table where editorial employes have been pressed into service to check the typists' copy against the original.

In the meantime, headlines for each story are written by copyreaders and sent separately to the art room where columns of Varityped material have been assembled. There the headlines are set by pasting strips of individual letters together with Scotch tape. When the typed stories

**The strike by compositors on the** *Chicago Daily Tribune* in 1947 gave us the first crude glimpse of the cold type and photo-offset newspapers which were to follow. (See pages 28–29.)

are brought in from the proofreaders they are matched with the proper headlines and pasted on sheets of cardboard which have been marked to show where news matter and advertising matter are to be placed on each page.

These pasted pages are sent to the engraving room where they are reproduced as zinc etchings by the photo-engraving process. The etchings are then put together page by page. Pictures and advertising displays are fitted into the news matter like pieces of a jigsaw puzzle until each page is complete. . . .

. . . Once all the pieces of the page are in place, the stereotype process of pressing a mat, drying it, and casting a type metal shell for the press cylinders is carried out in the usual manner. . . .[1]

Thus, the practicality of cold type was proved and more sophisticated "systems" of printing were just around the corner.

# The Cold Type Offset Process

Let us see how the *St. Louis Post-Dispatch*, a large and venerable Mid-west daily and Sunday publication went from letterpress to cold type offset production. The discussion that follows appeared in a special section of that newspaper at the time the changeover was made.[2]

## The St. Louis Post-Dispatch Spends $10,000,000 for Improvements

Radically new methods of printing and distribution are now being used by the *Post-Dispatch*, which is spending more than $10,000,000 in a program to improve legibility of the newspaper and provide much quicker delivery to readers.

New presses, computers, and other automated machinery have been put into operation, making the *Post-Dispatch* the first large metropolitan newspaper in the United States to be printed by the offset process instead of letterpress. In another major change, the newspaper is discontinuing use of hot metal in a switch to what is called "cold type."

The combination of cold type and offset printing is designed for more exact duplication of type and superior reproduction of pictures. Construction of an auxiliary printing plant in St. Louis county makes possible speedier delivery of papers to subscribers in outlying areas where population growth is greatest.

For almost 100 years newspapers have been using type that was set mechanically, by pressing keys on the clanking machine called a Linotype, a typesetter produced lines of type cast from molten lead, or hot metal. As he typed, he had to judge as best he could whether a line was running short and should be spaced out, or running long and should be compressed by allotting less space between words. Now this guessing is eliminated. A computer into which a dictionary has been incorporated takes care of spacing out the lines of type and hyphenating when necessary.

Abandoning the cumbersome Linotype, the printer now perforates tape by using a typewriterlike keyboard. The tape goes into the computer, then through a high-speed photocomposition machine. A lens in the photocompositor picks up images of type characters and transfers them to a paper film. After being run through a developing processor and dried, the picture of the type called cold type is pasted into the proper location on a page. Composition of advertisements is handled in the same way.

The *Post-Dispatch*, which also prints the *Globe-Democrat*, has installed five offset presses, each geared to print up to 55,000 papers an hour. A sixth press has been ordered.

The October 18, 1974 Research Institute Bulletin, published by the American Newspaper Publishers Association,

1. *Chicago Daily Tribune*, December 8, 1947.

2. Special Section, *St. Louis Post-Dispatch*, June 24, 1973. Written by Harry Wilensky of the *Post-Dispatch* staff. Photographs by Robert C. Holt, Jr., technical director of photography for the *Post-Dispatch*, unless otherwise noted.

# How The Tribune Continues, thru a New Method

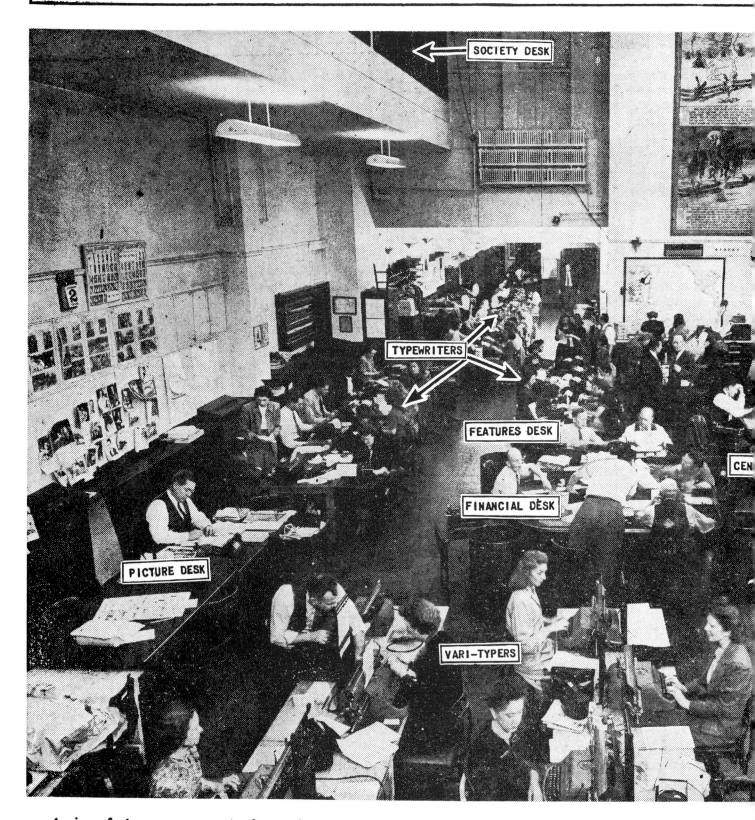

SOCIETY DESK

TYPEWRITERS

FEATURES DESK

CEN

FINANCIAL DESK

PICTURE DESK

VARI-TYPERS

A view of the newsroom on the fourth floor of The Tribune which for the last two weeks has been published without the aid of printers who are on strike. Legends indicate the various de produce editions with t

# Publish Every Day Without the Aid of Printers

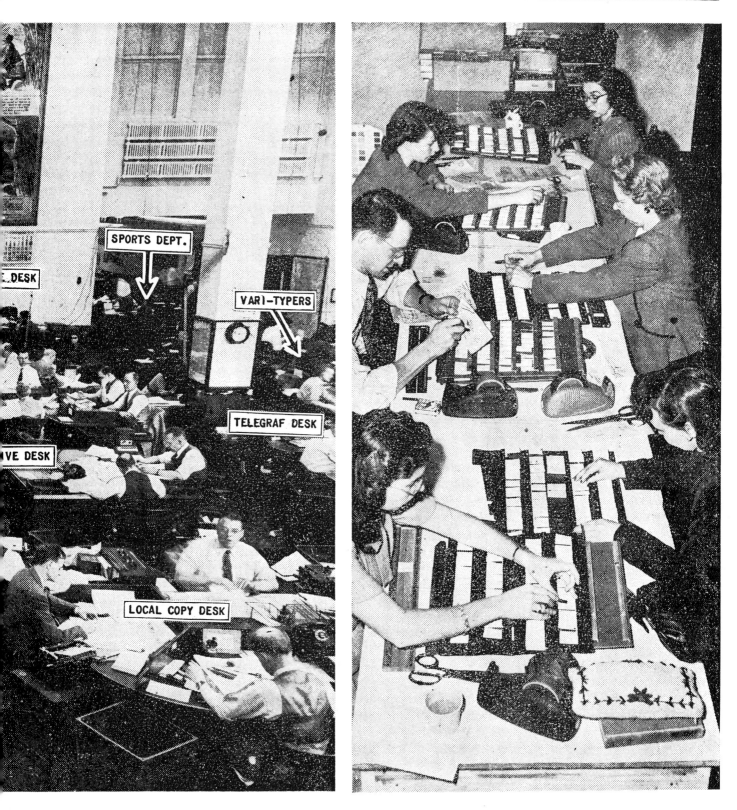

Photo-engraving process has made it possible to
yped stories. (Tribune Photo)

One of the desks at which heads are set by taping
cardboard letters together. (Tribune Photo)

featured a talk on Printing Plate Systems by Frank J. Stanczak. Among other things, Mr. Stanczak revealed that of the more than 1100 "newspapers with a circulation of 50,000, 68% are produced by photo-offset; 21% stereotype letterpress, and 11% from direct zinc, magnesium, or a photo polymer plate." Although the percentage varies in newspapers having a circulation of 10,000 and the larger ones, a breakdown gives a clue as to how printing processes are changing in the newspaper publishing world. Photo-offset has had a big effect on photojournalism—especially in the many suburban newspapers around large cities. Photo-offset production is more economical. More than that, it allows more versatility and greater fidelity in the reproduction of photographs.

The letterpresses printed from the raised surfaces of metal plates. The raised surfaces, after being inked, carried the impressions onto the paper, while the depressed surfaces did not print. The new offset presses print from flat, rather than raised, surfaces and use thin, lightweight aluminum plates instead of heavy castings.

The offset process is based on the natural repulsion between grease and water; moisture prevents greasy ink from sticking to the plate except where there is matter to be printed.

After the cold type and photographs have been pasted into place, each page of the newspaper is photographed to make a negative.[3]

Light passes through the negative and exposes the image onto the treated sheet of aluminum, and after the plate is placed on the press, a thin film of water is constantly directed on it. The part of the plate with the image rejects water and accepts ink; the nonimage area (constantly bathed in water) rejects ink.

The inked-plate image is not directly impressed on the paper. It is transferred from the plate to a rubber blanket

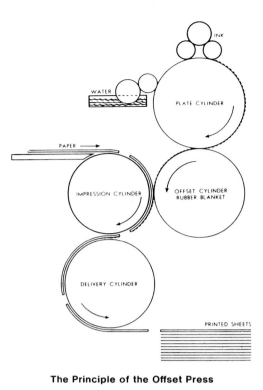

**The Principle of the Offset Press**

◄ The illustration is from a brochure, *Lithography's Place in Printing Production*, issued by the Lithographers National Association, Inc.

wrapped around a metal cylinder. The transfer is called "offset" and gives this form of printing its name: the inked image is offset to the rubber blanket, and the newspaper is printed from the blanket.

Offset printing, by virtue of much finer detail, provides better reproduction than letterpress.[4] Type (as well as illustrations) is more clearly defined, making for improved legibility.

---

3. Some newspapers prescreen the photographs to make a print, which is pasted in its proper place on the page layout. Then, using the process camera, they shoot the entire page as line copy before making the metal plate. Others shoot the line negative, and strip in the halftone negatives before printing the offset plate on metal.

4. Offset printing is a "kiss" impression and not a "squeeze" as is letterpress. Because of this, even though offset paper is little different than regular newsprint, it permits a much finer screen to be used.

## The *Post-Dispatch* and Offset Printing

The glass disk (*top*, following page) is an integral part of the cold type printing process the *St. Louis Post-Dispatch* has combined with offset press work in its new printing plant in St. Louis county. The two systems, and others in the new plant, represent some of the most advanced technology in the newspaper printing industry—a space age away from such hallowed figures in the printing world as Gutenberg and Caxton. . . .

Briefly described, the process begins with glass disk, on which are printed a number of alphabets, sets of numerals, and punctuation symbols in various type faces. Five such disks are installed in photocompositor machines, which photograph sequences of characters to make up lines of type.

Pasteups of full individual newspaper pages are then made and photographed. The photograph is called a "PMT print" (photomechanical transfer) and looks like the one at *lower left* (following page) emerging from a print dryer.

Using a telephoto transmission system similar to that used to transmit wirephotos, the picture of the page is sent to the *Post-Dispatch* printing plant.

It is received as a negative, such as the one being examined on the light table (following page, *lower right*). This negative, in turn, is used in the production of metal printing plates for the presses.

*Post Dispatch* narration by Harry Wilensky and photographs (except as noted) by Robert C. Holt, Jr., both members of the *Post-Dispatch* staff.

# Photo-offset and Computerization Are Here to Stay

In an article titled "Newspaper Industry Moving Into Computer Age" Roy Malone of the *Post-Dispatch* staff gave some interesting information:

> While some big city newspapers have folded or merged because of economic problems, the newspaper industry generally appears healthy. Since World War II the number of dailies has increased from 1,749 to 1,774 and the circulation rose from 43,384,188 in 1946 to 63,147,280 in 1973. In the last two years (1971–73), total circulation has gained by more than 1,000,000 according to figures in the *Editor and Publisher Yearbook*. . . . And the Occupational Outlook Handbook of the Labor Department for 1972–74 said growth can be expected in the newspaper industry with a 5 to 6 percent yearly increase in revenues amounting to about 12 billion dollars by 1980. . . .
>
> More than 100 newspapers in 1973 installed some type of new electronic copy processing system, using visual display terminals in place of typewriters or optical character readers.

> Visual display terminals [it was explained] consist of machines "with a television screen above a typewriter keyboard, linked to a computer, on which stories or advertisements can be written. Editors can call the copy onto their screens for changes or proofreading and then route it electronically to photocomposition devices for typesetting. (Picture storage and recall, too, is being used today.) At the *Post-Dispatch*, page layout is by pasteup, but eventually full pages, or the entire newspaper, may be set electronically."[5]

From the foregoing, we can see that newspapers, like photojournalism itself, are certainly not dead. Techniques will continue to change, of course, and the photojournalist of the future must be much more knowledgeable than was his successor a half-century ago.

5. *St. Louis Post-Dispatch*, April 28, 1974.

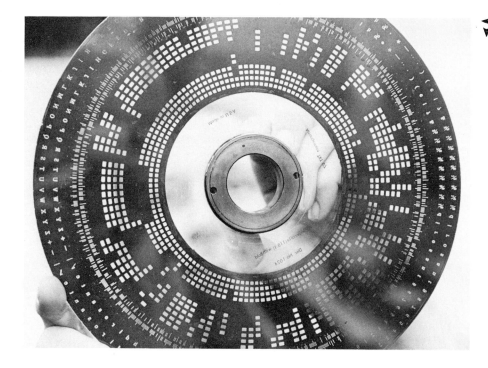

The glass disk on which are printed a number of alphabets *(above left)* is one of the integral parts of the cold type printing process that the *St. Louis Post-Dispatch* has combined with offset press work in its $10,000,000 modernization program. A PMT (photomechanical transfer) print emerges from a dryer *(lower left)*. Next, a telephone transmission system similar to that used to send pictures by wire is used to send the PMT print to the printing plant miles away. In the printing plant the transmission is received as a page-size negative *(lower right)* which is used to make the offset plate which goes on the press.

Type is set by computers in the photo-offset produced *Post-Dispatch*. A tape *(below)* is perforated and processed through a computer to obtain line hyphenation and justification. The computer provides a new tape which operates a phototypesetting machine at the rate of 150 lines per minute. This unit photographs the characters and transfers them to a sensitized paper which is used in the pasteup of advertising and news pages. (See illustrations at *left.*)

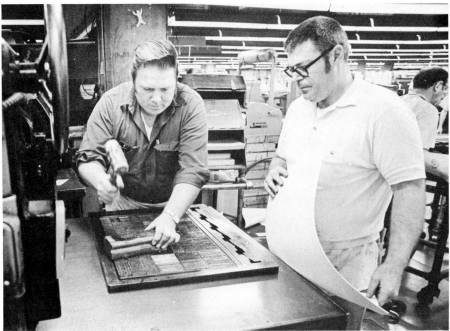

◄Workers at the *Post-Dispatch*
*(above)* in the letterpress
composing room used
considerably more space than is
required with the computerized
cold type system. The hot type
process in which the typesetting
machines squirted hot lead into
a mold to make the required
"lines of type" also were used
to make matrices *(left)* with
which to cast lead shells in the
stereotyping department. (Photo
by Jack January.)

◄ The picture *(left)*, taken in June 1973 at the *Post-Dispatch* downtown plant, shows the casting of a lead shell or plate in the stereotyping department. This casting is placed directly on the letterpress printing unit. This operation is not used in the offset printing method. Instead, a plate processor produces an aluminum plate that is mounted on the offset press.

◄ The *Post-Dispatch* uses five transmitters and five receivers connected by Southwestern Bell Telephone cables. A Velox print is placed on a transmission cylinder. It is electronically scanned and transmitted to the northwest plant where it is received as a film negative. After processing and drying, the negative is used for making an offset plate. Each transmitter can send a page in 2.55 minutes.

# Student Participation

As mentioned in a previous chapter, two of the three printing methods are letterpress (raised surface or relief), and photo-offset (planography). The third method of printing is gravure (intaglio).

1. Which of the three printing methods was used by the *Chicago Tribune* in the late 1940s when type compositors were on strike, and typewritten copy was photoengraved before being locked in a form, matted, and stereotyped?
2. How does this type of composition differ from metal slugs produced on a Linotype or Intertype linecasting machine?
3. What are some of the advantages of photo-offset printing as now practiced by the *St. Louis Post-Dispatch?*
4. Generally speaking, why does offset printing in a newspaper result in finer detail and better halftone printing than does letterpress?
5. Once again, as for chapter 3, select three examples each of newspaper letterpress printing, of offset printing, and of photogravure printing. This time get at least one example of each—letter press, offset, and gravure—in color.

# 5

# Photojournalism
## Photography Is a Language

Many years ago John R. Whiting wrote a book titled *Photography Is a Language.*[1] In its function as language, not only do many blessings accrue to photography, but also many responsibilities.

Whether the photographer is working on a local scene or on a battlefield far from his homeland, he many times literally takes his life in hand to do the job. Robert Capa, Werner Bischof, Dickey Chapelle, Larry Burrows, and many others died "in the line of duty." And deaths and injuries all too often have been the story of the photographer on the home front covering a shootout, an explosion, a fire, or other violent events. If he is to report a riot or a fire, the cameraman must be at the scene, and dangerously close to the heart of it. He cannot take a picture by making a quick telephone call. *He is the eyes of the world,* and those eyes must be close enough to see what is going on.

From 1839 when photography made its debut under the guidance of Daguerre to the present time there has been a steady movement toward *visual reporting.* Most artists felt the camera was an interloper—a competitor in the sketch and portrait fields. Laymen long had hoped for a means of artistic expression which did not require great skills or long periods of training. The fellow who could not draw or paint found what he wanted in photography. From the start, he was a devotee of the "new art."

Once the camera appeared upon the scene, it was given many chores. Not only was it an ideal instrument to record informal family portraits, but it also was soon recognized as an instrument for education, information, and entertainment.

The earliest records of war photography were not impressive. A few daguerreotypes were made in 1846 and 1848 in Saltillo, Mexico, and some were made during the Crimean War. Oliver Wendell Holmes, who had a hand in developing and popularizing the three-dimensional stereoscope, reported that the Franco-Prussian War (1859) also had its photographers. Holmes predicted that "the next European conflict would send us stereographs."

A few Brady photographs were copied by sketch artists and made into woodcuts. But, because they could not be reproduced as halftones, the photographs taken by Mathew Brady and co-workers during the Civil War had little or no market in newspapers and magazines. Brady hoped to make money from selling the stereoptican views direct to persons at home. With the

---

1. John R. Whiting, *Photography Is a Language* (Chicago: Ziff-Davis Publishing Co., 1946).

three-dimensional system he believed his customers would be able to see the battles in all their realism.

It did not turn out exactly that way, but Brady, Alexander Gardner, Timothy O'Sullivan, and others of the Civil War photographic team did produce a priceless set of Civil War pictures now in the national archives. Brady took photographs of the first engagement of the Civil War—the Battle of Bull Run, July 21, 1861. More pictures—many more—followed.

The war photographs which Brady and his crew produced, although seldom used by publications of that day, were seen in exhibits and in home photo albums where (mostly as portraits) they appeared as carte de visite pictures, printed to a standard 2¼ by 4 inches in size.

Many of the war pictures "by Brady," as many Currier & Ives lithographs, were helpful in building and maintaining fighting morale in the North. Lincoln, who gave Brady permission to follow the Union armies, was well aware of the value of the pictures produced by the diminutive photographer and co-workers.

The chief reasons for his being elected president were credited by Lincoln to the Cooper Union speech and a Brady photograph.[2]

Pictures of the Civil War (usually produced as line cuts) many times were used as propaganda. Jefferson Davis, president of the Confederacy, in speaking of the "atrocity photographs" taken of the Andersonville, Georgia, prison camp conceded that they "might have been genuine, but the way in which they were taken and the manner in which they were used were dishonest." Although the Andersonville pictures never appeared in Northern journals, they were given wide distribution. Roy Meredith claimed that they were distributed throughout the North and that copies of the pictures were shown to President Davis by his spies.[3]

Photography had an important role during the opening of the West. The work of Alexander Gardner, Captain A.J. Russell, and T.H. O'Sullivan (all of whom had photographically documented the Civil War) and the photographs of others, notably William Henry Jackson, had much influence on establishing our national park system and on inducing hordes of people to follow the railroads in their westward movement.

Coincident with the opening of the West, technological improvements gave a boost to photography and made it possible to do a better job. Better camera equipment, introduction of dry film as opposed to wet plates—plus invention of the halftone engraving—made it possible for magazines and newspapers to reproduce photographs "direct from nature."

As the Spanish-American War approached, tools for taking photographs under adverse lighting conditions and reproducing them in newspapers and magazines became available. "War passion was whipped to a frenzy by news stories, headlines, pictures, and editorials."[4] Typical of the photographs which appeared in the press were those taken for Collier's magazine by Jimmy Hare. Cecil Carnes introduced us to this ubiquitous photographer with these words:

He snapped the wreck of the Maine from every point of the compass. He caught divers still busy at the somber task of bringing up the drowned. . . . With the aid of an interpreter, Jimmy prowled through reconcentrado camps. He photographed swollen bodies with bones breaking through the skin; he took pictures of the emaciated living, and of babies ravaged by disease. Every ship that passed Morro Castle enroute to New York carried a packet of snapshots. Their influence upon public opinion can hardly be overestimated.[5]

---

2. Robert Taft, Photography and the American Scene (New York: Macmillan Co., 1942), p. 224.

3. Roy Meredith, Mr. Lincoln's Cameraman (New York: Charles Scribner's Sons, 1946).

4. Mott: American Journalism—A History of Newspapers.

5. Cecil Carnes, Jimmy Hare, News Photographer (New York: Macmillan Co., 1940), p. 15.

HOW THE OTHER HALF LIVES

STUDIES AMONG THE TENEMENTS
OF NEW YORK

BY

JACOB A. RIIS

WITH ILLUSTRATIONS CHIEFLY FROM PHOTOGRAPHS
TAKEN BY THE AUTHOR

NEW YORK
CHARLES SCRIBNER'S SONS
1904

GOTHAM COURT.

# Jacob Riis and the Muckrakers

Shortly before and a few years after the turn of the century (1890–1915), reform crusaders, in books, magazines, and in the daily and weekly press were quite common. Because he resented some of the things they said about him, Theodore Roosevelt gave the reformers the name of "muckrakers" and described their "probing and exposé activities" as "muckraking."

Among those who "beat the drums" for needed social changes in those days were Ida M. Tarbell, Lincoln Steffens and Jacob Riis. The latter, a great newspaperman, and a great philanthropist, took New York's "poor and downtrodden" as his particular area of concentration.

*The Children of the Poor* was one of Riis' earlier books, but *How the Other Half Lives*, is, perhaps his best known, and it is still in our libraries today. Copyrighted by Scribners in 1890, this book has been reissued many times.

Adding teeth to his verbal reports, Jacob Riis early learned how to use the camera. To enable him to take pictures in opium dens and other hell-holes in the poverty-stricken tenements, he brought the first flash gun to this country from Germany.

Above is the title page *(left)* and the frontispiece which appeared in the 1904 edition of *How the Other Half Lives.*

Photography reached a new level of importance in World War I. Then faked pictures became an important tool for propagandists. Many of the pictures released for publication during the years 1914 through 1917 have since been discredited.

In 1937 the *Des Moines Register and Tribune* published an article entitled "War Propaganda Exposed" which placed side-by-side identical pictures released by both the Allies and Germany. Sketches distributed in this country, showing German soldiers killing and mutilating French and Belgian children were in sharp contrast to the pictures made by German photographers showing German soldiers treating those children with kindness. In World War I, Kaiser Wilhelm, "the Beast of Berlin," did not cut off the hands of babies, as posters, newspapers, and even motion-picture strips sometimes led us to believe.

However, all World War I photographs were not fakes. Cameras, used on land and at sea, were first to reveal the use of camouflage. It was through pho-

tography that we became acquainted with and kept up with the exploits of Capt. Eddie Rickenbacker and other heroes.

For the record: Photographers in World War I were attached to combat units. Col. Edward Steichen, who went to France with the First American Air Corps, was made chief of the photographic section and was given command of all American photographic operations. Working with Gen. William (Billy) Mitchell, a man whom the colonel greatly admired, Steichen's photographers made daily reconnaissance and mapping flights over enemy territory.

Photography spoke loudly during World War II. One of the factors which made for efficient photographic coverage of this global conflict was the war photographic pool—a new concept in photographic reporting. World War II was far more complicated than preceding wars, and the demand for pictures was greater. The pool permitted everyone who wanted them to have pictures, even though all news and other organizations were not allowed to send photographers to the battlefronts.

For the first time during any war, pictures could be transmitted across the country by wire and across the oceans by radio. Not long after Pearl Harbor, the Navy Public Relations department asked Acme, Associated Press, International News, and *Life* to form a picture cooperative. When it heard of the arrangement, the Army asked that the pool cover land warfare as well. By 1943 the pool was spending $400,000 annually for war pictures. In April of that year, 28 pool photographers were on assignment, and the Army Signal Corps was transmitting pictures from North Africa to the United States.[6]

Stories told with pictures welded a strong bond of friendship between the United States and its allies and widened the gap between us and our adversaries. At home pictures helped fight fifth-column activities and made us eager to support patriotic drives. One exhibit, a great panorama of pictures entitled "Road to Victory," provided many emotional thrills. This exhibit was produced by the combined talents of the poet Carl Sandburg and his famous brother-in-law photographer Edward Steichen and was indeed a powerful bit of propaganda— a photographic masterpiece.

Many youngsters and their parents were thrilled by Joe Rosenthal's famous flag-raising picture "Marines on Mt. Suribachi." (See page 150.) Reproduced more than any other photograph up to that time, it must be one of the greatest propaganda pictures in history.

The wars which introduced the great work of Cartier-Bresson, Robert Capa, Larry Burrows, Eddie Adams, Michael Rougier, and hundreds of others prove beyond a doubt that "photography is a language."

But photography has served eloquently in peace time, also. Long ago the *St. Louis Post-Dispatch* used its photographic guns to argue that a Misouri Valley Authority similar to the Tennessee Valley Authority would be a good thing and were proved to be right. Long before there was national interest in ecological problems, the *Post-Dispatch* was fighting the smoke evil and the rat menace in the St. Louis area. And during a sustained drive of many years the *Post-Dispatch* consistently used a powerful word-and-picture combination to hammer home the message that in the St. Louis area it was a matter of "Progress or Decay."

Editorial, crusading, propagandizing photographs are not new. Frank Luther Mott partially summed up the importance of photography as a language when he said: "The camera has a devastating effectiveness in portraying evils. It is the best crusader of our time. Think of any abuse—social, economic, political—and sound and honest pictures which will bring the evils to our eyes suggest themselves immediately."[7]

---

6. "Journalism in Wartime, a Symposium held by the School of Journalism, the University of Missouri." Published by the American Council of Public Affairs, 1943; see especially the chapter by Ralph H. Turner, "Photographers in Uniform."

7. Frank Luther Mott, Foreword, *University of Missouri Third Annual Fifty Print Bulletin,* January 1946.

# One Word, Two Words, or Hyphenated?

Frank Luther Mott succeeded Frank Martin in 1942 as the third dean of the School of Journalism, University of Missouri, Columbia. One of the first things Dr. Mott did upon taking over his new charge was to enlarge the school's photographic offerings. Not only did he establish a "sequence in the photography department" to take its place alongside the news-editorial department, the magazine division, the advertising division, etc., but he also gave the new sequence a one-word name for the first time in academic history. From that time, in the Missouri School of Journalism, and in many other places as well, the word designating photo reportage has not been two individual words nor hyphenated, but one word: *photojournalism.*

The important fact, however, is not that Mott coined a new word, but rather the recognition of pictures—photographs, if you please—as important to the field of communications.

Prior to this time, in most journalism schools, photography was at best considered a "craft," not worthy of academic consideration. More often than not, it was believed to be something which one learned as an on-the-job apprentice or at a vocational or technical school. Certainly, many educators believed, and many still do, that photography has no place in a college or university curriculum.

Eventually, however, the camera has earned a place in journalism schools— an honorable one—and photographic reporting, too, slowly changed from a craft into a profession. Which, thanks to *Look, Life,* and a lot of great photographers, is where we find it today.

# Development of Photo Wire Services

One of the factors which "upped" the value of pictures and which helped the news and magazine photographer to find his place in the sun was invention of a system to transmit pictures by wire. Historians have told us how undeveloped film was sent out by pigeons during the siege of Paris (Franco-Prussian War, 1871) to let the rest of the world know what was going on. In the *Encyclopedia of Photography* David Eisendrath, at a much later date, told how *Chicago Times* photographers used carrier pigeons to rush exposed film back to the office to meet early deadlines.[8] In news photography speed and more speed were the order of the day. Pictures sent by wire provided speed never before dreamed of. Wirephoto, trade name of the Associated Press (AP) network, Telephoto, first owned by Acme and now by United Press International (UPI), and Sound Photo, originally the trade name for International News Photo and now a part of the UPI network, all had a part in bringing photojournalism into the spotlight.

The wire services made it possible to send and receive picture and word reports almost simultaneously. When techniques to transmit pictures by radio and satellite were perfected, instant global picture and word coverage became realities. Unfortunately, during the earlier years some people believed quantity, rather than quality, of pictures was the objective. But with the passing of time the world has come to value honest, meaningful, quality pictures.

At one time, within easy memory of many parents of present-day college students, newspaper photographs were looked upon as a "necessary evil," something tolerated only to meet competition. Some publishers sometimes referred to the news photographer as a "reporter with his brains knocked out."

In my mind, things were never quite that bad, but in the beginning the cameraman had a pretty poor image (no pun intended). In many cases news photographers had very little schooling and were incapable of writing a story or even a caption to accompany the pic-

8. *Encyclopedia of Photography*, 1st ed., s.v. "The Complete Photographer." New York, 1942.

# 1935 Magic—News Pictures by Wire

## Tribune in Virephoto System

By WHITLEY NOBLE

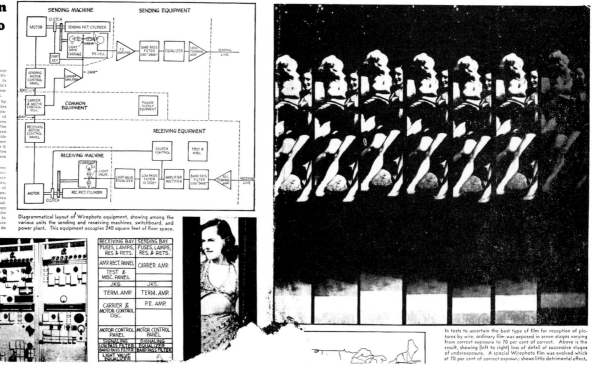

ALADDIN with his magic lamp and ring and the two frightful genii, slaves thereto, in their best moments couldn't have done it. They lacked imagination and never operated that fast.

The flashing of pictorial matter by wire across a continent 3,000 miles wide in the brief space of one-sixtieth of a second is a miracle of today. Wirephoto, the new system of telephotography by which The Chicago Tribune collects pictures and photographs from far and wide in somewhat the same manner (though far more marvelously) as it collects news by telegraph, operates with a speed approximately the same as that of light.

Photographs scanned by an uncanny "electric eye" are borne by electrical impulses along wires to other "electric eyes" in far-away cities, picked up at an amazing rate of speed, and reproduced immediately into duplicate photographs, so that readers within the daily circulation range of newspapers participating in the Wirephoto service may see them in just a matter of minutes and hours after they are taken. No longer do

Diagrammatical layout of Wirephoto equipment, showing among the various units the sending and receiving machines, switchboard, and power plant. This equipment occupies 240 square feet of floor space.

In tests to ascertain the best type of film for reception of pictures by wire, ordinary film was exposed in seven stages varying from correct exposure to 70 per cent of correct. Above is the result, showing (left to right) loss of detail at successive stages of underexposure. A special Wirephoto film was evolved which at 70 per cent of correct exposure shows little detrimental effect.

tures taken. Fortunately, the scene has changed. Today's successful photojournalist can do many things. He can take the picture, crop it, and lay it out in picture story form if need be. More than that, if he is a photojournalist from many journalism schools, he is quite capable of taking the picture *and* writing the story. Today's photojournalist is a journalist, first of all and secondly, a photojournalist.

The story of "pictures by wire" surfaced August 29, 1924, when a memorandum was sent by the American Telephone and Telegraph Company (Bell System) to "all chief engineers." Titled "Notes on Phototelegraphy," the bulletin explained some amazing experimental work which had been done in the speedy transmission of pictures. H.P. Charlesworth, plant engineer, sent the bulletin from the New York office that August day. It explained:

The first demonstration of this system was made a short time ago and during the Republican and Democratic conventions a large number of pictures transmitted between Cleveland and New York and between New York and Chicago were distributed to the press. It is expected that a further trial of this system will soon be made in order to determine the commercial possibilities of such a service. If, in the future, any specific cases come up in your territory where it is thought that a picture service might prove in, we shall be glad to furnish to you the latest information available.[9]

Even with such a successful start, pictures by wire required considerable selling before they were accepted. In 1927 in an annual book of printing achievements published by the Photo-Engravers Union, we find an historic advertisement—a two-page presentation of the AT&T accomplishment. It reads:

Rapid transmission of pictures has always been a goal of newspapers and magazines. During the siege of Paris (Franco-Prussian War), for example, homing pigeons were used to transmit messages and pictures from the capital city to let the rest of the world know what was going on. As late as the 1940s, according to David B. Eisendrath, Jr., the *Chicago Times* used carrier pigeons to transmit exposed film back to the office where it was quickly processed to meet early deadlines. Better than carrier pigeons to ensure quick transmission of pictures was the system introduced in 1934–35 of sending pictures by telephone. Radio transmission of visual images soon followed.

9. H.P. Charlesworth, "Notes on Phototelegraphy," 1924 (company bulletin, American Telephone and Telegraph Co.).

◀The American Telephone and Telegraph Company was *the* earliest pioneer in the picture-by-wire business. Realizing the tremendous importance of the invention, the Associated Press began its own Wirephoto network in 1935. *Left,* an early AP Wirephoto transmitter.

The ever-increasing use of Telephotographs in the business world is not surprising to those familiar with this method of picture transmission. It is obvious that if the Telephotograph can serve the daily newspapers by instantly reproducing pictures of big news events, it also can be of great value to commercial houses, industrial plants, and professional people. In the fashion field for instance, Telephotographs enable buyers for stores throughout the country to see and study the latest Parisian designs in hats, gowns, shoes, etc., within an hour or so of the arrival of such apparel in New York. The time of transmission is seven minutes.

The almost perfect reproduction of layouts and printed forms of all kinds makes the Telephotograph invaluable to advertising agencies and bond and security companies. Such matter cannot be transmitted accurately by any other rapid means. Likewise, financial statements, legal documents, finger prints, and x-ray pictures are among the many transmissions made daily over the long distance wires of the Bell System. Lithographs and wash drawings also make excellent Telephotographs. Anything that can be pho-

tographed can be sent by wire to eight important cities in the United States and from these cities the train and air mails complete a rapid and accurate service to all of the principal cities of the country[10].

Bell proved the worth of Telephotographs. In a short time the Associated Press, with the help of thirty-eight of its member newspapers, formed a 10,000 mile circuit—the world's first news-photo network. This story appeared in the *Chicago Sunday Tribune,* December 23, 1934—a year before the network was announced to the world:

The flashing of pictorial matter by wire across a continent 3,000 miles wide in the brief space of one-sixtieth of a second is a miracle of today. Wirephoto, the new system of telephotography by which the *Chicago Tribune* collects pictures and photographs from far and wide in somewhat the same manner (though far more marvelously) as it collects news by telegraph, operates with a speed approximately the same as that of light.

10. Louis Flader, ed., *Achievements in Photo-Engraving and Letter-Press Printing* (Chicago: Photo-Engraver's Union, 1927).

Photographs scanned by an uncanny "electric eye" are borne by electrical impulses along wires to other "electric eyes" in far-away cities, picked up at an amazing rate of speed, and reproduced upon negatives to be made immediately into duplicate photographs, so that readers within the daily circulation range of newspapers participating in the Wirephoto service may see them in just a matter of minutes and hours after they are taken. No longer do obstacles of time and distance compel news photographs to trail hours and days behind the actual news. Side by side with the day's grist of news, important stories of eventful happenings, accounts of vital and startling occurrences, flash on parallel wires the last-minute photographs that illustrate the news. Speeding trains and specially chartered planes, photograph vehicles of yesterday, are snaillike by comparison.

Wirephoto, materialization of a ten-year old dream and result of three or four years of careful planning, begins operating now, today, tomorrow, not later, according to schedule, than the new year. The *Tribune* and 37 other newspapers in 24 cities are joined in the 10,000 mile network of the Wirephoto circuit, which stretches from coast to coast and from as far north as Minneapolis to as far south as Miami, for the purpose of supplying each other with the important news pictures of the day.[11]

# Development of Modern Photojournalism

Almost parallel with introduction of Wirephoto were other events which influenced the maturation of photojournalism. Among them without a doubt was the birth of the great picture magazines *Life* (1936) and *Look* (1937). These publications spotlighted a full-grown style of picture reporting and brought in what some authorities refer to as the Golden Age of Photojournalism.

Another factor which gave dignity and importance to photojournalism was the rebirth of the documentary picture. The documentary photograph and its use and purpose as exemplified by Roy Stryker and the Farm Security Administration in this country during the thirties, is discussed in length in chapter 6.

"Modern photo reportage," says Tim N. Gidal "originated in Germany between 1928 and 1931. Three things which caused the breakthrough are development of the modern 35 mm camera; the emergence of a new generation of photo reporters . . . and the attitude assumed by the editors of the illustrated magazines. . . ."[12]

No one will contradict Gidal, who was himself a pioneer in the new photojournalism. Kurt Safranski, Alfred Eisenstaedt, and the great Dr. Erich Salomon all not only contributed enormously to documentary photography, but also gave distinction to photojournalism. Most of these pioneers were run out of Germany by Hitler and the pressures of World War II and came to the United States where they and the type of photographs they made greatly influenced the new photojournalism.

# Student Participation

Wirephoto and Telephoto are trade names which designate the systems allowing the Associated Press and the United Press International to send black-and-white and color pictures by wire. Color separations are made from the original color photographs. A black-and-white print is transmitted for each of the colors. After the black-and-white pictures are made into plate form, the separations carry the proper colors to the paper. The combination reassembles the colors during the printing process.

---

11. *Chicago Tribune,* 23 December, 1934.

12. Tim N. Gidal, *Modern Photojournalism* (New York: Macmillan Co., 1973; Frankfurt: Verlag C.J. Bucher, 1972).

These systems, radiophotos, and satellites enable picture syndicates and publications to send and receive pictures in a matter of minutes from across the nation or from remote areas across the sea.

1. How did picture transmission systems such as those mentioned here influence photojournalism?
2. Collect twenty-five pictures (black-and-white and color) from recent daily and Sunday newspapers. Pay particular attention to the syndicate credits at the end of the captions. (Credit lines on a news picture, just as on a written article, are very important.) Try in this project to gather a few radiophotos, and a few transmitted by satellite. In this study of credit lines, too, please notice how local newspapers credit hometown photographers.

# 6

# Documentary Photography—A Discussion

## Farm Security Administration Photography

Although the documentary style and philosophy of picture taking has been present since the days of Fenton and Brady, the technique was born anew with the arrival of the socially important photographs of Jacob Riis and Lewis Hine and others. But the documentary type of picture, exemplified by Erich Salomon and his peers, came into its own a few years later with Roy Emerson Stryker and the founding of the historic section of the Farm Security Administration (FSA).

Like a huge cake of yeast, the documentary concept and philosophy of the FSA photographers leavened the whole loaf of mass communications. Books, magazines, newspapers, and later television were all influenced by the concept. Considering its importance in the publishing industry, it is well now to find out a bit more about documentary photography. Just what is the difference between a documentary picture and the ordinary snapshot in a billfold or family album?

In his book A. William Bluem, then of the Newhouse Communications Center, thus defined the term:

. . . Documentary is more than an idea. It is an undeniable form of public communication, functioning within certain ascertainable conditions. Valid documentary must involve more than presentation of the records of life. There must be a second purpose in its conception and the use of a technology which permits a significant impact in its dissemination.[1]

A few years earlier, in 1959 to be exact, Werner Severin pointed out that ideally the time for the rebirth and prolific growth of the documentary picture was in the mid-1930s with the coming of the photographic division of The Farm Security Administration. In the introduction to his master's thesis Severin, now a communications research specialist at the University of Texas, wrote:

By 1935 the stage was set for documentary photography to record contemporary life on a larger scale than ever before. The technicians had provided the means to reproduce photographs in quantity. The picture newspapers, wire services, and magazines were available to distribute them to millions of readers. Fenton, Brady, Atget, Riis, Hine, the "f:64" group and others [notably Erich Salomon] had

**Parallel with photojournalism is the term "documentary photography" exemplified by Farm Security Administration pictures.**

1. A. William Bluem, *Documentary in American Television, Form, Function, Method* (New York: Hastings House Publishers, Inc., 1955, 1968).

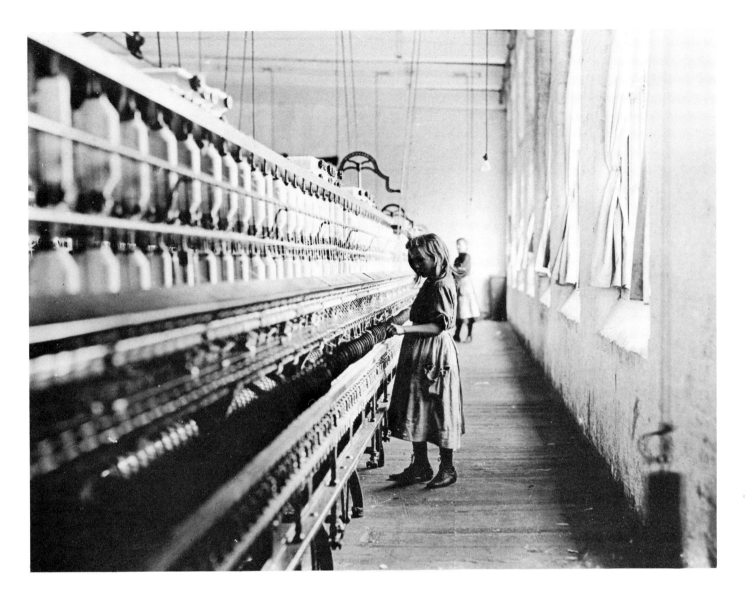

shown the way. The dust bowl and the great depression provided the need for this new documentary photography, and the Rural Resettlement Administration (later the Farm Security Administration) filled the need.[2]

After this brief introduction to documentary picture taking, as would-be photojournalists let us consider three important books on the FSA subject: *Portrait of a Decade* and *Russell Lee Photographer* by F. Jack Hurley and *In This Proud Land, America 1935–1943 as Seen in the FSA Photography* by Roy Emerson Stryker and Nancy Wood.[3] In these books one learns how Roy Stryker and a small group of FSA photographers

took some 270,000 photographs which mirrored the "Portrait of a Decade." Using eloquent, storytelling, challenging photographs, they produced a visual message which improved the life-style of millions of rural Americans.

The FSA pictures were simple, powerful, and believable statements. The photographers who took them were perceptive, sensitive, honest, involved people. Their objective at the outset was to photograph the migrant workers—"that mass of humanity attempting to earn a living from dehydrated, worn-out soil." It was a sad story, but one which needed to be told. The FSA photographers performed their task magnificently. Used

Lewis Hine, pioneer documentary photographer, once made pictures which Roy Stryker used in his economics classes at Columbia University. Fully appreciative of Mr. Hine's great sensitivity and capabilities, Stryker, without success, sought to hire him when he first began to document photographically the American Depression in the 1930s. The picture, *above,* made in 1908, is one of many Hine's pictures which pointed out the evils of child labor. Included in 50 Memorable Pictures exhibit.

2. Werner J. Severin, "Photographic Documentation by the Farm Security Administration 1935–1942; Cameras with a Purpose" (master's thesis, University of Missouri, 1959).

3. See Bibliography.

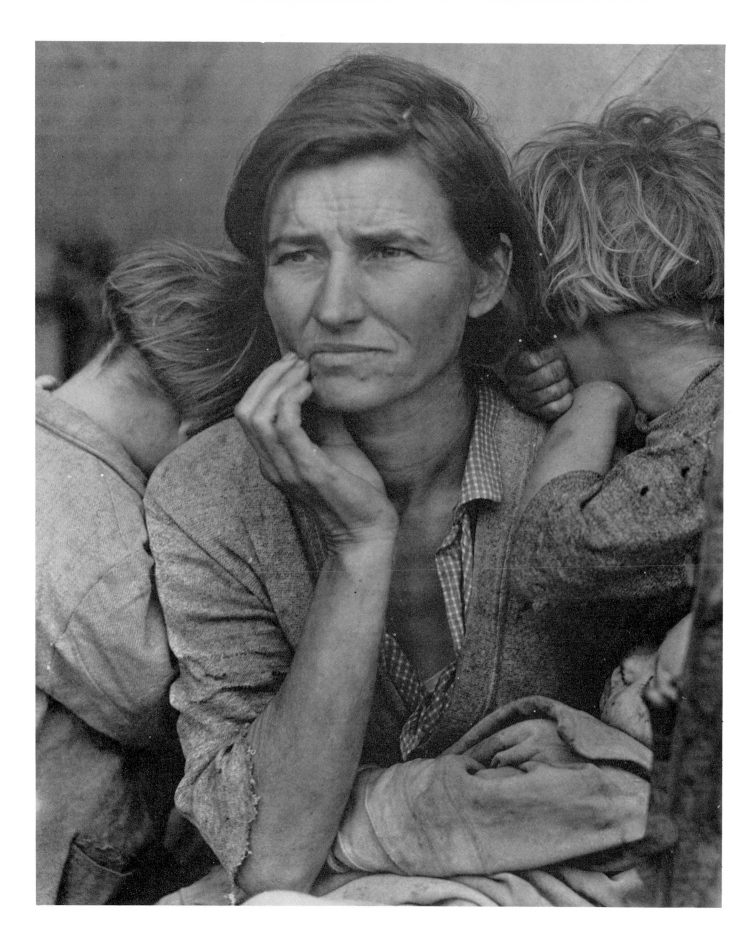

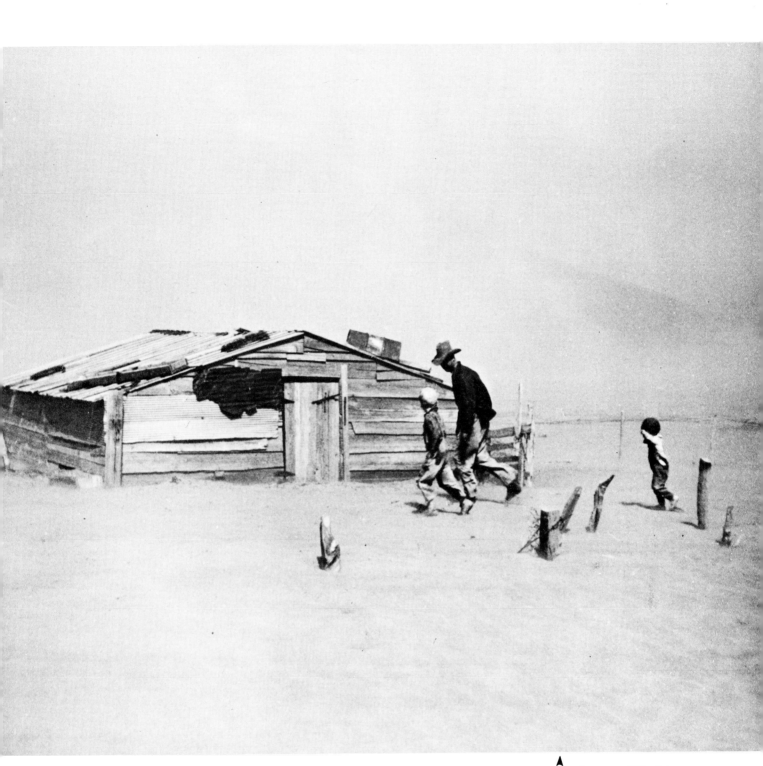

◄ *Left,* one of the greatest pictures
to come from the Farm Security
Administration photography
program in the 1930s is this one
by Dorothea Lange. The late
Roy Stryker, director of that
project, in his book, *In This
Proud Land* characterized the
portrait of the migrant woman
and her children as "the picture
of Farm Security." This picture
was a favorite in the 50
Memorable Pictures project.
(Library of Congress.)

▲
Another great FSA picture
which caused plenty of
argument is this one of the dust
bowl made by Arthur Rothstein
in Cimarron County, Oklahoma,
in 1936. "The inference," some
displeased Oklahomans have
told me, "is that the man and
his two children lived in the
pig shed behind them almost
covered by swirling dust."
Included in 50 Memorable
Pictures exhibit. (Library of
Congress.)

extensively in newspapers, magazines, and sociological books, FSA pictures were also shown in libraries, civic auditoriums, and museums. On these occasions their news value was recognized. Many times, too, they were seen as historical documents and in some instances as works of art.

In his master's thesis, Severin described the situation when Stryker, his job at FSA completed, left the government to work for Standard Oil of New Jersey. Of that particular period he wrote: "By the time Stryker left the government, many of the original FSA staff had already found other, more lucrative channels for their talents. The river of realism that was characteristic of Farm Security photography already was branching out into many little streams. As each followed its course, it carried the attitudes toward photography developed under Stryker. Later these streams, swollen with the hundreds they induced to join them on their way, rejoined to make up what is now considered the mainstream of American photojournalism."[4]

If one denies the close alignment between the documentary picture and photojournalism, let him consider the words which follow.

First consider the statement made by A. William Bluem early in his book that:

. . . In many ways photojournalism closely parallels the documentary movement in still photography. Continuing Bluem pointed out: "The photograph, in conjunction with print, served a distinct social purpose in that it involved a growing public in matters of vital concern. . . . In the tradition of William Henry Jackson, the news photographer could record scenes which underscored the need for better social conditions, better laws, and better people."[5]

Wilson Hicks wrote in the preface to his book:

One link, perhaps the most important link between photography as art and photography as journalism is, then, the socially significant picture. The question for the young photographer after he enters the profession of journalism is how broadly he can view the social scene . . . as he matures, he still can have an opportunity to act on the reform impulses of his beginning period.[6]

Considerably later, in 1973, at the National Press Photographers convention in Hot Springs, Arkansas, Gifford D. Hampshire, made an interesting statement: "Documentary photography is the genesis of photojournalism and photojournalism is excellent only to the degree that the photographer practices the intellectual discipline of documentary photography."

# Project Documerica

Since we have just mentioned Gifford Hampshire, director of Documerica, let us update his story. Mr. Hampshire says that the project corresponds in only a few ways with the program of the Farm Security Administration of the 1930s. The founding of Documerica in 1971, he says, "was the second time in our history that the federal government turned to still photography to document domestic problems."

Admitting that the experience and achievements of the Farm Security program can never be repeated, Hampshire

believes that Documerica is based on FSA concepts. He is quick to emphasize, however, that there are more differences than similarities. The differences, in part, are traceable to the fact that three generations of photographers separate us from the days of FSA.

At its founding, the long-term objective of Documerica was to document the changing environment in the 1970s–80s. The immediate objective was to establish a base line to show where the United States is committed to action

4. Severin, "Photographic Documentation."

5. Bluem, *Documentary in American Television.*

6. Wilson Hicks, *Words and Pictures: An Introduction to Photojournalism* (New York: Harper Brothers, Publishers, 1952; Arno Press, 1973).

which should arrest pollution and improve the air, land, and water.

Important as that goal was and is—plans have not worked out.

The first Documerica assignments were undertaken in April 1972, and by March of 1973 thousands of 35 mm color transparencies covering ecological problems had been produced.

In the beginning, photographers were selected from the ranks of professional photojournalists "who had successfully performed assignments for major media." The assignments averaged between ten and twenty days in length, and rarely, if ever, did a photographer get more than one assignment a year.

Although many think the need for Documerica continues, the pressure of other things and the lack of money for the program has had considerable affect. Not since 1974 have funds been available for assignments. Documerica is, however, still alive and "Giff" Hampshire, director, still maintains an office. The Documerica picture files are still active in the Public Awareness Environmental Protection Agency headquarters in Washington, D.C.

. . .

Believing in the importance of documentary photography, and that it is synonomous with much of what is considered "good news photography," the writer was surprised to read the following in a recent photographic magazine:

On July 28, 1978, photojournalism and documentary photography were declared officially dead. The pronouncement came from the self-anointed Pope of "The New American Photography," John Szarkowski, in an oracular essay accompanying the opening of the *Mirrors and Windows* exhibition at the Museum of Modern Art in New York. This exhibition purports to represent photographs "exemplary of the work of American photographers who have come to public attention during the past 20 years". . . .

The final Szarkowski seal of approval extends further the progressive creeping encroachment that uses "personal vision" as the justification for glorifying *any* photographic image. In this new photographic esthetic craftsmanship, form, content, and directness are replaced by incongruity and abstruseness. . . .[7]

Explaining the "Markets & Careers" feelings about the "parochial viewpoint of two decades of photography," Chapnick says "there is danger that images collected in the *Mirrors and Windows* exhibit shall become the contemporary photographic orthodoxy to the exclusion of documentary photojournalism."

Heaven forbid!

We believe, as did Wilson Hicks, Roy Stryker, Frank Luther Mott, A. William Bluem, and others no longer with us, that documentary photography is the backbone—the roots, if you please, of modern photojournalism.

Perhaps there's a place for the *Mirrors and Windows* type of picture, and, for that matter a place for the "snapshot aesthetic" advocated by the fine art photographers mentioned by Sean Callahan in his article on Photojournalism (pages 30–31) in the December, 1978 *American Photographer*. But that place is not as reportage. The sensitive, meaningful documentary type of pictures done by Jacob Riis, Lewis Hine, Eric Salomon, the FSA and W. Eugene Smith are extremely powerful . . . so powerful, in fact, that they are not really endangered by the fine arts pictures of the 1960s, nor by the snapshot aesthetic seen by some as "the new photojournalism."

In Chapnick's opinion—an opinion shared by many—"Documentary photojournalism was never more needed than it is today to add visual and textual dimensions to the questions of life and death which confront all mankind."

Classic documentary photography has earned its place in the scheme of things . . . documentary photography is here to stay!

---

7. See Markets & Careers column by Howard Chapnick in the November, 1978 (Vol. 83, No. 5) issue of *Popular Photography*.

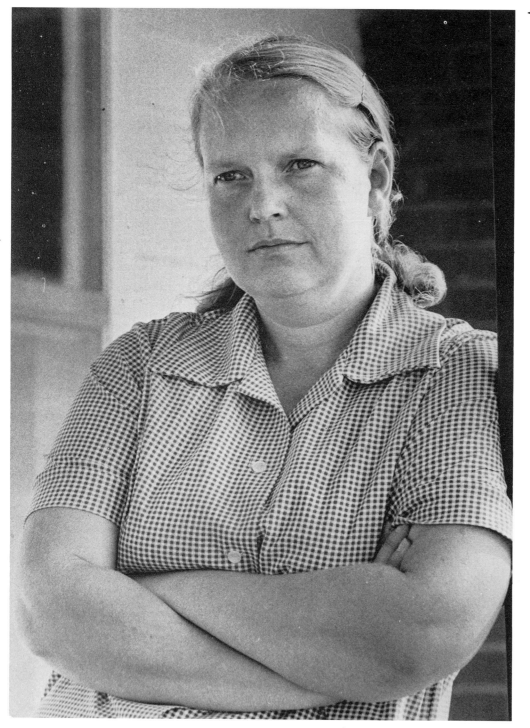

**Portrait of a Girl.** By Rick Solberg, Kansas City, Mo., *Star.* From the twenty-fifth Annual M.U. Photo Workshop, Kirksville, 1973.

**Note:** In addition to the F.S.A. Program and Documerica, which have received some emphasis in this book, the United States Government arranged for special photographic projects dealing with our Bicentennial year. As part of its regular program, the United States Department of Agriculture, inaugurated a year-long project to photograph the Face of Rural America. Pictures thus made appeared in a Department of Agriculture annual book and in traveling exhibits.

# Student Participation

Documentary photography, as exemplified by Jacob Riis, Lewis Hine, Erich Salomon, Roy Stryker, Eugene Smith, and many others, is the basis for present-day honest, effective photojournalism.

1. Select three pictures from current newspapers or magazines and tell whether they are snapshots or documentary pictures. Write one paragraph for each picture.
2. The federal government has on two different occasions entered the picture business on a national scale.
   a. What in your opinion was the purpose of the FSA picture program?
   b. What is the purpose of Documerica?
3. William Bluem in his book *Documentary in American Television* made this statement: "In many ways photojournalism closely parallels the documentary movement in still photography." In a paragraph explain what he meant.
4. In this day and age, good photographers—sensitive photographers—often are called upon to provide pictures for textbooks. Look in your public and/or school library for a good example of such a textbook. Bring it to class for discussion.
5. Search photo magazines (in your libraries) for a description of the Museum of Modern Arts *Mirrors and Windows* exhibit. Is Chapnick justified in his attack on John Szarkowski? Write a paper (one page) explaining your viewpoint.

# 7

# Photojournalism and Education

*Vme Smith*

**V**isual materials have long been used in the classroom as educational aids. Documentary illustrations are especially helpful for the child who may have difficulty reading or learning in the traditional way.

The use of photojournalism expands the limits of the classroom and helps familiarize the child with the "real world."

The child's sense of self can only be understood when he knows where he fits in his social environment.

Photography has been used to help children with special physical, educational or cultural problems.

Frank X. Sutman in his article "Self Esteem and Vocabulary Through Photography," *Science and Children,* January, 1977, discusses a study conducted at the Pennsylvania School for the Deaf for twelve children 12–14 years of age, all of whom had difficulty reading at the second-grade level.

At the end of the photography experiment the spoken vocabulary of each child had increased by an average of fifty words. Attendance was stable. An assembly program was developed with great enthusiasm. Children who had never stood up in front of their peers did so and appeared to enjoy it, indicating an improvement in the level of their self-esteem.

◄ Vme Smith, *(left)* long interested in migrant problems, is an assistant professor of sociology, Northern Virginia Community College. She is a consultant, Migrant Division, Maryland Department of Education and in 1976 edited "Upswing" a migrant publication issued in Frederick County, Maryland. Ms. Smith taught in the alcohol safety action program, Fairfax County, Northern Virginia Community College, and has served as Research and Production assistant, still photographer, and publications editor, Northern Educational Television,where she helped produce two "Emmy award" winning films. Other honors include an Ohio State award for children's programs. Ms. Smith's photographs appear in college texts, Head Start reports and in many booklets published by the Department of Health, Education, and Welfare.

►
Olivia, one of a group of migrant children, examines a Polaroid picture taken on a field trip. The project is to learn about people and things, and to present this material in words and pictures in their own personal newspapers.

Roger B. Fransecky in his article, "Visual Literacy and Migrant Youth," *NEWSLETTER*, New York State Center for Migrant Studies, 1969, states,

"One hundred . . . first, second, third, and fourth graders in the Sodus Migrant Summer School used cameras as pencils and told 'stories' that astounded their more verbal (and less visual) teachers."

Definite gains in self-concept, sense of environmental awareness, and growth in oral language skills were observed and statistically recorded.

Jay M. Van Holt in his article, "Visual Literacy: A Valuable Communications Tool," *INSTRUCTOR*, August/September, 1972, discusses a study used to develop vocabularies, self-image (one child had no idea what he looked like until someone else pointed him out in a photograph) and such abstract ideas as "brotherly love."

After two years under this project, "first graders at eleven pilot inner-city schools were reading at the national grade level for the first time."

Terry[1] and Lyntha Eiler, both professional photographers, became Head Start directors for 32 Indian children in Supai, Arizona.

▲
Olivia and friend examine a local newspaper. They are especially interested in learning what photographs can tell them about their own community.

---

1. Terry Eiler who continues to do freelance work is now a photography instructor at Ohio University, Athens, Ohio.

Olivia gets compliments and cooperation from her teacher and classmates. She learns it's lots of fun to take pictures with her newly borrowed Polaroid camera.

◄ Even more fun than taking pictures, Olivia learns (left) is to show the photographs to her "subjects." This print along with many others will find a place in Olivia's personal newspaper, Good Times.

Photojournalism and Education/57

The Eilers began using cameras two or three times a week, having the children focus on subjects most vital in their lives—their horses, the new houses the Government was building for their parents, and the crops and the stream that watered them.

As soon as a child took a picture, the Eilers mounted it on a card. Then they sat with that child and discussed the picture, recording and rerecording the conversation.

By the end of the nine-month regular Head Start term, the Eilers found that each child had learned to use about fifty English words and to express himself in uncomplicated sentences. ("Indian Children Find Words by Taking Pictures," King, Seth S. *The New York Times,* August 28, 1970).

The child of migrant workers is in special need of programs that improve and supplement his educational experience.

The average migrant child is two years behind in school and often is a seventh grade dropout.

Because the family "follows the crops," the migrant child is often taken out of school in April and he may not return until October.

Many children are not in school because they are working in the fields with the rest of the family. Or, if the parents are not working, they may keep the children home.

When the migrant child attends school there may be language problems or emotional difficulties if he is expected to renounce his cultural identity and conform to white, middle class values and behavior.

"Paralleling the educational gap is the lack of a positive self-image," according to the Caroline County, Maryland Migrant Proposal, "Bridging The Educational Gap With Migrant Children."

Self-esteem is enhanced by the development of skills. Language skills are especially important to the young child.

Verbal reports and discussions using photographs taken by the children encourage organized expression of feelings and thoughts.

With greater development of verbal language the child's self-esteem also improves.

In a recent study involving children in a migrant education program in Denton, Maryland, Polaroid cameras were used as a part of a social science project.

It was hoped that such a project would develop communication skills, increase knowledge of the child's social and cultural environment, and develop a more positive self-image. Each child was given pre- and post-tests of vocabulary level and self-esteem.

A separate classroom was used for the project. It was filled with local newspapers and photographs taken of children representing different racial and cultural backgrounds in family, school, and community situations.

The children seemed eager to use the cameras and take pictures they could show their friends and families.

Before any pictures were taken there was a discussion of the communication of feelings, ideas, and information.

The children looked at the local newspapers and discussed the pictures in the news and sports sections of the paper. They seemed particularly interested in a local track meet, firemen putting out a fire and a picture of a Day Care Center.

One child knew the classified section was "where you looked for jobs" and another knew the numbers in an ad indicated the price of paint.

The children were then asked to find pictures around the room that showed people who were:

1. Happy
2. Sad
3. Discovering Something
4. Happy to See One Another.

Although there were many examples of each situation, a child would usually only point to one. After one picture was identified as "Happy" the other children usually looked for a similar picture rather than looking for a "Happy" expression.

One student said she did not know what "Sad" meant. No one knew what "Discovery" meant.

The children took photographs in the school yard and on field trips. They were asked to take pictures of particular subjects, for example, "How many different shapes do you see in this area?" And, they were also given the opportunity to take pictures of their own choosing.

◄Being an editor is fun! Olivia soon discovers it's important to "lay out" the newspaper page in a neat and logical manner. Almost as important, she learns, as taking a good picture in the first place.

▼
But the layout *(below)* proves to Olivia and her friends that words and pictures go together . . . that the combination in newspapers has much to tell them. The individual newspapers, as a group, will be displayed so that students, teachers, and parents can examine them.

The last sessions were spent making individual "newspapers" called "GOOD TIMES" and featuring a picture of the child on the front page and as many of the child's own photographs as he wanted to use.

Each child was helped to write simple sentences about the photographs.

They wrote about friends and relatives they had photographed. They told about things they observed on a field trip to Frontier Land.

The "newspapers" were put in a glass display case in the library so they could be seen by all the students and staff. Then they were given to each "photographer" to take home.

The children involved in the use of Polaroid cameras were compared with children from the same class who did not use cameras, in the areas of Language and Self-Esteem.

Even in this brief two week study the group using cameras increased their vocabulary nearly four times more than the control group (Experimental group + 75 words, control group + 18 words).

It is difficult to measure self-esteem and, it is difficult to obtain accurate results for such a short period of time. Even so, the obvious pride shown by the children who took their own pictures and produced their own newspapers and the attention they received from peers and teachers would seem to contribute to a positive feeling of self-esteem.

Future projects, in addition to emphasizing conceptual thinking and writing skills, might be directed toward helping migrant children be more aware of their own communities and society in general.

Some photographic projects have been credited with the development of "community dialogue." ("A Way of Social Change Through Film," *The Washington POST*, March 2, 1969.)

Jean-Paul Kronenberg, principal at an experimental summer school in the Bedford-Stuyvesant section of New York, explained how the children were learning to read by using cameras.

"The children, in effect, write their own textbooks by describing in writing what they see in their pictures.

"When they don't like what they see, they write letters to their landlords, community leaders and city agencies such as the Sanitation or Health Departments.

"The reading program focuses on the environment surrounded by garbage-filled streets and decaying housing."

The children observe and express their concern about pollution and lack of safe playground space. ("Cameras Helping Children Learn to Read," *New York Times*, August 16, 1970).

Obviously we have not fully utilized photography as a resource tool to create awareness and understanding of self and environment and to develop academic skills.

# Student Participation

1. Name at least three instances where photographs, as visual materials, have helped children in the classroom.
2. Who are Terry and Lyntha Eiler? With what group did they work? What was the result of their experiment?
3. The average migrant child is _____ years behind and is often a _____ grade drop out. (Fill in the blanks above.)
4. When Polaroid cameras were used in a migrant education program, what did the director hope to accomplish?
5. Explain how Jean-Paul Kronenberg in an "experimental summer school" reports the children were learning to read by using cameras.

# 8

# Echoes of Roy Stryker

Long realizing the value of the documentary picture in photocommunication, and recognizing the great contribution Roy Emerson Stryker has made to modern photojournalism, the School of Journalism, University of Missouri, continues to use Stryker's philosophy on and off the campus.

In an effort to echo and reecho the Stryker concepts of picture communication, The Missouri Photo Workshop was founded in the summer of 1949. The Master Roy Stryker, John Morris, then picture editor of *Ladies Home Journal*, Stanley Kalish, picture editor of the *Milwaukee Journal*, Harold Corsini of New York, and Russell Arnold, a Chicago freelance were on hand at that first Workshop to point it in the right direction. Every year since that time the Workshop has brought approximately seventy-five "teachers" and "students" (many of them professionals) to some Missouri town. In a week-long soul-searching session, they (staff and students) attempt to see, to think, and to communicate what they have seen with sensitive, understandable pictures. Posing is *verboten*, and the photographs are taken with available light. The serious, in-depth approach to a picture story at a Photo Workshop adds to the spontaneity, the integrity, and the believability of the pictures.

Believing that most students of photojournalism are interested in the concept and philosophy of Missouri's Photo Workshop, and that you and your fellow students can draw enough from this project to organize a successful Workshop of your own, we submit a brief outline for your consideration. If you can't make your Workshop a week long, perhaps you can hold a week-end project.

First of all, the Workshoppers gather Sunday in a nearby Missouri town. This town must have ample housing facilities (usually a motel) and plenty of meeting room and darkroom space. We take with us, in addition to those who are going to shoot pictures, an editorial staff and a darkroom staff. Our students will be concerned only with finding a story, researching it, shooting it, and "laying it out." The "shooters" do not process their own film, make their own contact prints or their own black and white transparencies—all of which will be needed during the Workshop week. This is just as much a *think* shop as it is a workshop. We want our students, in this highly concentrated week to learn to see, and to feel and to shoot. Posing pictures is not allowed. Students are asked to select a story which will produce good images. Some stories, are word stories, and do not lend themselves to visual images.

But—back to our schedule.

1. Meet and check in at the Workshop desk by noon on Sunday.

2. First Workshop session at 2:30 Sunday afternoon.

3. A one-hour get-acquainted bus tour of the community at 4:30 p.m.

4. Dinner (with all Workshoppers and a group of towns people present) at 6:00.

Introductions are made during the dinner which is hosted by the local

**Missouri Photo Workshop Echoes the Voice of Roy Emerson Stryker.**

newspaper, Chamber of Commerce, and public officials.

5. Monday morning bright and early, each "shooter" appears before the editorial staff to "sell" his or her story idea. If the idea is accepted, the photographer begins shooting at once; if not, further looking for story ideas and further research is in order. Shooting lasts three days and each person is allowed a total of ten rolls of 36-exposure film.

6. Film, dropped periodically during the day (usually at 10, 2, and 4 o'clock) is processed by the darkroom crew. Two sets of contact prints are made; one for the student and one for members of the editorial staff. After the staff has an opportunity to check them over, contact sheets are returned to the darkroom where workers make marked frames into slides for the evening critique sessions.

When the shooting stops, the balance of the week is spent making layouts of the individual stories. To conclude the Workshop layouts, too, are approved (or disapproved) by members of the editorial staff. It is one busy, concentrated week—but worth every moment.

Advanced photo students at MU have their own style of photo workshops. Utilizing many of the time-tested features of the MU Workshop, they spend a week-end at a nearby town. Here, like the pros they are, they do research, shoot their stories and then combine their efforts in producing a very popular book on the host community. It's a fine educational venture—one that is well liked by all participants. Students are proud of the work they accomplish on these week-end sojourns, and the books are welcomed by citizens of the host community. Enough books are sold, incidentally, to pay publishing costs.

You ask how the host towns put up with the MU Photo Workshops? They love 'em. Here's what the editor of the *Lebanon*, Mo., *Daily Record* wrote Oct. 6, 1978, at the conclusion of the 30th annual Workshop:

Lebanon residents are tonight being offered a unique opportunity to examine "slices of life" from our community which just might be eye-openers to aspects of our area of which many of us might not have been aware. The occasion is a public exhibition . . . of the results of the annual Missouri Photo Workshop, which is winding up today. . . .

All of the photos that will be shown tonight involve area residents in day-to-day activities presented in such a way that they can be submitted to national newspapers and magazines for photo-story layouts. . . .

The opportunity offered us is the chance to take a look at Lebanon—at ourselves—as seen through the eyes of outsiders.

Photojournalists are trained to find the unique and interesting aspects of people and what they do. That's what they've been doing in Lebanon all week. It's quite eye-opening indeed to examine some of the work of these professionals and find out what the old man down the street or the young lady next door are up to. People many of us have lived with all our lives are really quite fascinating. We can watch them every day without quite realizing what they are contributing to our society.

Now, photojournalists from broadly divergent areas of our country have come here, picked out the most fascinating people of our area accomplishing the most interesting activities and recorded those people, those activities, on film.

After attending several "critiques" of the work being done, we've concluded that not only are the pros finding the interesting and unique aspects of Lebanon and its people, they're putting together stories which truly capture the spirit of our city and ourselves.

We urge anyone genuinely interested in our area to visit the Workshop. We think you'll find a new perspective on the community and its people in the presentations. And we think you'll realize that Lebanon has a rich blend of humanity—compassionate, loving, understanding, helping, caring, and fascinating humanity—which has made it well worthy of being the subject area for a nationally-known Photo Workshop.

Roy Stryker once proclaimed that one of the important ways for a student photographer to learn was to have a collection of good photographs. He should place them on a table—not hang them on a wall—where he could actually feel them and study them carefully at close range to find out what made them successful as statements—as bits of communication.

In the Missouri Photo Workshops we adhere to the Stryker philosophy. These pictures from recent Photo Workshop exhibits provide you with some fine examples of modern documentary pictures. Study them carefully; study them at close range; look at them again and again. And while you are at it, evaluate the photographs. Are they good? Why or why not? Would you have taken them?

**Canine on Doghouse** *(above)*. From the 1972 Washington, Missouri, Photo Workshop Exhibit, Photo by Lee Romero of the *New York Times*.

◄**Boy Scout and Senior Citizen** *(left)*. From the Bolivar Workshop, 1970. Photo by David Heaton of the *Oklahoma City Oklahoman*.

Echoes of Roy Stryker/63

**The Coach.** From the 1971 West Plains Workshop by William Grimes, *Atlanta Journal.*

**School Bus** (next page). By John Flanagan, Wilmington, Del., *News Journal.* Photo is from the 1970 Bolivar Photo Workshop.

▲►
This picture layout is from a
story by K. Kenneth Paik,
former illustrations director of
the *Kansas City Star and Times.*
Exhibited at the 1971 West
Plains Photo Workshop, it
portrays the lifestyle of a
veteran just returned from
Vietnam, and his young wife.

▲
**The Report Card** (*above*). Photo from the 1969 Forsyth Workshop by David Arnold, Topeka, Ks., *Capital-Journal.*

▶
**The Report Card** (*right*). From the 1969 Forsyth Workshop by Medford Taylor, free-lance photographer.

**Walks of Life.** By John J.
Wozniak, *Kansas City Times.*
Picture was taken at the 1972
Washington Photo Workshop.

►**Face of Nixon.** By William L.
Stonecipher, West Bend, Wis.,
*Daily News.* From the twenty-
fifth Annual Photo Workshop,
Kirksville, 1973.

**The Sawyer.** Pictures by Ann Stevens, American University, Washington, D.C. From the 1971 West Plains Photo Workshop.

◀**The Sheriff Gets a Hair Cut.**
From the 1970 Bolivar Photo
Workshop. Photograph by
Bianca Lavies, National
Geographic Society,
Washington, D.C.

# 9

# A Tribute to Barney Cowherd
## A Perceptive Photographer

Young Barney Cowherd was the first person to win the Photographer of the Year Award in the Pictures of the Year competition, in 1948. Not satisfied with "flash on camera" snapshots, his photographs (made for the *Louisville Courier-Journal*) were different, sensitive, and thought provoking. Barney was considerably ahead of his time.

The late Elwood Martin (Barney) Cowherd died in 1972 at the age of 50. He was a sensitive, innovative man, and a pioneer in modern photojournalism.

For thirty years of the half-century allotted him, Barney recorded the Kentucky and Indiana region as though he were a "poet with a camera." He spent the earlier part of his life as a photographer for the *Louisville Courier-Journal* and the *Louisville Times*. Later, he was photographer for Indiana University. Although Barney's "style" changed with the passing of the years, his pictures never ceased to challenge and to please those who looked at them.

As a salute to this man and an acknowledgement of his great contribution to photojournalism, William Strode, while Assistant Director of Photography at the *Louisville Courier-Journal*, wrote and produced a book called *Barney Cowherd, Photographer.*[1]

To learn more about this astounding young man and his philosophies, exam-

ine the pictures from Strode's book on the pages that follow and then refer to the address (chapter 10) that he gave to students at the School of Journalism, University of Missouri, in May 1948.

**Barney Cowherd (above), who in 1948 was the first person to earn the nationwide title of "Newspaper Photographer of the Year."**

---

1. William H. Strode III, *Barney Cowherd, Photographer* (Louisville: *The Courier-Journal & Times*, 1973).

◄The frontispiece of the book *Barney Cowherd, Photographer*, indicative of Barney's sensitivity, was a picture *(left)* of a little girl enraptured by the things she saw in a Christmas display window. This picture, which appeared in *The Family of Man*, was one of Barney's favorites (and one of the favorites of Bill Strode, who examined more than 1,600 Cowherd negatives in compiling the book). Strode used this picture not only as the frontispiece, but also on every division page, much as Edward Steichen used the little flute player in his Family of Man exhibit. The picture of the little girl served to unify the Cowherd pictures. Courtesy William Strode, *Barney Cowherd, Photographer* (Louisville, Ky.: The *Courier-Journal* and *Louisville Times*, 1973).

▼Below one of the most popular pictures in Strode's book, *Barney Cowherd Photographer*.

**U.S.A. 1948** *(above)*. When this Barney Cowherd photograph appeared in a Museum of Modern Art display, *Life* reported that it evoked "more comment than any other picture since the *Mona Lisa*." That might have been a slight exaggeration, but there is no denying that "U.S.A. 1948" commandeered its share of attention. Barney took the picture because it "signified the mass confusion of the time."

# 10

# Thoughts on Photojournalism

A good photojournalist is first of all a *journalist*. And a journalist is one who reports for a trade journal, magazine, or a newspaper, radio, or television. Journalists, some of them at any rate, use their cameras to do the bulk of their reporting. In my mind, a picture editor is also a photojournalist. This fact notwithstanding, the camera reporter, like the typewriter reporter, has a clear concept of news and what makes it. More times than not, a photojournalist has the ability to write with a typewriter, but for reasons of his own, prefers to do most of his communicating with pictures. The fact that he tells the major part of his story with pictures in no way demeans him or sets him apart as a lesser member of the communicative team.

As far as pay is concerned, good news photographers are considered creative individuals and in the same class with reporters and rewrite workers. Where guild contracts are in effect, a photographer does very well—usually in the top-salaried group.

Just how does one become a photojournalist? Photojournalism can, of course, be learned in an on-the-job training program or in a more formal way by attending a trade school, college, or university. The trend is toward the latter, and many of the young people hired as news photographers today have

journalism school backgrounds. And many journalism schools accept only those college students who have finished their sophomore class. They insist on a good, solid academic backing before a student starts journalism training. It is pretty clear that the time has passed when all a person needed to get a job as a photojournalist was the ability to click a shutter and elbow his way through a crowd.

In fact, if a person knows how to write as well as to take pictures, his chances of securing and holding a job in photojournalism many times are radically increased. This is especially true if one plans to work for a trade journal (house organ), or a small publication as many beginning photojournalists do.

When a small publication believes it cannot afford the luxury of a full-time photo staff, a reporter sometimes is expected to write as well as to take pictures. Certainly, the ability to do both makes him a more valuable person than the one who can only write or only do camera work. It is well to point out, too, that a person who learns to write achieves a discipline which carries over into his photography. He learns how to select the important elements and how to present them.

Today's successful cameraman is curious about the world in which he lives. He or she must know a great deal about

**The modern photojournalist, capable of using either a typewriter or a camera, may be a picture editor, or he may do most of his reporting with film.**

many things. He must have the sensitivity of a poet and the tough skin of a Marine Corps sergeant. Successful photojournalists are knowledgeable, tough, sensitive, perceptive, alive to all that is going on around them.

On his recent visit to Columbia, Missouri Giorgio Lotti of *Epoca Magazine* (Milan, Italy), winner of the 1973 Nikon World Understanding trophy, defined photojournalism as "much more than a documentary fact." He emphasized that the photographer has to put his sensibility and heart into his work. Only in this way can he understand and translate into visual images the reality of things. He must give a message full of humanity and truth.

To many who have watched famous photographers cover a fire, a riot, or a convention photojournalism seems an exciting, glamorous profession. Your definition of photojournalism we hope is far deeper. While it may be "glamorous" and "adventuresome" at times, much of photojournalism is just routine and plain hard work.

Roy Stryker and his crew of photographers in the days of the Farm Security Administration (FSA) referred to their photographs as "statements." And so they were. Hopefully, that is what your pictures will be. It is well to remember, however, that before a worthwhile statement can be made one must have something worthwhile to say. Empty words and empty, thoughtless pictures are a waste of time and money. Every picture cannot be a classic, of course, but every picture can have integrity and can be an honest statement.

Early in their project, FSA photographers learned that to cover a subject professionally one had to do plenty of preparatory work. Once on location, the photographer became an involved, sensitive observer and an honest reporter of the scene before him. An example of the type of research Stryker insisted that his photographers do is described by Carl Mydans in his report of the "cotton" assignment which he did for FSA.[1]

Before leaving to cover an FSA assignment on cotton, Mr. Mydans was called into Stryker's office and asked, "What do you know about this crop?" Stunned by the bluntness of the question, Mydans could not come up with a satisfactory answer, and the trip was postponed. Mydans was taken in hand by Stryker, the old college "prof." Stryker talked all morning, through the lunch period, all afternoon, through dinner, and all that evening about the history of cotton. According to Mydans his "eyeball" lecture covered "the one-crop system and the society that grew up around it." When he got on the train next morning, he had "both a mission and an inspiration," as he later told Severin.

It all added up to an experience which has remained with Mydans through his long and distinguished professional career. One of *Life's* first photographers, he has never forgotten the importance of research.

# Assessments of Present-Day Beginning Photojournalists

I asked three well-known young professional photojournalists to express their ideas concerning the "shortcomings of present-day beginning photographers." These men were college students themselves a few years ago, and their answers will, it is hoped, help stragglers to find the road to a successful photojournalism career.

## Rich Clarkson, Newspaper Photo Director

First is Rich Clarkson, photo director of the *Topeka Daily Capital-Journal*. Rich has earned the Joseph Costa award and the Joseph A. Sprague Memorial award, the highest honor that the National Press Photographers Association can give. Clarkson's staff photographers have four times earned the News Photographer of the Year title and once a Pulitzer award for photography.

1. *See* Werner J. Severin, "Photographic Documentation by the Farm Security Administration 1935–1942: Cameras with a Purpose" (master's thesis, University of Missouri, 1959); and F. Jack Hurley, *Portrait of a Decade* (Baton Rouge: Louisiana State University Press, 1972).

Clarkson has given much time to upgrading photojournalism and to helping young men and women who aspire to become photojournalists. Literally hundreds of college students knock on his door during any given twelve-month period. With portfolio and job application in hand, they have spent hours showing their pictures to Clarkson and telling him of their aspirations.

The following words reveal how he evaluates today's crop of would-be photojournalists.

This seems to be an era in which everyone is "doing their own thing." This is particularly true among young people, and while there's a lot to be said for this, photojournalism isn't the 'do-your-own-thing' affair that so many young photographers want.

We're not in the business of pleasing ourselves with our photographs. *The purpose is to communicate something to others.* I look at a couple of hundred portfolios a year and only a handful show any understanding of using the photograph to communicate.

Now, there's nothing wrong with making photographs for one's self-edification nor to decorate your own or someone else's wall.

But that's not photojournalism.

And photojournalism isn't a world of supergraphics either. I see a lot of pictures of graphic shapes and qualities—some even from the sunset-and-silhouette syndrome. But oftentimes, a portfolio full of those pictures is without meat and potatoes. Just frosting.

Many young photographers photograph primarily their own world. This is fine, but while much of today's youth culture is visually loaded and highly photographable and deserving of serious attention, it's not the only thing going on. *Young photographers should be as curious about other people and their worlds as they are of their own contemporaries.*

True, a few young photographers use their works to seriously communicate thoughts, ideas, and feelings. That's the basis of photojournalism.

Another shortcoming much in evidence in a lot of work turned in by young people is a lack of professional discipline—shooting discipline as well as working discipline. This is something that can come with experience, but it is also something that individuals can affect on their own—just by being aware of it and trying to improve one's own working habits. And I'm not talking about little things such as getting to work on time. My reference here is in the way one thinks through his shooting and then how he actually goes about photographing the story. Following that, how he edits and selects and prints.

Professional disciplines are most helpful, and young photographers should be aware of the need to organize one's thinking and efforts.

And finally, there is a general lack of technical expertise in today's 35 mm generation. Knowing how to expose, develop, and print 35 mm film properly is fairly general. Many make prints that are exceptionally fine.

But most young photographers have little knowledge of lighting, of other film sizes, and of different cameras and processes. Having enough curiosity to read, perhaps to experiment, and to at least know where to go for the answers to questions which may arise—this is far more important than many young photographers realize.

This doesn't take a thing away from the serious and more important goals of contemporary photojournalism, and I'm certainly not advocating anything approaching the camera club preoccupation with equipment (which is a problem with some photographers) nor the portrait photographer's preoccupation with formula lighting.

Most young photographers need to be far more technically proficient than they are—and it's not that difficult to learn.

In his study of photojournalism instruction, Steve Lamoreux of Colorado State University found that 55 percent of photojournalism teachers had earned either an M.A. or M.S. degree. Further, in his survey of photojournalism teachers, other staff members, and students he discovered that the majority of those surveyed (70 percent) reject the assertion that photography has little academic background or stature.

# Jack Kenward, Agricultural Photo Director

The second young man asked to evaluate present-day students is Jack Kenward of Farmland Industries, Inc., Kansas City, Missouri. A longtime news photographer, Kenward has many awards and trophies to attest to his prowess with the camera. Like Rich Clarkson, Kenward has an abiding interest and faith in his profession. Each year in search of a job and/or advice, many young photojournalists come to

see Jack Kenward. Following is his evaluation of the present crop.

What are applicants for jobs lacking in terms of photojournalistic skills?

The playwright Arthur Miller once said, "A newspaper is people talking to themselves." In that quotation I find identified the basic problem most young photojournalists face, a question of audience. No publication exists without an audience. Few of the aspiring photojournalists we've met in recent years demonstrate any con-

It is our duty to encourage and assist all members of our profession individually and collectively so that the quality of press photography may constantly be raised to higher standards. (National Press Photographers Association Code of Ethics)

cern for or interest in their existing or potential audiences.

We recently filled an opening for a position on our photo staff. We interviewed thirty or so applicants for that position. Of the thirty, all but a handful demonstrated a more-than-adequate range of technical abilities. Only about three demonstrated any sense of audience. We hired one of those three. The other two also found positions with other publications within a month or two after we made our decision. Many of the remainder are still seeking work several months to more than a year following interviews with us.

Verbal descriptions of photographs are not always precise, but in this group of about thirty portfolios, all but three seemed to be designed to impress other photographers, as though this was the only proper audience for a photojournalist.

If there is any single factor which distinguished for us the differences between the people we wanted and those we weren't interested in, it was this sense of audience—readers, if you please—and a companion sense of commitment to that audience.

I've not been able to precisely define this sense of audience to my satisfaction. I believe it is an important factor in enhancing the communicative quality of photojournalism. I suspect it reflects a degree of commitment to serve that group or groups of people who regularly form the readership of the publication in question. I know the photojournalist with a commitment to serve his audience possesses a markedly different personality from the photojournalist who is concerned simply with the development of his career through the constant parading of his ego in his published photographs and/or writings.

For most young photojournalists, this question of commitment to an audience or to a variety of audiences introduces a new criterion to the evaluation of their work. I believe this commitment and its degree can be seen in the work of individual photojournalists be they job applicant, contest entrant, or candidate for canonization in museums.

In addition to viewing portfolios, we conduct verbal interviews with job applicants which reveal further this lack of commitment to an audience. They have told us they like to travel; they have demonstrated interest in little beyond the narrow confines of their interest in the world of photography; they have lacked constantly editors who would grant them "good" assignments; they complain their "best" work is never published. We have learned from these job applicants a complete litany of despair and frustration and alibis, none of which are to us proper excuses for shirking their responsibility to their audience.

Our audiences do not exist to serve us; we exist and work to serve our audiences.

Newspaper headlines should be fully warranted by the contents of the articles they accompany. Photographs and telecasts should give an accurate picture of an event and not highlight a minor incident out of context. (Code of Ethics of Society of Professional Journalists, Sigma Delta Chi)

# Gifford Hampshire, Director of Project Documerica

The third person asked to point out the deficiencies in young photojournalists who have crossed his path is Gifford D. Hampshire, Director of Project Documerica. "Giff" received his journalism degree at the School of Journalism, University of Missouri, and for a time was a member of the *National Geographic Magazine* illustrations staff. Following is his answer to my question:

The first deficiency of photographers today is that they are not required to and do not discipline themselves to think logically, as well as emotionally, about *what* and *why* prior to using the camera . . . and too often *how* once they start shooting.

A photographer can be intellectually lazy and still succeed as a "photojournalist." In the institutional framework of a publication, picture researchers, writers, and editors bear editorial responsibility for knowing a subject thoroughly, and articulating a story line to the photographer—sometimes to the point of telling him how to do it.

The beginning photographer whose only thinking is have-camera-will-travel runs a grave risk of complete and permanent rejection. No matter how great his photographic talent or how impressive the portfolio shown, he or she should come to the interview with a prospective employer as an individual, knowing that any good editor or photography director seeking help will examine the applicant's intellectual qualities just as closely as his photographic abilities.

This is particularly true in documentary photography which, in the great tradition, is the product of an individual's mind and heart. Photojournalism is excellent to the degree that the photographer practices the intellectual discipline of documentary photography. I believe the beginning photographer should require of himself, or be required in his schooling, to undertake a documentary assignment. Before deciding on his subject the photographer should ask himself, "What do I want this

body of work to say about me as a person as well as a photographer?" . . .

The value of photographing a documentary story lies not only in learning all that is possible about the subject, but also in arriving at an intellectual as well as emotional conviction that the subject is worthwhile. Adequate research allows the photographer to plan his approach and decide how he is going to shoot the assignment.

If all this is done in advance, the photographer's mind and eye should work in harmony as he is shooting. Surprises should be serendipitous instead of tragic . . . In brief, the shooting should be highly rewarding. Finally, after all the film is processed, and the photographer sees all the images, he should be able to make a selection of pictures which meets or exceeds his objective.

There is one final step, in my opinion, which is essential to the completion of the assignment. The pictures or transparencies should be organized and captioned, and the text should be written so that the work can be reviewed by busy editors or photographic directors, and this with or without the photographer. The cameraman should also organize his "seconds" and "rejects" and have them available for review. Most good editors and photographic directors want to see the complete take if they are at all impressed by the photographer's selection.

The second deficiency I see in beginning photographers has a lot to do with the first. Many are taking to photography for the ego trip. Perhaps that's normal, and I know that photographers are part artist (my definition of an artist is one solely interested in self-expression). I think this deficiency will correct itself as the photographer learns intellectual discipline.

The ego comes under the control of the mind and shares a role with the heart, making the photographer more of a likable person.

Lastly, I must say I am shocked to see so much poor color photography by beginning photographers. I realize it is expensive to learn to use color film, but in this day technical mastery of color film is just as important as black and white for anyone calling himself a photographer.

# Advice from Barney Cowherd

To avoid ending this chapter on a pessimistic note let us consider the advice given several years ago to college students by one of their peers. The person speaking was the late Barney Cowherd (see pages 75–78), a very young man who earned the title News Photographer of the Year the first time it was offered. In his unassuming, whimsical, almost Will Rogers style, Cowherd gave this message to a group of college students just a few years younger than he who were assembled to pay tribute to him for winning the coveted title.[2]

Barney was a thinker. He was tired of those flash-on-camera snapshots. He thought, as did I (a young photojournalism teacher at the time), that photojournalism had much more to offer than the news photographers of the day were giving. The message these photojournalism students heard that day was revolutionary. The record of his address is worth playing again and again. Let's listen:

It appears that there's been some interest in my photographs. This makes me very happy. More than anything else I'm happy because people other than myself like to look at them.

I've decided that these pictures came out of my noodle. The reason they are appealing, if they are, is because I have an ordinary noodle just like most everybody else.

I take pictures of ordinary people doing ordinary things. I've discovered that the ordinary has become fresh because the public is overfed with the unusual, man-bites-dog stuff. We need more stories and pictures of dogs biting man.

A camera is like a typewriter. Typewriters do not write stories and cameras do not take pictures. The human mind writes stories and the human mind takes pictures.

But of course the camera is indispensable. The trouble is that too many of its users don't know that it is unimportant except for its presence.

Expensive cameras and a million gadgets profusely advertised as necessities for good picture making create a false view-

---

2. Address given by Barney Cowherd at the School of Journalism, University of Missouri, 1948.

point for the already struggling student of photography. Some pictures could not have been made without proper equipment, but usually particular cameras and gadgets on them, in them, around them, or underneath them have nothing to do with it.

Quite often the shooting of a flashbulb will kill a shot that would have been good with God-given light, and many a picture has been missed while exposure meter readings were being made.

In addition to what goes on inside your noodle, it's a matter of where you point the camera, the whatever at which you point it, and the particular instant you choose to shoot it. The "where you point it" is easily interpreted from the sad story about the fellow who thought he had taken a beautiful picture and later discovered his failure to include it in his viewfinder.

Who gives a hoot about the appearance of horse manure magnified a hundred thousand times? This brings us to the "whatever at which you point it." Things of universal, down-to-earth interest kick up quite a storm in comparison to the exotic or erotic.

But the timing probably is of greater importance than the where or what.

It is a certainty that if you fire either much before or much after so-and-so blows his nose, you will not have the ultimate in pictorial value—assuming that everything has pictorial possibilities.

Often it's desirable to catch the action just before the climax. Consider a picture of a partially clothed stripteaser and one of her as a nature girl. The "almost" print keeps you staring because you're curious to know how she'd look if. . . . The "all-gone" exposure shows you, but you're left flat, unless you wish to continue the observation for reasons not photographic. By arranging two or more pictures in sequence, we can add considerably to the storytelling possibilities of still pictures and come mighty close to the movies. Of course, we have no audible sound or physical motion, but they can be silently suggested on inanimate paper.

We see a change in time and appearance in the two pictures of the stripteaser. With more pictures, a change of location could be managed, and the imaginative person could even hear the Gayety band by looking at such a photo. A slow shutter speed would render the most active part of the subject's body as a blur, indicating motion.

Among the tribe of people who concern themselves with unimportant stuff, the question of whether photography is art has been overdiscussed. Let us put to death this concern of theirs—by recalling what Alfred Stieglitz once remarked about it. A group of painters said to him, "Of course, photography is not art, but we would like to paint the way you photograph." Stieglitz's reply was, "I don't know anything about art, but for some reason or other I have never wanted to photograph the way you paint."

Some photographers prefer not to call themselves artists; not that they feel that photography is more solid than dabbling, but that names are names and that's all. Possibly that preference is because of the prevailing idea that art has to do with something or other called esthetic—moods, feelings, temper tantrums, and the like.

But it's obvious that these things occur in other people chasing other pursuits. If these idiosyncrasies seem to be present in photographers to any degree, it can be attributed to the extra share of disappointment suffered by them because of their closer relationship with the ungodly manner in which humanity behaves.

The photographer's eyes are diseased with over-sensitivity—they see too much. So many of us engage ourselves in the daily activities of living without being concerned with what our fellowmen are doing, what they look like while they're doing it, or why they do it.

Everybody is different from everybody else. This doesn't sound like too much of a startling observation; however, photographers consciously think in this simple, apparently low level, which is popularly accepted only subconsciously; and, as a direct result, they turn out pictures which are the most honest and realistic records of this life.

We don't spend all of our time trying to figure out what life is all about; perhaps we believe that it can't be figured out, only accepted as it is, such as it is, and presented as it is.

Such as it is, it is not a pretty language. The continuous appearance of the sin-and-strife theme is an indication that we are honest reporters. Our productions are almost in keeping with the modern writers' idea of what's predominantly going on. Unlike the writers, however, we produce a slightly larger percentage of the good-humor variety.

Even though there is an adequate understanding of the technicalities, the mechanics, and the chemistry related to its successful operation, photography continues its insidious habit of getting into man's blood. This is largely because of the miraculous feeling it gives the individual who picks up a picture that he has taken or was in—or even one that was taken while he was looking on.

Whether he realizes it or not, he can hardly believe that such a thing is possible unless the mystics had something to do with it.

# Student Participation

The men quoted in this chapter believe in essence that a word reporter or a cameraman to be successful must have a "sense of audience." In my mind this means that the writer and/or photographer has an obligation to his readers to bring them significant facts about the news or feature event under surveillance. Do you agree?

1. Bring to class for discussion three pictures which are valid reports—pictures which provide information about some local or national happening.
2. Bring to class for discussion three pictures which in your opinion say little or nothing and should not have been printed.
3. Gifford Hampshire, director of the governmental project Documerica, says that "a photographer can be intellectually lazy, and still succeed as a photojournalist." Do you agree? Why? Why not?
4. Read carefully the address given by Barney Cowherd in 1948. Mr. Cowherd was a thinker, an innovater. What are some of the things he said that set him apart from run-of-the-mill photographers?

◄A great picture is a storytelling picture. The picture at *left* by Sam Caldwell of the *St. Louis Post-Dispatch* was taken in 1947 at Centralia, Illinois, where a mine explosion claimed 111 lives. Note the anguish and grief of the woman who, with many others, waits, hopes, and prays that her husband is still alive. Included in 50 Memorable Pictures exhibit.

# 11

# Milestones in the Career of a Young Photojournalist

*Bill Eppridge*

It would be more in keeping with traditions of the journalistic profession to say I started out by writing obituaries for our high school newspaper. But we didn't have too many of them. Actually, in my sophomore year I was writing and editing a column called "Class Notes"—things like "Father Diny is still looking for three more sophomores who were involved in the strangling of Bob Haggerty's cat at his St. Patrick's day party."

I didn't really want to be a writer. I had always been fascinated by an old 35 mm German "Beira" camera my father had purchased in Argentina when I was born. It had an uncoated Schneider f:2 lens, a bellows, a rangefinder, shutter speeds from 1-1/400th sec., was dead silent and folded up to fit into a pocket.

At the start of my junior year, Father Paider, who taught chemistry and had the monopoly on the school's Speed Graphic, was transferred to Wisconsin. That left us without a school photographer. Mr. Cates, the English teacher and newspaper and yearbook monitor asked me, for some reason, if I knew anyone at school who could take pictures. I told him I'd let him know the next day.

I went home that evening, got my sister to show me how to operate our Weston Master exposure meter and how to correlate it to the Beira. Next day I went

back to school and told Mr. Cates I could handle it. He said, "O.K. you're the school photographer."

I then went out and bought every copy of *Popular Photography, Modern Photography*, and *U.S. Camera* I could lay my hands on and discovered available light. I had to because the Beira had no flash synch. I started seriously looking at *Life* magazine and the way their photographers used available light.

I sent my first film out to a local camera store for processing. They blew it—they knew only about processing flash pictures. I had to learn the darkroom fast because if I didn't they'd find out at school that I knew very little about making pictures. If I couldn't be the school photographer, there'd be no excuse for cutting classes.

By the time basketball season came around, I had become somewhat proficient and brazen enough to take my work to *The Wilmington (Del.) Sunday Star*. They agreed to process my film free and paid me $7.50 for each of my pictures they used on the sports page. With this arrangement, I had arrived!

My senior year was mainly a problem of keeping my grades up enough to be accepted into college. I decided on St. Michael's college at the University of Toronto, as an archaeology major.

► **Stormy** *(right)*. This picture was made by Bill Eppridge while he was a student at the University of Missouri and has earned many awards and worldwide acclaim. Bill is now a photographer with Time-Life, Inc., and has produced many winning pictures including those for the famous drug story featured in *Life* several years ago and of the assassination of Robert Kennedy.

Because photography tended to affect my grades, I made a deal with my parents that I would not take a camera to college that year. What I did do, however, was work all summer as a messenger for the Du Pont company. Here I saved enough money to buy a Leica *after* I got to college.

The student newspaper at the University of Toronto was called the "Varsity." As soon as I got to Toronto, I asked for a job.

"The Varsity" was published five days per week and ran sixteen to thirty-two pages per day. Without too many questions I was hired as a staff photographer at $32 per month. But in case anyone at home would see the paper, I used the pseudonyms of "Antoine Tzinkevitsch" and "Yodar Kritsch" for my picture credits.

Next year I was allowed to bring my camera, and I was made Director of Photography at "Varsity." Helping me was a staff of four.

I very well remember the Hungarian revolution caused great anger and consternation on campus. Some of us at Varsity, were so upset we managed to arrange for a chartered aircraft and a source for automatic weapons. In our flamboyant, youthful way, we planned to fly a plane load of Canadian "Freedom Fighters" into Budapest. Our little

In 1977 Mr. Eppridge made an extended tour of Africa for *Sports Illustrated*. The ostrich mother and her chicks *(left)* and the curious zebras *(below)* were photographed near Kenya. They were a part of Bill's on "The state of the game" coverage, following a poaching problem.

adventure was shot down (pardon the expression) however, because none of us had a passport.

Putting out that newspaper was tough on my studies. We sometimes worked thirteen or fourteen hours a day, many times ending up at dawn at the printing plant. Being in charge of four student photographers often meant I had to do their work myself.

It just wasn't possible to simultaneously be a full-time journalist and a full-time student. Something was going to suffer, and it probably would be my grades.

As I pondered the problems, several things came to mind. First, I decided it was pretty silly to spend all that time in a University to earn a mere pittance of $32 per month on the school paper. Second, I sort of knew what I was doing, but didn't know why. Third, the thought of an archaeological career in Canada in the middle of winter was not very appealing.

I thought I should go to a journalism school. Several of my professors said the best was at the University of Missouri. I wrote and was accepted.

When I got to Columbia, I rented a little room 100 yards from the journalism school and settled in for several years.

At that time, in the late fifties, Professor Clifton C. Edom was head of the Photojournalism sequence. There were only four or five photo majors, however, so our training was very personal and very intense . . . picture editing classes, for example, met Thursday evenings at the Edom home. They started at 8 and sometimes went until 2:00 a.m. the next morning.

The University of Missouri was recognized by many as the center of U.S. photojournalism education. The College Picture Competition and what later was the Pictures of the Year Competition and Exhibition, were both judged at MU. The judges were some of the finest editors and photographers in the country. Journalism Week brought the winners to receive their awards. In such an atmosphere, a fledgling could certainly learn a lot by just hanging around and listening.

In addition to the picture competitions, etc., it seemed any photographer traveling through Missouri would stop in for a visit. When this happened,

Edom would corral him for at least one class period.

Many of those people who visited MU and the photojournalism department played a significant part in my career. Some still do.

During those years I won the College Picture Competition twice. I even had one picture, "Stormy" (see p. 87) win first place, Pictorial, in national competitions.

In those days, first prize for the KAM College Competition was a one week internship at *Life* magazine in New York. I well remember my first trip. I thought I had died and gone to heaven. Sitting in with Photography Director Ray Mackland and his assistant, Philip Kunhardt, and *Life's* department heads while they picked and chose particular photographers for particular assignments based on their special abilities was a real eye opener for me. Prior to this, I had never really realized there were specialists. I thought everybody could do everything.

—Listening while Cornell Capa explained to picture editor, Peggy Sargent, his feelings about an essay he had just completed.

—Watching Andreas Feininger turn a dull looking ship into a beautiful piece of art.

—Climbing around in the core of a nuclear reactor with Yale Joel.

—Watching Managing Editor, Ed Thompson completely remake a ten-page lead in fifteen minutes on closing night.

Those two summer weeks, as the stereotype goes, were "worth their weight in gold." They gave me a pretty fair idea what it was like in the real working-for-a-living photojournalism world. I loved it!

Then came graduation time and the military draft on my neck. I knew if I started a serious career the war wouldn't let me finish it. So I went back to New Castle, Delaware, and into a partnership with a photographer-friend who had just left the *Wilmington Journal*. We opened a little operation we called the "Unique Studio."

My partner prided himself on his ability to get clients. We did a couple of weddings, a few portraits and things of that nature, but our chief source of income was a local steel foundry that needed photographs of all their cast-

◀Edward Villella, dancer, *(left)*, top of page, was the subject of Eppridge's picture essay for *Life* magazine on New York City's ballet.

◀*(Left)*, bottom of page. During his cross-country look at Highway 80 for *Life* magazine, Eppridge photographed this silhouetted boy and girl on a backyard trampoline in Cheyenne, Wyoming.

This *Life* photograph *(above)* was taken by Bill Eppridge of racing near Las Vegas as vehicles churned through caliche dust.

ings. These castings I'll never forget, weighed between 200 and 300 pounds and our studio was on the third floor of the 200-year-old town hall.

Of course, we had no elevators. In this ancient building, a rickety 2 ½ foot wide stairway ran up the outside of the structure. It was quite a challenge to get ready for work, let alone to make the picture.

One day I got a most welcome phone call from Bill Garrett (at that time a picture editor of *National Geographic* magazine) asking if I was interested in photographing a traveling school on an around-the-world trip. Providing material for a possible *Geographic* article, the flying school would, Bill told me, visit twenty-two major cities and would be gone nine months.

Glancing at our long list of upcoming steel casting assignments, I didn't think long before telling Garrett I would leave in thirty minutes if he wanted.

Next morning I was in Washington where I got a passport, visas, a wallet full of traveler cheques to buy cameras and lenses in Tokyo (first stop), a plane ticket about as thick as my wrist and a suit case full of Kodachrome. My previous experience with color was minimal (maybe two rolls). So I thought I should ask if there were any particular tricks. Bill's answer was "forget about the color—shoot it like it's black and white." That advice would horrify some people, but it has sure worked for me.

Suddenly to find yourself in Tokyo— where you'd never been before—with new cameras you'd never used before— with a group of twenty-five people you'd never met before—with film you'd never used before—on your first professional assignment for practically the most prestigious publication in the whole world, could be a bit disconcerting.

Luckily for me, the leader of the school was Ed Kern—on leave of absence from his job as Education Editor of *Life* magazine—and a thoroughly professional world-travelled journalist. So, from the start, it wasn't at all like being alone out there.

The next nine months we travelled from Tokyo to Bangkok—Calcutta—Agra—Cairo—Istanbul—Athens, etc. All this time, I carried on an airmail conversation with *Geographic* editors in Washington. This arrangement seemed pretty close to running blind. I hoped at each city that our next stop would bring a box of rejected transparencies taken in a city three-stops before. And once the rejects arrived, I remember how furious I was because they looked "so terrible"—as rejects often do. It was tough trying to mentally reconstruct the situation and remember what the good frames were—the frames which they kept in Washington. Now-a-days *Geographic* field photographers get a set of beautiful 8X10 color Xerox prints of the original selects.

Returning to Washington after nine months or so, I was asked to stay around the *Geographic* building until my story was edited, laid out and approved. This was probably because I was the only person who knew where the pictures were taken. I wrote such lousy captions on that first trip.

During this "layover" period, I spent about six months working as an assistant in their color labs. We were processing most of *Geographic's* Ektachrome at that time and I learned how the experienced photographers used color.

At that time, too, we were printing dye-transfers and making wall-sized Ektacolor prints. This spoiled me. I have yet to find a commercial lab that produces similar quality.

These things took place in the early sixties. I learned that *Geographic* was going to offer me a permanent job. It all seemed fine and proper until an editor (and friend) advised that I reject the job offer. He sat me down and told me what was happening in the world. The Civil rights problems all through the South . . . extreme unrest in Latin America . . . Southeast Asia on the verge of a Communist takeover. These were stories a serious journalist should be concerned about, and because of *Geographic's* non-political philosophy, they would not be involved.

He suggested I go to work for *Life*. This was pretty presumptuous, I thought. *Life* had just dropped eight photographers from their masthead. Surely they weren't interested in hiring an inexperienced youngster. As a

▼ Over the falls *(below)* is an Eppridge picture taken for *Life* magazine at Newport Beach, California.

◄Hundreds of motorcycles started in this Mojave desert race near Barstow, California. This low-level aerial photograph was taken for *Life* magazine by Bill Eppridge, a passenger in a helicopter.

"starter" then, my *Geographic* friend suggested I take my rejects from the world trip and see Howard Chapnick at Black Star Picture Agency.

With the rejects and a portfolio of my photographs under my arm, I left for New York and a visit with Black Star. Without an appointment, I knocked on the door at Black Star only to learn that Howard Chapnick, the man I most wanted to see, was in Europe. I could always come back later, I thought. Disconsolately, I headed for the Time-Life building.There I would look up a reporter I had met during one of my summer weeks at the magazine. Maybe he'd buy me lunch.

Standing at the corner of 51st and 6th Avenue (across from the Time-Life building), a voice next to me queried, "Bill Eppridge, is that you?" I turned and recognized Roy Rowan who had been *Life's* Chicago Bureau chief and a judge at one of the College Picture Competitions in Columbia, Mo. A contest, incidentally, which I had won.

Mr. Rowan told me he had become Director of Photography at *Life* and was looking for young photographers.

It's pretty rare to have a job interview begin while waiting for a traffic light to turn, but that's what happened. Shortly thereafter, I was in Rowan's office showing my portfolio and the *Geographic* rejects. We struck a deal. I was to move to New York and *Life* would use me as a freelancer. If it worked, all well and good. If it didn't—well, I could always go back to Delaware and haul castings up that two flights of stairs into the studio.

During my early stint at *Life,* Ed Kern found me a $46 per month apartment in Chelsea with a bathtub in the kitchen. I had about $260 cash, a 1957 Chev, and the Nikons from the *Geographic* trip. I got a telephone and then sat next to it for five weeks. Finally it rang. My first freelance assignment resulted in a two-day trip to Buffalo.

At a time when *Life's* kill rate was about ten to one, (ten assignments killed to one accepted) my story was published. My next eight stories were also published.

Following these successes, I started spending time between assignments in the *Life* photographers' room. This was a community room with a secretary, telephones, a couple of typewriters and light tables. It was a gathering place for all those great names who were bylined on the pages of *Life:* Gordon Parks, Alfred Eisenstaedt, Ralph Morse, Yale Joel, David Douglas Duncan, Leonard McCombe, W. Eugene Smith, Grey Villet, George Silk, John Dominis, Paul Schutzer, Larry Burrows, Dimitri Kessel, Fritz Goro, and others.

In this informal information center, I picked up bits and pieces of advice, which I carefully stored away in my mind. In addition, I spent time when I could, in the picture editor's office. That's the place to find out about mistakes.

I learned one of my abilities was how to disappear into the woodwork—the ability to walk into a situation and make everybody forget I was there.

As far as *Life's* editors were concerned, this ability to make myself invisible "categorized" me. It got me out of the studio, got me away from set-ups, and fashion pictures and other forms of manipulative photography. I knew then I was mostly interested in straight photographic journalism. I grabbed at pictures and caught them as they passed. The candid moment was the product.

My first *Life* cover happened during the Cuban missile crisis. It was my portrayal of a worried look between two U.N. ambassadors.

During the New York newspaper strike in January (1963), *Life* decided to publish a special weekly supplement for New York City. This put all of their young photographers to work seven days a week. We were covering fast breaking news in New York City even without the proper radio-equipped cars. We offset this disadvantage. We operated out of chauffeur-driven Cadillac limousines. With radio telephones and a reporter at police headquarters, these limos had no trouble getting through police lines.

After the New York supplement a pile of money from day rates and page rates was burning a hole in my pocket. I had an offer to be chief photographer at Giancarlo Menotti's Festival of Two Worlds in Spoleto, Italy. I realized later the title meant I was to shoot all the pictures and do all the darkroom work, and take all the flak from actors who thought I was deliberately not photographing their good sides. To this day, I take some perverse delight in badsiding actors.

One of Eppridge's greatest challenges as a photojournalist resulted from *Life's* assignment, along with a writer, to a study of heroin addiction. Bill and the writer, James Mills, produced such a sensitive word and picture story on drugs that a great deal of good legislation resulted. For his part, Eppridge lived with a married couple— heroin addicts—three and a half months. He photographed their lives during the entire period. This, perhaps, was the first time anyone had so conscientiously studied and just as conscientiously told the story of modern drug addiction.

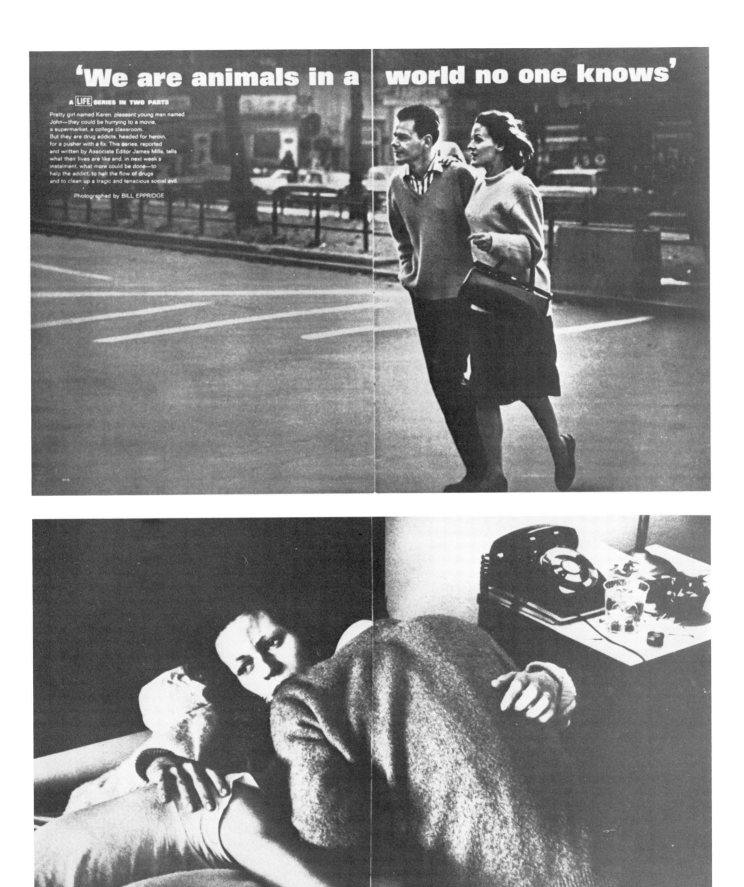

# 'We are animals in a world no one knows'

A **LIFE** SERIES IN TWO PARTS

Pretty girl named Karen, pleasant young man named
John—they could be hurrying to a movie,
a supermarket, a college classroom.
But they are drug addicts, headed for heroin,
for a pusher with a fix. This series, reported
and written by Associate Editor James Mills, tells
what their lives are like and, in next week's
instalment, what more could be done—to
help the addict, to halt the flow of drugs
and to clean up a tragic and tenacious social evil.

Photographed by BILL EPPRIDGE

*Her arms around Johnny and his
brother, Bro—also an addict—Kar-
en lies hopelessly on a hotel bed. On
the table next to her rests a glass of
water for dissolving heroin, a bot-
tle-top cooker and burnt matches.
On following pages she and Johnny
discuss the hidden world they live
in—a place called "Needle Park."*

CONTINUED

From Spoletto, I took a trip into the Alps for *Geographic,* and then covered an earthquake in Yugoslavia, returning to the Alps for more *Geographic* assignments.

In November 1963 I returned to the United States and *Life* magazine where Dick Pollard, then Director of Photography, put me on contract and sent me to the Chicago Bureau. While in the Windy City, I was assigned to the revolution in Panama, and to a startling story on homosexuality.

In 1965, *Life* offered me a staff position and brought me back to New York. With James Mills, staff writer, I was asked to "work up something" on the ever-expanding heroin problem. New York City seemed to be Heroin Central and every day the *Daily News* had a "Dope Fiend" story. The inference was that dope addicts were the cause of all the city's ills. One captain on the New York Police Department felt the best way to handle the situation was "throw the addicts in the East River and when they bob up, shoot 'em."

As subjects of our heroin story, Mills and I found a husband and wife (Karen and John), both of whom were heroin addicts. Both were educated, both were from good families, and both had about a $100 per day habit. The couple lived in a trashy apartment near 72nd street and Broadway—"Needle Park" they called it.

Mills and I approached this couple with absolute honesty. We told them who we were and that we wanted to live with them to document their lives in words and pictures for several months. They asked for money and we explained that if we paid them the story could no longer be valid . . . that they would then be using our money to buy drugs. Karen was a prostitute and John had to steal for drug money. We also told them that perhaps this story would keep some others away from heroin. They agreed.

For three and a half months I spent approximately twenty-two hours per day with our addicts. This was the time when "fading into the wall" was crucial. I made pictures of them "shooting up," of Karen with her "clients" and John breaking into taxicabs. I made pictures when a Harlem dope dealer was in the room. I was there when Karen saved the life of a fellow junkie who had overdosed. I made pictures of her as she was being searched by the Police. I made pictures in jail. I fit so well into the scene that I was stopped and searched three times by the Narcotics squad.

Very little research had ever been done on the subject. When we wrote that the pure heroin addict was nonviolent and that his problems were not criminal but mental, howls of outrage went up. The *New York Daily News* sent reporters out to find our two subjects and to find out how much we paid them and whether they were indeed addicts— or actors. Our story stood. It eventually became the basis for a book and a movie, "Panic in Needle Park."

In 1965 I was asked to go to Vietnam—to cover the Marines. At that time there were only three battalions of Marines in Vietnam. My job was to sit and wait for a significant battle.

Arriving in Danang, I was flabbergasted to see an American Wire Service photographer, whom I knew, coming in from a patrol in full battle dress. He carried a .45 on his right hip, a camera bag on his left hip, a Thompson submachine gun over one shoulder, one camera around his neck and two cameras over the other shoulder. I commented on the fact that he wasn't carrying any ammunition. "Look, when you're with the Vietnamese Rangers, you only gotta *look* like you can hold up your side," he said. "Ain't no way in hell I'd ever fire one of these things, but they won't let me go with them unless I carry guns. And besides, bullets are too heavy."

This was very early in the war and the Vietcong were not yet ready to go against the Americans. Marines had little skirmishes here and there but nothing of the significance my editors (a couple of them ex-Marines) were looking for. I had to wait a long time.

Finally, after many weeks, both AP's Eddie Adams and I learned the Marines had gone out in full force against a Vietcong company-sized unit on a small island near Chu-Lai. We talked our way onto Gen. Lou Walt's personal helicopter and on landing found ourselves in what remained of a battle zone about a mile behind our lines. There were bodies of Americans and Vietnamese all over the place. The general stayed a few minutes, and then asked if we wanted to go back out with him. We said no thanks and he left.

Within thirty minutes, we spotted three Marines, a corporal, and two privates, who were headed forward. We tagged along. The trail led through a burned-out village. A Marine spotted someone hiding in the rubble—a young Vietnamese, perhaps 18, wearing surprisingly clean, well-pressed clothes. The Marine called to him in Vietnamese "come here," but he wouldn't move. They went over to get him, but the youth broke and ran. The corporal dropped his rifle, chased him down and tackled him. The Vietnamese was terrified. He broke away and ran again. Again the Marine chased and caught him. The youth fought and managed to break away a third time. This time the corporal said "kill him." A private got down on one knee, aimed his rifle at the fleeing figure and fired once. The boy was dead.

Eddie and I had both photographed the entire sequence. As far as we knew it was the first time anyone had photographed an American actually killing a Vietnamese. We both felt the film was pretty significant.

We managed to get the film out to Saigon and then remained two more days photographing the rest of the action on that island before returning to Danang.

Eddie's film somehow mysteriously disappeared from the Saigon AP Bureau and never showed up any place.

A couple of weeks later, when *Life* magazine appeared in Saigon, there was one picture from the sequence—three Marines walking past the body. I got pretty angry and called New York. My boss told me the editor's reaction was "Marines never shoot anyone in the back." The sequence was never published.

It took some time to return to New York from Vietnam. When we returned, the U.S. seemed pretty dull and unexciting.

Soon the 1966 political campaigns started. It was obvious that Senator Robert Kennedy was going to be an important factor in American politics. He was a natural candidate for 1968. *Life* wanted a major piece on Kennedy and asked me to photograph it. The fact I had never covered politics didn't matter.

That year (1966) Bobby was hopping around the country working for other candidates. Although he was not up for election, his trips had all the trappings of a full-blown presidential campaign. The Kennedy name was magic, and the man was controversial. At the magazine we spent a lot of time discussing this story before I was sent out. Certain "theme" pictures were necessary, and they could not be posed. There were the elements of his tremendous appeal; his ability to maintain "the legend" of his brother; his attitude toward the then-president, Lyndon Johnson, and his obvious aspirations toward the presidency in 1968.

I spent three months campaigning that year with some carefully preconceived ideas in mind. I knew what we wanted to say, but had to watch and wait for the moment and be ready when the precise situation arrived. Our cover picture—Bobby applauding in front of an almost ghostly portrait of J.F.K.—happened so fast I had time to make only three frames. The situation never repeated itself. This was the one and only time during the entire period that there was any kind of visual connection between the two.

To photograph the enmity between R.F.K. and L.B.J., was difficult indeed. Only one time during those three months were the two near each other. It was at a bridge dedication in New Jersey. Kennedy knew how to control his expressions and emotions, but just once he allowed his feelings to show.

It was easy to see Bobby's popularity in crowd shots but the graphic quality of the Kennedyesque silhouette before a Berkeley crowd said it differently and with more visual impact.

The most important factor in these pictures was time. The magazine had given me enough time to thoroughly understand my subject—to be able to anticipate his handling of a situation and to be there—ready—when the picture happened.

The year 1968 was quite another matter. The campaign that year was "for all the marbles." I was in the Colorado Rockies when I heard on a transistor radio that R.F.K. had announced for the presidency. Immediately I drove twenty miles down jeep trails to a phone so I could get my bid in to be *Life's* permanent photographer on the campaign. Dick Pollard was really glad I called. It seemed nobody else was interested in all the hassles, the long hours and the mobs.

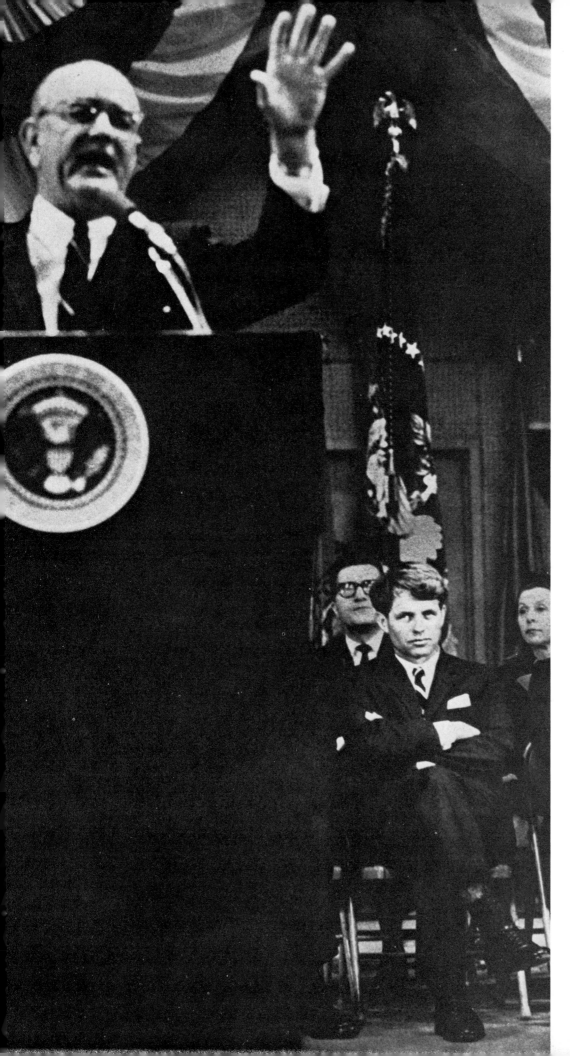

"Point Photographs" are
important to every
photojournalist. In this Bill
Eppridge photograph taken for
*Life* in 1966, Bobby Kennedy's
feelings toward President
Lyndon Johnson are pretty well
revealed.

There was no Secret Service protection for candidates at that time. To get through crowds cameramen had to form a wedge and actually run interference in front of the candidate. Our wedge was composed of a three-man TV crew in the center and a still photographer on either side forming, as it were, a human spear point. We would walk backward into the crowd, opening a path, and the candidate would follow. This would provide the candidate with an open path to the podium and it also gave us picture situations. When people got knocked about, they blamed the press and not the candidate. It worked out well all the way around but we had to expect a few bruises for our efforts.

The campaign started well and Bobby was running full tilt. He had forced Lyndon Johnson to announce his retirement and was catching up with Eugene McCarthy—antiwar candidate and poet.

*Life's* attitude was different this time. This was the real campaign and I was doing straight news coverage as part of a three-man writer-reporter-photographer team. There was not much time to look for carefully thought out concepts. Weekly deadlines had to be met.

▼
With a Bill Eppridge photograph of Robert Kennedy on the November 18, 1966 cover *Life* asks if Bobby "will dare to run for the presidency in 1968." In this picture, J.F.K., the martyred president, is looking over the shoulder of his brother, who also was to die by an assassin's bullet.

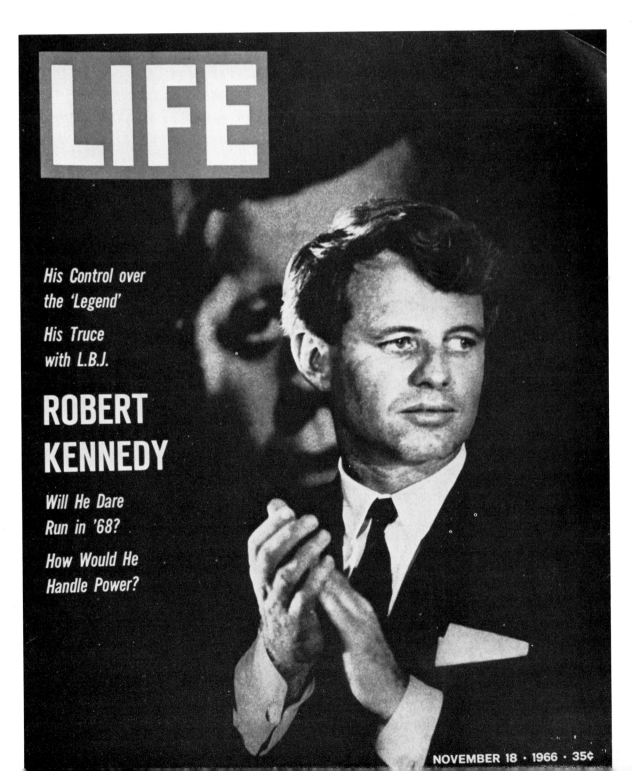

LIFE

His Control over
the 'Legend'

His Truce
with L.B.J.

ROBERT
KENNEDY

Will He Dare
Run in '68?

How Would He
Handle Power?

NOVEMBER 18 · 1966 · 35¢

First published as a double-truck (two-page spread) in the 1966 *Life* magazine, this Eppridge photo was published in 1968 as a wrap-around cover for a *Life* Special Edition after Bobby Kennedy's death. Senator Robert Kennedy once told Eppridge that this was his favorite photograph.

LIFE

SPECIAL EDITION

The
# Kennedys

And deadlines weren't our only problem . . . we were fighting for space against other *Life* teams who were with the McCarthy and Nixon campaigns. We were also fighting the Republican proclivities of Time, Inc.'s management (*Life* later came out and editorially endorsed Richard Nixon for president).

But Bobby kept winning. Week after week his ratings went up in the polls. His primary victories were impressive, but there was a certain uneasiness in the press corps. This was too much of a good thing. We started nervously looking at windows and rooftops during motorcades. There were several rumors that "a man with a gun" had been seen, or had been picked up by local police. None of this could be substantiated.

Of course, Bobby had no official protection. He refused to have uniformed police close around him. Bill Barry was an ex-FBI agent and a Kennedy family friend. He was along, but he was only one. Eventually, the Senator was convinced he should let Roosevelt Grier and Rafer Johnson and occasionally other pro-football players come along. There was no advance security at all. So the only buffer Robert Kennedy could really depend on was our "wedge."

As the campaign moved into late May, there was open discussion among the 50-odd members of the press corps. What was the possibility of an attempt on Kennedy's life. CBS assigned a second camera crew permanently to the campaign.

We arrived in Los Angeles for the California primary, and knew we were in trouble when the motorcade from the Airport to the Ambassador Hotel was presented tickets for 156 traffic violations by the L.A.P.D. (Mayor Yorty graciously had the violations quashed after the Senator was killed.)

Crowds greeting the Senator were huge and uncontrolled. In most cities, police escorted campaigning political groups but Los Angeles provided no such escort for Robert Kennedy.

There were portents: one, the day before the primary in San Francisco, someone in Chinatown, threw a packet of firecrackers at the Senator's convertible. There was a split second of frozen terror on his face then he dove for the floor of the car. Cameramen in the preceding and trailing cars were unable to move. Nobody made any film of that

incident but it did serve to reawaken all our fears.

Primary night James Wilson, CBS cameraman and I had both asked the Senator if we could be included in his immediate party. We felt this would be the most politically significant night of the campaign. He had already won South Dakota and a California victory would send his campaign into orbit. He agreed to let us be with him.

Early that evening in the Kennedy suite, looking at a TV picture of an incredible mob scene in the ballroom of the Ambassador Hotel, I decided to cut my equipment to a minimum as I knew I'd never be able to get a camera bag through that crowd. I pared down to two cameras, stuck an extra lens and four rolls of film in my pockets.

The primary election looked like a sure thing for Kennedy around 10:30 p.m. Then it was time to go face the mobs and accept the victory. The Senator, a small group of friends, Wilson, his crew and myself all went down a back elevator through the kitchen where Kennedy shook hands with a cook before going out into the ballroom.

The crowd was even larger and more undisciplined than we had anticipated. We had to fight to get the Senator onto the stage. I remember having an elbow-knocking session with Jesse Unruh, a state campaign coordinator and my good friend.

Bobby's acceptance speech made, we formed a wedge to get the Senator out. Bill Barry had set the direction, toward a side door away from the kitchen. Barry said, "This way, Senator." Pointing toward the kitchen, R.F.K. replied, "No, Bill, I'm going that way." Barry reiterated and this time firmly said, "No, Senator. We're going out this way." Bobby turned and headed alone toward the kitchen. We quickly reversed our direction, but by then others had gotten between the Senator and his "wedge."

He was about twelve feet in front of us going into the kitchen. We were going through the swinging doors when I heard what sounded like firecrackers. I hit Wilson on the shoulder and said, "Jimmy—25 calibre" (I was slightly off, they were .22 calibre). People ahead were falling or scrambling to get out of the way. Wilson and I were running directly into the gunfire. I stopped for a couple of quick pictures of one

# LIFE

SENATOR
ROBERT F.
KENNEDY

JUNE 14 · 1968 ·

# LIFE
## ATLANTIC

The Death of
**ROBERT KENNEDY**

A Family's History
of Tragedy

A ................... S 10
M .................... Fr 18
H ISLES ............ 3/-
RK ................ Kr 2.75
D ............... Fmk 1.50
.................. 1.80 FF
NY .............. DM 1.50
.................... Dr 12
D .... 3/- (INC. TAX)
................... IL 1.20
.................. Lire 220
........................ 3/-
RLANDS ........ Fl 1.25
Y .............. Kr 2.50
AL .............. Esc 10
.................. Pts 25
.............. Kr 2.00
RLAND ........ Fr 1.50
.................. Krs 325
MED FORCES .... 30¢
AVIA ...... N.Din 4.50

**JUNE 24 · 1968**

downed man, who for a second I thought was Barry. We moved forward to find the Senator—fallen—bleeding—being held by a hotel busboy who was the last to shake his hand. Bobby's eyes were open and he was trying to speak. He was clinching and unclinching his right fist. In the corner, I could see Bill Barry, Rafer Johnson, Rosie Grier and George Plimpton all piled up on somebody—I assumed the gunman. Rosie was yelling "Don't kill him. Don't kill him."

Two photographers ran past me—out of the room. One, a lady I knew from the campaign plane, screamed at me "you can have it, you vulture!" I started to choke up and froze.

Right about then instinct (or some other automatic function) took over. I remembered saying to myself, "O.K. you've had ten years training for a moment like this . . . now go to work." I went into a kind of time warp. Time slowed almost to a standstill. It was as though nobody else was in the room but the Senator, the busboy and myself. I went to Kennedy's feet because the lighting from Wilson's movie light was better. I realized I had no film to waste and bracketed four frames. By this time,

Wilson had run out of film. He shut down his light and single handedly started to move the crowd back.

Ethel Kennedy, was brought into the room. She wanted all photographers removed. I, very deliberately, moved back and helped to hold back the crowd—at the same time, however, and with a wide angle lens on my camera, I began taking pictures from the hip. Nobody noticed me.

Twenty-one minutes in that kitchen seemed like an eternity. When it was over, I found I had shot less than 2 rolls of film.

I made pictures all the way back—at St. Patrick's Cathedral—the Funeral Train from New York to Washington. At the cemetery I held a candle—and cried.

Two days later Dick Pollard called me into his office and told me there was a lovely story to be done on Wild Horses out in the mountains of Wyoming and Montana.

"When do you want me back?" I asked. "When you feel like it," he said.

Three months later I felt like I had the Wild Horses, so I came back. But it was a lot longer before I got involved in any more political campaigns.

# Student Participation

1. Since early high school days, Bill Eppridge has had an undying love for the camera, for world travel, and for people. In reading "Milestones in the Career of a Young Photojournalist" you are made aware of these things. Are these same "loves" important to all would-be photojournalists? Explain.
2. Soon after graduation from college, Bill Eppridge had the opportunity to work with *Life*, *Look* and *National Geographic* magazines. He chose *Life*. Which publication would you have selected? Why?
3. One admonition given to beginning photojournalists is "that they understand and know their subjects," but that they not become involved with them. Explain how Eppridge followed this rule in

covering the heroin story, and the Bobby Kennedy campaign trail.
4. When given the job of photographing a world-traveling school by National Geographic's W. E. (Bill) Garrett, how did Eppridge prepare for the assignment?
5. He feels that "from this moment on" he was preparing to handle assignments like the one on drugs and the Bobby Kennedy assassination. Do you agree?
6. What affect did the 1963 New York newspaper strike have on Eppridge's career as a photojournalist?
7. In taking the famous picture of the fallen Robert Kennedy, why did Eppridge shoot from the direction of Kennedy's feet?

▼ Bill Eppridge said "much of Bobby Kennedy's political support came from the Blacks, and from the poor and under-privileged."

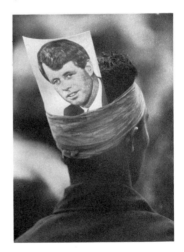

8. Now a "special contributor" to *Sports Illustrated,* what type of pictures do you expect Eppridge to take? (His portfolio in this chapter provides the answer.)

9. During the period he covered the Bobby Kennedy campaign, Eppridge became quite fond of the presidential candidate. What one incident in this chapter best indicates this is so?

10. In a recent edition of *Bootstrap,* a regional NPPA publication, Frank Hoy, teacher at Arizona State, asked the question, "Should a photojournalist be a college graduate?" Basing his answer on his twenty years as a newspaper photographer and his nine years as an educator, his answer was a resounding YES. Based on your own observations and experiences, how would you answer this question? Can there be any exceptions?

**Burst of Joy** by Sal Veder of the
Associated Press. This picture
made a clean sweep of the
many competitions in which it
was entered in 1974. It earned
first place, general news, in the
Thirtieth Annual Pictures of the
Year competition. Among the
other honors were first prize,
World Press Photo, Amsterdam,
Holland, and the Pulitzer prize
for feature photography. It
portrays the return of Lt. Col.
Robert Stirm as he arrived at
Travis Air Force Base in
California after more than five
years in a North Vietnam
prison. (Wide World Photos.)

# 12

# Winning a Pulitzer Prize

Note: On this page we begin translation of a tape recording dictated especially for this book by Brian Lanker, prizewinning photographer then with the *Daily Capital-Journal*, Topeka, Kansas. Editing has been kept to a minimum to insure that you get a true picture of Lanker's thoughts and feelings as he went about producing the story which won for him a 1973 Pulitzer award in photography.

June 10, 1974

Right now it is 2:30 in the morning, and about 4 o'clock, less than two hours from now, I leave for a several-day trip to western Kansas to do a custom harvester story. But this seems the best time to get things done as the days are so hectic with tornadoes, etc.

In regard to the childbirth story: It started out by my seeing an article in our paper on the Lamaze classes. One of our photographers did the story showing how the husbands and wives, as a part of a class of instruction, go through different exercises to prepare themselves for the birth of a child.

For me, and for the community, the natural childbirth approach was new. It was new especially to see the relationship of the husband and wife during a natural childbirth, as opposed to the norm, where so many times the husband is shoved to the far end of the hospital where he reads a magazine or chews his fingernails. It was news to me—and to a lot of people—to find out that the husband is a vital part of the natural childbirth story.

Up to this time, the big problem with a birth story, in my mind, was that they had really missed what it was all about. They missed showing the birth, missed showing the two of them—mother and father—together.

So I set out to find a couple who would not mind a photographer in the delivery room with them. I didn't think it would be easy, but little did I know how hard it would be. Well, six months' worth of these classes (each class lasts only a month) meant that six groups went by before Jerry and Lynda Coburn came along and said "Yes, we really believe in the Lamaze method of childbirth, and we think it would be good if in some way we could let other people experience what natural childbirth is all about." With their permission to photograph the birth of their baby, things started to happen.

The story really never was scheduled for the paper. I didn't go to a great deal of trouble to tell them what I was doing. I was playing it low key because I had no idea of what kind of photographs

**Brian Lanker, formerly with the Topeka, Ks., *Capital-Journal*, and now Director of Photography at the Eugene, Ore., *Register-Guard*, tells us how he photographed the story of natural childbirth and gained worldwide acclaim.**

might come from this story. The only thing I did in regard to the staff in the newsroom was to constantly leave a number where I could be contacted should a call come from the Coburns. I stayed home at nights, refraining from all other activities so I would be available. I did, however, go to the Coburn home many times—became acquainted with them, had tea, and joked with them. They gave me a book on *Childbirth Without Pain*. I read it at home. That basically is where the preparation for shooting the story and my relationship with the Coburns began. It wasn't a close relationship at the start, but it was destined to become very close. When it came time for the child to be born, I was the first to receive a call. Lynda advised she was calling her husband and the doctor and asked if I was ready.

Of course I was ready, but the same day the child was to be born—and almost at the same time as it worked out—I was scheduled to give a talk at the local Rotary Club. The executive editor at the newspaper had made the arrangements, and I couldn't say no to the several hundred Rotarians—mostly out-of-towners in Topeka to attend the legislature then in session.

I had this speaking engagement hanging over my head as I went to the hospital that morning. The real excitement and anxious moments, however, came from thoughts of the impending birth. I guess I sort of prayed things would work out. And they did. Recalling the situation I can tell you that I didn't have an inkling of an idea about the excitement in store for Jerry, Lynda—and myself, as well.

I was so elated and so involved with the whole idea of birth and this birth in particular that by the time the baby was born, I really felt like it was mine. I guess this goes against the journalistic principle which insists that you have to be an uninterested, objective observer. I was quite a bit a part of this birth—so much so, in fact, that I don't remember actually seeing the images and then clicking the shutter, as I usually do on assignment. Things were happening too fast, and the camera just became an extension of my eye. I focused fortunately—and wound the film—but until it was over, I was unaware of what really was going on.

Lynda gave birth to Jacki Lynn just moments before noon. I finished photographing, and quickly removed the cap, gown, and protective covering for my shoes, all of which were worn in the delivery room. Frantically I rushed to the hotel where the Rotary Club was meeting. Although I arrived too late for the luncheon, I was in time to make the scheduled talk and slide presentation. During the talk I explained where I'd been and what had just happened. Several days later when many of those in the room finally saw our newspaper and the picture page, I suppose, they understood a little better the excitement I was talking about. . . .

Usually, after an assignment I return to the office where an hour or so later I process the film. I didn't do that this time. Admittedly I had qualms about how well I had covered the situation. I didn't feel that whatever I had done could come close to capturing the feeling, the aura, and the importance of the husband and wife experiencing this very beautiful moment together. I put the film away and developed it several days later. The winning of the many photographic honors is now a matter of record.

The childbirth pictures were entered in the National Press Photographers Association clip contest, the Pictures of the Year Competition, the Missouri-Kansas Associated Press contest, and of course for the Pulitzer Prize. . . . The photographs and the story of natural childbirth must have an almost universal appeal. Never did they lose a competition nor were they ever given second place. They were picked first in every competition in which they were entered.

It is not that being first—or even second—is important. What is important is that these pictures really got close to people. They really communicated something, and that is what we are trying to do.

In concluding his story Lanker dictated these words which should be of interest to persons in photojournalism:

After finding a couple for my story, there was a little research to be done. I read the book *Childbirth Without Pain*. I also got permission to photograph the event from the hospital and from the doctor. It was an easy matter to meter the light and figure the exposures before

Brian Lanker has earned just about every possible honor in newspaper photography. A staff photographer on the Topeka *Capital-Journal* when these childbirth pictures were taken, Lanker has earned five National Press Photographers Association regional Photographer of the Year awards, one in Region 8 (in 1968) and four in Region 7 (1969-1972). Topping this record, Lanker was the youngest photographer (1970) to earn the title National Newspaper

Photographer of the Year. Going one step further, Lanker won the Pulitzer prize for feature photography for a story on natural childbirth in 1973. In 1976 he again won the National Newspaper Photographer of the Year award. Presently he is Director of Photography for the Eugene, Ore., *Register-Guard*. Lanker serves as an instructor in many photojournalism workshops throughout the country.

**From Contact Sheet to Printed Page:** With a self-assigned story, "The Moment of Life," Brian Lanker earned the 1973 Pulitzer prize for feature photography. During the time he was in the delivery room with the parents (Jerry and Lynda Coburn) Lanker was so involved that he was not sure he had actually taken the important pictures. Professionalism won out, however, and Lanker had many fine exposures on his contact sheets, one of which is pictured *above*.

How the story was used in the *Topeka Capital Journal* is shown on the next page.

Life comes with a tug.

A mother's face tightens white against her cheekbones, her face rushes red as she makes the final effort to deliver the child.

In the psychoprophylaxis method of delivery, such as the Lamaze childbirth method once reserved for the hardy few, the man stands next to his wife, letting her squeeze his hand, reminding her to push down. It is an alternative to the usual anesthetized, and isolated delivery room procedure.

Topeka hospitals report a growing number of Northeast Kansas parents are using the new method. In it the mothers are trained in the latter two months of pregnancy to develop conditioned responses through muscle relaxation and breathing exercises to intercept the pain stimuli and thus reduce pain. They learn what to expect at each phase of delivery and how to apply the breathing and relaxation techniques effectively.

Stormont-Vail and St. Francis hospitals report the method is growing in popularity with from two to six mothers, including some hospital personnel, each week choosing it.

"I was excited beyond belief. I kind of forgot what to do. It was a true high. I needed him to tell me what to do," she said.

"I couldn't do much being there but she needed me," he said.

"It was the most important thing to me, having him there."

Both believed the reserved waiting room where he could sit in a plastic molded chair surrounded by Redbook magazines and smouldering ashtrays was not the place to be at the moment of childbirth.

It's his baby too.

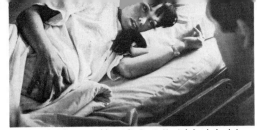

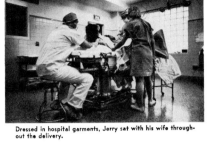

Dressed in hospital garments, Jerry sat with his wife throughout the delivery.

While Lynda Coburn was in labor at St. Francis Hospital, her husband Jerry was right there with her, ready to give both moral and physical support whenever needed.

# The Moment of Life
# An Experience Shared

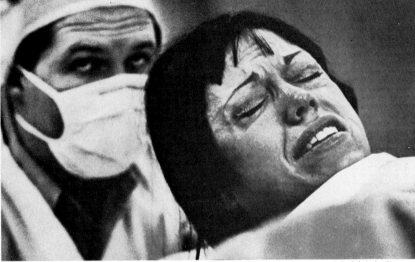

During the final contractions Lynda strained every muscle in her body and then radiated joy upon arrival of their daughter.

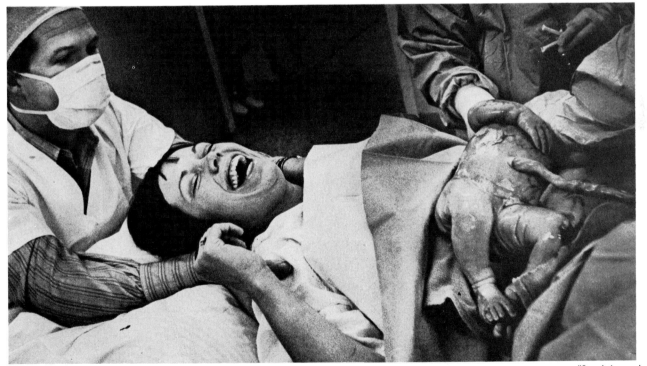

"One minute your stomach is so big and then in a second you have this hot, little, heavy, wet, body on top of you, alive . . . it's overwhelming."

Jacki Lynn Coburn was born to Mr. and Mrs. Jerry Joe Coburn in St. Francis hospital at 11:45 a.m. on Thursday the 27th day of January, 1972.

photos by BRIAN LANKER

Topeka Sunday Capital-Journal
for
and
about
THE FAMILY

It was all over. Jerry walked from the now empty delivery room where moments earlier he had helped to deliver his daughter. "I didn't think it would move me that much, but I was very surprised and excited inside."

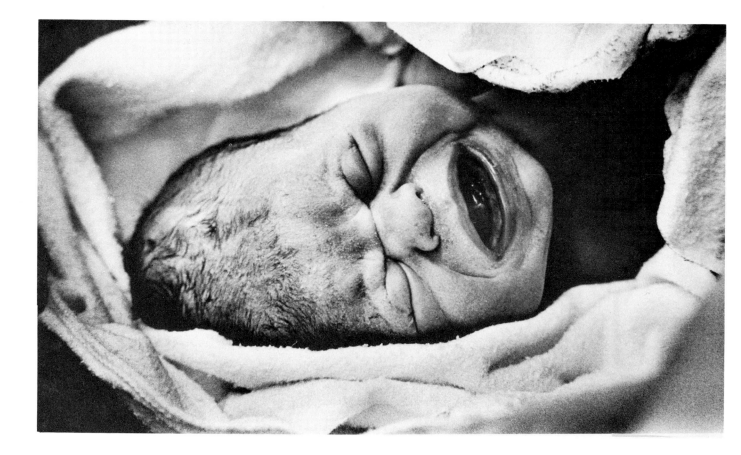

the happy event occurred. I knew what
the conditions and the light were going
to be. I knew what lenses and what cam-
era settings I would use. There weren't
any surprises—photographic surprises—
I was in for.

# One Last Thought

In 1973, the year Brian Lanker earned
a Pulitzer Prize, another Pulitzer Prize
in photography was given for a photo-
graph from Vietnam. This one, by Nick
Ut of the Associated Press, portrayed the
horrors of war, showing a group of
screaming, frightened children just sub-
jected to an accidental Napalm strike.
So: we have a Pulitzer Prize won on one
hand by a horror picture of a distant war
and on the other hand by portrayal of
a very beautiful moment, the birth of a
baby in middle America. That's what
photojournalism is all about.

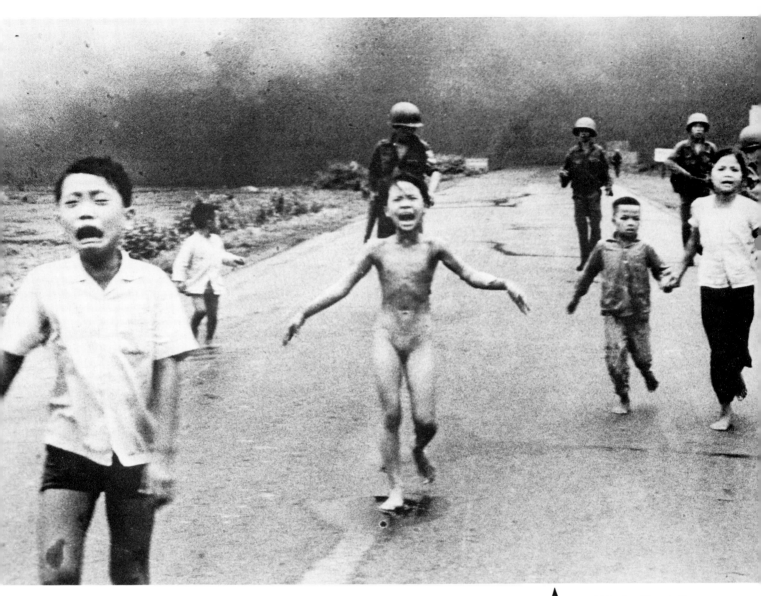

**Terror of War** by Huynh Cong
(Nick) Ut of the Associated
Press. This picture won first
place, spot news, in the thirtieth
annual Pictures of the Year
competition. He also won the
Pulitzer prize for spot news the
same year that Brian Lanker of
Topeka earned the Pulitzer
prize for feature photography.
(Wide World Photos.)

# 13

# Picture Editing

Far more pictures were printed this last year than ever before. Paradoxically, only a few publications have bonafide picture specialists on their administrative staffs. Far too many with the title of picture editor are picture editors in name only. They have little or no authority and are not allowed to instigate significant changes. True, not too many of them are trained to assume administrative responsibilities in the photojournalism realm, and unfortunately not too many photographers want to take over directorship of a photojournalism program.

In spite of this foreboding picture, a few publications today do give authority and cooperation to picture editors. A number of these picture editors do an excellent job of getting the most out of the photojournalism dollar. They are recognized as important, well-paid people—and so they are.

In the preface of a book on picture editing you will find these words:

The key to successful picture editing is the feeling for pictures. This cannot be over-emphasized. A person who is going to edit pictures successfully must live pictures, must sense pictures, must interpret every experience in the light of pictures it suggests. Thus far there has been too little of this feeling for pictures. In many a newspaper office picture editing is nothing more than a spare-time job for a newsman. Often the captions are written by anyone who is available, although caption writing is as specialized as is headline writing. Publications (and the whole publishing industry) sadly need people who have a knowledge of picture editing.[1]

**Paradoxically there are only a few publications with well-trained picture specialists on their administrative staffs.**

## Functions of a Picture Editor

J. Bruce Baumann, formerly a member of the picture staff of *National Geographic Magazine,* and now photo director of the San Jose, Calif., *Mercury-News,* gives the following evaluation of picture editors and their status in present-day photojournalism. A fine photographer as well as a fine picture editor, Baumann has had important positions on newspapers in Indiana and Michigan and is well qualified to give an authoritative approach to the subject of picture editing. Here is what he has to say:

1. Stanley E. Kalish and Clifton C. Edom, *Picture Editing* (New York: Rinehart & Co., Inc., 1951).

Picture editors should be in charge of all illustrations which appear in print.

In the past, job descriptions have varied for picture editors from place to place, depending on individual management. Today, only a few uneducated managing editors or publishers hold back the authority necessary for a responsible and professional picture-editing job.

The new awareness level of some word editors to accept highly skilled people in the area of pictures is directly responsible for a more sophisticated press. The photographer, who once played the role of illustrator, now takes an active part in the role of journalist. Therefore, as we have had copy editors to polish writer's manuscripts, we have picture editors to make judgments on editorial images.

The role of the picture editor seems deceptively simple. It is, in fact, a job so complex that there have been few textbooks written on the subject. This may further be emphasized by the fact that, although there are thousands and thousands of writers and photographers, there remains only a handful of qualified picture editors. The numbers, however, are growing with each year. A qualified picture editor is much in demand.

What qualifies "qualified?" Two things. He must have a complete administrative and creative hold on the reins. Let's first discuss the administrative aspect.

As established earlier, the picture editor must be in charge of all illustrations which appear in print. It is therefore necessary to regard the picture editor as a member of the news executives. His title is irrelevant as long as he functions with the authority of an assistant managing editor. He must be on a par with the executive news editor, one step below managing editor. At this level of management he is in a positive position to make editorial decisions in the area of graphics.

Why should a single individual be charged with such decisions? Primarily, because committee decisions are inefficient, compromised, and generally nonprofessional—ineffectual. One person, in charge, can direct a balanced visual product. Second, why would a publisher want to accept anything but a trained, expert, and professional picture editor?

As an administrator a picture editor's responsibilities are these. First, as a *news executive* he should have a list of assignments for each department. He must be aware of all events that concern the publication.

Next, he must sort through the assignments and *determine what is editorially important and visually interesting.* Here he must weed out the mundane and the non-visual.

The next responsibility is vitally important. *The picture editor must match up the proper photographer* with the *specific assignment.* Similarly, as a sports writer would not be sent to cover a political convention, an unspecialized photographer should not be out covering a specialized story.

The problem of the wrong photographer will remain a problem as long as publications continue to carry a ten-to-one ratio of reporters to photographers. A more practical ratio would be five to one.

A picture editor should provide his photographer with background information. It is his responsibility to provide the knowledge necessary to communicate the story visually.

Second, but not secondary, is the creative aspect of the picture editor's role. It is most certainly an interactive and functional part of his position. It is that ingredient that gives quality to his work.

When the story is completed, the picture editor edits the entire take (either from contact sheets or electronic devices). He must keep in mind the editorial content as well as the visual image. He is, in fact, searching for the accumulative statement—the single frame which communicates with editorial and visual impact.

Having found the photograph which will best exemplify the story, he must first crop the image in a way to project the information that it contains. Many pictures have been lost by a butcherous hand on a grease pencil.

Another of his more vital roles is to carefully select the portion of the image which is to be cropped in (as opposed to being cropped out). I prefer the former terminology to the latter, since what is left in has more importance.

Following this procedure, it is then necessary to determine the proper size that the photograph will appear in print. First, let me say that bigger isn't necessarily better. Sizing a picture larger than it merits only emphasizes its shortcomings. On the other hand, sizing a photograph smaller than it needs to be to communicate its information can reduce or eliminate its editorial importance. Finally, sizing a photograph to fit a predetermined hole is just plain ignorance. Each picture needs individual care and handling. It must be cropped with skill and sized according to merit and need. The chances of properly filling a predetermined hole are as good as filling that same hole in said editor's head.

The placement of photographs on the printed page is as important as any of the previous steps. When a picture is placed on a page, it must work with everything else on that page. It is necessary that headlines, type, and illustrations on a given

page complement each other rather than compete.

This may well be the most difficult to achieve. In the rapid pace of production and dissemination of news, it is rare when words and pictures come together at the same time a page editor is planning his product. However, since type wraps, bends, and jumps, it is not an impossible goal.

The creative picture editor knows that ideas are valued commodities. Finding a person who will not close his mind to change is what keeps photojournalism so valid.

The picture editor must be able to sort through the assignment suggestions and decide which stories are best told in pictures and which ones would better be communicated in words.

So many assignments are made because the reporters and editors were struck with telefrightous—the inability to say no over the telephone. The type of assignment that he will accept is based on his imagination of what the potential results might hold. This influential role in the newsroom is the creative activity (which can be a driving force) in producing ideas from writers and editors.

Another important creative function is to guide the photographer's approach. This does not mean, by any stretch of the imagination, that the picture editor should manipulate the photographer. Rather, he should guide him into what should be said photographically, seeing pictures where they are and not contriving them. It is important for the picture editor to keep in mind that he is there to make the photographer think and to remind him that content is the most important substance.

Finally, cropping and layout are the ultimate in picture handling. It is not so strange to expect a picture editor to edit and arrange photographs with as much talent and excellence as is expected of a copy editor and his words.

When laying out sets of photographs, the creative picture editor is the one who knows how to make each picture work with the others. A picture is like a paragraph, beginning and ending with one thought. Each must be arranged and emphasized in the most functional, storytelling manner. Some will be larger because they offer vast amounts of information and visual impact. Others will be smaller because they make a certain point that connects each piece. In the end, the pictures will tell the story.

**There's an Art to Cropping a Picture.**

**Among other things, cropping focuses the attention of readers on a given part of the original photo. It allows cutting out of unwanted areas and control of the size of the picture as it finally appears.**

## Mathematically Speaking

Selecting and preparing pictures for publication are among the many important responsibilities of the picture editor. After deciding a print has the desired content and storytelling qualities, the next step is to prepare it for publication.

The preparation includes cropping the picture, if cropping is called for, and scaling it to the size it will appear in the newspaper. Whether the publication is letterpress, offset, or gravure sometimes influences selection and sizing. The fine screen used in photo-offset and the offset system itself permit a more faithful rendition of tonal range than does the coarse screen halftone used in newspaper letterpress. For the latter, the editor would insist on "picture copy" of adequate contrast.

Regardless of the printing method, the editor knows the reproduction should be large enough to be seen and readily understood. Far too many papers—even in these days of cold type and/or photo-offset—"play" their pictures too small.

Granting that most of the time in a newspaper space is at a premium, one still should not use pictures too small. If the twinkle in the eyes reveals character, the reproduction should be large enough for the eyes to be clearly seen. If the bride's gown is essential to the story, then the illustration should be large enough to show it in detail.

Action in a picture means more than a fast-moving person or object. A grimace, a smile—these things, too, often are the story. In such cases, the reproduction should be large enough to let the reader see them.

Crop marks made with a grease pencil on the white border of the picture indicate the portion which the halftone cameraman will reproduce. Cropping should be done to emphasize the essentials and keep the picture from being confusing. Cropping also is a means of controlling the size of the finished illustration. Scaling, or proportioning, allows the picture editor to fit the allotted space on the newspaper or magazine page.

It is easy to figure reproductions and enlargements. The tools used for this job are a line gauge or pica rule, a slide rule, or any other type of calculator. The whole job could be done mathematically, of course, but the "tools," once one knows how to use them, are timesavers.

The reproduction is always in exact proportion to the full size or cropped copy from which it is made. When the width of a picture is increased or decreased, the depth changes proportionately, and when the depth of a picture is increased or decreased, the width proportionately does the same.

When pictures are scaled, the halftone areas increase or decrease in mathematical progression. A one-column picture enlarged to two columns quadruples (not doubles) in area.

One thing to remember in cropping and scaling pictures: Poor pictures often can be improved by cropping. Good pictures sometimes can be made better by cropping. On the other hand, they can be completely ruined and robbed of their storytelling value by careless cropping. If a picture does not need it, *don't crop!*

# Relationship of Graphics and Design to Picture Editing

William Kuykendall former photojournalism instructor and now a photographer and editor of a mining magazine in Keyser, W. Va., believes that graphics and design are closely allied to picture editing, indeed, are a part of the process as he explains in the following:

Photojournalism must no longer comprise merely the making of fine, storytelling pictures. The time is ripe for renaissance communicators: journalists sensitive not only to relationships within pictures but also to relationships among pictures; journalists with a feeling for type—its structure, its weight, its mood; journalists with an ear for the written word, both the prose of text and the poetry of headlines and blurbs. There must be journalists who can understand and harness their behind-the-lens creative energies and focus them on the problems of the layout table.

The photographer working only with camera and enlarger is a note taker, an author of paragraphs. The editor to whom he hands his pictures rights or wrongs the story through *his* selection and emphasis of pictures. If the editor goes beyond just arranging pictures with words . . . if he writes and juxtaposes meaningful display lines with the correct pictures . . . if he enhances the story with a complementary type face or a tasteful arrangement of white space, then he rightfully deserves much of the credit for the success of the story. If he fails, only the photographer looks bad. . . .

Picture stories are not produced by the sampling method. They require deep involvement yet intellectual detachment. The photojournalist must see the story in depth and perspective just as the writer must. . . . Just as the expert interviewer researches his subject and composes a list of incisive questions, the photographer must appear on the scene thoroughly backgrounded and alert for storytelling picture opportunities. He must be aware of subtle nuances of personality in his subject and be prepared to capture them. He must watch for interactions among everyone involved. He must know his equipment and use it automatically. He must think ahead and consider the effect of lens, shutter speed, aperture, light, and camera angle on every scene, every episode. He must choose the appropriate technique, position himself, and anticipate the probable action in time to capture it. And if he guesses wrong, he must be ready to move instantly to a favorable combination without losing the gist of the activity. This applies whether you are photographing politicians at rallies or spinsters at home with their cats. Subtle stories require the greatest discipline. . . .

There are few rules in photojournalism. But one guideline that is useful is to consider the progress of your shooting in cinematic terms.

Film producers seeking to establish visual continuity employ some basic devices to orient the viewer and carry him from scene to scene.

First is the establishing shot: This is a long view showing the setting, usually with an important aspect of the subject small, but in the center of attention.

Show the reader where the action is taking place; put it all into context with the establishing shot. Pay attention to small details of composition and have a strong center of interest.

Next is the medium shot: Come close on certain processes or activities; show the major character(s) in relation to the people or objects with which he(they) are interacting.

Then comes the closeup: Move in close to show fine detail or emphasize an aspect of your subject's personality. Always strive for at least one tight, dramatic portrait on your main subject.

Keep in mind the pictures you have shot and watch for opportunities to collect images which differ in content but resemble others in composition, thus enabling you to capitalize on graphic similarities during layout.

You should try to think of your story title while shooting, especially if you are writing it yourself. And think of the lead picture you associate with it. This exercise not only is helpful in securing a strong lead, but also helps you place the overall story in perspective. You should try for a strong ender—one which repeats the overall mood of the story or works as a logical stopper.

The more you "think layout" as you shoot, the more options you will have when it comes time to sit down with pica pole and proportion scale. And the more you work arranging pictures and text, the more sensitive you will become to the editorial realities while shooting. . . .

If you have considered the layout while you were shooting and printing, you probably will have arrived at some major design decisions before approaching the layout table.

If coverage is good, you should have an opener, a headline, and an ender in mind. You should know what the story is worth in terms of space and have strong candidates for the body of the layout.

Even if you have decided on your favorites, you should take a fresh, overall view of your pictures.

Lay all of your enlargements on a large table or on the floor and stare at them until you begin to see a progression from picture to picture. Identify your opener and ender. Try to come up with a "meaningful" story title (story labels such as "Picnic Party," "Operation Outreach," or "Local Ladies Help Out Poor" are pretty trite and unworthy of even cheap ink).

As your ideas begin to jell, pick up a small scale layout sheet and sketch in your proposed layout. . . .

With the thumbnail layout you can rough in your preliminary designs quickly and evaluate them for balance and harmony. If you are dissatisfied with your first rough, you can put it aside and sketch another. Gradually, as you play with the images in miniature, you should evolve an arrangement of pictures and text which works on the page.

This will be your guide in producing the comprehensive. Do not involve yourself in sizing pictures during the thumbnail stage. Generally, the more you

disassociate the mathematical equivalents (points, picas, and inches) from the early creative stages of design, the more you can concentrate on the content of the pictures and their relationships.

It is smart, though, to estimate the amount of copy before starting the thumbnail. This can be a rough estimate based on the commonly used type face set to a 13-pica measure. If, during the course of sketching the thumbnail, you decide on a wider or narrower measure, you still have a basis for estimating the new depth of copy.

Rough in body copy as light horizontal lines on the thumbnail.

Rough in the story title and blurbs in lines approximately their actual "weight" proportioned to the thumbnail. Draw fine, horizontal lines for cutlines and credit lines.

All of these should be included in the thumbnail so that you can estimate the effect of the finished design.

Once a satisfactory effect has been achieved you are ready to do precise headline and body copy fitting, fit cutlines and blurbs, and scale the pictures to the comprehensive.[2]

# Mechanics of Laying Out a Picture Story

Using the experience gained at the thirty-year-old Missouri Photo Workshop, herewith are what I believe to be helpful instructions not only for doing story layouts, but also for picture editing.

When he is at work in the field, every photographer is a picture editor. He makes the judgment on whether to take a picture, decides how to compose it, and often has complete editorial control over the picture at the moment of decision. The business of laying out pictures is an extension of editing.

1. Gather all of the materials you will need to work on the layout. This material will consist of 8 ½-by-11-inch paper, grease pencil, ruler, transparent tape, razor blade or scissors, and magnifying glass or viewer.
2. Collect all of your contact sheets. Next, making sure they are identified by roll so that you can find the numbers of the negatives when you need them, circle each frame you think may have a place in the layout.
3. Cut out (make sure the roll number is on the back of each) marked frames from only one contact sheet at a time. Leave sprocket holes and frame numbers. This is the only way you will be able to find the negatives.

4. Do not be afraid to pick too many frames. They can be edited later.
5. Your cutouts are known as "selects."
6. Arrange your selects into subject groups such as portraits, long shots, situations, etc.
7. Decide which pictures are best in each group. So far as possible, choose a horizontal and vertical of each situation.
8. Pick your lead or cover picture. It should be an eye-catcher and a stopper. It should also suggest what the story is about. For instance, if your story is about an individual, it not only should show what the person looks like, but also should suggest the nature of his work or the theme of your story. This picture should be excellent both photographically and editorially.
9. Arrange selects in the order in which you think they will best tell your story. This is where you should do some really hard thinking. Shuffle and reshuffle your contact prints. Look for parallels or contrasts. Remember, the traditional picture story has a beginning, a middle, and an end.
10. Now, begin weeding out the pictures that essentially say the same thing. You must be critical of photographic quality as well as of content. Ask yourself whether your

---

2. Kuykendall, a magazine editor and photographer, is a former member of the photojournalism staff at the University of Missouri and has taught both graphics and photojournalism. Quoted here are excerpts from a release he prepared for use at a special agricultural editor's photo school held at Columbia, Missouri.

selects say something without the necessity of explaining.

11. Since you are working on a pseudomagazine layout, you must decide whether you want to open your story on a right-hand page or a spread (two pages).

12. Arbitrary rule: Let us not plan for more than six pictures on a spread. A sequence may be considered as a single picture. If you can use less than six, your layout will be better. No layout should be more than six pages, and you probably can do it better with four. Keep in mind that a very effective story can be made on a two-page spread.

13. Find a closer, a picture which says The End to the viewer.

14. Cropping: Not all of your pictures are cropped exactly in the camera. To make a better picture, you may have to crop it in print form. An ugly, space-grabbing tree in the foreground may have to be cropped from the bottom of the frame. A striking horizontal view may be made even more eye-catching by "shallowing" the picture at both top and bottom. A picture of a tall man may make him look even taller when cropped from one or both sides. Perhaps you shot the frame to show a detail. Cropping down on the detail may add emphasis. Watch for the shot that can be cropped, with reason, into an exceptionally deep, narrow vertical. These shapes

often permit a spread with real impact. Do your cropping first with a grease pencil and not with a razor blade!

15. Sizing: See the diagram on opposite page for the mechanics of this process.

16. Indicate headlines, copy blocks, and captions on the layout. The copy block is usually composed of straight lines; the captions, by wavy lines.

17. For your miniature layout, use an 8 ½-by-11-inch sheet of paper, folded through the center, as a two-page spread. With pencil and ruler, draw in the shape and approximate size of each picture. Place each contact-sized print in the lower right-hand corner of the space you have dummied or given to this particular picture. Tack it down with scotch tape and only along the top. Do *not* put tape over the picture itself.

If you do not like the layout as it is, do another and another until you get one you do like. This is the way to find out whether you have told your story clearly and effectively. The procedure given here for magazines is also adaptable to newspaper picture pages. Whether doing magazine or newspaper layouts, make sure that your doodling paper—your miniature layout sheets—will scale to the size of the finished product: the printed page.

# Student Participation

When he selects a picture for publication, the first consideration of a picture editor is to focus on and evaluate the content of the picture. Next, he is concerned with cropping and sizing.

1. Cut a half-dozen pictures from current publications and crop them (with a grease pencil) to increase their effectiveness.

2. Collect a half-dozen pictures from current newspapers or magazines. Using the same yardstick you would use in evaluating a word story (i.e., importance, etc.) explain whether you think the pictures you have chosen are played too large, too small, or the right size.

3. Collect pictures from a magazine picture story or essay and use five or six of the pictures to do a standard (not tabloid) newspaper picture page. Scale the pictures to their final size, draw in headlines, copy blocks, and captions. In selecting your pictures for the newspaper page, make sure you have a beginning, middle, and end.

▶
In making an enlargement or reduction, one dimension—either the width or depth—is always known. When using the diagonal system recommended here (see next page), lay a ruler or straightedge across the photograph so that it accurately divides the angles of the lower-left and upper-right corners. If your final illustration is to be 5½ inches wide, make a dot at exactly the place where 5½ inches intercepts the diagonal made by the ruler. Dropping a line from this point to the base will give you the dimensions of your enlarged print. This rule of the diagonal will help you to quickly arrive at the size of enlargements or reductions. And you can use it on horizontal shapes as well as on verticals (*dotted lines*).

Layout sizing technique
using diagonal lines

In addition to running the activities program at the Boone Retirement Center, Mary Hoffman keeps the patients

# In touch with reality

Mary Hoffman would like to see the stereotype image of nursing homes changed, and through her job as activities director at the Boone Retirement Center, she is doing just that.

The physical conditions at the center are not the best. The building is old, dating back to 1934. The medical facilities and patient conveniences are minimal. They will be improved when the center moves in December to its new building near Boone County Hospital.

But physical conditions are not all-important. They can do little to cure the boredom often found in nursing homes. The patients must have something to occupy their time, and they need someone who cares about keeping them active.

Mary is originally from Wales, where she was trained as an occupational therapist. Her Welsh accent may sound a little out of place in mid-Missouri, but she seems right at home in her work. When she isn't supervising one of her regularly scheduled activities, such as handicrafts or bingo, she can usually be found "making her rounds," helping someone with an individual project, or just chatting with someone in need of a little friendly conversation.

She also coordinates a library book program with the Boone County Library. Twice a month a traveling librarian visits the center, picks up old books and magazines, and with Mary's help, distributes new selections to the residents.

Her job includes a daily session known as "reality orientation." It is a technique used to help those who have lost touch with reality find their way back. It can be used not only for elderly people, but also in the treatment of certain types of mental illness.

During these sessions, Mary asks questions. She might ask what day of the week it is, or whether it's hot or cold in the room. Or she might hold up an apple or a letter of the alphabet and ask the patient to identify it. Simple questions like these can help patients get a grasp on the things they have lost to old age. "The important thing," Mary says, "is to get them to exercise their minds."

At times the sessions are discouraging. Often the patients are not able to respond; sometimes they just don't want to. And Mary's other duties won't permit her to spend as much time as she would like to in the sessions. Ideally,

reality orientation would be a constant activity. But even on a limited basis, the sessions serve an important purpose. Without them, these people would remain idle and drift farther and farther away from reality.

Mary is modest about her role at the center. She has an attitude about her job that makes it more than a job: "It's not enough to just do things for people. You have to want to do them. Then it becomes rewarding for both parties involved." She cares about her people and sees her work as more than making a living. She does it because she wants to.

Although activities programs in small nursing homes are almost unheard of, Mary is proving that it can be done. Such things as handicrafts and bingo give patients something to look forward to each day.

TEXT AND PHOTOS BY NICK DECKER

During daily reality sessions, Mary asks patients to identify such things as vegetables or letters of the alphabet. While the sessions seldom produce dramatic results, they are beneficial in the long run.

It was a time for playing, sharing and working, but mainly . . .

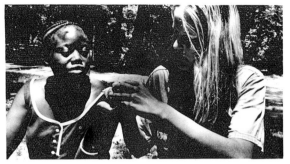

# A Time for Friendship

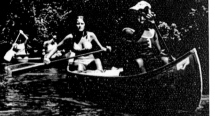

"I'm the only black person here."

"Just pretend that you've got a tan."

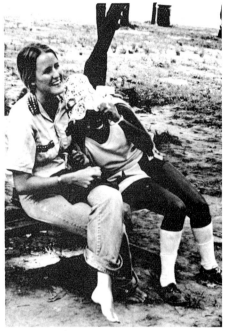

Margaret Hayes is a 14-year-old black girl; Sabra Meyer is an 18-year-old white. They shared a river, a canoe and a friendship that will last longer than their one day trip.

Margaret and Sabra met on a Camp Fire Girl float trip down the Current River. It was a new experience for Margaret, who had never seen a river's rapids. Sabra has been canoeing for several years and was an assistant counselor on the trip.

They stuck together and learned how important teamwork was in floating a river.

Between swimming and playing, Margaret and Sabra shared lunches and spills, and the aching muscles that go with eight hours of paddling.

According to Sabra, "We got to be more than just friends. We really like each other and got along great from the beginning. Margaret is very outgoing and we got to know each other really fast."

Margaret felt that "Sabra is really nice, and funny too. I hope we can get together again. It's kind of hard with her going away to college. I really think of her as a sister."

Racial differences were not ignored; they were something to joke about. "Being black and white made it a little different," said Sabra. "But you really forget it after a while. We could kid each other about it."

When Margaret got tired of paddling, she would sit back and smile at Sabra. "Come on, steer girl. You're the slave now." And they laughed as Sabra answered, "Yes, Ma'am."

Margaret was pleased with Sabra's attitude. "She really got along with my color. It made things really fun."

Their biggest problem in the canoe was steering. Sabra said she "had trouble turning, so Margaret always got into the trees."

But they survived the trip and are eager to go on another one. "Next time," they both agreed, "we have to do it longer."

TEXT AND PHOTOS
BY MARY GLYNN

◄ The School of Journalism, University of Missouri, has for many years offered a major in photojournalism. Along with news editorial, advertising, radio-television, and other sequences, the Journalism School provides a full sequence in photojournalism. Photo majors learn more than how to click a shutter. Part of their education is devoted to word-reporting, advertising, editorial writing, and all other phases of newspaper and magazine work. In addition, the photo major receives a thorough grounding in the liberal arts. He also receives thorough training in photojournalism. He takes photographs for the daily newspaper, the *Columbia Missourian,* and learns how to write feature articles and news stories as well as headlines and captions. Going one step further, he learns how to scale pictures to the proper size, how to do pasteups, and how to produce camera-ready pages for newspapers and Sunday magazines. The newspaper pages (left and above) were done under the direction of Prof. Angus McDougall, director of the photojournalism sequence. (Courtesy of Angus McDougall and *Columbia Missourian.*)

▲ Most newspapers which use picture layouts sometimes hold them to something smaller than full-page size. This horizontal half-page layout (it could have been adapted to perpendicular makeup) is a format frequently used by the *Columbia Missourian.* (Courtesy of Angus McDougall and *Columbia Missourian.*)

This layout *(above)* is a picture story from the 1970 Bolivar Photo Workshop by Bill Luster of the *Louisville Courier-Journal.* Workshoppers select their own stories. Bill was impressed with this wonderful nine-year-old youngster who had lost a leg in a motorcycle accident. He wanted to show that despite her handicap she asked no favors and held her own in the schoolroom and on the playground. It's a beautiful story—one of the most inspiring ever to come from a University of Missouri photo workshop.

**Pancho Villa on the March.**
This picture by an unknown photographer is in possession of Brown Brothers. Portraying Villa and his army of guerillas, it was probably taken in 1916, the year Villa and his raiders attacked Columbus, New Mexico, killing twenty Americans. Included in 50 Memorable Pictures exhibit.

◄

William Stephenson, professor emeritus, was named distinguished research professor at the School of Journalism, University of Missouri, in 1958. Born May 4, 1902, in Durham, England, Dr. Stephenson was educated at the University of Durham, the University of London, and Oxford University. A consultant to Central Trade Test Board, R.A.F., a consultant psychologist to the British Army where he ranked as Colonel R.A.M.C., and Brigadier-General, War office. Dr. Stephenson holds membership in many learned British and American professional organizations. Before coming to the University of Missouri, he had been on the staffs of many British and American universities. A prolific writer and lecturer, Dr. Stephenson has contributed an untold number of articles to learned journals and publications.

# 14

# Principles of Judging Photographs
## What Makes a Good Picture?

Tastes differ, and no two persons are likely to give the same answer to the question—What is a good picture? Individual judgment, as far as evaluating pictures is concerned, is based on a person's education and background . . . on how closely he or she can associate with the photograph under scrutiny.

This fact came sharply into focus several years ago when the writer headed a committee to select "The Fifty Best News Pictures of the Last Half-Century."[1] Co-sponsors were the National Press Photographers Association and the *Encyclopaedia Britannica.* The same institutions, incidentally, were partners at that time in sponsoring the Pictures of the Year Competition and Exhibition—a nationwide project then in its sixteenth year.

Selecting the Fifty Best Pictures seemed an easy assignment. The committee would be small, it was decided, and all participants would be experts in the communications field.

The committee was finally chosen, and it was a great one: Harold Blumenfeld, executive newspicture editor, United Press International; Joseph Costa, King Features (chairman of the board, National Press Photographers Association); Murray Becker, chief pho-

tographer, Associated Press; Arthur Rothstein, Technical Director, *Look;* John Faber, former news photographer, now with Eastman Kodak Co., press division, New York City, and historian for the National Press Photographers Association; Yoichi R. Okamoto, chief, visual media, U. S. Information Agency (and later personal photographer to President Lyndon Johnson); Robert Gilka, illustrations staff (now photographic director) *National Geographic Magazine;* the late Julius Klyman, then editor, St. Louis *Post-Dispatch* Sunday Pictures; the late Dr. Frank Luther Mott, then dean emeritus, School of Journalism, University of Missouri; James Colvin, then public relations director, and Roger Lone, then in the public relations department, *Encylopaedia Britannica.*

Each member was given 100 identical pictures, selected from literally thousands, with which to work. From the 100 pictures, each judge was to select 25 pictures, listing them in order of preference. Tabulation was to be as follows: First-place pictures were to receive 25 points, second-place pictures 24 points, third-place pictures 23 points, etc. It all seemed so easy—a matter of simple arithmetic. How wrong I was!

It soon was apparent that we could not agree on the title of the project, let

---

1. As part of the commemoration of the fiftieth anniversary of the School of Journalism, University of Missouri.

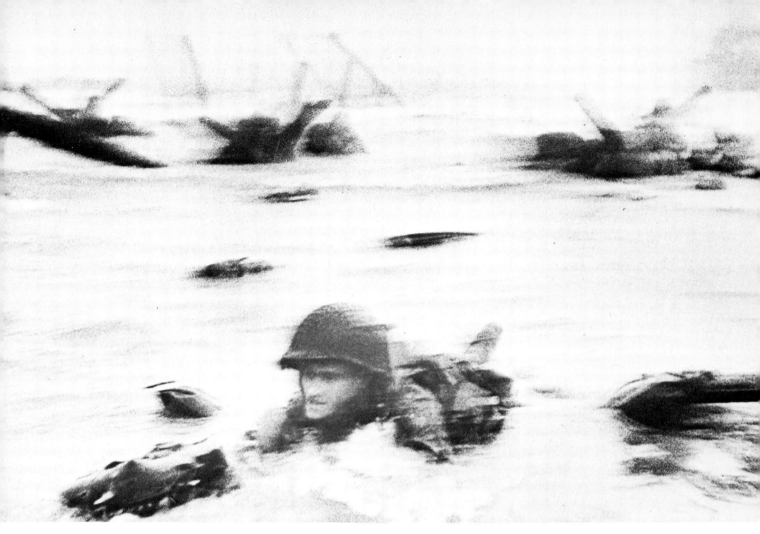

alone on the pictures. Finally, in the name of harmony, we changed the name from "Fifty Best Pictures" to "Fifty Memorable Pictures of the Last Half-Century."

But other problems remained, the most important of which was the element of time. Some committee members were having difficulty making selections. Would we ever meet the deadline? A careful and honest appraisal of the situation indicated this to be unlikely.

After several months of struggle, Dr. William Stephenson was asked to take a hand. He responded with his Q-sort system of judging photographs and saved the day.[2]

The following two paragraphs are excerpts from the news release sent out at the conclusion of the project:

The Selection Committee and the sponsors make no claim that these are the only great photographs of this period. We concede that other selections could be vigorously defended. We also acknowledge that in several instances where nearly identical photographs were taken by different photographers of the same action it was often almost impossible to select one photographer's work as significantly better than another's.

However, the Selection Committee and the sponsors worked at this project for many months. They accumulated and inspected tens of thousands of prints. The number of man-hours contributed by the Selection Committee was staggering. The sponsors wish to express their appreciation. It seems probable that no photographic selection of a similar scope ever received so much concentrated attention on the part of so many highly qualified specialists.[3]

It is of interest to note that Stephenson is of the opinion today that his research technique has stood the test of time.

**D-Day in Normandy** by Robert Capa for *Life*-Magnum. Capa shot more than a hundred pictures on D-Day, but only eight were usable because a darkroom worker overheated the film during the drying process. This error, while it adds something to the dramatic quality, perhaps, is largely the reason for the fuzziness of the picture. Included in 50 Memorable Pictures exhibit.

2. See Appendix for "Principles of Selection of News Pictures."

3. News release, "Fifty Memorable Pictures" project, School of Journalism, University of Missouri, 1958. The findings of this study, together with representative pictures were released in 1958 to newspapers and magazines throughout the country.

# Fifty Memorable Pictures of the Last Half-Century

Following is a list of the photographs that appeared in the commemorative exhibit of the School of Journalism, University of Missouri, 1958.

1. "Dead Americans at Buna Beach," George Strock, *Life.*
2. "Dazed POW Repatriated," Michael Rougier, *Life.*
3. "Christmas in Korea," David Douglas Duncan, *Life.*
4. "Ethiopian Soldier," Alfred Eisenstaedt, *Life.*
5. "Gestapo Informer," Henri Cartier-Bresson for Magnum.
6. "Spanish Soldier Dies," Robert Capa for *Life*-Magnum.
7. "D-Day in Normandy," Robert Capa for *Life*-Magnum.
8. "Sewell Avery Gets Bum's Rush," Harry Hall, Associated Press.
9. "Panic in Chungking Bomb Shelter," F.T. Durdin, Associated Press.
10. "Boys Against Tanks," photographer unknown; distributed by Associated Press.
11. "Weeping Frenchman," George Mejat, Fox Movietone News; distributed by Associated Press.
12. "Well, I'll Be Darned!" Francis Grandy, *Stars and Stripes* photograph.
13. "Koreans Flee Red Horde," Max Desfor, Associated Press.
14. "Yalta Conference," Richard Sarno, United States Army; distributed by Associated Press.
15. "Flag Raising On Iwo Jima," (Marines on Mt. Suribachi) Joseph Rosenthal, Associated Press.
16. "Russian Revolution," Associated Press.
17. "Four Killed at Republic Steel Plant," Carl Linde, Associated Press.
18. "Black Sunday," Lasar Dunner, United Press International.
19. "Death of King Alexander," George Mejat, Fox Movietone; distributed by United Press International.
20. "Hindenburg Explosion," Sam Shere, United Press International.
21. "Hungarian Freedom Bridge," Dieter Hespe, United Press International.
22. "Yank Fighter Wheeling Baby," United Press International.
23. "He Who Laughs Last," Al Muto, United Press International.
24. "Execution of Communists in Shanghai," Warren Lee, United Press International.
25. "Radiant Queen," Charles James Dawson, United Press International.
26. "The Lone Eagle," Frank Merta, United Press International.
27. "Mussolini and Friends Hanging by Heels," photographer unknown; distributed by United Press International.
28. "Wall Street Bombing," Vincent Palumbo, United Press International.
29. "Firpo Knocked Dempsey Out of the Ring," Henry Olen, *New York Daily News.*
30. "Ruth Snyder in the Electric Chair," Tom Howard, *New York Daily News.*
31. "Sinking of the *Vestris*," Fred Hansen, *New York Daily News.*
32. "Bonus Marchers," Joseph Costa, *New York Daily News.*
33. "Wife Beater Gets Whipping," Joseph Costa, *New York Daily News.*
34. "Midget on Morgan's Knee," Willie Hoff, *New York Daily News.*
35. "Pea Pickers," Dorothea Lange, Farm Security Administration.
36. "Dust Bowl," Arthur Rothstein, Farm Security Administration.
37. "Hitler's Jig," United States Office of War Information.
38. "Sinking of the *Arizona* [Pearl Harbor]," Official United States Navy photo.
39. "Bikini-Baker Day," United States Air Force.
40. "Over the Top in World War I," United States Department of Defense.
41. "The Babe Bows Out," Nat Fein, *New York Herald-Tribune.*
42. "Three Queens in Mourning," Ron Case, Keystone Press Agency, Ltd.
43. "Shooting of Mayor Gaynor," William Warnecke, *New York World-Telegram and Sun.*
44. "Eastland Disaster," Fred Eckhardt, *Chicago Daily News.*
45. "Japan Surrenders," Larry Keighley, *Saturday Evening Post.*
46. "Waiting at the Mine Disaster," Sam Caldwell, *St. Louis Post-Dispatch.*
47. "Cotton Mill," Lewis W. Hine, George Eastman House collection.
48. "Norman Thomas Hit by Egg," Ralph Morgan, Denver, Colorado.
49. "Crisis in Little Rock," Wilmer Counts, *Arkansas Democrat.*
50. "Pancho Villa on the March," Brown Brothers.

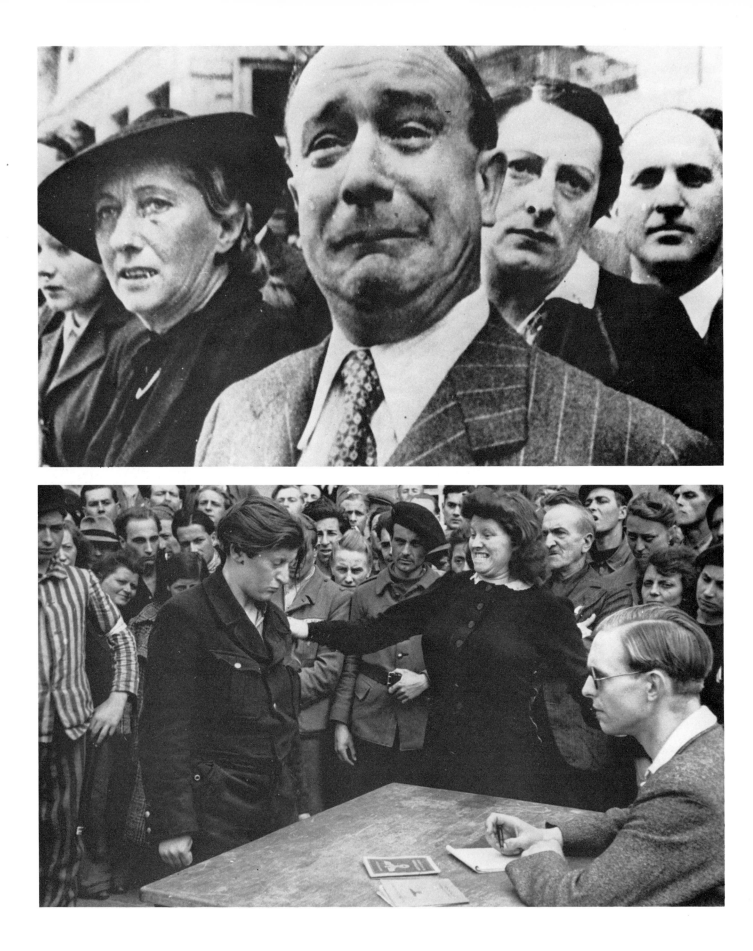

**Weeping Frenchman** *(left)* by George Mejat, Fox Movietone News. This is one of the most emotional pictures to come out of World War II. A French civilian weeps as he watches historic battle flags being taken from Marseilles for protection from the Nazis. Included in 50 Memorable Pictures exhibit. (Wide World Photos.)

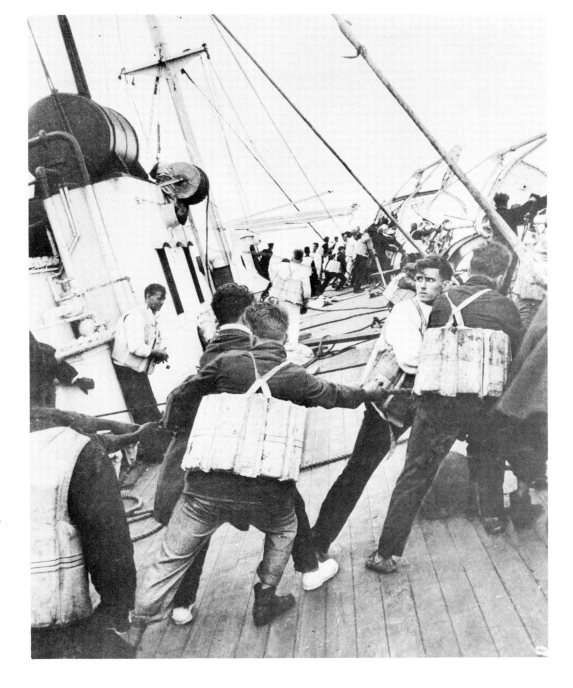

**Sinking of the Vestris.** Many great news pictures, and this is a good example, have been taken by amateur photographers. This dramatic photograph made by Fred Hansen, an assistant pantry man on the *Vestris*, was taken with a camera purchased just before the start of the tragic voyage. The sloping deck of the British steamer and the fear on the faces of passengers are storytelling, indeed. The *Vestris* sank with a loss of 112 lives. Hansen sold his roll of undeveloped film to the *New York Daily News* for nearly $1,000. Included in 50 Memorable Pictures exhibit.

**Gestapo Informer** *(left)* by Henri Cartier-Bresson for Magnum. Here's what happened when an informer was discovered in the midst of a German concentration camp during World War II. The make-believe refugee was denounced by camp inmates. Included in 50 Memorable Pictures exhibit.

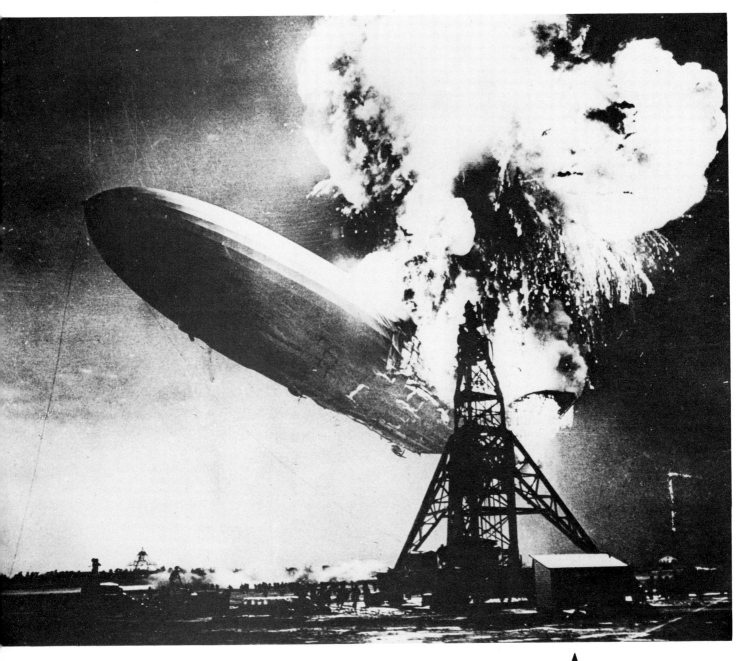

**Hindenburg Explosion** by Sam Shere of United Press International *(above)*. This picture was taken May 6, 1936. The airship was completing its first North Atlantic crossing of the new season when the hydrogen used to inflate the balloon burst into flames. The *Hindenburg* was completely demolished, and thirty-six passengers were killed. This picture had been considered the greatest news-picture of all time until Joe Rosenthal's picture of the flag raising on Iwo Jima. Included in 50 Memorable Pictures exhibit. (United Press International.)

**Sewell Avery Gets Bum's Rush** by Harry Hall, Associated Press *(right)*. All prize-winning photographs are not hard to get. Some, like this one could have been taken by a 12-year-old child with a box camera. It was selected for the 50 Memorable Pictures exhibit because of its social significance. Several photographers took similar pictures of this event in 1944, when Avery was forcibly removed from his Montgomery Ward and Company office in Chicago as the United States government forced compliance with wartime labor regulations. Included in 50 Memorable Pictures exhibit. (Wide World Photos.)

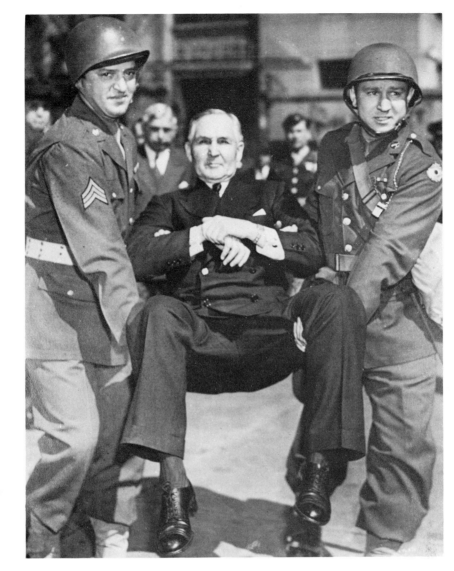

**Yalta Conference** by Richard Sarno *(below)*. Taken for the United States Army, the picture was distributed by the Associated Press. This is one of the few photographs that was selected more for its historical significance than for its drama. In retrospect, the selection committee for the 50 Memorable Pictures exhibit felt that the emotion aroused by the aftermath of the Yalta Conference in 1945 lends inescapable drama to the picture. Included in 50 Memorable Pictures exhibit. (Wide World Photos.)

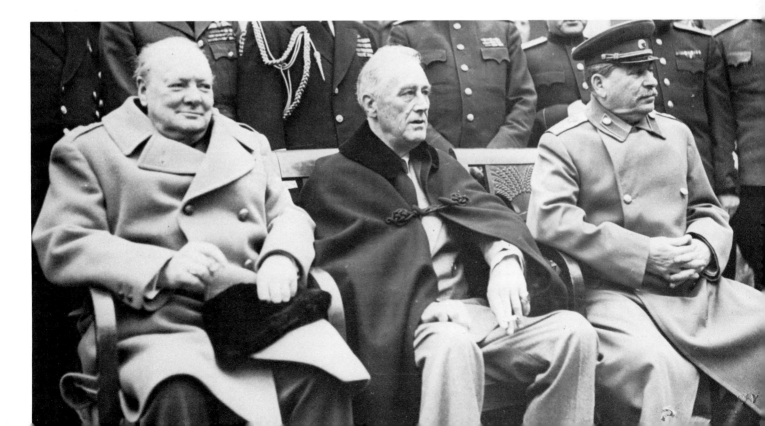

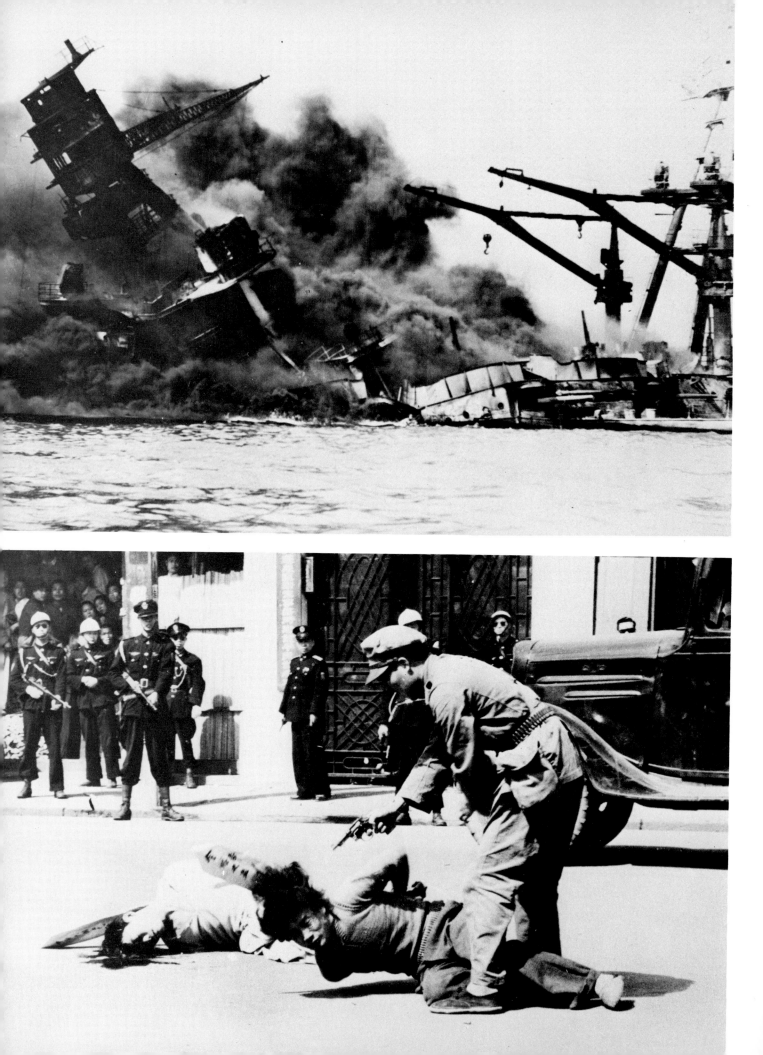

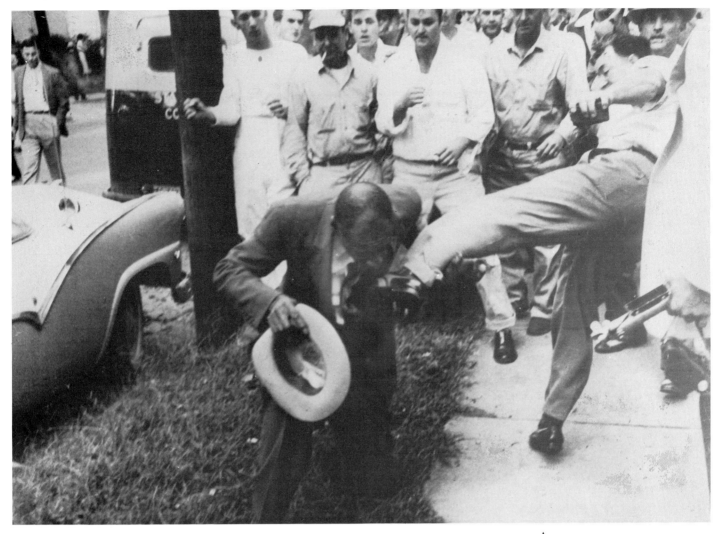

**Pearl Harbor** *(left).* Crumpled
and listing, the battleship
*Arizona* pours clouds of smoke
into the air after the surprise
Japanese attack on Pearl Harbor,
Hawaii, December 7, 1941. A
bomb reportedly passed down
the smokestack, exploding the
boiler and forward magazine.
Damage at Pearl Harbor was so
extensive that it was carefully
concealed by the federal
government. (Official U.S. Navy
photograph.)

▲
**Crisis in Little Rock** by Wilmer
Counts for the *Arkansas
Democrat (above).* One of the
violent incidents in the 1958
struggle over the integration of
Little Rock Central High School.
Included in 50 Memorable
Pictures exhibit. (Courtesy
*Arkansas Democrat.)*

◄
**Communists in Shanghai** by
Warren Lee *(left).* Before
abandoning Shanghai to
Chinese armies in 1949,
Nationalist police executed
communist prisoners in the
streets. Included in 50
Memorable Pictures exhibit.
(United Press International.)

Principles of Judging Photographs/137

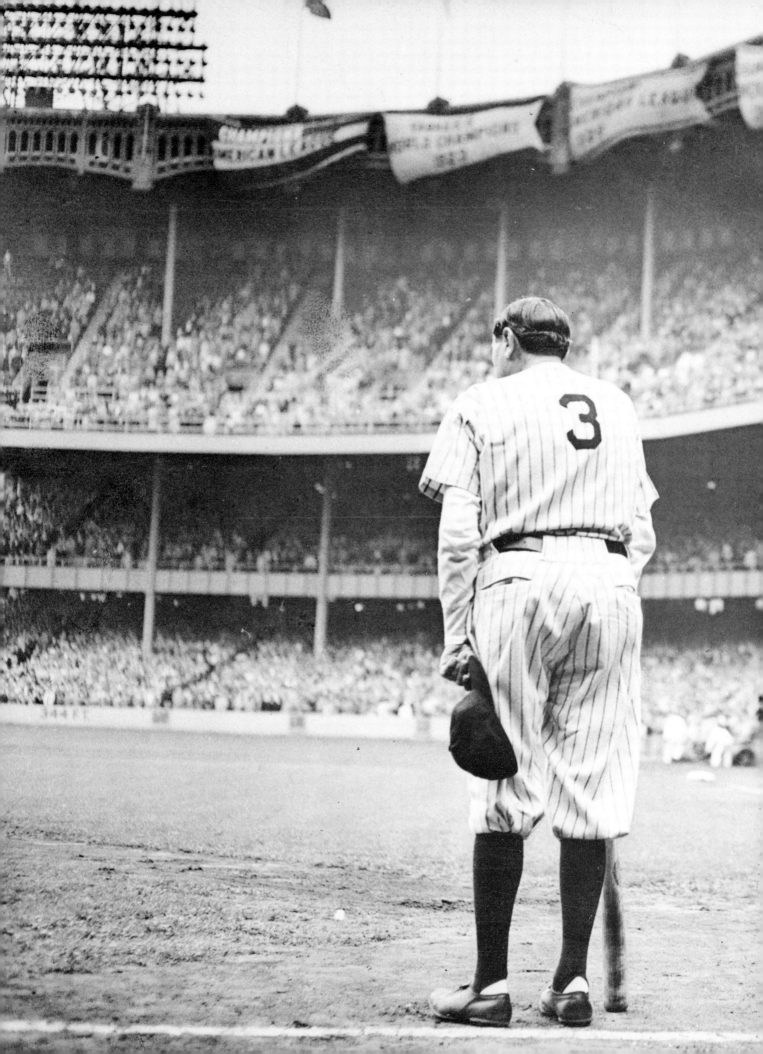

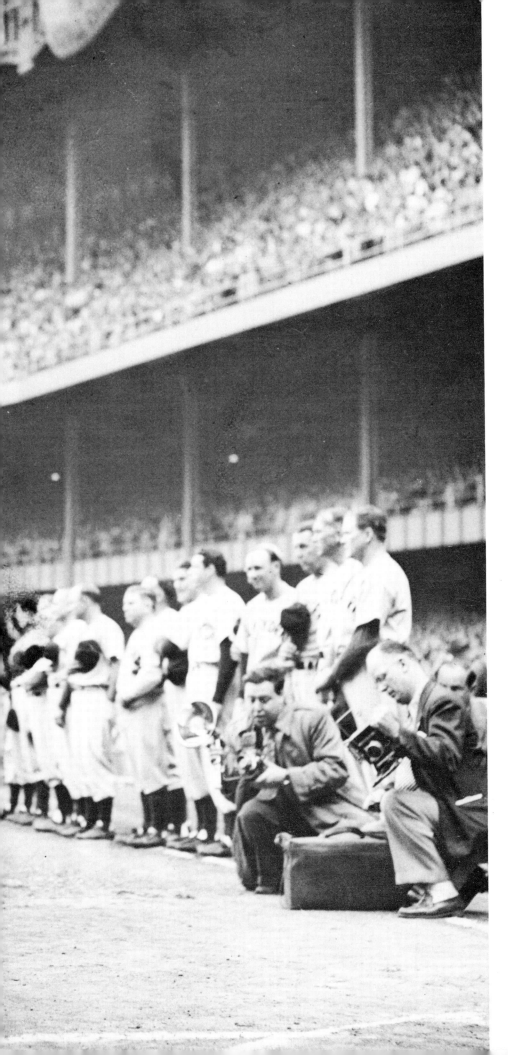

◄**The Babe Bows Out** by Nat Fein for the *New York World-Telegram.* This portrayal of Babe Ruth's final appearance in New York's Yankee Stadium in 1948 is one of the most famous of all sports pictures. Cited as a classic example of good photographic thinking, instructors often point out that Mr. Fein did not "follow the pack" in selecting the spot from where he would take the picture. By isolating himself from the others, he was able to come up with this great picture. Shooting from Ruth's rear, he made the lonely, easily recognized figure the center of interest. Adding to the storytelling quality of the picture is the vast crowd shown paying the final tribute to the bambino. Fein also recorded the Babe's teammates and a few photographers at work. Included in 50 Memorable Pictures exhibit.

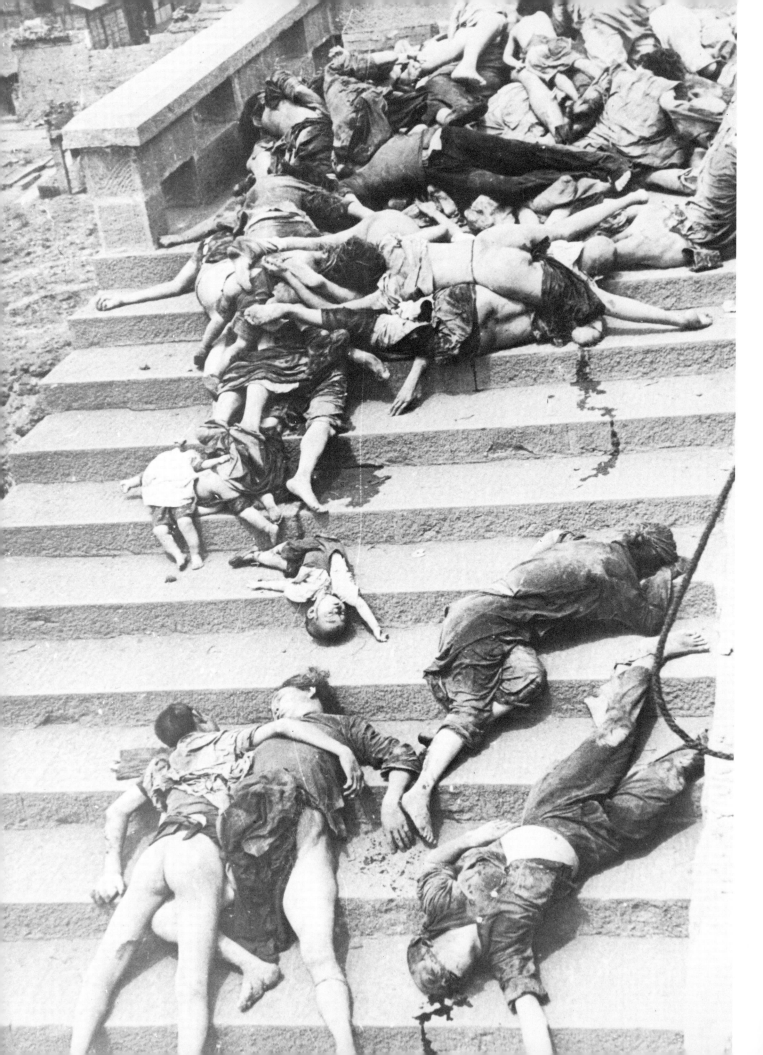

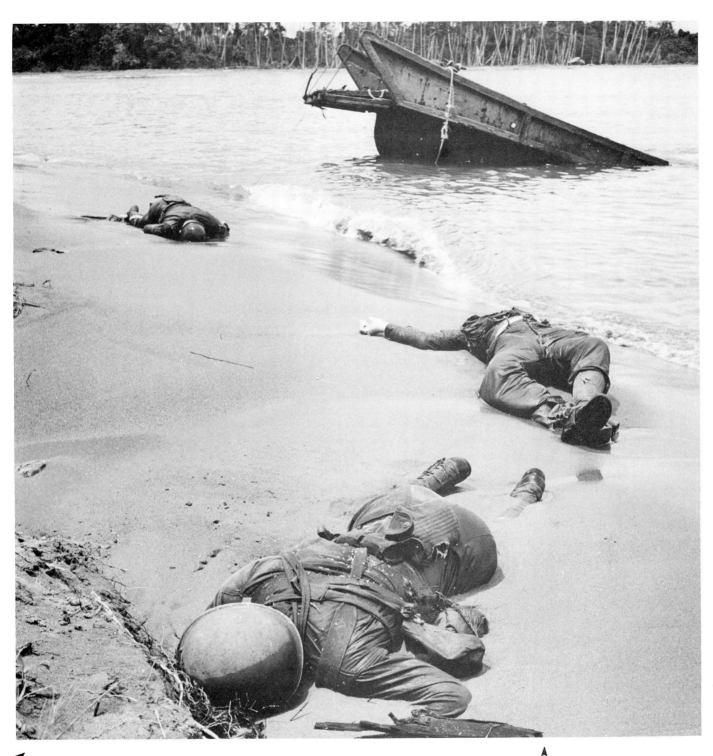

◄
**Panic in Chungking Bomb
Shelter** by F.T. Durdin *(left)*.
The horrors of war are grimly
portrayed in this picture of a
Japanese air raid. Seven
hundred persons died in the
stampede to the shelter. The
picture was distributed by the
Associated Press. Included in 50
Memorable Pictures exhibit.
(Wide World Photos.)

▲
**Dead Americans at Buna Beach**
by George Strock for *Life (above)*.
This is one of the first pictures
of American military dead
released during World War II.
Many more Americans died
before the coming of victory.
Included in 50 Memorable
Pictures exhibit. (Photo by G.
Strock, LIFE Magazine © Time/
Life, Inc.)

Principles of Judging Photographs/141

▲
**Shooting of Mayor Gaynor** by William Warnecke, *New York World-Telegram and Sun (above).* William T. Gaynor, Mayor of New York, was shot but not killed on August 9, 1910, by a discharged city employe aboard the deck of a liner on which he was to sail for Europe. Other photographers had taken their pictures and departed. Warnecke's late arrival permitted him to get this famous "scoop." Included in 50 Memorable Pictures exhibit.

**Boys Against Tanks** (*right*). Here is another picture by an unknown photographer which, like the one *below*, was distributed by the Associated Press. The incident occurred in 1953 during the rebellion against Russian occupation forces in Berlin. Included in 50 Memorable Pictures exhibit. (Wide World Photos.)

**Russian Revolution** (*below*). One of the most powerful pictures in the history of photojournalism, this tragic scene was recorded in May, 1917, by an unknown photographer. The setting is a street scene in Petrograd (now Leningrad) when revolutionists began firing machine guns. The picture was distributed by the Associated Press. Included in 50 Memorable Pictures exhibit. (Wide World Photos.)

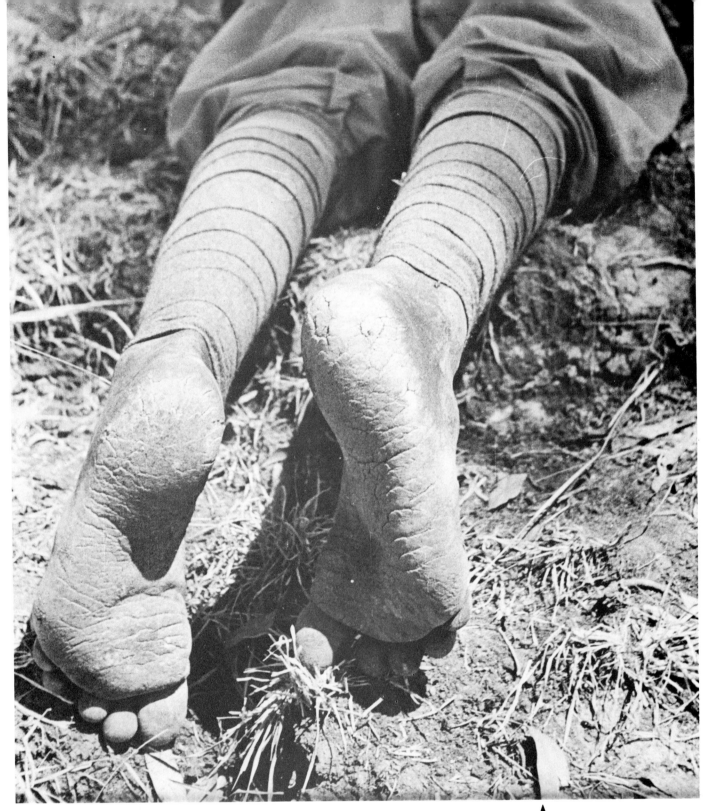

**Ethiopian Soldier** by Alfred Eisenstaedt for *Life (above)*. This picture was made during the Italian campaign in Ethiopia. For those willing to "read" it, it is an outstanding example of a picture that tells a dramatic story without words. Included in 50 Memorable Pictures exhibit. (Photo by A. Eisenstaedt, LIFE Magazine, © Time/Life, Inc.)

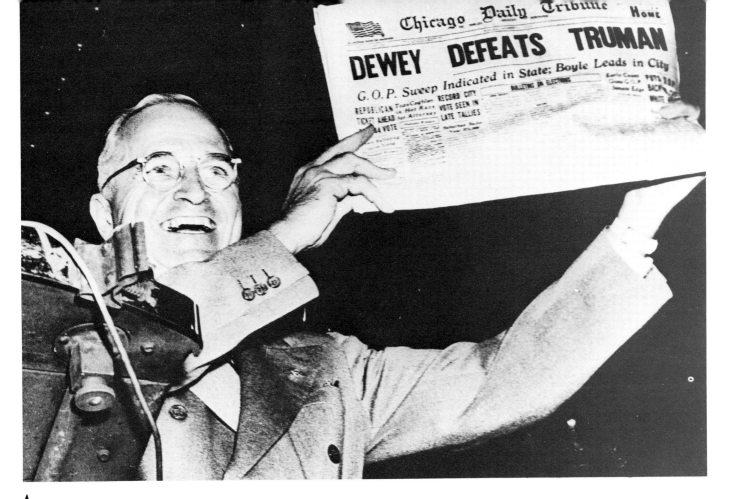

**Last Laugh!** (He Who Laughs Last) by Al Muto for United Press International *(above)*. The picture was taken in St. Louis aboard a train enroute to Washington, D.C. A smiling and obviously pleased Harry Truman holds a newspaper which proclaimed Truman the loser, though he had won the 1948 presidential election. Included in 50 Memorable Pictures exhibit. (United Press International.)

► **Well, I'll Be Darned!** by Francis Grandy for European *Stars and Stripes.* In 1951 at the climax of the Korean War, while Gen. Dwight Eisenhower was commandant of NATO forces in Europe, he learned that Gen. Douglas MacArthur had been relieved of his Korean command by President Harry S Truman. Eisenhower's reaction to the news was a quizzical shrug and the comment, "Well, I'll be darned." Included in 50 Memorable Pictures exhibit.

**Dazed POW Repatriated** by Michael Rougier for *Life (above)*. Unbelief is written on the face of this GI, whisked from the hopelessness of a prisoner-of-war camp back to his comrades. The incident occurred during the Korean War. Included in 50 Memorable Pictures exhibit. (Photo by M. Rougier, LIFE Magazine, © Time/Life, Inc.)

**Christmas in Korea** by David Douglas Duncan for *Life (left)*. The buildup of Chinese forces resulted in a violent attack upon United Nations troops late in 1950. The retreat from near the Manchurian border gave the free world a bitter foretaste of stalemate. Included in 50 Memorable Pictures exhibit. (Photo by David Duncan, LIFE Magazine, © Time/Life, Inc.)

**The Lone Eagle** by Frank Merta. Present generations find it hard to believe that the praise given to the late Charles A. Lindberg because his was the first successful solo flight across the Atlantic Ocean in 1927 was just as great as that accorded Neil Armstrong, the first man to step on the surface of the moon. Reproduction of this photo *(above)* had an honored place in thousands of American homes for many months, if not for years. Included in 50 Memorable Pictures exhibit. (United Press International.)

**Hitler's Jig** (*above*). This picture is from a frame of motion-picture film shot by an unknown photographer. It was made available in this country through British sources during World War II. The Fuehrer is shown gleefully dancing after the surrender of France in the same railway car in which German officials had surrendered in 1918. The jig took place in the Forest of Compiègñe in 1940. Included in 50 Memorable Pictures exhibit. (United States Office of War Information.)

**Radiant Queen** by Charles James Dawson (*left*). This picture is accepted almost universally as one of the finest portraits ever made of royalty. It portrays Queen Elizabeth II passing in a royal carriage shortly after her coronation. Included in 50 Memorable Pictures exhibit. (United Press International.)

148

**Three Queens in Mourning** by
Ron Case, Keystone Press
Agency, Ltd. *(above)*. The picture
shows Queen Elizabeth II after
the death of her father, George
VI. With the queen, forming
this tragic group of mourners,
are her mother and
grandmother. Included in 50
Memorable Pictures exhibit.

**Flag Raising at Iwo Jima**
(Marines on Mt. Suribachi) by
Joe Rosenthal of the Associated
Press. For many years after it
was made (February 23, 1945)

this picture undoubtedly was
the most reproduced picture in
history. Like a gigantic breath
of fresh air it swept the nation,

raising morale and symbolizing
the march to victory. Included
in 50 Memorable Pictures
exhibit. (Wide World Photos.)

◄**Bikini – Baker Day.** This photograph helped record the beginning of the atomic age when United States forces conducted "operation crossroads," a test for atomic weapons and their effect on ships and materiel. The picture was taken in 1946 on Bikini Atoll in the Marshall Islands. Included in 50 Memorable Pictures exhibit. (U.S. Air Force photo.)

# Student Participation

In reviewing the list of winning photographs and in carefully examining the photographs from the "50 Memorable Pictures" project included in this text, we must admit that the winners portray hard news events: tragedy, enshrouded usually by an aura of death. Considering that these 50 pictures were taken during a half-century which was predominately a period of war, this is not surprising.

The kinds of pictures called "great," with the exception of undeniable classics such as the Hindenburg Disaster, etc., vary from generation to generation.

With this fact in mind, check through a half-dozen years of magazines, books, and newspapers collected from your home and/or school library and compile a new list of 25 Memorable Pictures of the last few years. Be prepared to defend your choices in class discussion. Among those on your list I predict will be: The assassination of President John Kennedy, man's first step on the moon, views from the Watergate story, and Richard Nixon resigning the presidency.

What changes (if any) can you detect between the taste in present-day pictures and that indicated by the original "50 Memorable Pictures?"

# 15

# New Legal Aspects of Photojournalism

*Dale R. Spencer*

The newspaper, magazine, or television cameraman, whether staff or free lance, leads a complex, demanding, and sometimes dangerous life. Often we read how a member of this important reportorial group is injured or how his equipment is smashed while covering a riot, shoot-out, protest march, prison break, or other news event. The news photographer is a marked person. He or she is subject not only to physical threats, but also to legal harassment. It is important, therefore, that the modern photojournalist know how to protect himself physically, and more than that, that he have a knowledge of the legal problems.

The photojournalist, indeed, does have legal problems. There are legal problems in the broad areas of defamation and invasion of privacy that affect all journalists. In photography there are legal problems in the specific areas of print and negative ownership, releases, copyright, and the like.

Dale R. Spencer, professor of journalism and a member of the Missouri Bar and the American Bar Association, looks at the legal aspects of visual reporting.

## Ownership and Copyright of Prints and Negatives

Two types of ownership are concerned in photography:

First, who owns the prints and/or negatives?

Second, who owns the copyright?

Both of these questions are essentially contract concerns. This means that if a free-lancer gets an assignment and his customer or client asks for a specific job of so many prints at a certain price the law is clear. The customer or client has agreed to purchase that specific number of prints and they are his. As one court said:

> The usual contract between photographer and his customer is one of employment.[1]

This is true in either a written or an oral contract. Once the assignment is made and understood by both parties, the contract is made.

Contracts usually do not mention the negatives, and the law is indefinite as

---

1. Lumiere v. Robertson-Cole Distributing Corp., 280 F. 550 (2d Cir. 1922). Cert. Denied, 259 U.S. 583 (1922).

to who should be the owner.[2] Some cases hold that the negatives "belong" to the customer. Other cases say that the photographer in the absence of an agreement to the contrary has the "right to retain the negative." In effect, however, these courts are saying the same thing: This right to retain the negatives has an important qualification. If the photographer does in fact retain the negatives, he may not "make any use of the negatives without the permission of the customer."

Thus, the best principle to work under seems to be that the customer or client has purchased the prints and the negatives, but the photographer can keep the negatives. The logic for the courts is that the assignment was for the prints only and the negatives are simply work materials that the photographer may retain but not use. The negatives are part of the job package the customer bought.

One court said this general rule does not apply where a cameraman takes a photograph gratuitously, for his own benefit and at his own expense, it having been held that under such circumstances he is the owner of the photograph and the negative.[3] If the photographer then sells the print, the negative remains the property of the photographer. He can make and sell additional prints to other clients or customers.

If, however, there is an agreement that this is an exclusive sale to this client, the photographer is not free to make and sell additional prints to others. If the picture is sold for a specific purpose, that is, for use in a single publication without reuse privileges, the client or customer cannot use it for any other purpose. He cannot make and use additional prints from the print he bought.

The situation is clearer and more definite when a photographer is working full time for an employer. Working on a full-time basis means the employer owns and can have possession of the prints and negatives. Problems may arise if the employee moonlights or free-lances for others. These problems can be avoided or solved satisfactorily only if the photographer and his employer enter into a contract as to the duty and off-duty creative effort.

The problem of off-duty creative effort is one which applies to all artists, writers, and the like, as well as to photographers. The contract as to off-duty effort should be as clear and as specific as possible. If the contract says all of the creative efforts of the photographer belong to the employer, there is no legal possibility of free-lancing during the evening or on weekends.

Ownership of copyright presents similar contract problems. Early cases held that a photograph was not a "print or engraving" and was not, therefore, a proper subject of copyright. In 1865, Congress extended copyright protection to negatives and photographs by expressly including them among the articles for which copyright was provided. The express designation of photographs has been continued in all subsequent copyright statutes.

The first major revision in copyright law in 67 years became law January 1, 1978. The biggest change in the law was a single non-renewable copyright good for the life of the copyright owner plus 50 years. This copyright protection exists from the moment of creation. This means for a photographer that copyright protection begins as he clicks the shutter. Statutes and court decisions have established that the essential effect of copyright is to give the photographer or his agent or employer the exclusive right to multiplication of copies of his or her creations for sale.

The courts have held that it is an undeniable fact that a photograph may embody original work and artistic skill and be in fact an artistic production. This is true because it is the result of original intellectual conception on the part of its creator due to the arrangements of lights, groupings, posing, and other details—to produce an artistic, pleasing picture.

The basic purpose of copyright protection is to provide compensation to authors for contributing to the common good by publishing their works and for photographers by publishing their pictures. Copyright however is not pri-

2. Hochstadter v. H. Tarr, Inc., 61 N.Y.S. 2d 762 (1957); Colton v. Jacques Marchais, Inc., 61 N.Y.S.2d 269 (1946).
3. Press Publishing Co. v. Falk, 59 Fed. 324 (1894).

marily for the benefit of the photographer or author, but primarily for the benefit of the public.

The new copyright law allows both published and unpublished photographs to be copyrighted. The photographer must affix the copyright notice to each print. This notice consists of the word *Copyright* or the symbol © plus the name of the copyright owner and the year of first publication of the work. The statute says the "notice shall be affixed to the copies in such a manner and location as to give reasonable notice of the claim of copyright."

The owner of the copyright may obtain registration of the copyright claim by delivering to the Copyright Office in Washington, D.C. a deposit of $10 and one copy of the photo for unpublished and $10 and 2 copies for published photos. To secure forms for registration of copyright write to the Library of Congress and ask for Form VA (for works of the visual arts).

Protection under the new statute lasts for the life of the photographer plus 50 years. On photographs made for hire the copyright endures for a term of 75 years from the year of its first publication, or a term of 100 years from the year of its creation, whichever expires first.

A copyright may be sold, assigned, even bequeathed by will, but the agreement or intention must be in writing and signed by the owner of the copyright. This again is contract law, and the new owner or assignee has all of the rights of the original owner. The agreement may specify any limitations on the ownership the parties to the contract may agree upon.

Ordinarily, the photographer who creates the picture is the owner or copyright proprietor. However, as in ownership of prints and negatives, the situation may be different if the photographer is hired to make the picture for a customer or client. In most cases the courts say the customer or client is entitled to the copyright.

# Restraints on Photographers

Recent cases of "prior restraint" concerning photographers and journalists having access to and taking pictures in public places have been decided in favor of the press. In one case, a Duluth, Minnesota, photographer's movie camera was taken from him by a police officer.[4] The photographer had filmed the arrest of suspected burglars from a public boulevard where there was no restriction on the public. The federal district court said the right to use the camera could be restricted only if it interfered with police duties. The court cited the Pentagon Papers case[5] in deciding against the prior restraint of the police and the resulting "chilling effect" on the press.

In another case a federal district court in Indiana gave newsmen a constitutional right to have access to and to make use of public streets, roads, and highways for the purpose of observing and recording in writing and photography the events that occur on these streets, without interference.[6]

The concern is important enough that a bill to make it a crime to interfere with a working journalist was encouraged through the legislature by the Long Island Press Photographers Association in November 1973. The bill would make it a crime to so interfere and punishable by as much as a year in jail and a $1,000 fine.

If property where a photographer wants to take a picture is privately owned and privately used, the owner must give permission to come onto his land. Likewise, in places such as museums and theaters permission usually must be given by the owner of the property. Even when privately owned, the public use of areas such as shopping centers will allow access in many cases for photographers and other members of the press. But if there is doubt, per-

▶ **Ruth Snyder in Electric Chair** by Tom Howard of the *New York Daily News.* This is the famous or infamous "stolen" picture (Curtis D. MacDougall, *News Pictures Fit to Print . . . Or Are They?* [Stillwater, Okla.: Journalistic Services, Inc., 1971], p. 98) The picture was made January 12, 1928, in the death house at Sing Sing Prison. Howard, a Chicagoan and unknown to New York prison authorities, had strapped a subminiature camera to his ankle, with a cable release controlled from his pocket. The illegal picture was certainly a breach of ethics and of journalistic principles. Ruth Snyder and Henry Judd, who also was electrocuted, had been convicted of murdering the woman's husband. Included in 50 Memorable Pictures exhibit.

---

4. Channel 10, Inc. v. Gunnarson, 337 F. Supp. 634 (1972).

5. New York Times Co. v. United States, 403 U.S. 713 (1971).

6. Gazette Publishing Co. v. Cox. Unreported decision by Judge Cale J. Holden, U.S. District Court Southern District of Indiana. May 2, 1967.

mission should be requested because the property is privately owned.

In the area of trespass in private homes when covering disasters, such as fires, the Florida Supreme Court recently gave some help to photographers in Florida and some guidance for other states.[7] The problem arose when a woman sued a newspaper that had published photographs showing a "silhouette" left by the body of her daughter who was killed in a home fire. Among other things the woman alleged trespass and invasion of privacy by a photographer.

The fire marshall at the scene of the fire had asked the photographer to take the picture which was made a part of the official investigation. The photographer turned in his picture to his newspaper and it appeared along with other pictures and a news story about the fire. The woman learned of the facts surrounding the death of her daughter when she read the newspaper story and saw the photos. She sued.

The newspaper and the photographer won at the trial level because the trial judge said the trespass was "consented to by the doctrine of common custom and usage." The trial judge cited earlier cases to the effect that the "law is well settled in Florida and elsewhere that there is no unlawful trespass when peaceable entry is made, without objection, under common custom and usage."

The trial judge also pointed out that the fire marshall and detective sergeant testified that it was "common custom and usage to permit the news media to enter under the circumstances" of this case and they had permitted it a great number of times in private homes. Affidavits were filed with the court attesting that it is common usage, custom and practice for news media to enter private premises and homes under similar circumstances by the sheriff and Florida attorney general as well as from the Chicago Tribune, Tallahassee Democrat, Pensacola Journal, Miami Herald, Florida Times-Union and Jacksonville Journal, Washington Post, New York Daily News, Milwaukee Journal, Birmingham Post-Herald, Memphis Commercial Appeal, Macon Telegraph,

Tampa Tribune, the Associated Press and United Press International, the presidents of the American Newspaper Publishers Assn. and Radio and Television News Directors Assn., ABC-TV News and television stations in Jacksonville and Miami.

The Florida Supreme Court's decision pointed out that "the only photographs taken and published were of fire damage—none were of deceased or injured persons." Thus the Florida justices got rid of the invasion of privacy question and said the only question before the court was whether there was a trespass by the news photographer. The opinion said simply "the entry (by the photographer) in this case was by implied consent."

It was explained by the court that the implied consent doctrine is one "under which a person, who does not have express consent from the owner or possessor of premises, may legally enter under circumstances which imply consent (common usage, custom and practice)." So at least one state supreme court applies the idea that photographers have implied consent to enter areas to report on matters of public interest or public disasters.

But, one interesting case that should concern photographers is *Galella* v. *Onassis*.[8] Under the First Amendment protection of free speech and press Donald Galella, a free-lance photographer, had sought damages and an injunction against former President John F. Kennedy's widow for interfering with his photographing her. The widow, now Mrs. Jacqueline Onassis, and the Secret Service agents in opposition sought an injunction against Galella's interference with the agents' activities protecting the Kennedy children.

After a six-week trial the court dismissed Galella's claim and granted relief to Mrs. Onassis and the Secret Service. The court enjoined Galella (1) from keeping Mrs. Onassis and her children under surveillance or following any of them; (2) from approaching within 100 yards of the home of Mrs. Onassis or her children, or within 100 yards of either child's school, or within 75 yards of either child or 50 yards of Mrs. Onassis;

7. Florida Publishing Company v. Fletcher, 340 So. 2d 914 (1976).
8. Galella v. Onassis, 487 F. 2d 986 (1973).

(3) from using the name, portrait, or picture of Mrs. Onassis or her children for advertising; and (4) from attempting to communicate with Mrs. Onassis or her children except through her attorney.

The federal district trial court found Galella guilty of harassment, intentional infliction of emotional distress, assault and battery, commercial exploitation of Mrs. Onassis' personality, and invasion of privacy. The appeals court said that evidence at the trial showed that Galella had on occasion intentionally physically touched Mrs. Onassis and her daughter, "caused fear of physical contact in his frenzied attempts to get their pictures," followed Mrs. Onassis and her children too closely in an automobile, and endangered the safety of the children while they were swimming, water-skiing, and horseback riding.

The appeals court said that Galella had "insinuated himself into the very fabric of Mrs. Onassis' life . . . ," and the relief granted Mrs. Onassis was framed in part on the need to prevent further invasion of Mrs. Onassis' privacy. The appeals court was not sure whether Galella's actions "accords with present New York [privacy] law," but the court said there is no doubt that it is "sustainable under New York's proscription of harassment."

Thus the appeals court based its decision on "harassment" and not on invasion of privacy. The court said Galella's actions went far beyond the reasonable bounds of news gathering. The court added:

When weighed against the *de minimis* public importance of the daily activities of the defendant, Galella's constant surveillance, his obtrusive and intruding presence, was unwarranted and unreasonable.

However the appeals court did modify the lower court's order to prohibit only (1) any approach within 25 feet of Mrs. Onassis or any touching of the person of Mrs. Onassis, (2) any blocking of her movement in public places and thoroughfares, (3) any act foreseeably or reasonably calculated to place the life and safety of Mrs. Onassis in jeopardy, and (4) any conduct which would reasonably be foreseen to harass, alarm, or frighten Mrs. Onassis.

9. 487 F. 2d 986 (1973).

The court added:

Any further restriction on Galella's taking and selling pictures of defendant for news coverage is, however, improper and unwarranted by the evidence.[9]

Although the decision in the appellate court was based on harassment and not on invasion of privacy, the possible threat of this interpretation looms large for photographers. The tort of invasion of privacy or the right of a person to be left alone has grown during the past eighty years. It concerns the protection of a person's name, portrait, image, likeness or picture, sketch, signature, coat of arms, and the like, by another but without the person's consent. It can be violated by use of voice, musical, or other style, as well as by print, broadcast, or photographs in story, dialogue, dramatization, fictionalization, testimonial, and the like.

Defamation, an ancient tort, is almost synonymous with invasion of privacy to many persons today. Defamation is concerned with damage to a person's reputation and has nothing to do with the right to be left alone. The camera has been involved in many invasion-of-privacy suits because the camera records the entire scene without selecting individuals or parts as a writer does. So anyone in the news picture may feel his privacy has been invaded. Plaintiffs suing any of the mass media today can file a suit in each area, one for libel and another for invasion of privacy, for the same incident—and collect on each.

Defamation is the broad term that covers both libel and slander. Libel concerns printed defamations. The courts explain this by saying that it is a libel if it has "permanence of form." There is no doubt that negatives and prints have permanence of form. *So photographers are concerned with libel and not with slander.*

Libel, damage to reputation, is a false publication of a story and/or a picture that is capable of a defamatory meaning. This means the person is claiming to have been brought into hatred, contempt, or ridicule to a substantial and respectable group, according to an interesting old case. This case concerned a picture of a nurse in a testimonial advertisement in praise of "Duffy's Pure Malt

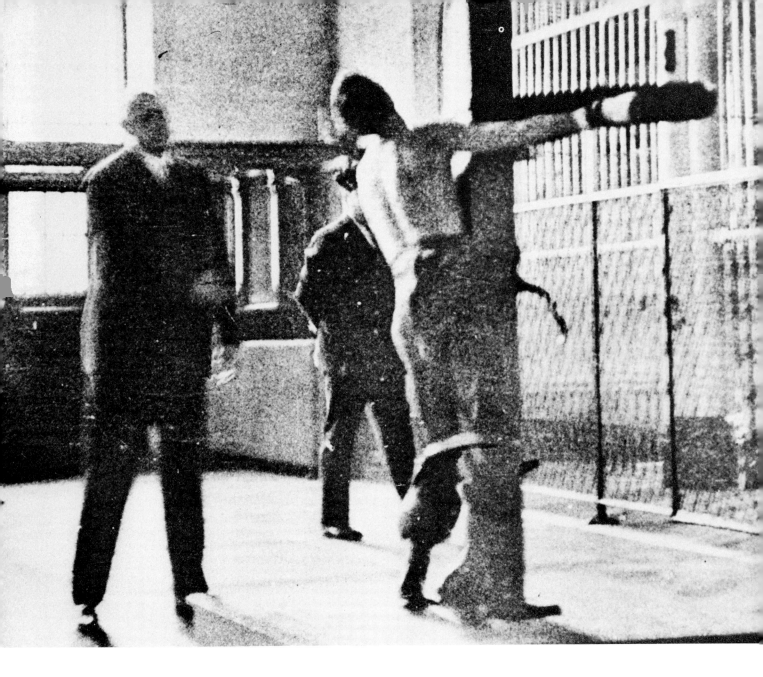

Whiskey." The catch was that the photograph used was of one person while the name was that of another. A successful libel action resulted. True, the use of the portrait of the nurse in the advertisement may not have been libelous to many persons, but the Supreme Court said this did not matter if the advertisement obviously would hurt this woman in the "estimation of an important and respectable part of the community."[10]

The important area of the law about the statement of a picture being "published" in the legal sense is not of much concern to the photographer. If a picture appears in print or is broadcast—it is published. *The idea in "publication" is that the defamation was communicated to a third person.*

Once it is established to the satisfaction of the court that a person's reputation has been damaged and that a jury would understand the publication in a

**Wife Beater Gets Whipping** by Joseph Costa of the *New York Daily News (above)*. This was another stolen camera shot. This picture is in better taste, perhaps, and not so well known as the preceding picture. This picture was taken in a Baltimore jail as a wife beater received a twenty-one lash sentence when the court invoked an ancient ruling. Included in 50 Memorable Pictures exhibit.

10. Peck v. Tribune, 214 U.S. 185 (1909).

defamatory sense, the defenses come into play. Libel defenses for the press are simple and basic: *truth and privilege.*

The defense of truth usually is believed to have started with the John Peter Zenger trial in 1735. Andrew Hamilton advanced the novel concept at Zenger's trial, and it became almost impossible to convict a colonial editor who published the truth. Most state statutes say truth is a complete defense to a libel action. The problem of what is truth is more difficult for writers than for photographers. The picture usually speaks for itself—and thus is not libelous.

Optical illusions, however, are sometimes created by the camera, and one such situation resulted in a successful libel suit. The plaintiff appeared in a picture used in a Camel cigarette advertisement holding his saddle in such a way that the stirrup strap appeared to be an obscene and ludicrous deformity.[11] It was also a defamation to print a picture in juxtaposition with an article on evolution and a photograph of a gorilla.[12]

Another defense involves the three branches of government and the idea that certain occasions in the public interest demand protection for individuals to speak freely and fearlessly. Thus an absolute privilege arises for public officials in the legislatures in the course of any of their functions in the legislative chambers. Judicial proceedings also have an absolute privilege attached when in the courtroom. The executive department has this same absolute privilege for the head of state and the major officers of executive departments of the federal and state governments. (This immunity from tort damages should not be confused with executive privilege to testify before judicial and legislative bodies.)

The participants in these three governmental areas thus have an absolute privilege from tort liability while performing their official functions. The press has only a "conditional privilege" to cover these governmental bodies as long as the coverage is full, fair, and accurate.

When coverage of the courts is mentioned the subject of Canon 35 arises. This judicial canon, for many years a concern of news photographers, has to do with use of a camera in courtrooms. It was adopted within two years after the 1935 trial of Bruno Hauptmann for kidnapping the Lindberg baby. The American Bar Association adopted Canon 35 of its judicial ethics which prohibited the "taking of photographs in the courtroom during sessions of the court or recesses between sessions."

At one time all of the states except Colorado, Oklahoma, and Texas had adopted Canon 35 or some modification of it by statute or some state court rules. Some states allowed the judge to make decisions as to the use of cameras in his courtroom.

Canon 35 was amended in 1963 to include television in its ban against use of cameras in the courtroom. The American Bar Association (ABA) has now adopted Canon 3 (A) (7) of the Code of Judicial Conduct. The new code is mainly concerned with television coverage, and still cameras get similar treatment as in the old Canon 35. Cameras are permitted in the courtroom only when they will not distract or impair the dignity of the proceedings.

This canon has to be adopted by the various states in some manner before the Bar Association canon is effective on the state courts. However many trial court judges adopt ABA canon as operating procedure without waiting for their state supreme courts or legislatures to take any action. But a new wind is blowing into the courtrooms. The best test of this change may come with the appeal now going up through the appellate courts concerning the Ronald Zamora trial in Florida. Zamora was the teenager whose defense to a murder charge was the effect of television violence on him. However the test will come because almost the entire trial was broadcast under an experiment conducted by the Florida Supreme Court.

At least twelve states now allow some televising of court proceedings. Florida's experiment is the best known. Alabama has a new judicial canon to

---

11. Burton v. Crowell Publishing Co., 82 F. 2d 154 (1936).
12. Zbyszko v. New York American, 239 N.Y.S. 411 (1930).

allow cameras and other equipment into the courtrooms with permission of every party involved. The states of Washington and Nevada also require permission. Georgia is in the process of implementing new rules in this area. There is no statewide rule in Kentucky but some courts are allowing cameras in. New Hampshire's Supreme Court has amended its code to allow cameras as of Jan. 1, 1978. The Wisconsin Supreme Court has ordered its rule suspended for one year to allow experimentation similar to Florida's. Montana began a two-year experiment on April 1, 1978. Colorado has been allowing cameras in its courtrooms for 20 years. Texas and Minnesota allow appellate court coverage.

The use of cameras in legislative bodies is as varied as the many federal, state, and local legislative bodies that are in session over the United States. Some allow unlimited photo coverage, while others are like the Congress and refuse access to their proceedings by cameras of any sort.

The national, state, and local executive department officials are somewhat more open to photo coverage. The conditional privilege of the press to cover these bodies and officials is valuable protection against civil liability in def-

amation—but full, fair, and accurate coverage is essential.

The defense of fair comment and criticism is also available to photographers but appears to be less important than the primary defenses of truth and privilege.

The traditional libel defenses are not available in invasion of privacy suits. If an event or person is newsworthy, then the person involved cannot invoke the right of privacy if a newspaper or television station uses his name and/or picture in the publication of a matter of legitimate public interest concerning his public life.

The defenses for suits against the press for invasion of privacy are: first, that the person or event is newsworthy and, second, if the picture is used for advertising or "for purposes of trade" then consent is the only protection for the photojournalist and his employer. Consent is a release signed by both parties and thus is a contract between the publication and the subject. Written contracts are required in states that have statutes concerning privacy. So when working in the advertising or "for purposes of trade" areas, a professional photojournalist gets a release from the subject or subjects involved.

# Constitutional Protection in Libel and Privacy

The twin torts of libel and invasion of privacy had separate but simple defenses until 1964. If a suit against a publisher was for libel, he had the defense of truth or if the coverage involved the three basic areas of government the press was conditionally privileged to cover full, fair, and accurate.

If a suit involved invasion of privacy, the publisher or radio or television station owner had a release signed by the individual unless the person or event was newsworthy. In 1964 the Supreme Court decided the landmark *New York Times* v. *Sullivan* case and added a constitutional defense to aid journalists.[13] The court said in this case that a person who was a public official could not collect libel damages unless the publication used "actual malice." That is:

Knowledge that it [the publication] was false or with reckless disregard of whether it was false or not.[14]

Later cases interpret this "reckless disregard" rule to mean that editors, photographers, or reporters on the publication entertained "serious doubts" as to the truth of the publication. Publishing with such doubts, according to the justices, shows reckless disregard for truth or falsity and demonstrates "actual malice."

Two years later the Supreme Court expanded the *New York Times* actual malice rule to include public figures in addition to public officials. In 1971 a plurality of the court expanded the *New York Times* protection to a defamatory publication about an "individual's

---

13. New York Times v. Sullivan, 376 U.S. 254 (1964).

14. 376 U.S. 254 (1964).

involvement in an event of public or general interest."[15] So in less than ten years the Supreme Court took the constitutional protection afforded the press in discussing and photographing public officials and expanded this immunity to discussions or photographs of "events of public or general interest."

In 1974 the Supreme Court retreated enough to allow the states to decide the standard of fault when a private individual was trying to prove libel damages. In Gertz v. Welch the justices said the standard could be less than actual malice.[16] Since this case at least three states have maintained the actual malice standard of fault for private individuals as well as for public figures and public officials.[17] New York requires the standard of media fault when writing about private individuals should be gross negligence. Twelve states and the District of Columbia say the basis of fault for private individuals should be negligence.[18]

While this protection was developing in the libel area, the courts were also involved in protection for invasions of privacy by the media. In 1967 the Supreme Court justices said the First Amendment protects the press against privacy suits for false reports of matters of public interest in the absence of proof that the publisher or the broadcaster published the report "with knowledge of its falsity or in reckless disregard of the truth."[19]

This case concerned the use of photographs with an article about a play of a family trapped by convicts in their home. Life had photographed the actors during tryouts of the play in Philadelphia. The photographs were taken in the James Hill home where the real incident had taken place. The Hill family had moved prior to the filming. The magazine article included photos of the son being roughed up by the convicts and the daughter biting the hand of a convict to make him drop a gun.

The James Hill family referred to in the article and shown in the pictures had been released unharmed. They even said they had been treated courteously by the convicts. After the pictures and article appeared in Life, the Hills sued because they said the article gave the impression that the play mirrored the Hill family's experience which Hill said Life knew was "false and untrue."

Life used the traditional defense that the article was "a subject of legitimate news interest," meaning it was "newsworthy." The court discussed the possibility that the article was published "for trade purposes," but added this did not remove the constitutional protection afforded Life. Thus Life received constitutional protection against having to pay damages for invasion of privacy. This case moved the "actual malice" test into the privacy area.

Despite this added protection for photojournalists given in the Time, Inc. versus Hill case, the importance of consent or releases should not be overlooked. A release is a contract signed by both parties and requires the three elements of any contract: offer, acceptance, and consideration. Thus a photographer offers a subject a certain sum for the right to use his or her picture "for purposes of trade"—use it, that is, for an advertisement, to illustrate an article, and the like. The subject accepts the offer of the photographer and the sum of money agreed upon, and use of the subject's likeness is the consideration to make a contract.

Since releases do involve contract law, it is important to have the contract cover the uses of the photo intended by the parties. In a recent case concerning

15. Rosenbloom v. Metromedia, 403 U.S. 29 (1971).

16. Gertz v. Welch, 418 U.S. 323 (1974).

17. Colorado, Indiana, and Louisiana.

18. The states of Arizona, Connecticut, Hawaii, Illinois, Kansas, Massachusetts, Maryland, Ohio, Oklahoma, Tennessee, Texas and Washington have adopted the negligence standard when dealing with private individuals. All states are required to use the actual malice standard when dealing with public officials or public figures. The negligence standard requires a finding by a court that the photographer failed to act as "a reasonable man," or more precisely a "reasonable photographer under the same or similar circumstances."

19. Time, Inc. v. Hill, 385 U.S. 374 (1967).

# RELEASE OR CONSENT FORM

Here is an example of a model photograph release:

Date _____

I, (we) ___(name)_____ being of legal age and in consideration of One Dollar ($1) and other good valuable consideration, the receipt of which is hereby acknowledged, hereby consent and authorize the ___(publication)_____ to use and reproduce my name and photograph (or photographs) taken by ___(name)_____ on ___(date)_____ and circulated the same for any and all purposes, including publication and advertising of every description. No further claim of whatsoever nature will be made by me.

_(witness)_____

___(name)_____

___(address)_____

___(photographer)_____

(Note: Most publications do have their own release forms. It is important that the form be drafted by an attorney familiar with the law in your state and area.)

*Newsweek* magazine the court said it simply:[20]

It is true that if the plaintiff consented to the use of his photograph in connection with this article he would have waived his right of action for invasion of privacy.

However, if the court found that he had consented to the photo's use in a daily newspaper and not in a weekly newsmagazine, the plaintiff's right to be left alone would have been invaded, and the newsmagazine would have had to pay damages.

The most recent decision by the Supreme Court concerned the "right of publicity." The justices said in a decision June 28, 1977 that the "Great Zacchini" had a right in his performance that was superior to the First Amendment rights of a television station news cameraman. The decision concerned a 15-second act that was videotaped of the "Great Zacchini" being shot from a cannon and used in its entirety on a newscast. It is possible the decision is unique because there are not many 15-second acts in show business. Also the court did not say the media have to pay damages in a case like this. The court said the trial court was to decide if the broadcast of the act has caused any damages to the human cannonball.[21]

---

20. Raible v. Newsweek, Inc. 341 F. Supp. 804 (1972).
21. Zacchini v. Scripps-Howard, 433 U.S. 562 (1977).

# Student Participation

Amendment No. 1 to the United States Constitution states: "Congress shall make no law respecting an establishment of religion, or prohibiting the free exercise thereof; or abridging the freedom of speech, or of the press; or the right of the people peaceably to assemble, and to petition the government for a redress of grievances."

1. Study Amendment No. 1 carefully and thoughtfully use it as the basis for a discussion of this chapter.
2. To better understand our legal system and Mr. Spencer's presentation of the legal aspects of photography, look up at least three cases cited in this chapter. Use either a private or a public law office for your research.

Dale R. Spencer is professor of journalism and member of the American Bar Association and the Missouri Bar. He began his career as a reporter in his hometown, Pocatello, Idaho, before World War II. Professor Spencer graduated from the School of Journalism, University of Missouri, in 1948. After a short time as instructor in journalism at the University, he became sales manager for E.W. Stephens Publishing Company. Spencer worked on the copydesk at the *Buffalo Evening News* in 1952. He served as assistant managing editor of the *Columbia Missourian* and taught copy editing from 1950 until 1973. In 1973 Spencer became acting managing editor of the *Missourian*, a position he held until 1974. In 1958 he began teaching a course in communications law. He has written more than a dozen articles on law, two editions of the book *Law for the Newsman*, ◀ and a textbook on copy editing.

# 16

# Photojournalism Research

*Keith P. Sanders*

People like pictures. Pictures make people laugh, cry, sympathize. Pictures communicate. Yet, despite common sense and what hard facts we have—both of which tell us that photographs are very important—very little research has been conducted into photojournalism.

Malcolm S. MacLean, Jr., who probably has contributed more to the understanding of photojournalism than any other researcher, once wrote: "It is curious how little research has been done on pictorial communication. A good picture, we believe, can tell a lot—fast—and with a big wallop that the readers won't forget. Yet we have practically no research on how we can best make or select those 'good' pictures to do such jobs for us. Despite the thousands of readership and other studies, editors and photographers still have to pretty much fly by the seat of their pants in their decisions on pictorial communication."[1]

People like pictures of themselves and pictures of other people, other places, other things. Pictures are so popular, in fact, that numerous studies have shown that photographs in newspapers and magazines consistently draw more readers than the words in print which the photographs accompany. The Continuing Study of Newspaper Reading, for example, demonstrated that the popularity of news photographs was several times that of written material.[2] The study reported that the average news story in newspapers was read by only 13 percent of the men and only 11 percent of the women. In the same newspapers, however, three times as many men and four times as many women read the average one-column picture as read the average news story (and readership increased considerably with an increase in the size of the picture).

A picture may not actually be worth a thousand words, but its appeal either as a separate entity or as a complement to a verbal story goes beyond the strength of the words. Arnold summarized the impact well: "With their distillation of a moment's essence, pictures command attention in a way that words cannot. A memorable picture tells the

**Although considerable research has been done, there is much that needs to be done before visual communication receives full recognition. Dr. Keith P. Sanders, professor of communication research at the School of Journalism, University of Missouri, tells us what has been learned about pictures and about the area that needs further study.**

---

1. Malcolm S. MacLean, Jr., and Anne Li-An Kao, "Picture Selection: An Editorial Game." *Journalism Quarterly* (40):230–232.

2. Advertising Research Foundation. *The Continuing Study of Newspaper Reading* (New York: started in 1939).

story. If the picture is good enough, no further explanation is necessary. As adjuncts to words, pictures also exercise their strength. As a segment of an integrated story, pictures expand the ability of the words to explain, just as the words expand the graphic interpretation of the pictures. Here, words and pictures balance and add to each other, making the final whole greater than the sum of its parts."[3] It is not a question of photographs *competing* with words. It is a question of what combination of words and photographs will most effectively communicate an idea to a reader.

Research has served photojournalism well, although much more needs to be done. In the 1930s the *Des Moines Sunday Register* studied reader interest in pictures using recently developed techniques by a newcomer to the research field—George Gallup. It was found that readers were more interested in looking at pictures than they were in reading columns of unbroken print. After trying various combinations of pictures and words, the newspaper's circulation increased by 50 percent.[4] In addition to showing the potential for increasing readership, the study presented evidence that pictures spoke a universal language, a language that seemed to appeal to all people. Gardner Cowles saw the possibilities of publishing a magazine that would concentrate on the use of a "picture language "—a language that could reach and inform millions of people regardless of age, sex, income, education—and founded *Look*.[5]

The remainder of this chapter is devoted to a review of photojournalism research. The review is not intended to be inclusive; rather it concentrates on research that seems to have particular relevance. If the reader is interested in pushing deeper into the literature, he is invited to consult the bibliography included at the end of the chapter. There have been thousands of readership studies, but very few of them are

Keith P. Sanders is professor of communication research at the School of Journalism, University of Missouri. He also has taught at Bowling Green State University and at the University of Iowa.

Dr. Sanders, a former newspaper sports editor and television sports newscaster, has had both professional and research interests in photojournalism.

In 1973 he received the Joyce A. Swan Distinguished Faculty Award, which was presented for a number of years to a member of the Missouri School of Journalism faculty in recognition of outstanding achievement.

He is a member of the International Communications Association, Sigma Delta Chi, Kappa Tau Alpha, Omicron Delta Kappa, and the Association for Education in Journalism (twice serving as research chairman for the Mass Communication and Society Division). Dr. Sanders is the author of several articles published in scholarly journals such as *Journalism Quarterly* and *Journal of Broadcasting*.

reviewed here for the reason that one readership study is pretty much like all previous such studies—only the names and places have been changed. Although every newspaper should regularly conduct readership studies, such studies produce little that can be generalized to picture readers elsewhere. This review, therefore, has opted for research findings that have particular theoretical value. The final section of the chapter is devoted to a discussion, albeit brief, of where photojournalism research might go from here.

3. George Arnold, "Theoretical Views of the Photography Editor as Gatekeeper" (master's thesis, University of Missouri, 1974).

4. Gardner Cowles, "Visual Excitement in Modern Publishing," in *Art Directing* (New York: Hastings House, Publishers, 1957).

5. Ibid.

# Content: The Crucial Variable

What is it about a photograph that attracts people to it? In a word, it's content. Of the various "variables" one can use to judge a photograph—such as composition, focus, balance, rhythm, unity, lighting, contrast, etc.—the content variable stands far out from all the rest. Subject matter orientations have consistently been found to be the main determinants of interest in a photograph.[6,7,8]

One of the earliest systematic attempts to determine what kinds of photographs are most read concluded that pictures of babies and children had particularly high overall interest value. Pictures of travel, scenery, people, animals, nature, and science were found to have middle-range appeal. Pictures of sports, society, fashion, and finance were found to have low overall interest. Conducted in the 1930s by the Advertising Research Foundation, the study attempted to summarize dozens of newspaper readership studies.[9] The conclusions need to be tempered by the fact that the previous studies are difficult to compare because of the use of many different category and definition systems.

Swanson studied the readership of 3,353 photographs and found that the most read categories were Fire and Disaster, War, Weather, Consumer Information, Human Interest, Major Crime, Country Correspondence, Accidents and Mishaps, Science and Invention, Defense, Local Government, and Agriculture. The lower read categories, in ascending order, were: Home and Family, Fine Arts, Sports, Popular Art, Entertainment and Features, Social Relations, and Relation and Morals.[10] Swanson found that men and women have quite different photographic preferences in certain areas. There were major differences in readership of Home and Family photographs, for example, which were read by only 14.2 percent of the men but by 55.4 percent of the women. Comparatively, women much preferred the categories of Social Relations, Popular Art, and Fine Art, while the men preferred Sports. However, Swanson noted that women in general seem to be far more picture-minded than men. Although there were only two categories that received less than 45 percent readership by the women (with a low of 24 percent), there were 10 such categories for the men (with a low of 14.2 percent). Other researchers have found differences in content preferences between men and women. Harrison found that men tend to prefer photographs of events and women tend to prefer pictures of people. Both sexes look at pictures of women more than at pictures of men.[11] Woodburn found that men rated high photographs of Human Interest, National Defense, Crime, Servicemen's News, and Sports. They rated low photographs of Food, Fashions, Women's and Society, and Weddings and Engagements. Women rated high photographs of Weddings and Engagements, Children and Babies, Women's and Society, Crime, and Human Interest, but rated quite low Sports.[12]

Instead of concentrating on actual readership of published photographs, MacLean and Hazard conducted an

6. Randall P. Harrison, "Pictorial Communication." *Search,* vol. 6. National Project in Agricultural Communication, East Lansing, Michigan, 1962.

7. Cliff Ganschow, "Contribution of Certain Compositional Factors to Photographs' Effectiveness." Mimeographed. Department of Technical Journalism, Iowa State University.

8. William R. Hazard, "Responses to News Pictures: A Study of Perceptual Unity." *Journalism Quarterly* (37):515–524.

9. Advertising Research Foundation, *The Continuing Study.*

10. Charles Swanson, "What They Read in 130 Daily Newspapers," *Journalism Quarterly* (32):411–421.

11. Randall Harrison, "Pictorial Communication."

12. Bert W. Woodburn, "Reader Interest in Newspaper Pictures," *Journalism Quarterly* (24):197–201.

experiment to determine women's interest in different types of photographs.[13] They asked 152 women to rate a set of 51 news magazine photographs. Factor analysis of the photograph ratings produced six factors, or groupings, of photographs that had been scored in similar ways. The six basic content groups, or factors, were:

1. Idolatry: This group included pictures of successful, glamorous, and wealthy women, especially if portrayed in a "happy family" situation.
2. Social Problems: This group included pictures of people causing "trouble," such as strikes and riots, pictures about people "on the wrong side of the tracks," and pictures of people who did not "fit in" with popular ideals.
3. Picturesque: This group included salon pictures, moody pictures, dynamic pictures, pictures portraying loneliness and escape from other people, and pictures of people doing things with their hands.
4. War: This group included pictures of war, fear of involvement in war, horror at the gruesome results of war, pictures depicting the glory of American armed power, and pictures exhibiting sympathy for the victims of war.
5. Blood and Violence: This group included pictures of people injured or killed through crime or accident.
6. Spectator Sports: This group included action pictures of sports that normally command large audiences.

Most readership studies concentrate on overall readership and, consequently, ignore the commonsense notion that people are different. A quite different approach to photograph readership, then, is to group people together on the basis of their similar preferences. Ideally suited to such an undertaking is Q-methodology, as described by Stephenson[14,15,16] and MacLean.[17] MacLean and Kao used Q-methodology to develop types, or groupings, of people who had similar preferences for photographs.[18] They asked people to literally sort through a set of 60 photographs and to indicate how much they liked or disliked each. Each person's "Q-sort" was then correlated with every other person's sort and then factor analyzed. Four major factors or types resulted. Each factor was composed of people who had sorted the photographs in very similar ways. The factor thus represented a "hypothetical person," a "type" of reader—a composite of the people who sorted the photographs in similar ways. The determination of the four types represented but one phase of the MacLean-Kao study. Some of the other phases will be reported later in this chapter. The current phase will be reported here in length not only because of its innovative and imaginative contribution to research methodology, but also because of the rather considerable insight it provides into what kinds of photographs people like and why.

Type A liked pictures about young marriage, fame, performance, glamour, and art and readily identified with the subjects or things portrayed in such photographs. Throughout, there was a strong sense of self-identification. Type A rated high pictures of a family scene, flowers, a party, an outdoor scene, a mother and son, animal loving, and the like. Type A liked those photographs because he considered them to be "real,"

13. Malcolm S. MacLean, Jr., and William R. Hazard, "Women's Interest in Pictures: The Badger Village Study," *Journalism Quarterly* (30):139–162.

14. William Stephenson, "Principles of Selection of News Pictures," *Journalism Quarterly* (37):61–68. (See Appendix)

15. William Stephenson, *The Play Theory of Mass Communication* (Chicago: University of Chicago Press, 1967).

16. William Stephenson, *The Study of Behavior: Q-Technique and Its Methodology* (Chicago: University of Chicago Press, 1953).

17. Malcolm S. MacLean, Jr., "Communication Strategy, Editing Games and Q," in Steven R. Brown and Donald J. Brenner, eds., *Science, Psychology and Communication* (New York: Teachers College Press, 1972).

18. Malcolm S. MacLean, Jr., and Anne Li-An Kao, *Editorial Predictions of Magazine Picture Appeals* (Iowa City, Iowa: School of Journalism, University of Iowa, 1965).

"beautiful," or to have general interest, for escape or enjoyment, because of good expression and good composition. "Beauty" is a word the people who composed this type used frequently to explain their liking for the pictures. Type A liked children, family togetherness, peacefulness, the carefree life, sports, and sex. Type A admired talent and athletic ability. In all these, he could either actually or ideally identify with what was depicted in the pictures. Type A disliked death, war, destruction, crime, and victims of poverty or a bad system. These caused the Type A person to feel uncomfortable, disgusted, and disagreeable; he tried to avoid such things. MacLean and Kao noted three obvious tendencies about the Type A person: The Type A women all agreed on their Like-Dislike pictures; Type A people, especially women, tend to like what they can ideally or actually identify with; higher educated Type A men tend to like more humane and feminine subject matter as the Type A woman does.

Type B had the strongest feelings for pictures about death, soldiers, performance, young marriage, social problems, sports, and offbeat material. Type B was indifferent about art, fame, politics, pattern, science, and show. Among the highly accepted pictures for Type B were the strikingly sad and horrible, and the pleasant, happy family, and performance scenes. Type B people commented that they hated war and violence. Some of the photographs reminded them of their own sad experiences. These pictures showed suffering, agony, pain, and sorrow. Hatred of war, sad memories, unbearable scenes of suffering, and pictures of pleasant life were the main elements that elicited strong feelings, although not necessarily *a liking* for the picture, in Type B. Type B rejected all three pictures of big, gala parties, and most of the close-ups. Type B also rejected photographs of people "doing nothing."

Although somewhat similar to Type A, Type C was clearly more interested in a physical and masculine type of content. The people composing Type C were predominantly men and were very

athletically inclined. Type C liked the pictures of sports, particularly those of a physical and spectacular nature. He also liked pictures of sex, design, and glamour. He identified and felt strongly toward such matters. Type C's identification is readily understandable when one considers his sports participation. Type C was an active participant; he played at least one kind of sport and very likely belonged to some kind of league or had recently entered some kind of tournament. He sensed the power, beauty, and meaning of action to be found in photographs showing physical sports. Type C rejected photographs portraying fame, pattern, death, soldiers, and politics.

Type D was made up of young people, college students for the most part. Type D rejected identification with scenes depicting death and misery, soldiers, and social problems. He identified with those depicting sports, politics, performance, and offbeat material. Type D was concerned with global tension, his own future, and with current events. He praised glorious actions and muscular expressions and advocated hard work in everything. He liked and cared about what he had experienced. Type D didn't care for art, and some of the pictures of girls and children seemed ridiculous to him.

From a theoretical standpoint one of the major findings of the MacLean-Kao study was the relationship between subjects' Like-Dislike and Intensity-of-Feeling Dimensions. They found a consistent U-shaped curve between the two. This means simply that the pictures that aroused the strongest feelings in people were the ones people either strongly liked or disliked. A photograph that does not arouse strong feelings is not likely to be *either* much liked or disliked. This finding substantiates the earlier observation by Kalish and Edom that a picture's *impact* is a major determinant in how well liked or disliked the picture will be.[19]

The literature on photographic content preferences is neither extensive nor consistent. It can be seen that certain types of content—animals, people, scenery, and highly topical news items—are

---

19. Stanley E. Kalish, and Clifton C. Edom, *Picture Editing* (New York: Rinehart & Co., Inc., 1951).

well liked and highly read. Pictures of war, destruction, death arouse great intensity and are highly read, but apparently are not well liked by most people. Women seem to be generally more picture "conscious"—at least, they consistently read more pictures than men do. There are quite clear-cut preferences between men and women. One reason for the sometimes conflicting results, of course, comes from the fact that so many different categories have been used. MacLean and Kao point out, for example, that two photographs that normally would be placed in the same category can get quite different ratings. For example, Type C liked sports photographs containing a great deal of highly physical action, but disliked most other sports photographs. Then, too, one must keep in mind the constant changing of our society. During World War II, for example, photographs that showed the glory of the American war effort likely would have received high ratings. A study involving similar photographs conducted during or after the Viet Nam War, however, very likely would receive quite different ratings, at least from a significant portion of the reading public. It is for such reasons that a photography editor must periodically "reacquaint" himself with his readers and their likes and dislikes.

# Perception: The Hidden Dimension

Photographs are rich in connotative meaning. The meaning people perceive in a photograph is of considerable interest. As Osgood and Tannenbaum put it, "the effect of a photograph is closely related to the attitude or meaning a person has toward the photograph. It is therefore important in studying the effects of photographs to look at what the photographs mean, and why they mean what they do, to the readers."[20] Meaning and attitude are interrelated; that is, one's attitude influences the meaning he will perceive in a photograph and the meaning he derives will influence the continual process of attitude formation.

What a photograph "means" to a person is the result of a complex interaction between the photograph and the person's prior experiences and perceptions (his apperceptive mass). The *intention* of the photographer is relatively unimportant; people will perceive what they want to see. There probably is no more humbling experience for a professional communicator than to expend great amounts of time and effort to produce a message only to have the audience fail to see what you were trying to accomplish. Studies have shown that photographs are effective in creating attitudes, changing attitudes, and generally persuading people—although not necessarily in the direction intended. One is reminded of the classic Mr. Biggott studies.[21] The purpose of this experiment was to see if strong prejudice could be reduced or eliminated by getting the subject to see how absurd prejudice was. The procedure was to show people a cartoon series featuring Mr. Biggott, a prudish figure with exaggerated antiminority attitudes. It was thought that if people saw how foolish Mr. Biggott's attitudes were, they would change their own attitudes. Instead, the propaganda served to reinforce the existing prejudice!

Although there have been several studies that tested photographic effects, very few of them have been concerned with news photography. Mehling concluded that a newsphotograph with a cutline was more effective in producing attitudinal change than a newsstory lead with a headline.[22] Kishiyama studied the effect photographs have on how a suspected criminal was perceived. He presented people with a set of pictures

20. Charles E. Osgood and Percy H. Tannenbaum, "The Principle of Congruity and Prediction of Attitude Change," *Psychological Review* (62):42–55.

21. E. Cooper and M. Jahoda, "The Evasion of Propaganda," *Journal of Psychology* (23):15–25.

22. Reuben Mehling, "Attitude Changing Effect of News and Photo Combination," *Journalism Quarterly* (36):189–198.

portraying the "suspect" with varying facial expressions. He found no difference between the various photographs.[23]

People look for, and find, meaning in photographs with which they can identify. Hazard found that readers respond positively to pictures related to their own daily concerns.[24] Spaulding observed that people like pictures that relate to their daily life and to daily events that are personally significant.[25] Schramm and White found that photograph readership increases with education and higher economic status.[26] This is consistent with the identification concept since it has been repeatedly shown that one effect of education, and higher economic status to a somewhat lesser degree, is to expand a person's experiential world. Or to put it another way, educated people are likely to have more subjects with which they can identify. Harrison observed that readers are more likely to accept messages that offer opportunity to identify in sex, age, race, and major social characteristics.[27]

The MacLean-Kao study delved deeply into the matter of identification, particularly with news photographs.[28] In reviewing the MacLean-Hazard study (see note 13), they noted two chief essentials of content: visible forces and intangible forces. The visible forces (close-ups, action, contrast) served to *attract* readers. The intangible forces (interest, drive, and feeling for the picture—such as adventure, ambition, combat, love, romance, anger, hate, etc.) served to *arouse a response* in the reader. MacLean and Kao broke the two elements into four dimensions: Like-Dislike, Intensity-of-Feeling, Ideal Self-Identification, and Actual Self-Identification. They found that Self-Identification, especially Ideal Self-Identification, had a lot to do with liking of pictures. The pictures the readers liked or disliked most were the ones that aroused the strongest feelings.

# Stylistic Elements: What Works?

Although content has been shown to be the primary focus of the reader's attention, other elements are at work as well.

Research has shown that picture size is an important variable in determining readership. Woodburn reported that the *Continuing Study of Newspaper Reading* (see note 2) found that readership increased in direct relationship to an increase in the size of the photograph.[29] For men, readership increased from 37 percent for a one-column photograph to 49 percent for two columns, 62 percent for three columns, and 64 percent for four columns. For women, readership increased from 45 percent for a one-column picture to 61 percent for two columns, 67 percent for three columns, and 73 percent for four columns. Spaulding reported similar findings[30] and Neubert found that cropping decreased comprehension and impact.[31] Particularly high readership has been found for picture pages.[32,33] In the first 100 studies

---

23. David N. Kishiyama, "News, Photographs and Attitude Change" (master's thesis, University of California at Los Angeles, 1973).

24. William R. Hazard, "Responses to News Pictures."

25. Seth Spaulding, "Research on Pictorial Illustration," *Audio-Visual Communication Review* (3):35–45.

26. Wilbur Schramm and David M. White, "Age, Education, Economic Status: Factors in Newspaper Reading," *Journalism Quarterly* (26):149–159.

27. Randall Harrison, "Pictorial Communication."

28. Malcolm S. MacLean, Jr., and Anne Li-An Kao, *Editorial Predictions.*

29. Bert W. Woodburn, "Reader Interest."

30. Seth Spaulding, "Research on Pictorial Illustration."

31. Michael T. Neubert, "The Effects of Selection and Emphasis Upon Reader Responses to News Pictures" (master's thesis, University of Wisconsin, 1966).

32. Seth Spaulding, "Research on Pictorial Illustration."

33. Keith P. Sanders and Won Ho Chang, "What They Read in the *Columbia Missourian.*" Mimeographed. School of Journalism, University of Missouri, 1974.

reported in *The Continuing Study of Newspaper Reading*, full picture pages received a phenomenal 89 percent readership, while other pages averaged about 60 percent. Sanders and Chang found that a picture page was the most read page of the paper.

Greenlee tested to see if color photographs were preferred to black-and-white photographs. He found that a well-liked photograph is a well-liked photograph regardless of whether it is black and white or in color.[34] Spaulding, on the other hand, concluded that color increases readership. The apparent discrepancy may be explained this way: for "good" photographs color makes little difference, but for "poor" photographs color may attract more readers than will black and white.

Culbertson studied photographic iconicity—the resemblance between a pictorial symbol and its referent. He hypothesized that the more precisely the photograph represented its subject—in terms of shape, detail, and magnitude—the greater would be its effect. Although he found no significant differences in degrees of iconicity, he did note some evidence to suggest that iconicity of magnitude may aid comprehension.[35]

Hazard found that shape and concentricity of the organization of the photograph ranked behind subject matter as determinants of interest.[36] Leu concentrated on three aspects of composition: balance, rhythm, and unity. He found a tendency, although not significant, toward "systematic differences in the way compositional elements are used in the judgment of photographs."[37] He also noted that compositional elements become more important to people in judging photographs as their background in art and photography increases. Spaulding made these recommendations about pictorial composition: young children prefer simple drawings, while older children and adults prefer complex illustrations; illustrations should be constructed in keeping with the clockwise motion of eye fixations; the number of items in illustrations should be limited to assure notice of what is most important; the most significant objects and actions should be emphasized by placing them in the center and upper left of illustrations; illustrations require the motion of eyes in horizontal paths rather than in vertical ones.

Lighting angle has been found to be a significant compositional element. Tannenbaum and Fosdick tested four lighting conditions: 45-degree lateral angle, below, flat, and with the light at the camera. The most favorable effect was that caused by the 45-degree angle condition.[38] Contrary to the views of many experts, lighting from below did not lower ratings.

In a later study, Tannenbaum and Fosdick studied how a group of professional news photographers used compositional elements to encode a message in a photograph.[39] They concluded that "certain stylistic elements are used in consistent ways to modify the meaning which a message topic will have for the reader." The photographers used similar techniques in the use of light contrast, number of lights, background tone, and print density. There also was significant agreement on camera angle and image size.

34. Robert D. Greenlee, "The Influence of Subject Matter Areas on Preference for Color vs. Black and White Photographs" (master's thesis, Iowa State University, 1968).

35. Hugh Culbertson, "Basic Research in Visual Communication: Iconicity." Paper presented to the Photojournalism Division, AEJ Convention, Lawrence, Kansas, 1968.

36. William R. Hazard, "Responses to News Pictures."

37. Jon Robert Leu, "The Effects of Photographic Compositional Elements on the Selection of News Pictures by Various Groups of Individuals" (master's thesis, Iowa State University, 1972).

38. Percy H. Tannenbaum and James A. Fosdick, "The Effect of Lighting Angle on Judgment on Photographed Subjects," *Audio-Visual Communication Review* (8):253–262.

39. James A. Fosdick and Percy H. Tannenbaum, "The Encoder's Intent and Use of Stylistic Elements in Photographs," *Journalism Quarterly* (41):175–182.

Photographs with captions or overlines have been found to increase both readership and understanding.[40,41,42,43,44] In two separate studies, Kerrick found that captions can change or modify the meaning of a picture, especially when the picture itself is complicated and/or ambiguous. A caption can make a picture "sad" or "happy," "good" or "bad." Captions that are incongruent with the content of the picture will be ignored and interpretation will be based primarily on the picture alone. Kerrick noted that, although the influence of a caption can usually be anticipated by the writer, captions sometimes produce meanings opposite to those intended.

The combined effect of a picture and a caption is stronger than that of the picture alone or the caption alone. Kerrick observed that the caption tends to lend more evaluative meaning, but the picture tends to lend more potency or strength. This latter finding was reinforced by Mehling, who found that photographs with words were more effective in changing evaluative judgments than were words or pictures alone.[45] Harrison noted that readers prefer full and informative captions to increase comprehension.[46] Misunderstanding is particularly likely to arise when the message is complex, where there is ambiguity, and where the object or event is unfamiliar.

# The Photo Gatekeeper: Where It All Begins

Pictures are "nonverbal messages, encoded by a communicator in much the same manner as are the verbal messages of the poet, the novelist, the newspaper reporter, or the radio news commentator."[47] The choice of a suitable picture to accompany a story can be a crucial decision in the communication process. The person who daily makes this decision—the photography editor—will often have the ability to influence, if not determine, the reactions of his audience to the events described in the story he is illustrating. Since photographs have the potential to create far greater impact than mere words, in a very real sense the photography editor's selections of which photographs to use are more important than the selections a word editor must make. The intentional or subconscious reasons for which he selects pictures for publications can, and likely will, mold the attitudes of his audience.

Despite the many studies that show the power of photographs to increase readership, to enhance effective communication, and to shape the attitudes of readers, the photography editor has frequently been treated as an ill-favored stepchild in the newsroom. Blake, writing as recently as 1965, observed that "many editors think of photographers as 'shutter-trippers'—lacking an appreciation of news value and a knowledge of journalism fundamentals. They have not accepted the photographer as a member of the editorial family. This type of editor complains that photographers don't understand editors' picture needs and seldom produce pictures with sufficient news content."[48] Earlier Walters reported that in most newsrooms photographs were handled as nuisance jobs by city editors, news editors, or managing editors. "These busy men do not make the same study of cropping or reproduction or the news

40. Jean S. Kerrick, "Influence of Captions on Picture Interpretation," *Journalism Quarterly* (32):177–184.

41. Jean S. Kerrick, "News Pictures, Captions and the Point of Resolution," *Journalism Quarterly* (36):183–188.

42. Seth Spaulding, "Research on Pictorial Illustration."

43. Randall Harrison, "Pictorial Communication."

44. Reuben Mehling. "Attitude Changing Effect."

45. Reuben Mehling, "Attitude Changing Effect."

46. Randall Harrison, "Pictorial Communication."

47. Fosdick and Tannenbaum, "The Encoder's Intent and Use."

48. Donald P. Blake, "The Editor vs. the Photographer," *Quill*, December 1965, pp. 18–20.

value of the picture that they make of the written word."[49] The second-class status of photographs was demonstrated in 1952 by Siebert. He found that whenever space was restricted, photographs and other graphic materials were usually the first things cut. On the other hand, when extra space became available, graphic materials were not as quick to expand as were the other, verbal, types of content.[50]

Kalish and Edom and Walters pointedly rejected the idea that photojournalists were lacking in journalistic ability. Walters said, "There should be little distinction in newspaper offices or in courtrooms or any other place between the men who report a story through the photographic lens and those who use the typewriter."[51] And Kalish and Edom said, "It should never be a question of 'pictures versus words' when a decision is reached about the content of the paper; rather it should be 'pictures *and* words.' "[52]

The ideal journalist, Leahigh reasoned, would be one who combined the talents of the newswriter/reporter with the talents of a photojournalist. On the typical American newspaper, of course, a person is either a photographer or a reporter. Leahigh, however, studied a newspaper (the *Daily Pantagraph* of Bloomington-Normal, Illinois) that combined the functions. The paper used a system in which each reporter was equipped with a camera and was expected to take his own pictures. Leahigh asked, "If a newswriter could master a thorough understanding of pictorial reporting and if he could appreciate reader interest problems involving pictorial matter and display, would he not, theoretically, be able to operate as effectively and as efficiently

as a traditional news photographer?"[53] Leahigh compared the *Daily Pantagraph* photographs with those from three comparable newspapers. He found that its photographs were rated slightly higher than two of the traditional system newspapers but considerably lower than those of the *Telegraph Herald* of Dubuque, Iowa. The *Telegraph Herald* has been generally recognized as one of the most photography-conscious newspapers in the Midwest.

Principles of photograph selections have been the focus of several studies. One of the most significant, and earliest, was conducted by Stephenson (see note 14) and is reported elsewhere in this book (chapter 14 and the Appendix). Ganschow found a high level of agreement among professional photographers concerning what is effective composition, as did Tannenbaum and Fosdick.[54,55,56] Wagner found that one group of people with experience in picture selection consistently gave low ratings to obviously posed photographs.[57] Other low-rated photographs were described as trite, staged, or generally lacking in clear expression of any kind of human experience. The editors placed emphasis on spontaneity of the photographs, and ranked high photographs that portrayed either action or social problems of poverty and hunger. The expression of human emotion was a common theme among the highly rated pictures.

The photography editor has a dual function: to determine if a picture should be printed and to decide how it should be played. In selecting a picture, the editor's ability to sense a good picture is important. Equally important is the fact that readers will interpret the

49. Basil L. Walters, "Picture vs. Type Display in Reporting the News," *Journalism Quarterly* (24):193–196.

50. Fredrick S. Siebert, "Trends in the Use of Pictures by Three Newspapers," *Journalism Quarterly* (29): 212–213.

51. Basil L. Walters, "Picture vs. Type Display."

52. Stanley E. Kalish and Clifton C. Edom, *Picture Editing*.

53. Alan Kent Leahigh, "Reporters with Cameras: A Comparison of Newspaper Photography Systems" (master's thesis, University of Missouri, 1971).

54. Cliff Ganschow, "Contribution of Certain Compositional Factors."

55. James A. Fosdick and Percy H. Tannenbaum, "The Encoder's Intent and Use."

56. Percy H. Tannenbaum and James A. Fosdick, "The Effect of Lighting Angle."

57. Barbara Wagner, "Picture Value of Potential Editors," Mimeographed. School of Journalism, University of Missouri, 1973.

picture in the light of their personal feelings and experiences. Successful picture selection consequently combines a feeling for pictures with an understanding of the audience.[58]

The most thorough and systematic study of picture editing to date is that done by MacLean and Kao.[59] In the final phase of their five-phase project, they attempted to determine what kinds of information about the audience would be most useful to picture editors. They selected three kinds of photography editors: "Senior Editors"—professional editors, picture editors, and photographers of publications; "Junior Editors"—students majoring in journalism who knew photography and who had had experience in some sort of picture editing; "Naive Editors"—junior and senior education majors in college who had not had any experience in photography or in picture editing.

"Typical" readers were asked to sort through two sets containing 60 photographs each. The three types of editors were then given differing amounts of information and asked to sort the same photographs as they thought the readers had sorted them. In short, they were taking part in a complicated editing game that involved the prediction of what readers liked and disliked. There were four types of information provided:

1. Minimal Demographic Information: Age, Sex, and Level of Education.
2. Detailed Demographic Information: Age, Sex, Education, Occupation, Position in the Household, Income, Family Members, House Ownership, Type of Dwelling Unit, Newspaper and Magazine subscriptions, Car Ownership, Religion, Politics, Hobbies, Favorite Sports, and Movie Going.
3. Subject Q-sorts: The editors were shown how the subjects actually sorted one of the sets of photographs. The editors were then asked to sort the second set of photographs

as they thought the subject would have sorted them.
4. Subject Q-sorts and Detailed Demographic Information: The editors were given the information described in no. 2 and no. 3 above.

MacLean and Kao hypothesized that the more information the editors were provided, the more accurate they would be in predicting the likes and dislikes of the readers, and to a certain extent that's what they found. The editors' predictive Q-sorts were correlated with the actual sorts of the subjects.[60] The correlations ranged from a low of—.069 to a high of .799. Statistically, a correlation of less than .260 could be obtained by chance alone—merely by assigning photographs to ranks at random, for example. A correlation greater than .260, however, could only very rarely occur by chance, and the higher the correlation, the greater the accuracy in prediction.

As predicted, accuracy of prediction increased according to the amount and kind of information provided to the editors, but the pattern was less than perfect. The Senior Editors did barely better than chance when given Minimal Demographic Information (.270) and Detailed Demographic Information (.260). Accuracy improved considerably for the Senior Editors who had been given the Predictee's Actual Q-sort (.439), and it increased still more when given the Q-sort and Detailed Demographic Information (.554). It is interesting to note that accuracy actually decreased when the Junior and Naive Editors were given the maximum information.

It is clear that providing editors with examples of the types of photographs that people actually like gives the editor the best information he needs to accurately predict reader response. Minimal Demographic Information is not terribly valuable. Surprisingly, highly Detailed Demographic Information did not help

---

58. Gardner Cowles, "Visual Excitement."

59. Malcolm S. MacLean, Jr., and Anne Li-An Kao, *Editorial Predictions.*

60. The Pearson Product Moment Correlation Coefficient, as used in this study, can be considered a measure of agreement. If two people liked exactly the same pictures and disliked exactly the same pictures, their correlation would be + 1.00. If they completely disagreed—the pictures one liked the other disliked and vice versa—their correlation would be − 1.00. If they agreed on some but disagreed on others, their correlation would fall somewhere around 0.00. The correlation, thus, ranges from − 1.00 to + 1.00.

**Table 1**
Correlations Between Editors' Predictive
Sorts and Readers' Actual Sorts

| Picture Editors | Demographic Information | Overall | Male | Female |
|---|---|---|---|---|
| *Senior editors* | 1. Minimal information | .27 | .48 | .07 |
| | 2. Detailed information | .26 | .37 | .16 |
| | 3. Predictee's Q-sort | .44 | .43 | .45 |
| | 4. Q-sort & detailed | | | |
| | information | .55 | .49 | .61 |
| | overall: | .39 | .44 | .32 |
| *Junior editors* | 1. Minimal information | .24 | .25 | .23 |
| | 2. Detailed information | .38 | .41 | .35 |
| | 3. Predictee's Q-sort | .56 | .42 | .70 |
| | 4. Q-sort & detailed | | | |
| | information | .47 | .36 | .58 |
| | overall: | .43 | .36 | .47 |
| *Naive editors* | 1. Minimal information | .31 | .37 | .24 |
| | 2. Detailed information | .23 | .05 | .40 |
| | 3. Predictee's Q-sort | .53 | .43 | .64 |
| | 4. Q-sort & detailed | | | |
| | information | .52 | .50 | .53 |
| | overall: | .42 | .34 | .45 |

much. This suggests that the editors were unable "to figure people out" and to make the deductive leap from one set of data (demographic information) to another set of data (liking of pictures). The concern here must be with the editor's *understanding* of his audience. The editors' inability to grasp what people are like suggests that they do not understand people nearly as well as they should.

Overall, the three types of editors were equally successful (statistically speaking) in predicting reader preference. The fact, however, that the Senior Editors were not more accurate than the others is strong evidence for the need for additional study of audiences by photography editors and would-be photography editors. The Senior Editors, given their experience, would have been expected to have done better than they did, which suggests once again that they may be out of touch with readers. The Senior Editors were surprised at the picture preferences of the readers in this study. Quite clearly they had developed stereotypes about reader preferences, and this study showed that those stereotypes were not very accurate.

Nowhere was this more evident than in the Senior Editors' predictions of women's photographic preferences. Until the Senior Editors were shown the women's actual Q-sorts, they were quite inaccurate in their predictions, correlating only .069 with Minimal Information and .157 with Detailed Demographic Information. On the other hand, they were easily the most accurate at the first two levels of information in predicting men's readership. To their credit, the Senior Editors made the most of the additional data, even to the point that one editor, armed with Detailed Demographic Information and the Q-sort, predicted a woman's preferences at .705. It is interesting to note that the Naive Editors did the best job of predicting women's readership when given only Minimal and Detailed Demographics. This probably can be explained by the fact that these "editors" were, after all, readers and not editors and that they were therefore "close" to understanding fellow readers. Once again, this supports the observation that Senior Editors are out of touch with their readers.

MacLean and Kao concluded that information about the typologies of audience members in terms of their reaction patterns helped editors predict better than the traditional kind of survey research demographic information.

# Where Do We Go From Here?

The research literature on photography as an art form is extensive and rich, but the research literature on photography as a journalistic form is not very extensive. Aside from a few studies, most photojournalism research has constituted a part of some larger research project. Most readership studies look at photographs almost as an afterthought. A recent National Survey of the Content and Readership of the American Newspaper didn't include photographs at all![61]

Despite the pioneering efforts by Stephenson and MacLean, we still know relatively little about how photography editors choose pictures. One approach that might prove valuable would be to study intensively a few photography editors as they perform their selection process, along methodological lines developed by White, Gieber, and Snider in their studies of wire editors.

There is evidence to suggest that photography editors still use a "fly by the seat of their pants" approach to selecting pictures. The relatively poor performances of professional editors in the MacLean-Kao study indicate a continuing need for photography editors to assess the interests of their readers. Local readership studies, therefore, are particularly beneficial. Such studies, however, should concentrate on actual picture preferences instead of on mere demographic data unless the editors are prepared to make more of such data than they have in studies thus far conducted.

Since the first edition of this book, two areas of interest have developed to the point where they legitimately can be called trends. Each promises a bright future for photojournalism. These trends are: an increased awareness of the sociological impact of pictures and the application of "life style" research to mass media, particularly newspapers.

Widespread interest in self-identity, fulfillment and, more generally, with the roles people play in society began in the mid-1960s and has increased ever since. The spotlight has focused on the status of women and minority groups. The primary issue, however, is to be found in the roles different people are *expected* to perform. The first line of research sought to define roles, or stereotypical activities. Research then sought to determine what caused the formation of the stereotypes. One prevailing theory suggests that we form our role expectations largely on the basis of what we see in the mass media. Wald argued, "Pictures reflect and define the values society gave to women and the roles into which they were cast."[62] Miller found that photographs of men outnumbered those of women three-to-one in one major newspaper and two-to-one in another.[63] Trayes and Cook found that 91.6 percent of front page photographs in 16 metropolitan dailies contained people. Two-thirds of the photographs pictured men only. Only 11.2 percent showed men *and* women. Only 3.4 percent of the photographs showed blacks and whites together. Eighty-one percent were of whites only.[64] The attention to role portrayal likely will intensify, giving the photojournalist an even greater opportunity, and responsibility, to portray life as it is.

The quite recent application of life style research to newspapers is a major advancement in audience analysis.

The problem with the typical readership study is that it groups people together on the basis of some demographic variable—or a combination of demographic variables. The simple fact remains, however, that all too frequently demographic variables are poor indicators of picture interest. One thirty-year-old college-educated woman

61. Newspaper Advertising Bureau, Inc. "A National Survey of the Content and Readership of the American Newspaper" (New York: 1972).

62. Carol Wald. *Myth America: Picturing Women, 1865–1945.* New York: Pantheon, 1975.

63. Susan H. Miller, "The Content of News Photos: Women's and Men's Roles," *Journalism Quarterly* (52):70–75.

64. Edward J. Trayes and Bruce L. Cook, "Picture Emphasis in Final Editions of 16 Dailies," *Journalism Quarterly* (54):595–598.

with a high income may very well read quite different photographs than another thirty-year-old college woman with a high income. The concern in finding reader preferences, thus, should be with grouping people together on the basis of their preferences, not on the basis of their demographics.

Successful communicators know that the most important consideration in communication is to "Know Thy Audience." People are unique. Fortunately, people have similar patterns of preference that make it possible for us to deal with both their uniqueness and their similarity. What is needed is a system for identifying major patterns of preferences. If that can be done, we can vastly simplify, and at the same time vastly improve, the editing process. MacLean stated the advantage: "Instead of trying to deal with some amorphous man-in-the-street, or at the other extreme, with five million different individuals, we can develop strategies for aiming communication differentially to perhaps five or six different types of persons, types which pretty well cover the five million individuals."[65]

Life style research represents one method of segmenting the audience on the basis of interests, activities, and opinions. Market researchers began using life style research in the early 1960s but it wasn't until the last couple of years that it was applied by the mass media. The end result is to "tailormake" a newspaper for the various segments of the audience. This is more than just the old "a little bit of something for everyone" editing philosophy; quite literally it means that each audience segment would receive a different edition of the daily newspaper. *The Louisville Courier-Journal* already has demonstrated its ability to package and home deliver such tailormade newspapers. *The New York Times* likewise is into life style research in a major way.

Like most audience research, life-style investigations need to be conducted on individual publications. Some sweeping generalizations are beginning to emerge, however.[66] Life styles vary considerably from individual to individual and demographic group to group. We are beginning to see, for example, that the main competition for newspapers comes not from other mass media but from other activities open to people. As the amount of leisure time increases, it can be expected that the competition will become more intense.

Researchers have found that the life styles for people aged 21–34 differ markedly from those of older adults.[67] The 21–34 group represents the first generation of adults to grow up with television. Partly because of television, these young adults are considerably more visually oriented. Compared to the older group, they are much more interested in taking photographs and in wanting to see more photographs in the newspaper. They also are more concerned about personal matters, such as how-to-do-it tips. *The Miami News* has revamped its paper to accommodate such changing life styles. By putting more emphasis on news briefs, features, photographs and graphics, the *News* claims to be the newspaper for people who watch television.[68]

MacLean and Kao described another method for segmenting audiences on the basis of psychographics. They suggested a combination of Q-methodology with Talbott's Q-block approach.[69] Briefly, the system consists of showing a relatively small sample of people, say twenty-five to thirty, a selection of photographs and asking them to rank them on a Most-Liked to Least-Liked basis. The Q-sorts would then be factor analyzed, probably producing about three or four factors, or types of people. After weighing the rankings according to the factor loadings, the photographs would be ranked (by standard scores) for each

65. Malcolm S. MacLean, Jr., "Some Multivariate Designs for Communications Research," *Journalism Quarterly* (42):614–622.

66. Barbara E. Bryant, Frederick P. Currier and Andrew J. Morrison, "Relating Life Style Factors of Person to His Choice of a Newspaper," *Journalism Quarterly* (53):74–79.

67. Ernest F. Larkin, Gerald L. Grotta, and Phillip Stout, "The 21–34 Year Old Market and The Daily Newspaper," ANPA News Research Report. No. 1, April 8, 1977.

68. John Consoli, "Cox Makes Miami News into a Feature Newspaper," *Editor & Publisher*, April 23, 1977, p. 42–43.

69. A.D. Talbott, "The Q-block Method of Indexing Q Typologies." Paper presented to the Theory and Methodology Division, AEJ Convention, Lincoln, Nebraska, 1963.

type. The photographs that were ranked particularly high or low would in essence "define" the type. Using only those photographs, a much larger sample would be contacted. Those people would be asked simply which photographs they liked. People would be assigned to types on the basis of how many times they picked photographs that a particular type had earlier selected. The advantage of such a system is two-fold: first, it enables one to identify what percentage of the readers "belong to" what picture preference type, and, second, the assigning of people to types is fast, efficient, and easy to do. In the likely event that the photography editor does not have access to either someone familiar with factor analysis or a computer program to actually do the analysis, the same result can be achieved more simply, although perhaps with less precision. The procedure would be something like this: Have a small number of people go through a relatively large set of photographs (say, 60) and rank them on a 7-, 9-, or 11-point scale or Most Like to Least Like. Correlation coefficients, which are quite easy to compute, would be calculated between each pair of people. Still simpler would be to note the number of times two people agreed on

the rating of photographs. In short, any system that would group people together on the basis of their similarities in picture preferences will suffice. Finally, take those photographs that were ranked particularly high or particularly low and conduct a survey.

We have a long way to go to develop a better understanding of why people like photographs. For example, it seems particularly strange that so little attention has been given to the importance of stylistic elements in news photographs. Once again we find a considerable amount of such research in the photography-as-an-art-form research literature, but little in the photojournalism literature.

A follow-up study on the massive MacLean-Kao study seems much in order. The study is rich with theoretical implications very much in need of testing. Why is it, for example, that the Naive Editors performed so well, compared to the Senior Editors? One also wonders how well the editors would have been able to predict if they had been given *no* information. After all, it is exactly that situation—no information about the audience—that the typical photography editor has to confront all too frequently.

# Bibliography

Advertising Research Foundation. *The Continuing Study of Newspaper Reading.* New York: started in 1939.

Arnheim, Rudolf. *Art and Visual Perception.* Los Angeles: University of California Press, 1966.

Arnold, George, "Theoretical Views of the Photography Editor as Gatekeeper." Master's thesis, University of Missouri, 1974.

Arpan, Floyd G. ed. "Photo-Journalism." *Journalism Quarterly* 24: 193–249.

Baker, E.L., and Popham W.J. "Value of Pictorial Embellishments in a Slide-Tape Instructional Program." *Audio-Visual Communication Review* 13:397–404.

Baker, Stephen, *Visual Persuasion.* New York: McGraw-Hill Book Co., 1961.

Ball, John, and Byrnes, Frances C. eds. *"Research, Principles, and Practices in Visual Communication."* East Lansing, Michigan, National Project in Agricultural Communications, 1960. (Washington, D.C.: Department of Audio-visual Instruction, NEA, 1964.)

Barnett, Norman L. "Beyond Market Segmentation," *Harvard Business Review.* January-February, 1969.

Bartley, S.H., and Adair, H.J. "Comparisons of Phenomenal Distance in Photos of Various Sizes." *Journal of Psychology* 47:699–704.

Berlo, D.K.; Lemert, J.B.; and Mertz, R.J. "Evaluations of the Message Source: A Basis for Predicting Communication Effects." Research Monograph, Department of Communication, Michigan State University, East Lansing, Michigan, 1966.

Blake, Donald P. "The Editor vs. The Photographer." *Quill,* December 1965, pp. 18–20.

Bourisseau, W.; Davis, O.; and Yamamoto, K. "Sense-Impression Responses to Differing Pictorial and Verbal Stimuli." *Audio-Visual Communication Review* 13:249–258.

Brown, Roger. *Words and Things.* Glencoe, Ill.: The Free Press, 1959.

Bryant, Barbara E.; Currier, Frederick, P.; and Morrison, Andrew J. "Relating Life Style Factors of Person to His Choice of Newspaper. *Journalism Quarterly* 53:74–79.

Bush, George S. "Survey Shows New Needs for Photo-Journalism." *Journalism Quarterly* 38:216–217.

———. "Technique vs. Meaning in Photo-Journalism." *Journalism Quarterly* 37:97–101.

Butts, G.K. "An Experiential Study of the Effectiveness of Declarative, Interrogative, and Imperative Captions on Still Pictures." Ph.D. dissertation, University of Indiana, 1956.

Carlson, V.D. "The Resolution of Photographic and Labelling Factors in Affective Impressions." Ph.D. dissertation, Vanderbilt University, 1963.

Consoli, John. "Cox Makes Miami News Into a Feature Newspaper." *Editor & Publisher,* April 23, 1977.

Cook, J.J. "Indices of the Meaning of Photographs in Relation to Concomitant Physiological Activity." *The Psychiatric Institute Bulletin* 2:4.

Cooper, E., and Jahoda, M. "The Evasion of Propaganda." *Journal of Psychology* 23:15–25.

Cooperman, Gary. "A Historical Study of *Look* Magazine and Its Concept of Photo-journalism." Master's thesis, University of Misouri, 1966.

Cowles, Gardner. "Visual Excitement in Modern Publishing," In *Art Directing.* New York: Hasting House, Publishers, 1957.

Culbertson, Hugh. "Basic Research in Visual Communication: Iconicity." Paper presented to the Photojournalism Division, AEJ Convention, Lawrence, Kansas, 1968.

———. "Words vs. Pictures: A Comparison as to Perceived Impact and Connotative Meaning." Paper presented to the Graphics Division, AEJ Convention, Carbondale, Illinois, 1972.

Culbertson, Hugh, and Powers, Richard. "A Study of Graphic Comprehension Difficulties." *Audio-Visual Communication Review* 7:97–110.

Davies, Edward J. "The Effects of Photographic Compositional Elements on the Selection of News Photographs and Abstractions of Photographs by Artists, Photographers, and Non-Professionals." Master's thesis, Iowa State University, 1969.

Dickinson, John A. "A Q-Sort Analysis of Men and Women's Reading Interest in Pictures." Master's thesis, Louisiana State University, 1972.

Edom, Clifton C. "Photo-Propaganda: The History of Its Development." *Journalism Quarterly* 24:221–226.

Fosdick, James A. "Stylistic Correlates of Prescribed Intent in a Photographic Encoding Task." Ph.D. dissertation, University of Wisconsin, 1962.

Fosdick, James A., and Tannenbaum, Percy H. "The Encoder's Intent and Use of Stylistic Elements in Photographs." *Journalism Quarterly* 41:175–182.

Ganschow, Cliff. "Contribution of Certain Compositional Factors to Photographs' Effectiveness." Mimeographed. Department of Technical Journalism, Iowa State University.

Gervin, Robert E. "Photography as a Social Documentation." *Journalism Quarterly* 24:207–220.

Gibson, L. "A Theory of Pictorial Communication." *Audio-Visual Communication Review* 2:3–23.

Graham, M.D. "The Effectiveness of Photographs as a Projective Device in an International Attitudes Survey." *Journal of Social Psychology* 40:93–120.

Greenlee, Robert D. "The Influence of Subject Matter Areas on Preference for Color vs. Black and White Photographs." Master's thesis, Iowa State University, 1968.

Gropper, M. "Why Is a Picture Worth a Thousand Words?" *Audio-Visual Communication Review* 11:75–95.

Hall, Edward T. *The Silent Language.* New York: Doubleday & Co., Inc., 1959.

Harrison, Randall P. "Pictic Analysis: Toward a Vocabulary and Syntax for the Pictorial Code, with Research on Facial Communication." Ph.D. dissertation, Michigan State University, 1965.

Harrison, Randall, "Pictorial Communication," *Search*, vol. 6, National Project in Agricultural Communication. East Lansing, Michigan, 1962.

Hazard, William R. "Responses to News Pictures: A Study in Perceptual Unity." *Journalism Quarterly* 37:515–524.

Hicks, Wilson. *Words and Pictures.* New York: Harper and Brothers, 1952.

Hochberg, J. "The Psychophysics of Pictorial Perception," *Audio-Visual Communication Review* 10:22–54.

Kahan, Robert S. "Magazine Photography Begins: An Editorial Negative." *Journalism Quarterly* 42:53–59.

Kalish, Stanley E., and Edom, Clifton C. *Picture Editing.* New York: Rinehart & Co., Inc., 1951.

Kelly, Wayne. "Effectiveness of News Photographs in Attitude Formation." Master's thesis, University of California, 1963.

Kepes, Gyorgy, *Language of Vision,* Chicago: Paul Theobald & Co., 1959.

Kerrick, Jean S. "Influence of Captions on Picture Interpretation." *Journalism Quarterly* 32:177–184.

———. "News Pictures, Captions and the Point of Resolution." *Journalism Quarterly* 36:183–188.

Kessen, W. "The Role of Experience in Judging Children's Photographs." *Journal of Abnormal and Social Psychology* 54:375–379.

Kishiyama, David N. "News, Photographs and Attitude Change." Master's thesis, University of California at Los Angeles, 1973.

Kline, F. Gerald. "Media Time Budgeting as a Function of Demographics and Life Style." *Journalism Quarterly,* 48:211–21.

Korn, Jerry, *et al. Photojournalism.* New York: Time-Life Books, 1971.

Larkin, Ernest P.; Grotta, Gerald L.; and Stout, Phillip. "The 21–34 Year Old Market and The Daily Newspaper." ANPA Research Report No. 1, April 8, 1977.

Leahigh, Alan Kent. "Reporters with Cameras: A Comparison of Newspaper Photography Systems." Master's thesis, University of Missouri, 1971.

Leu, Jon Robert. "The Effects of Photographic Compositional Elements on the Selection of News Pictures by Various Groups of Individuals." Master's thesis, Iowa State University, 1972.

Leuba, C., and Lucas, C. "The Effects of Attitudes on Description of Pictures." *Journal of Experimental Psychology* 3:517–523.

Lippmann, Walter. *Public Opinion.* New York: Macmillan Co., 1922.

Logie, M. "Photojournalism." *Gazette* 3:109–128.

MacLean, Malcolm S., Jr. "Communication Strategy, Editing Games and Q." In Brown, Steven R., and Brenner, Donald J., eds. *Science, Psychology and Communication.* New York: Teachers College Press, 1972.

———. "Some Multivariate Designs for Communications Research." *Journalism Quarterly* 42:614–622.

MacLean, Malcolm S., Jr., and Hazard, William R. "Women's Interest in Pictures: The Badger Village Study." *Journalism Quarterly* 30:139–162.

MacLean, Malcolm S., Jr., and Kao, Anne Li-An, *Editorial Predictions of Magazine Picture Appeals.* Iowa City, Iowa: School of Journalism, University of Iowa, 1965.

―――. "Picture Selection: An Editorial Game." *Journalism Quarterly* 40:230–232.

Mare, Eric de. *Photography.* Fourth ed. Baltimore: Penguin Books, Inc., 1968.

Marphetia, Toranj A. "Image Creating Potential of Photo Journalism." Master's thesis, Marquette University, 1973.

Mauro, John B. and Weaver, David H. "Patterns of Newspaper Readership." ANPA News Research Report No. 4, July 22, 1977.

McLeod, Jack M. and Choe, Sun Yuel. "An Analysis of Five Factors Affecting Newspaper Circulation." ANPA News Research Report No. 10, March 14, 1978.

Mehling, Reuben. "Attitude Changing Effect of News and Photo Combination." *Journalism Quarterly* 36:189–198.

Mich, Daniel D. "The Rise of Photo-Journalism in the United States." *Journalism Quarterly* 24:202–206.

Miller, Susan H. "The Content of News Photos: Women's and Men's Roles." *Journalism Quarterly,* 52:70–75.

Nafziger, Ralph O.; MacLean, Malcolm S., Jr.; and Engstrom, Warren. "Useful Tools for Interpreting Newspaper Readership Data." *Journalism Quarterly* 28:441–456.

Neubert, Michael T. "The Effects of Selection and Emphasis Upon Reader Responses to News Pictures." Master's thesis, University of Wisconsin, 1966.

Newspaper Advertising Bureau, Inc. "A National Survey of the Content and Readership of the American Newspaper." New York, 1972.

Osgood, Charles E., and Tannenbaum, Percy H. "The Principle of Congruity and Prediction of Attitude Change." *Psychological Review* 62:42–55.

Otto, W. "The Differential Effects of Verbal and Pictorial Stimuli Upon Responses Evoked." *Journal of Verbal Learning and Verbal Behavior* 1:192–196.

Rhode, Robert B., and McCall, Floyd H. *Press Photography.* New York: Macmillan Co., 1961.

Sanders, Keith P. "A Q Study of Editors' Attitudes Toward Journalism Research." *Journalism Quarterly* 49:519–531.

Sanders, Keith P., and Chang, Won Ho. "What They Read in the *Columbia Missourian.*" Mimeographed. School of Journalism, University of Missouri, 1974.

Sanders, Keith P., and Pritchett, Michael. "How Appearance Influences Television Newscaster Appeal." *Journal of Broadcasting"* 15:293–301.

Schramm, Wilbur. "The Nature of News." *Journalism Quarterly* 26:259–269.

Schramm,. Wilbur, and White, David M. "Age, Education, Economic Status: Factors in Newspaper Reading." *Journalism Quarterly* 26:149–159.

Schweitzer, John C. "Life Style and Readership." ANPA News Research Report No. 8, Dec. 2, 1977.

Scodel, A., and Austrin, H. "The Perception of Jewish Photographs by Non-Jews and Jews." Journal of *Abnormal and Social Psychology* 54:278–280.

Severin, Werner J. "Cameras with a Purpose." *Journalism Quarterly* 41:191–200.

―――. "The Effectiveness of Relevant Pictures in Multiple-Channel Communications." *Audio-Visual Communication Review* 15:386–401.

―――. "Pictures as Relevant Cues in Multi-Channel Communication." *Journalism Quarterly* 44:17–22.

Sidey, Hugh, and Fox, Rodney. *1000 Ideas for Better News Pictures.* Ames, Iowa: Iowa State University Press, 1956.

Siebert, Fredrick S. "Trends in the Use of Pictures by Three Newspapers." *Journalism Quarterly* 29:212–213.

Spaulding, Seth. "Research on Pictorial Illustration."*Audio-Visual Communication Review* 3:35–45.

Spencer, Otha C. "Twenty Years of *Life:* A Study of Time, Inc.'s Picture Magazine and Its Contribution to Photojournalism." Ph.D. dissertation, University of Missouri, 1958.

Stephenson, William. *The Play Theory of Mass Communication*. Chicago: University of Chicago Press, 1967.

———. "Principles of Selection of News Pictures." *Journalism Quarterly* 37:61-68.

———. *The Study of Behavior: Q Technique and Its Methodology*. Chicago: University of Chicago Press, 1953.

Swanson, Charles, "What They Read in 130 Daily Newspapers." *Journalism Quarterly* 32:411-421.

Swink, Eleanor Sue. "Effects of Priming, Incubation and Creative Aptitude on Journalistic Performance." Master's thesis, University of Missouri, 1966.

Talbott, A.D. "The Q-block Method of Indexing Q Typologies." Paper presented to the Theory and Methodology Division, AEJ Convention, Lincoln, Nebraska, 1963.

Tannenbaum, Percy H., and Fosdick, James A. "The Effect of Lighting Angle on Judgment on Photographed Subjects." *Audio-Visual Communication Review* 8:253-262.

Tipton, Leonard. "ANPA Newspaper Readership Studies." ANPA News Research Report No. 13, July 12, 1978.

Trayes, Edward J., and Cook, Bruce L. "Picture Emphasis in Final Editions of 16 Dailies." *Journalism Quarterly*, 54:595-598.

Wagner, Barbara. "Picture Value of Potential Editors." Mimeographed. Paper, School of Journalism, University of Missouri, 1973.

Wald, Carol. *Myth America: Picturing Women, 1865-1945*. New York: Pantheon, 1975.

Walters, Basil L. "Picture vs. Type Display in Reporting the News." *Journalism Quarterly* 24:193-196.

Wells, William D. "Life Style and Pschographics: Definitions, Uses and Problems." In Wells, William D. (ed) *Life Style and Psychographics*. Chicago: American Marketing Association, 1974.

Wendt, P.R. "The Language of Pictures."*Etc.* 13:281-288.

Wilcox, Walter. "The Staged News Photograph and Professional Ethics." *Journalism Quarterly* 38:497-504.

Willem, Jack M. "Reader Interest in News Pictures." In Morgan, Willard D., and Lester, Henry M., eds. *Graphic Graflex Photography*. New York: Morgan & Lester, 1946.

Wolseley, Roland E. "Photo-Journalism: An Annotated Bibliography." *Journalism Quarterly* 24:243-249.

Woodburn, Bert W. "Reader Interest in Newspaper Pictures." *Journalism Quarterly* 24:197-201.

Wrolstad, Merald E. "Adult Preferences in Typography: Exploring the Function of Design." *Journalism Quarterly* 37:211-223.

# Student Participation

Research has shown that the best communicators are those who know and understand their audiences. A corollary is that all too frequently we make mistaken assumptions about our readers. The following exercise will help you better understand your readers and your photographs. Approach the exercise with an open mind and be prepared for some surprises.

First, collect a set of six photographs. You can clip them from magazines or newspapers, or you can use photographs you have taken yourself. Get at least two photographs that you think are very good and at least two photographs that you think are very bad. Try to vary the content somewhat (don't make them all portraits, all pictures of children, or all of animals, for example). For ease in handling, mount the pictures on cardboard.

Select a couple of people you know well (friends, roommates, spouse). The advantage of starting with someone you know is that you can practice your interviewing "technique" on them. Armed with your photographs, interview each person individually. Start by asking them to choose the photograph they liked the most and the one they liked the least. Ask them what it is about the photographs that they liked or disliked. What do they "see" in the photos? What makes them interested in a particular picture? Do they normally pay much attention to photographs in newspapers and magazines? Did they like the same photographs you liked? For the same reasons? The object of this questioning is to get them talking about photographs in general. Your selection of photographs should help considerably.

Friends and associates, of course, are apt to be very much like you, with the same interests and experiences—indeed, that is probably why they are friends. So, after you have talked to a couple of friends, deliberately seek out a couple of people who are quite different from you (in terms of factors such as age, sex, education, social status, and the like). Go through the same procedure with them.

You likely will find that some of your assumptions about people were incorrect, but you also will be pleased to find that many of your assumptions were right on target. At any rate, you should now have a much better basis for communicating effectively through photographs.

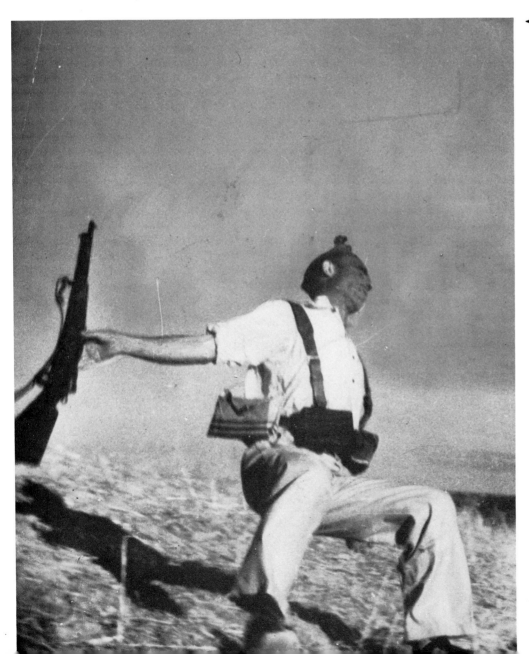

◀**Spanish Soldier Dies** by Robert Capa for *Life*-Magnum. Unique in war coverage, this is one of the most dramatic exact-moment pictures of all time. The camera clicked just as a Loyalist soldier was shot through the head by a Falangist machine gunner. The incident took place in 1936 near Cordoba, Spain. Included in the 50 Memorable Pictures exhibit.

# 17

# A Matter of Ethics

The poet has said, "It takes a heap of living to make a home. . . ."

Philosophically speaking, he could also have said, it has taken a long time to bring photography from its crude beginnings to the sophistication of the present day. "The two aspects of photography, chemical and optical," Peter Pollack has said[1] "had a thousand year history before the fertile minds of men in the early nineteenth century completed its evolution."

But much of photography's evolution—a part which Pollack did not touch upon in the foregoing statement, took place far beyond the perimeter of technical things. How about the evolution in taste, and in ethics?

Since the days of Oscar Rejlander, and Henry Peach Robinson in the 1850s, there has been a continual argument as to whether or not photography is art. Echoing the sentimentality of the Victorian age, both resorted to "composite prints" to produce allegorical pictures. In 1856, using thirty different negatives, Rejlander produced his famous picture "Two Paths of Life." Thirty-one by sixteen inches in size, this photograph contrasted the lives of two young men. The life of the first was serene, philosophical and religious; while the other was a pleasure seeker and a gambler. Ultimately, the "sinner" committed suicide. Two years after Rejlander's masterpiece, Henry Peach Robinson, with five negatives struck a blow for "art photography" and for combination printing. His "composite" photograph titled "Fading Away" portrayed a dying girl with her grieving sister and parents. Both composite pictures were criticized by a minority group for "misrepresenting the truth."

Robinson, and Rejlander nevertheless became famous in their day and the latter, England's leading pictorial photographer in the 1860s, sold many of his composite photographs to the Royal family.

But times do change. The morality of ten or fifteen or a hundred years ago is not necessarily the morality of today. The combination pictures—specifically the art photographs of Rejlander and Robinson were accepted by many in the 1850s. But in the days of Yellow Journalism, the "composographs" were never accepted by newspaper or magazine readers. . . .

To test exposure and film for movie producers, Oskar Barnack of Germany designed the Leica camera in 1913. It, and the horde of miniature cameras

**The chemistry and optics of photography have had a thousand years of history.**

1. Peter Pollack, The Picture History of Photography From the Earliest Beginnings to the Present Day. (Henry N. Abrams, Inc., Publishers, New York, First Edition, 1958.)

which followed ushered in the age of the so-called "candid camera." The faster lenses, faster shutter speeds and faster film, permitted the taking of pictures previously impossible. But—once again photographers had to learn how to use the newly improved tools.

The dignity exemplified in Germany by Erich Salomon and his type of candid documentary pictures was lost in this country when news photographers in the early 1930s began using the "minnies." It was a popular thing, then, to capture important people in awkward, embarrassing poses. For example, to catch President Franklin Delano Roosevelt licking his fingers while eating a hot dog or even in a more compromising gesture, completely out of context with the story, was considered good news photography.

While much of the early candid photography did little to dignify the profession, some serious photographers like Arthur L. Witman of the *St. Louis Post-Dispatch* used judgment and fair play in making pictures with the 35 mm camera.

At a time when the 4 × 5 (with flash on camera) was standard equipment, Witman and a few other newspaper photographers proved the worth of the miniature camera. They showed their editors that a miniature "body" with interchangeable 35, 50, and 90 mm lenses could cover almost any assignment. More importantly, the informal miniature cameras made for greater believability and greater fidelity in pictures than the larger cameras permitted.

Over and beyond equipment changes news photography through the years has had considerable trouble growing up. There was, for instance, the period during and following the Spanish-American war which historians refer to as "the age of Yellow Journalism." The distinguishing technique of newspaper publishing, at that time, according to the late Frank Luther Mott was "the lavish use of pictures, many without significance." This practice, according to Dr. Mott, "invited the abuses of picture-stealing and faking pictures."[2]

But even this period did not mark the greatest degradation in photojournalism history. "The bottom really dropped out," Mott reported, "during the 'War of the tabs' in the mid-1920s." It was during this period that Bernarr Macfadden and his editor, Emile Gauvreau started a new tabloid, the *New York Daily Graphic* (not to be confused with *The Daily Graphic*, which printed the first halftone March 4, 1880). Macfadden and many of his competitors used the confession-story technique and composographs. The latter illustrations were made by combination and faked photography. They featured sensational news such as the Hall-Mills murder case, the Ruth Snyder electrocution[3] and the Daddy Browning and Peaches story. Describing the messy journalism practiced by some publications at that time, Mott wrote that "the older Yellow Journalism seemed pale by the side of the saffron of the new tabs."

Thankfully, this gutter journalism was short-lived. Technical and philosophical advances resulted in a change for the better in the early 1930s. Then, abandoning much of their cuteness and irresponsibility, even the tabloid newspapers showed signs of growing up.

In today's code of ethics for the National Press Photographers Association, we read:

It is our duty to encourage and assist all members of our profession individually and collectively so that the quality of press photography may constantly be raised to higher standards.

And today, the code of ethics of the Society of Professional Journalists (Sigma Delta Chi), informs us that:

Newspaper headlines should be fully warranted by the contents of the articles they accompany. Photographs and telecasts should give an accurate picture of an event and not highlight a minor incident out of context.

Today, too, members of Kappa Alpha Mu, Collegiate Honorary Photojournalism Society, pledge that they

"Shall never knowingly submit a dishonest picture for publication, nor a picture of any kind which betrays the highest of journalistic ethics."

There was . . . the period during and following the Spanish-American war which historians refer to as "the age of Yellow Journalism." The distinguishing technique of newspaper publishing at that time . . . was "the lavish use of pictures, . . . this practice invited the abuses of picture-stealing and faking pictures."

---

2. Frank Luther Mott, American Journalism—A History of Newspapers.

3. See Page 155

In spite of all of these "codes of ethics" there still are many shortcomings in journalism and photojournalism. Too many times dishonest pictures—pictures which give the wrong slant on things, are used. Often a picture is given an untrue meaning through cropping, or even the selection of the camera angle in which the picture is taken.

Realizing there is yet much to be done, and believing that photojournalists have a serious concern for their profession, we conclude this chapter with the words of a philosopher-ethicist, John C. Merrill. Although you may not agree with everything he says, you owe it to Dr. Merrill and to yourself to read and carefully weigh his words.

# A Sound Ethics for Photojournalism

*Dr. John C. Merrill*

It seems as if the whole field of journalism has just recognized the importance of being ethical—or trying to be—and is presently astir with flurries of conferences, workshops, and lectures on the subject. One trouble with ethics conferences—and with essays on ethics, for that matter—is that everybody thinks he is an authority. Very few persons who hold forth loud and long on ethics have made any systematic study of philosophy, even to the degree of studying the history of ethical thought; but they have their opinions and feel no reluctance in rhetorically transforming these opinions into moral "gospel."

At the risk of doing exactly the same thing myself, I will hazard a few observations and opinions on ethics in photojournalism. Certainly these remarks are made with the realization that a discussion of ethics is like trudging through a marsh without a compass under hurricane conditions. But here goes:

A photojournalist would be wise, in trying to find a reasonable ethical ground upon which to stand, to consider combining deontology and teleology. He would start with basic principles or maxims to which he could reasonably pay allegiance, to which he feels he has a kind of duty to follow. Some such maxims might be:

• Never "stage" a picture and pass it off as a "real" or "candid" shot.
• Never purposely distort a picture so as to achieve a predetermined end—e.g., to present a negative image of a politician you don't like.

• Never achieve a distorted impression and thereby mislead the viewer of the picture through selecting only a "slice" of the reality to shoot—or through cropping out aspects of a picture in order to create a pseudo-view of what really happened.
• Never purposely ignore a picture which, if taken and used, might go against the policy of your newspaper or magazine.

In other words, the photojournalist starts with *deontology*—a basic dedication to certain ethical principles or maxims. He feels a "duty" to conform to them; they are, to a real degree, com-

◄ John C. Merrill, *left*, has worked as a reporter, feature writer, editorial writer, and wire editor, and has also done college public relations work. He has taught English and Journalism in colleges and universities in six states and several foreign countries. The author or editor of nine books, Dr. Merrill was on the faculty of the School of Journalism, University of Missouri from 1964 to 1979. He is now a distinguished professor at the University of Maryland. His main teaching areas are mass media and society, international communication, and the philosophy of journalism. In 1976 he received an M.A. in philosophy from the University of Missouri, fourteen years after receiving a Ph.D. in mass communication from the University of Iowa.

mandments which he feels are basic to his total ethical stance. Such a deontological foundation—giving allegiance to certain ethical principles—should be very important to the photojournalist for it not only provides stability for his own professional ethical life but it also gives others some yardstick for predicting what he will do as a photojournalist.

But more should be said. The wise and concerned ethicist in photojournalism should not stop here; he should not consider such maxims as general rules which absolutely must not be broken; he should not look upon them as guides which should, in every conceivable case, be followed blindly. The photojournalist must show a willingness—quite in line with intelligence and basic moral sensitivity—to deviate from such principles when he feels he *should*—when reason dictates another course, when projected or anticipated consequences tend to warrant the desertion of these basic ethical maxims.

The important point is this: The photojournalist should not abandon *the idea* of basic principles or maxims of conduct; he should not forsake overriding guidelines for ethical action. He must retain a body of codes or maxims to which he is basically (generally) dedicated. He must feel a kind of duty to uphold them and to respect them as normal guides for his actions. They are what gives his ethics a sense of meaningfulness and considerable predictability. Having an allegiance to such maxims gives him some concept of loyalty to principle which most people need in order to consider ethics seriously as a guide to right conduct.

But having said this, it is important to stress that the photojournalist must not blindly and unthinkingly follow these basic ethical maxims. The journalist must think about particular ethical situations—in short, he must consider some modification of these principles when his ethically conscious intellect deems such modification imperative. He must be flexible, in other words—but always with a flexibility motivated by *ethical* considerations. He must be willing to modify or moderate a basic ethical tenet *in order to reach a higher ethical objective*, dictated by a reasoned analysis of the ethical situation. But it is important to stress that he should never capriciously break a rule or maxim to which

he has dedicated himself. An "exception" must be made only after serious thought.

It is therefore absolutely incumbent on the photojournalist who reasons, who thinks, to bring anticipated or likely *consequences* into his analysis. When he does this, he begins shifting to a teleological orientation. To think ethically, he comes to realize, is to be concerned with consequences as well as with general ethical maxims. Teleological determination of ethical action seems essential to the photojournalist concerned with ethical decision-making; so he recognizes that it is sound for him to graft teleology onto his basic sense of duty to certain principles; in short, he merges teleology with deontology.

This merger of deontology and teleology is really not so strange. In fact, it seems to me that even a strict deontologist (dedicated to duty to a maxim and oblivious to consequences) is one who *originally*, at least, formulated his duty-maxim through considering in some way the consequences which would accrue either to himself or to others from accepting his maxim or basic principle as ethically valid. Therefore, it might be said with considerable justification that even the deontologist in ethics is fundamentally a teleologist—at least he is if he bases his duty-to-a-maxim on reason.

A word of caution should be injected here for those photojournalists tempted to stray too far over into the fields of teleology, thinking too much about consequences; this opens up the possibility of becoming simply a *majoritarian* thinker, and making decisions on the basis of numbers alone. For example, accepting as a guide the utilitarian (a variety of teleological ethics) principle of the Greatest Happiness or Greatest Good to the Greatest Number is questionable in journalism because acting on this principle can be tantamount to ignoring the desires, feelings or fate of the minorities. It would lead, no doubt, to a lowering of the general level of journalism growing out of an effort to please a larger and larger segment of the population.

So the photojournalist *must* consider as his ethical guide something other than utilitarianism or some other teleological variant such as ethical egoism.

And this "something other," of course, would include a deontological loyalty to some ethical principles that stand above and beyond a concern for consequences.

In addition, it should be stressed, as Immanuel Kant never tired of stressing, that *simply* thinking of consequences before making an ethical decision is likely to lead to a kind of expedient action; and, as Kant said, expedience motivation is a kind of "nonethica." Or said another way, seeking certain consequences from an action may well wash away any real ethical meaning in the action. This means that deontology is a very deep-seated consideration in any kind of journalistic ethics; when we talk of a "principled news photographer" or of a photographer as a "person of principle," we are implying a strong dedication to deontology. This position stresses that the journalist should accept the duty to do what is right *always*—even when he does not really feel inclined to do it.

Acting out of duty to principle does, in fact, have a strong appeal to those who would act ethically. Acting in anticipation of certain consequences, on the other hand, may indeed put the emphasis on selfish or altruistic (pragmatic) concerns and deemphasize the ethics of the matter.

Therefore, what appears to be the best position for the photojournalist (or any journalist) is the Middle Way of Ethics, i.e., the synthesis of deontology and teleology. The photojournalist is thereby a basic or principal deontologist, but at the same time he is a rational teleologist—willing to depart from his basic loyalty to principle from time to time to achieve what he reasons is a *higher* moral decision. Said another way: He conforms to the maxim or principle that from time to time he must depart from all other ethical maxims or principles in order to seek a greater ethical level.

What are some of the practical ramifications of such an ethical synthesis? Let us consider a few:

• The photojournalist can in certain cases cut persons out of a picture even when they are part of the "event,"

although he is basically dedicated to an ethics of full disclosure.
• The photojournalist can in certain cases withhold a news picture from his editors, although he is basically dedicated to an ethics of giving the public its right to know.[4]
• He can, on occasion, act ethically by refraining from identifying persons in a picture although he normally subscribes to the principle of identification.
• He can, at times, ethically "stage" or set up a picture (after the event has taken place in reality) although he subscribes to the general maxim of news-picture "honesty."
• He can, from time to time, justify his ethics in *not* "letting the people know" in respect to certain pictures which he may have gotten access to, although normally he believes in making such pictures public.

Now, many persons will say that such a photojournalist is compromising his basic ethical principles when he rationally deviates from following them. There is no doubt but that he does compromise his principles, but he compromises them in the name of, and for the sake of, *a higher ethics,* one that he arrives at *conscientiously, rationally,* and *in good faith.*

It seems that even the strict deontologist could not seriously object to such a teleological departure from time to time. Why? Because it shows a *good will* or ethical motivation. And the deontologist puts great stock in a good will and in the motive of a person taking an action. And, besides, it might even be argued that this "Middle Way" ethicist is dedicated in reality to a basic principle or maxim; it might be worded in this way:

Accept a basic maxim and act on it out of duty, deviating from it when, and only when, using reason, you feel that probable consequences stemming from nondeviation will result in a less moral action.

So here we have a kind of deontology (dedication to this maxim) which in itself permits the journalist *to act teleologically* when he feels he should. In

---

4. A majority of newspaper and magazine photographers, feel that the "right to publish is in the hands of editors and publishers." They most likely would not, therefore, withhold what they consider to be a technically good picture from a superior.—C.C.E.

other words, by following the above maxim the journalist is permitted to be fundamentally a deontologist and at the same time allows room for reason to intrude itself in the ethical situation and makes it possible for teleological readjustment in the cause of a higher morality. It would seem that this synthesis of deontology and teleology—or this "Middle Way of Ethics"—is a sound one for the photojournalist of today who treasures loyalty or commitment and at the same time desires a flexibility of action based on reason.

\* \* \*

From my long-time observation of journalists (and this includes photojournalists) making decisions which they hope are ethical, it has become clear that most of them have adopted, perhaps without realizing it, this synthesis of deontology and teleology which has been described above. Oftentimes, however, they are apologetic or defensive about this, for they feel they are in some way guilty of a "watered down" or inauthentic ethics.

This attitude is unfortunate and it must be abandoned. The Middle Way position between deontology and teleology is quite *rational* and *ethical.* And it is as authentic as any other. Just because this ethical stance does not have a firmly established label in the history of philosophy is no reason why it is not a valid and sensible stance. The great impact of formal logic through the years has rendered such a synthesis stance unreliable—or at least has endowed it with much suspicion. But, for those who find great value in the logic of Hegelian dialectic as an alternative to the formalism of Aristotle, this synthesis ethics of deontology-teleology not only makes sense, but offers the soundest foundation for a journalistic ethics.

# Student Participation

1. Compare the evolution (technical) of taking news pictures with the evolution of thinking which has taken place in photojournalism.
2. Philosophically, how do the "composite" pictures of Rejlander and Robinson differ from the "composograph" pictures of Bernarr Macfadden?
3. Use a dictionary to clarify Dr. Merrill's words, "deontology" and "teleology."
4. Write and bring to class your own photographic code of ethics (not to exceed one paragraph in length).

# 18

# Photojournalism Today

*William H. Strode III*

A newspaper's function is to serve the public. This service takes many forms: keeping people informed about local, national, and international happenings, making the news clear and relevant, and at the same time providing human interest and entertainment.

The photographer plays an important role in fulfilling these functions. Lewis Hine, who photographed in the early 1900s, said, "Photography could light up darkness and expose ignorance."

Photographs used skilfully in a newspaper can accomplish these ideals. So newspaper photographers must be responsible journalists who follow the advice of Carl Mydans, "Take your pictures with your mind, heart, and a camera."

This is the approach to which we aspire at the *Courier-Journal,* The *Louisville Times,* and the *Courier-Journal & Times Magazine.*

To achieve these goals, we seek to put as much responsibility as possible on the individual photographer. He is thought of as a journalist. He is encouraged to produce his own ideas. And he is responsible for the content of his photographs. With these concepts in mind, we built our present photographic operation.

There seems to be a new feeling, a new horizon as to what today's newspapers are trying to achieve. As Norman Isaacs, former executive editor of the *Courier-Journal* and the *Louisville Times,* once said, "Many descriptions have been given of what we are seeking to achieve in depth reporting, and in interpretive journalism, in bringing about the evolution to a form of a daily news magazine."

Whatever the description, what we say we are striving for is a journalism different from what we have today. We are striving for a way to take the news of this complex society of ours and pre-

**Wm. H. Strode III, former assistant director of photography at the** *Courier-Journal* **and the** *Louisville Times,* **explains the philosophy behind the photographic operation of a great newspaper. Mr. Strode now has a freelance photography business and regional publishing company based in Louisville.**

sent it in a far more intelligible form. We want our readers—and viewers—to have something other than the bits and pieces of today's journalism. We want them to see the world in a broader context with a background and interpretation that will enable the citizen to understand the real meaning of the events that evolve around us.

The photographer as a communicator must use his pictures to enable the reader to understand his fellow man and discover the world around him. The photographer must probe the individual mind and probe the larger society. He must present people to people. His pictures must have content and meaning, and they must convey this meaning to the reader and viewer.

In our constant effort to achieve meaningful pictures, we try to give each photographer time to cover his assignment adequately, regardless of whether that time is one hour or three months. We try to find photographic assignments that are meaningful to the community, and we expect the photographer to photograph with understanding and feeling.

There is a commitment to good photography from management and from editors. And there is a continuing education program professionally and academically for photographers. Picture page and magazine photographic essay ideas are discussed by editor and photographer. Our stories often look not only at the event, but also behind the event to report its cause or deeper meaning.

Obviously, not every photograph in the newspaper is a profound statement. There is a definite place for pictures that simply and quietly mirror the world around us and the way we live in it, pictures that bring a smile or a moment of relief to a reader in an otherwise hurried day. The little things as well as the big make up life.

# Structure of Photographic Department

Our photographic department has a combined staff of twenty-seven people who work for both the *Courier-Journal* and the *Louisville Times.* The department is organized into many areas of responsibilities.

## News

Twelve general-assignment photographers produce the news and feature pictures and picture stories for both the morning and evening papers.

## Sunday

In addition to the general-assignment photographers, two photographers work exclusively for the combined *Courier-Journal & Times* Sunday paper and the *Sunday Magazine.*

## Special Assignment

Even though each photographer is capable of covering any type of assignment, we have several areas where the majority of work is done by specialists.

Most of our aerial photographs are taken by one person, who also pilots our plane. The single-engine plane is flown almost daily for taking aerial photography, for making film pickups, or for transporting reporters and photographers around our two-state (Kentucky and Indiana) coverage area. Kentucky state coverage is very important. No individual photographer lives in an area of the state that lets him or her be in constant contact with the people and the news of the region. Color food photography is another area of specialization. *Scene,* a Saturday tabloid leisure magazine, has one photographer who does the majority of its work.

## Advertising Photographs

One photographer works exclusively for the newspapers' advertising department.

## Laboratory Technicians

Even though our photographers do much of their own laboratory work, we have four specially trained technicians.

## Picture Editors

The *Courier-Journal* and the *Louisville Times* each has a picture editor and an assistant picture editor. Even though they are part of the combined photography department, each set of editors works only for his or her particular paper.

## Administrators

Administrators include the directors of photography, a photographic department manager, and a secretary.

# Picture Editors

The picture desks are the focal points for all visuals produced by each paper. Assignments for both pictures and artwork are the responsibility of those on the picture desk, who also advise how they are to be used.

Picture editors work with the city desks, reporters, and photographers to produce the daily picture assignments. Each department's requests for picture assignments are filtered through the picture desk, where they are approved or killed. Part of the picture editor's job is to see that there are enough pictures each day to meet the demands of publication and also to make certain we do not cover more assignments than we can use. When assignments are held to a reasonable number, the photographer knows the paper has the room and the intention to publish his picture if the event turns out to be as worthy as anticipated. This puts a responsibility on the photographer to produce. It also helps give him the time he needs to make good pictures by eliminating marginal assignments that could keep him running instead of thinking and photographing.

The picture desks are also responsible for the selection of pictures. This is sometimes done by conferring with the photographer, but more often than not the editor makes his selections from contact sheets. These selections are then presented to page editors. At this point, too, the picture editors discuss cropping and sizing with the page editors and at the same time do a bit of lobbying for what they believe is the most effective use.

Besides the pictures and photographic illustrations that go with stories, the newspapers publish many freestanding pictures. Assignments for these pictures come from the picture editors. It is up to them to ferret out the news events that have visual human interest potential independent of story coverage. These possibilities are gleaned from future stories, suburban or community newspapers, area magazines, working relationships built up with news sources in agencies and organizations, photographers, reporters, and telephone tips. The picture editor, in effect, is a visual city editor.

Even though the picture editors are part of the photographic department organizationally, they are on a level with city, womens', and sport's editors.

*The Louisville Times* as well as the *Courier-Journal,* often produce a picture page. These picture layouts, which are usually on a single subject, sometimes relate to a front page story. More often than not, however, it is a feature layout telling its own story. Sometimes a series may run for three or four days on a single topic. Both features and news stories are used for the picture page.

The picture desk gives the photographer the opportunity to conceive, photograph, and lay out the picture page if he wishes to do so. Even though the photographer is given the opportunity to present a completed package, more often than not the picture editor and the photographer work together on the picture selection and layout.

The picture editors also work with all the department editors and the art department on other picture layouts in the other sections of the paper.

There are times when a drawing or sketch will illustrate a story better than a photograph. The picture editors work directly with the art department in planning such illustrations.

Dull and posed pictures, those depicting check passing, ground breaking, handshaking, and large groups of people are almost never assigned or used in the *Courier-Journal* or the *Louisville Times*. Instead, we use our time and effort to make pictures that are of more concern to the entire community, pictures with content that tell the important story of a news-related event or the reason for the event. For example, we would seek to publish a story and pictures of overcrowded conditions at the community hospital—the reason for a new hospital ground breaking—rather than a picture of the ground breaking itself.

Freestanding feature pictures often result from the enterprise system. Under this system, a photographer is allowed time to photograph an idea he has or to roam the city or countryside looking for pictures.

Our photographic coverage sometimes takes staff photographers across the country and sometimes around the world, but our primary job, we feel, is to give good local coverage to Louisville and good regional coverage to Kentucky and Indiana.

Because we believe our first responsibility is to our community, we photograph city council meeting activities (or related problems), local high school and college sports events, and other local events more than we do national or international events.

We use many criteria in selecting a staff photographer. The most important are: his ability to "see" photographically, his feeling and understanding of people, his potential, and his educational background.

We expect our photographers to have the ability to handle any photographic situation including available-light candid photography, 8-by-10-inch studio photography, fashion and food pictures, and lighting of complete buildings or arenas.

▼
Pictures must have content and meaning. A successful picture is one that makes a statement or tells a story. This one tells us that more than a tornado had come through town. It shows the reaction and emotion of a tornado victim.

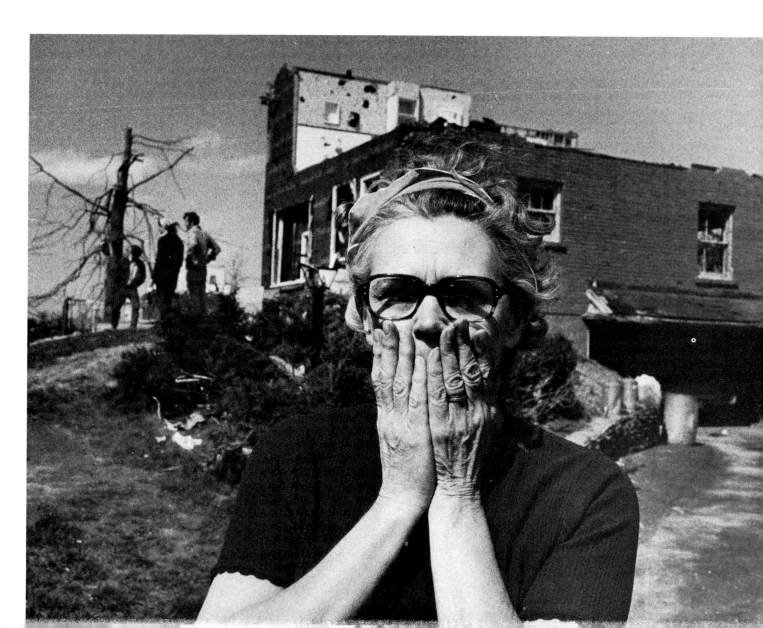

TOIL 'N' BROIL
Muggy Low 70s tonight.
Then mid-90s.
TODAY'S HOURLY TEMPERATURES
1 8 5 7 9 10 11 12 1 2 3
T2 72 60 60 76 81 84 87 89 91 90
Full data, Page A17

# THE LOUISVILLE TIMES

VOL. CLXXIII- No. 64 ★★★★★ LOUISVILLE, TUESDAY EVENING, JULY 14, 1970 48 PAGES TEN CENTS

RED FLASH

# Enthusiastic Welcome by Kentuckians Draws Happy Response From President

## Top Aides Also Arrive For Meeting

By DICK KIRSCHTEN
Louisville Times Staff Writer

President Richard Milhous Nixon on an exuberant strole into the "heart of America," shook hands with citizens on Louisville street corners early this afternoon.

The President, whose plane touched down at Standiford Field just minutes before noon, left his automobile twice to mingle with the crowds as his motorcade wended its way toward the new Federal Building.

Mr. Nixon, who was here to confer with the governors of 11 Appalachian states, and representatives of two others, received an enthusiastic welcome from

More pictures on the President's visit to Louisville are on Page B1.

thousands of sundrenched citizens who patiently massed at the airport and lined the route of his downtown passage.

Police estimated the crowd at Standiford Field variously at 5,000 and 7,500.

Police Chief C. J. Hyde said about 7,500 persons were at the airport. He said he drove the route of the President ahead of the President's car and estimated the number of persons along the route at 50,000 or so.

Mr. Nixon arrived at the Federal Building at 1 p.m.

On his way, he left his car at Fourth and Broadway and again at Fourth and Walnut to make physical contact with the cheering crowds which surged forward to shake hands with their President.

Secret Service agents looked on uneasily as the crowds pressed toward the President, but there were no untoward incidents.

At the Federal Building, approximately 2,000 people crowded into the Federal Square park area north of the building, awaiting Mr. Nixon. The President, after shaking hands with the Appalachian governors, pushed his way through the throng to the microphone and introduced himself.

He said, "I want to tell you how very grateful I am for this wonderful reception."

The President spoke haltingly at first, still breathing heavily from his exertion in pushing through the crowd. He said, "The President meeting with the governors is not unusual. It's not unusual for the Cabinet to meet with the governors. What is unusual is Washington coming to Kentucky, the government coming to Kentucky."

In his brief remarks at the airport, Mr. Nixon concentrated on the theme that the "real America" and he implication, the real current of public opinion, is to be found in such inland centers as Louisville.

The President was accompanied by several of his top advisers, including presidential counselors Bryce N. Harlow, John Ehrlichman and Daniel Patrick Moynihan; George Shultz, director of the newly created Office of Budget Management; Donald Rumsfeld, director of the U.S. Office of Economic Opportunity; Secretary of Agriculture Clifford M. Harding and Secretary of Labor James Hodgson.

Mr. Nixon, tanned and wearing a blue suit, was greeted at Standiford Field by Kentucky Gov. Louie B. Nunn, Jefferson

See ENTHUSIASTIC
Back page, col. 1, this section

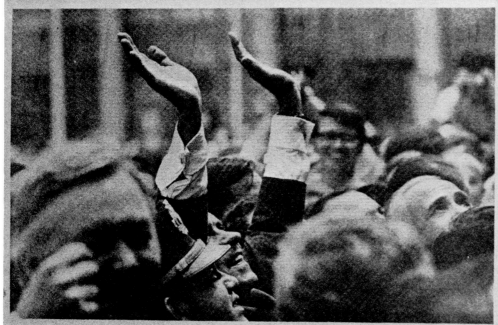

Staff Photo by Bryan Moss
Hands high and face beaming, President Nixon is surrounded by a welcoming crowd at the Federal Building. Presidential counselor Daniel P. Moynihan is at left.

## Louisvillians Get a Look At a President

The youngster—he couldn't have been more than 10 years old—was pushed forward by the press of the crowd.

He looked up at a face a few feet in front of him, one of many in the pushing throng. He recognized the face immediately.

"Boy, it's the President!" he exclaimed.

This was the scene at Fourth and Broadway where President Richard M. Nixon paused in his motorcade trip from Standiford Field to the new Federal Building shortly after noon today.

Mr. Nixon was greeted by enthusiastic crowds as his car swept along Broadway from the North-South Expressway to Fourth, but the most excited response came as he ordered his car stopped and stepped out into the crowd at Fourth.

### Bodyguards Look Worried

The President, flanked by worried-looking Secret Service agents and Louisville police officers, was immediately swamped by hundreds who had awaited his arrival under a very hot noonday sun.

Mr. Nixon beamed as he briskly shook the proffered hands. After several minutes of mingling—and occasionally struggling with the crowd, he returned

to his car and again turned to the people.

The President spotted a black youngster boosted onto someone's shoulders and beckoned for him to be brought closer. Leaning precariously from his open-roofed car, Mr. Nixon grasped the child's hand.

More hands were offered. A few were briskly gripped and shaken.

Gov. Louie B. Nunn, traveling in the same car as the President looked uncomfortably hot and at one point lapsed into a grimace which quickly turned into a smile.

The governor joined in the handshaking, and then the brief stop was over.

At the corner of Fourth and Walnut, the cheering and clapping continued, and then a hush came down as the President left his car to shake hands and thank his welcomers.

After working through the crowd for awhile he returned to his car, climbed on its roof and offered a now familiar gesture, spread hands above his head. Then he bopped back down into the crowd.

The visiting over, the President climbed back in his limousine, not to get out again until he reached the Federal Building.

At about Founders Square, Mr. Nixon dropped his smile for a moment, checked

his watch, and the procession sped up, police reporters and Secret Service men all breaking into a run.

He whizzed past a small contingent of young people carrying antiwar signs, such as "Get Off the War" and "Thanks for Cambodia" at the corner of Walnut and Sixth.

At the Federal Building, the 113th Army Band from Ft. Knox struck up "Ruffles and Flourishes" and "Anchors Aweigh" just before the President's arrival a few minutes before 1 p.m.

The President and Gov. Nunn stood together with their heads and shoulders through the open sunroof of the presidential limousine. Perspiring Secret Service men trotted on foot in front of and beside the presidential car and police on motorcycles forced the crowd back on each side.

The President shook hands with a large number of spectators and waved several times at the federal employes who lined the windows of the building above him.

The 11 visiting Appalachia-area governors emerged from the Federal Building before the President's arrival. Most of them stood in a group, chatting in the

See LOUISVILLIANS
Back page, col. 1, this section

JUDGE SAYS IT'S OK

## The Latest in Courtesy: Offer a Lady a Barstool

FRANKFORT, Ky. (AP)—Franklin Circuit Judge Henry Meigs has ruled that women cannot be prohibited from tending bar or being served mixed drinks at a bar.

The judge said the state civil-rights act overrides or supersedes statutes that prevent such activities by women.

The anti-discrimination statute, he said, carries the clear and necessary implication that bias against women in this field is to be removed.

The ruling was handed down yesterday in a Louisville case.

The state Alcoholic Beverage Control Board (ABC) had suspended for five days the alcoholic beverage license issued to Dixie Sherman Burke, doing business as Dixie's Elbow Room, 516 Fifth.

The citation alleged that Mrs. Burke employed a woman bartender and allowed women to be served at the bar.

Mrs. Burke's appeal to the court charged discrimination on the basis of

sex in violation of both state and federal law.

The ABC board did not indicate immediately if it would in turn appeal Meigs' ruling to the Court of Appeals, Kentucky's highest court.

The statutes involved say that women may serve only as waitresses, ushers or cashiers in premises where liquor or beer is sold and may be served only at tables where food is served—though food need not be served at the same time as liquor.

Meigs said the ABC board order against Mrs. Burke was "unreasonable and contrary to law" because the civil rights statute repudiates what he called the discriminatory portion of the other statutes.

A similar suit was filed in March 1969 in U.S. District Court in Lexington by a Covington cafe owner and his barmaid, John Reed and Betty Morris, on the basis of federal anti-discrimination laws.

Kentucky ABC regulations permit a woman to act as a bartender only if she holds the license for the establishment.

## In Today's Times

### Louisville Needs Pride

A dose of "fierce emotional commitment" would result in a new stadium to serve as a symbol of the city's pride, businessman William Stone declares in "Sound Off!", The Times' forum for comment. Page A11.

### Just Like Old Times

Ex-Yankee Jim Bouton describes his return to a pennant race in the last of a 10-part series on B5.

### Where to Look

| | | | |
|---|---|---|---|
| Business | B10 | Movies, Stage | A16 |
| Calendar | | News of Record | A15 |
| Of Events | A14 | Obituaries | A12 |
| Editorials | A10 | Sports | B4 |
| Lemme Doit | B1 | TV, Radio | B2 |
| | | Women's News | A18 |

## President Doesn't Sway Weather

Leaping lizards! Mr. Weatherman.

Sure, we want our Very Important Visitor to feel at home. And we know Washington, D.C., is noted for its uncomfortable summer weather.

Today, we can understand. But, tomorrow, too?

Tomorrow is expected to be mostly

sunny and humid again with a high in the mid-90s after a low tonight in the low 70s. One added ingredient tomorrow will be a 10 per cent chance of rain.

Thursday is supposed to be slightly cooler, but with a chance of thundershowers.

Louisville's cup of hospitality runneth over.

## Governors Are Lent A Presidential Ear

By JIM RENNEISEN and FRANK CLIFFORD
Louisville Times Staff Writers

The governors of Appalachia had a blue ribbon audience for their lobbying efforts here today.

Seated around a rectangular conference table in Room 829 in the new Federal Building were President Richard M. Nixon and several of his top aides.

Eleven Appalachian governors were lobbying on behalf of the regional concept of dealing with the nation's domestic problems.

Reporters were not allowed inside the conference. However, according to a presidential press aide, Mr. Nixon told the governors:

"Sometimes when we think of Washington, those of us at the highest levels feel as though we are in an isolation booth. Like on the old quiz shows where the man inside cannot hear what's going on outside. What we're doing here today is trying to break out of the iso-

lation booth. We have come here today to get your views."

At the start of the meeting, it was learned that the governors outlined the basic administrative guidelines they think are necessary to adapt the approach of the Appalachian Regional Commission (ARC) on a nationwide basis.

In essence, the guidelines would combine state and federal resources for the sake of solving regional problems and for making regional improvements.

The governors said, "During the last five years we have witnessed the implementation of a highly successful and innovative program conducted by the ARC. We believe that the major key to the success of that program has been the partnership and the decision-making role that has been given to the Appalachian states."

The governors represented 11 states from Pennsylvania to Mississippi.
Kentucky Gov. Louie B. Nunn is host to

See GOVERNORS
Back page, col. 3, this section

A picture that is different—one that tells a story—is the objective of every photojournalist. The page-one picture used in the *Louisville Times* Tuesday evening, July 14, 1970, met these requirements. This picture by staffer Bryan Moss portrays the reactions of local people when President Nixon came to town.

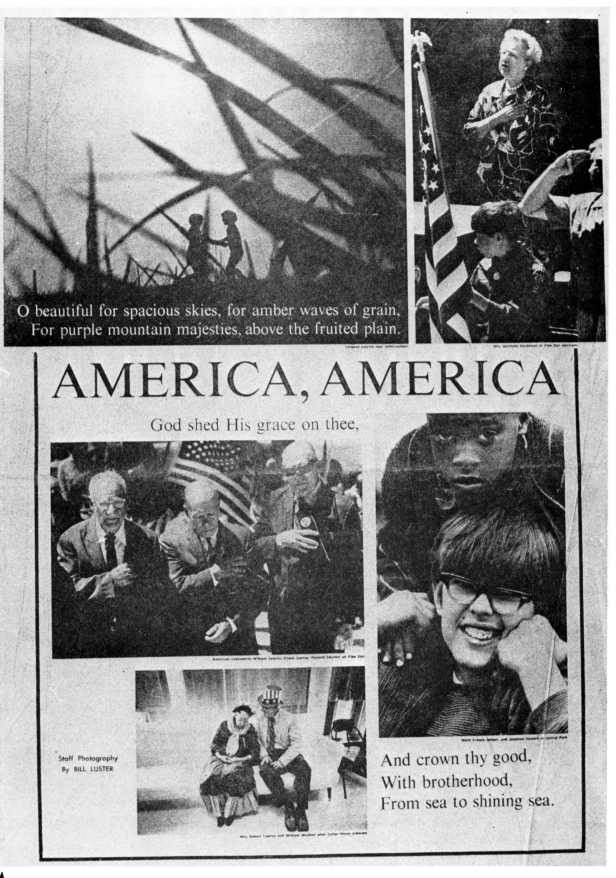

O beautiful for spacious skies, for amber waves of grain,
For purple mountain majesties, above the fruited plain.

# AMERICA, AMERICA

God shed His grace on thee,

Staff Photography
By BILL LUSTER

And crown thy good,
With brotherhood,
From sea to shining sea.

▲ This picture page *(above)* in the *Courier-Journal & Times Magazine* is an example of teamwork by both photographer and picture editor. Bill Luster had been shooting this July 4 feature for several weeks while covering other assignments.

**By HOWARD ROSENBERG**
Louisville Times Staff Writer

BRANDENBURG, Ky. — An Army chaplain from Ft. Knox looked inside Central Elementary School and decided he had seen it all before.

In Vietnam.

And the Rev. Thomas Stokes, pastor of Wolf Creek Baptist Church in nearby Battletown, stood outside the building and said:

"Some of them don't even look like they got faces. One woman got a stick right through her face."

This was tornado-ravaged Brandenburg, Ky. It's the seat of Meade County, just down the Ohio River from Louisville.

Earlier in the day, the school had been a building of laughing and playing children.

Last night it was a building of death, a temporary morgue, caught in the piercing flash of blue emergency lights and the bark of police radios. Men in jackets with shirttails out stared into the lights with glazed eyes.

Inside were the disfigured remains of those who died in the tornado—30 had been counted by 6 a.m. The town's population is about 1,700.

Many more were missing and the death toll was expected to rise with the coming of daylight.

It was a grotesque, unforgettable sight, bodies resembling torn rag dolls lying in the school's dimly lit corridor.

They were on the floor. There weren't enough cots to go around.

A middle-aged man walked up to the building. "Anybody know who is in there?"

"Looking for someone?"

"My wife and three kids."

Practically everyone was still looking for someone.

The dead were removed from the morgue during the night and taken to area mortuaries for embalming. They were to be returned in the morning for viewing and identification.

Mr. Stokes was there to comfort relatives of victims. A few identifications were made by close relatives. Most bore up well.

But one man asked Mr. Stokes, "If God is a good god, and He loves us, why did it happen?"

"That was a good question," Mr. Stokes said.

"I answered that God didn't do it. It happened."

Evidence of the happening was everywhere. "You pick bodies up, and they break all to pieces," said a state trooper.

Meade County Judge James Greer was in his Courthouse office, talking to a man who wanted a beer license, when the twister touched down in the distance at approximately 4:10 p.m. "I could hear a whistle in the background," he said. "And it kept getting stronger and stronger."

Postmaster Thomas Tichenor saw it coming. "We wanted to get to a wall. It was kinda twisting back and forth. We didn't know which way to go."

Tichenor made it under a table just before the Post Office window blew in. "It screamed like it was a jet," he recalled.

But Post Office clerk Owen Dugan's

See BRANDENBURG
Back page, col. 2, this section

# THE LOUISVILLE TIMES

VOL. CLXXX—No. 130    88 PAGES    THURSDAY EVENING, APRIL 4, 1974    TEN CENTS    HOME EDITION

Copyright © 1974, The Louisville Times

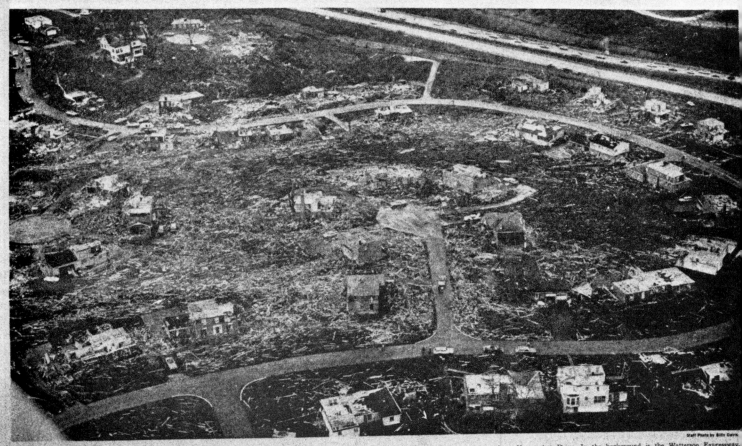

Big new homes became piles of sticks and bricks yesterday after a tornado struck the sixth-class city of Northfield. This view looks southward from Newmarket Drive. In the background is the Watterson Expressway. *Staff Photo by Billy Davis*

# Killer tornado rips 10-mile gash in county

**By MARTIN E. BIEMER**
Louisville Times Staff Writer

Nature's forces collided over a broad part of the nation yesterday, and it may take Louisvillians many weeks to recover.

A tornado, part of a storm system that stretched from Alabama to Ontario, cut a 10-mile-long swath through densely settled residential and commercial areas in Louisville.

The death toll was almost miraculously low. Officials said four people died as a direct result of the storm in Jefferson County.

For the nation, it was the worst tornado disaster since Palm Sunday, April 11, 1965, when 271 people were killed.

For Kentucky, it was the worst tornado disaster since March 27, 1890, when at least 76 people lost their lives in Louisville alone. Seventy-seven persons reportedly died across Kentucky.

In addition 63 persons were reported dead from twisters in Indiana.

The tornado that struck Louisville yesterday apparently was the same one that struck Brandenburg, Ky., about 25 miles southwest of Louisville along the Ohio River.

The death toll at Brandenburg was 30. John Burke, meteorologist-in-charge at

### Storm section

Coverage of yesterday's storm is concentrated in a special section, which begins on Page B1.

the National Weather Service station at Standiford Field, said the twister was tracked on weather-service radar.

He said it apparently lifted into the air after leaving Brandenburg, passed over West Point and Kosmosdale, and may have clipped the top of the hill in Iroquois Park.

"It touched down in the parking lot right here at the airport," he said. "A

piece of roof from the west wing of the terminal blew off."

Then, Burke said, it continued to swirl "along the ground or very close to it" in a northeasterly path across the city until it appeared to lift into the clouds somewhere northeast of Brownsboro Road and Lime Kiln Lane.

Burke said the swirling winds in the funnel probably reached "200 to 300 miles per hour" as it smashed across the city.

The extensive damage began at the Kentucky State Fairgrounds and continued through Audubon Park, Calvary Cemetery, along Eastern Parkway to

Cherokee Park, through the park, over or past the Interstate 64 tunnel, Grinstead Drive, past the Louisville Water Co.'s filtration plant, and through the suburbs of Rolling Fields, Indian Hills, Northfield and areas between them.

More damage was reported north of Northfield, near the entrance to the Barbour Manor subdivision near Pilot Lane and Brownsboro Road.

Kentucky National Guardsmen and all available police officers in the

See KILLER TORNADO
Back page, col. 1, this section

## Water expected to be restored today; boil before drinking, company warns

**By RICHARD KRANTZ**
Louisville Times Staff Writer

Water was expected to be restored to most Louisville-area homes and businesses by early afternoon today. But all drinking water should be boiled until further notice, spokesmen for the Louisville Water Co. said this morning.

All industries and schools were asked to shut down today in order to help rebuild the water supply, the water company said. Schools announced they would be closed today.

### Where to look

About six main roads in eastern Louisville and Jefferson County were partially blocked during the morning, but officials said they hoped to have them open by noon today.

These streets included sections of Bardstown Road, Eastern Parkway,

Frankfort Avenue, Grinstead Drive, Brownsboro Road and Top Hill Road.

As dawn broke over Louisville, the crippled city seemed to face several days of struggle before its daily life returned to a semblance of normalcy.

Water shortage was the most critical problem that threatened the city immediately following the devastating tornado.

Louisville Water Co.'s pumping facilities shut down totally for nearly 12 hours as the storm severed all electrical power leading to the central pumping facilities

## Cooler weather is returning with clouds

Cooler weather is returning to Louisville with a low tonight in the upper 30s and a high tomorrow of around 50.

Tomorrow will be mostly cloudy, with a 30 per cent chance of showers.

Gusty winds to 20 miles an hour are expected tonight before diminishing tomorrow.

Today's temperatures:

| Midnight | 70 | 5 a.m. | 57 |
|---|---|---|---|

## Aides say Nixon may need a loan to make tax payment

**By FRANK CORMIER**
Associated Press

White House officials say President Nixon, facing a federal tax bill for about half his reported net worth, probably will be forced to borrow money to make the payments.

Mr. Nixon announced through aides last night that he would pay about $465,000 in back income taxes and interest. He acted after being told privately a day earlier that the Internal Revenue Service (IRS) calculated he owed an extra $432,787 in taxes for his first four years in the White House.

Nixon proposed to meet a taxes-on-est bill of about $465,000, said he use some resources and probably

The White House announced the IRS report contained no suggestion of fraud on the part of the President.

The IRS contended he claimed deductions for business and a controversial gift of his vice-presidential papers to the National Archives. The papers were valued at $576,000.

The federal tax collectors said that the President failed to report capital gains on sales of a New York apartment and part of his estate in Clemente, Calif.

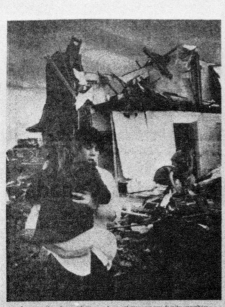

It was a time for comforting and consolation among family members.

# Northfield:
## a community in the wake of tragedy

One of the areas hardest hit by yesterday's tornado was the suburban development of Northfield, at the junction of Interstates 71 and 264. People left homeless and in shock by the storm dug out and began leaving the area to take refuge elsewhere.

STAFF PHOTOS BY LARRY SPITZER, EXCEPT AS INDICATED

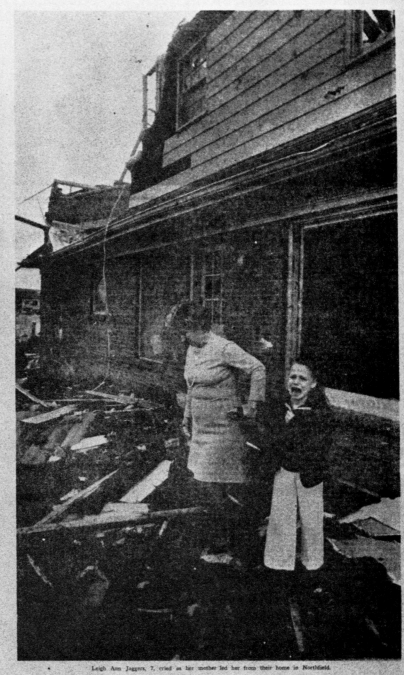

Leigh Ann Jaggers, 7, cried as her mother led her from their home in Northfield.

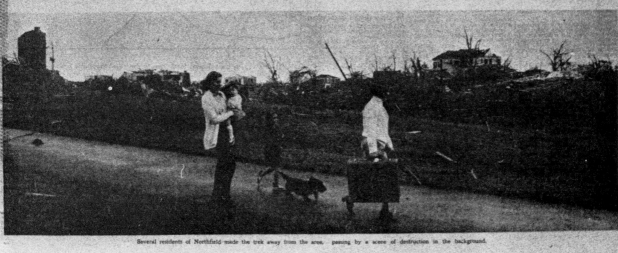

Several residents of Northfield made the trek away from the area, passing by a scene of destruction in the background.

# Ethics

Over the years newspapers have built a credibility gap of their own. The remark that "you can't believe what you read in the newspapers" applies to photographs as well as to words. Unfortunate as it is, there are many reasons for this kind of thinking. The credibility gap of the visual image has been widened by television's early exploitation of photography.

If the desecration of the visual image continues, even the long established fact that photography is rooted in reality will not save it. Photographers must protect the faith in the photograph. To do this, they must be responsible, and responsibility among other things means serving with good taste. It also means operating with regard for the public and photographing only the truth.

If a photographer pictures—and we publish—an untrue situation, even if only one person is involved, two people will know it. The person photographed and the photographer. That is two too many.

The responsibility demanded of journalists today is far beyond anything we may have ever dreamed possible, and we can never forget it.

To this end we do not set up situations on the pretense that they are actually happening. We do not contrive pictures. (We do use photographic illustrations, but they are clearly identified as such.) We do not mutilate photographic prints by cutting, extensive retouching, or pasting in objects. These are all lies, and our paper does not publish lies.

If an honest, human mistake is made in our paper, we correct the error as soon as it is discovered in columns called "Beg Your Pardon" and "We Were Wrong."

In another area which has to do with ethics, our news people do not accept free tickets, free transportation, free samples, free memberships, or anything free from our news sources. Members of the news staff also do not work for pay (moonlighting) for any company or any other profit or nonprofit organization in our circulation area.

This policy is absolutely necessary, because our papers claim always to be neutral and fair in their handling of news. If we are to be *believed by others* we must be neutral, fair, and untainted by outside influence.

# Sunday Magazine

Locally edited Sunday magazines have a unique opportunity to add another dimension to newspapers by providing a magazine approach to news.

Magazine journalism is quite different from newspaper journalism in its approach, style, and content.

Locally produced stories, written or photographic, about and for local people have a distinct advantage that national magazines cannot provide.

Unfortunately, far too many Sunday magazines have been forever gentle, unprovocative, and sweetly amiable. There is certainly a place for beautiful fashion, for peaceful scenes, and for light, lovely essays. In addition to these light features, however, Sunday magazines must also have a solid, vigorous voice and an impact of their own.

At the *Courier-Journal & Times*, we try to create such a magazine in a regional situation by using the best techniques of photography, writing, and editing found in the national magazines. This means giving writers and photographers the opportunity and time to produce in-depth stories and essays. It also means giving advanced thought and planning to stories and to carefully use space to take full advantage of the opportunity for good reproduction of photographs and illustrations.

Here, even more so than on the daily papers, photographers are called upon to be professional journalists. They are continually asked for story ideas and layout suggestions. There are no written assignments for the magazine photographers to follow. The concept used is a team approach with photographers, writers, and editors collaborating on story ideas. Some stories are photographic essays with the writer produc-

ing text to fit a photographic layout. At other times, the photographer is illustrating a written story. The approach that best communicates the story is the one used.

Daily news photographers are encouraged to submit ideas to the *Sunday Magazine.* If they are accepted, the photographer is given the opportunity and time to photograph that particular story.

Many editorial decisions are made at a weekday meeting where editors, photographers, writers and art director discuss upcoming stories and look over the photographs that have been taken. On occasions such as this, a critique of the previous week's magazine is also held.

## Food Pictures

Each week the magazine has a food feature, written by our food editor and photographed by one of several photographers. It is the photographer's responsibility to decide how and where the food picture will be taken. He has known for several months what type of food he will photograph on a particular day, and he must have all the necessary props available and have decided if he wants to photograph on location with a 35 mm or 2 ¼ camera, or a 4 × 5 or 8 × 10 inch camera in our color studio, adjoining the food editors' kitchen.

The decision as to which camera to use is made by the photographer on the basis of what equipment will do the best job. Most news assignments are photographed with 35 mm cameras, but staff photographers will use the camera which best lends itself to the job.

Even with advance preparation it often takes one or two days to complete one food picture. The photographer is responsible for his picture's content, but the food editor, photographer, and art director work together during the shooting session.

Both transparencies and color negatives are used for the food pictures.

## Fashion

The majority of fashion layouts produced for our papers are published in the *Sunday Magazine.* The use of color, the magazine format, and space make the magazine the logical choice. The same type of advanced planning that is necessary for food photographs is also necessary with fashions.

Much careful thought about presentation, style, approach, and lighting is necessary before a shooting session takes place. Models must be chosen, locations scouted, or the studio prepared, and any special props that will be needed must be obtained.

The fashion editor makes a preliminary selection of clothes in New York, Chicago, Houston, or elsewhere and has them flown to Louisville to be photographed. When the clothes arrive, the fashion editor and photographer make a final selection of the outfits to be photographed, and then the shooting session begins.

Many styles of fashion photography are used, as well as many different photographic approaches. The proper approach, as well as good rapport between photographer and model, is very important in obtaining the mood that will best explain and display the clothes.

Fashion photography sessions are usually scheduled over several days to benefit from different locations or different models.

# Illustrations

Photographic illustrations are playing an increasingly important role in our papers as well as in all publications. An illustration is used when we are not reporting, but are making a statement (either the photographer's or the papers') or are expressing a story idea or point. To be completely fair to our readers, each illustration is labeled as an illustration by a cutline or by some other means. The studio, special lighting, rear projection, and complicated location set ups are all used extensively in our photographic illustrations.

Both story illustrations and editorial illustrations give the photographer a great opportunity to think and create.

The Courier-Journal & Times
# MAGAZINE
SUNDAY, MARCH 4, 1973

## Beautiful dreamers
*The new nightwear is for daydreaming, too.*

# plum good

By LILLIAN MARSHALL, Food Editor

IN TEMPERATE parts of the world, the plum has endeared itself to humans for thousands of years. Of 100 recognized plum species, some 35 are indigenous to North America, the rest mostly to Japan and Europe. Consider that the 100 species break down into a couple of thousand distinguishable varieties and you might expect to step on several plums in the course of a short stroll. Yet, for some reason, we have left it to the Europeans to glorify this elegant fruit. One of the most delectable desserts imaginable is plum goule (dumplings) that Mrs. William Turner Jr. of Corinth, Ky., learned to make from her late grandmother, who came to this country from Czechoslovakia as a young girl. They're not a convenience food by any means, but they're worth the time it takes to make them. Try them and some other (simpler) recipes that follow to rescue the plum from obscurity.

Photographed by C. THOMAS HARDIN

## Chinese Plum Chutney

4 pounds fresh plums, halved and pitted
2 quarts vinegar
1 1/2 pounds brown sugar
1 pound granulated sugar
1/4 pound ginger root, soaked well in water, drained and chopped
1/4 pound salt
1/4 pound mustard seed, crushed
1 7-ounce can green chili peppers, seeded and diced
2 4-ounce cans red pimientos, seeded and diced
1 small onion, chopped
2 cloves garlic, peeled and chopped

Cook the plums in one quart of the vinegar until soft. Make syrup of the other quart of vinegar and the sugars in another kettle. Bring to boil and cook until syrupy. Add the plum-mixture and other ingredients. Simmer for 1 1/2 hours, stir frequently until sauce is thick as jam and most of liquid has cooked away. Seal in sterilized jars. Makes about 8 cups.

## Plum and Grape Catsup

3 pounds fresh plums
2 pounds fresh seedless grapes
3 cups water
Sugar
1 1/2 pints white vinegar
1 tablespoon ground cinnamon
1 tablespoon ground allspice
2 tablespoons ground cloves
1 1/2 teaspoons ground nutmeg

Cook fruit in water until very soft, about 30 minutes. Press through fine sieve, discarding pits and skins. Measure pulp; add half that amount of sugar and other ingredients and mix in heavy kettle. Cook, stirring frequently, about 1 hour and 20 minutes until mixture is very thick. Skim. Pour into sterilized jars and seal tightly. Makes about 4 half-pints.

Continued

## Advertising Photography

There is a strong policy on our newspapers to make sure there is no conflict of interest between the editorial and advertising departments.

In keeping with this policy, and because advertising photography is a very specialized field, we employ one photographer whose sole job is to do advertising photography. Even though he is part of the photographic department, he works only for the advertising department.

Much of his work is done in the studio with complex lighting, large format view cameras, and specially designed worktables. Rings, watches, silverware, dishes, and shoes are but a few of the products photographed for the local advertisers. For the photographer's services, the advertiser pays an appropriate fee.

◄▲
Food and Fashion (originals in color). Food and fashion photographs are important in the production of the *Louisville Courier-Journal* and the *Louisville Times*. A photographer who specializes in food and fashion illustration does much of his work in a studio. He is a member of the *Courier-Journal* and *Louisville Times* photographic team, but makes pictures only for the departments which use his specialized type of pictures.

# COWHERD
## *a photographer's last look at Indiana*

Some many months ago The Courier-Journal & Times Magazine commissioned Barney Cowherd, a nationally known photographer, to create a photo-essay to be entitled "In Search of Indiana." Cowherd, a Louisvillian who had become a Hoosier by choice, accepted the assignment with a sense of personal curiosity: He had experienced Indiana as a matter of course for years; what would he find if for the first time he focused deliberately on scenes so familiar to him? Barney Cowherd never fully accomplished his mission. Last month, after a long struggle with cancer, he died. What he did complete was a series of photographs that will ever remain a tribute to his skill. And something else, as he says below. Barney Cowherd found himself.

*At Mount Vernon*

### By BARNEY COWHERD

Most people think everything that happens in a state happens in a city. That's not entirely true.
In search of Indiana I went to the land. Anyone could go around his home block and find man if he would only stop and look. What I found around the block of rural Indiana was a place where you can still enjoy the land—and yourself.

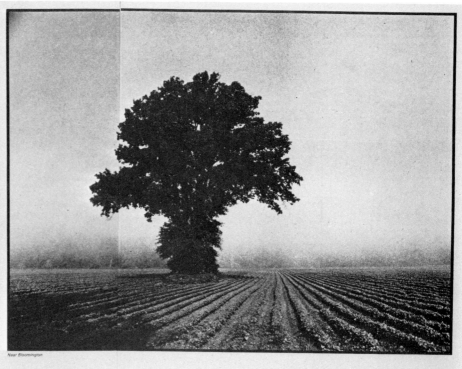

*Near Bloomington*

Paoli

Monroe County

Near Bromer

## COWHERD

Have you ever listened to
the clippity-clop
of a squeaky Amish buggy,
the wash blowing
in the breeze, or the
laughter of the young?

Have you ever listened to
the trees growing?
Sometimes just sit and
listen. You will find
another Indiana, and maybe
another you. I did.

Posseyville

Greenville

◀**Photo Essay.** This photo essay
on Indiana is typical of those
run by the *Louisville Courier-
Journal & Times Magazine.* The
essay was a tribute to the
memory of Barney Cowherd
and appeared with appropriate
black border in the issue of
September 10, 1972, after
Barney's death.

Hindostan Falls near Loogootee

McLissa I Love you
9/27/70

Near New Albany

## COWHERD

Small, unrelated things brought the biggest
question of my search: Whatever happened to love?
I saw a man wanting to sell his love seat
and asked why. He said he didn't need it any more.
The bad news of the war, crime in
the streets, tensions and fears, they were all right
here in Hoosierland. But in the young people
I saw love—and answers to many
questions. Behind the masks of long hair, drugs,
free love, nudity and the rest, there
were only people. I do not know if I found
Indiana in my search. But I found that among
the people and places I photographed, I belonged.
In my search I found a home
and myself. Too bad it was too late.

Borden

Photojournalism Today / 203

Staff Photos by Bryan Moss

"I wish all the rich people could see how it is to be poor. . . ."

"For the white and black man to get along together."

"For people that need love to feel like they are going to get it."

# What I want for Christmas . . .

**By JUDY ROSENFIELD**
Louisville Times Staff Writer

Once upon a time, it seemed every child's Christmas dream was a blank check in a toy store or a pet shop, a candy store or a sporting goods store.

It was a matter of the more gifts the merrier.

Last week some Louisville youngsters made out their Christmas lists in their school classes.

Some of them, to be sure, chalked up lengthy catalogues of toys and games and clothes.

But what others wanted for Christmas isn't advertised on Saturday morning TV, can't be bought on sale or stuffed in a stocking or gift wrapped and piled under the tree.

The youngest children, first-graders at Rivers Elementary School, chose relatively simple pleasures—books, pets, bikes, dolls.

"I want a football suit," wrote Jimmy Welch, "because my Dad wants me to have muscles."

Cindy Delozier said, "I want one of these film deals. It's a square box and you see movies in it."

"We decided to let Santa pick me a dolly," said Valerie Young, who added, "Then I can pretend to be a Mommy."

Chris Starr, another Rivers first-grader, wrote, "I would like a puppy dog 'cause I just want one."

At Goldsmith Elementary, third-grader Tom Merta wished that "the war would come to an end. So the Army men that fight for us could rest and have peace. If the war stopped, I'd be the happiest boy on earth."

"I would like to give to Good Will," wrote Jeff Lowe, another student in the third grade there. "Why? Well, some people don't have Christmas and I'd like for them to have one."

His classmate, Kevin Meredith, said he'd like a table-tennis set most of all:

"It is something that the whole family can play. And my family is more im-

*'I would like for everyone to have a merry Christmas, to have food and money, and for everyone's dream to come true . . .'*

portant to me than anything else in the world."

From another third-grader there: "I would like a baby sister for Christmas because I like my sister and I want another one." Signed, "Love, Jill Henry."

"If I could have anything I wanted," decided Tracy Mulligan, "I would want an angel. If I could have an angel I would be the happiest kid in the world because I think an angel is neat."

Donna Sheets, one of Tracy's third-grade classmates, said, "What I would really and truly want is for pollution to be stopped. It's something that is poisoning our air and water and other things. I think that if we all worked together we could stop it."

Pets and bicycles were tops on the lists of sixth-graders at Waller Elementary. Robert Gosling wanted not only a bike, but games, a race car set, and fishing, basketball, football, volleyball, ice-skating and roller skating equipment.

And, he concluded, "a basement to put all this stuff in."

"If I could have anything for Christ-

mas, I would like for the war to stop and there would be peace all the time from now on," said Don Lamar, another Waller sixth-grader.

"Then for the white and black man to get along together because we're all made of the same things. Why? Because the world would be better off."

Jeff Haag wrote a long list, including a coupler for his pogo stick "because my bops go over ever on," but his number one wish was "a swim in the Pacific Ocean. I have never done it before."

Mary Beth Barrow's Christmas list was well-planned.

"I would like a big white stallion to ride around the world and a dark green speedboat for when I came to water," she declared.

"I would like a movie studio so I could make millions of scary movies and Rock & Roll movies and a drum set so I could be in the Rock & Roll movies.

"I would like some brown leather boots with fringe hanging from the top so I could look Western on my horse. I would like a motorcycle, a bike one with saddle bags, so I could show it off."

Betty Roederer's holiday wish was "for my future brother-in-law to be able to come home from Vietnam. He's only been away for about two months," she conceded, "but it seems like centuries. The reason I want him home is so he can share the fun we have at Christmas."

Some eighth-graders at Shawnee Junior High wondered if they weren't a little old to be making out Christmas lists. They seemed to have no trouble.

Cars, clothes, an end to war and being with their families were their Christmas wishes.

Mike Reed's list was most specific: "If I could have anything I wanted I would want some snake skins (socks), a whole indoor basketball court, a deuce and a quarter, an El Dog, and a hog (ears), a

stereo and some more silk T shirts, some balloon-sleeved shirts, some more open-door bellbottoms, a pair of alligator studcins (shoes).

"A mansion with butlers and maids all over the place and a pool table," he continued. "Peace all over the world. No more crimes, no wars. A horse and more money. Lots of money."

His classmate, Robert Ewing, also was pining for new clothes, "like five or eight pairs of shoes and 10 or 12 pairs of pants and about 20 knits."

He explained: "I want these clothes so the girls can go crazy over me like they always do.

"I want to get my nephew some clothes, too, so the girls can go crazy over him, too. I like my nephew very much."

A pool table was eighth-grader Kenneth Colgate's choice. "This way," he said, "we can have fun for nothing. I mean $100. Maybe we'll gamble a little, say a quarter every ball we knock in the hole.

"If I win," he confided, "I think I'll

start my Christmas savings for next year."

Ursula Thomas, another Shawnee eighth grader, cautioned that her wish was a little unusual.

She said, "I'd like for my parents to go on a vacation for two weeks and leave my sister and I everything that we would need. I don't think my parents trust me. For one thing, I'm the oldest and they probably think that I just might get into some kind of devilment.

"If I could only prove to them that I can be T-R-U-S-T-E-D!"

"I wish I had the feeling that I was never scared of anything or anybody," wrote Rica Bridgewater. "I wish I could be very good at singing or acting and become a star on television never being nervous at all."

Shawnee eighth-grader Deborah Sinkfield wants "someone to take all the hate and dislike from this earth, put it in a rocket, send the rocket to Pluto and blow the rocket up."

Jeryna Barnwell's wish was for a hundred dollars. "I'd give it to the poor people and give them Christmas presents. The poor people do not have a beautiful and neshy Christmas."

Sheilah Little decided, "I mostly want

love from everybody and for people that need love to feel like they are going to get it."

World peace was Loni White's greatest Christmas hope—only she wasn't very hopeful.

"I think that if we have this great gift, children would grow up in a better world. In this world in which we live, children only learn to fight and hate.

"Race against race and sometimes people of the same race against each other. It's almost like the Civil War. If the world keeps up like this, the world will end sooner than we think."

Aaron Martin, in the eighth grade at Shawnee, was equally pessimistic.

"If I had all the money in the world—which I don't—I would buy the world state by state," he wrote. "The first thing I would do is stop the wars throughout the world. I would feed the hungry, help the sick, find a home for all unwanted babies.

"I would give the hippies and the drug pushers two states to themselves. After I had tried to solve all the problems of the world I would send man to the moon and all nine planets."

But, he concluded, "After all I have ac-

complished, it would amount to nothing—because the world will be destroyed by fire."

His classmate Herron Clark wished for "some clothes and some money—not too much, just enough to get me something.

"I would like for everyone to have a merry Christmas. And I would like for everyone to have food and money that doesn't have them. I would like for everybody's dream to come true."

Finally, he said, "I wish all the rich people could see how it is to be poor and without things you really need."

Another student, in tiny, neat handwriting and green ink, explained:

"I wish I were with my family and with my brothers and sisters. My mother is very sick. I wish she was well and could see.

"I wish I could go home and be with the whole family on Christmas. My biggest brother is in the Army and hardly gets to come home for Christmas. I feel like I am in the Army being so far away from home and I feel sad.

"I miss being with my little brother, helping put his toys together for him, then when all the snow has melted we go out and ride our bikes together. And just have lots of fun."

"I wish that the war would come to an end. So that the Army men that fight for us and die for us . . . could rest and have peace."

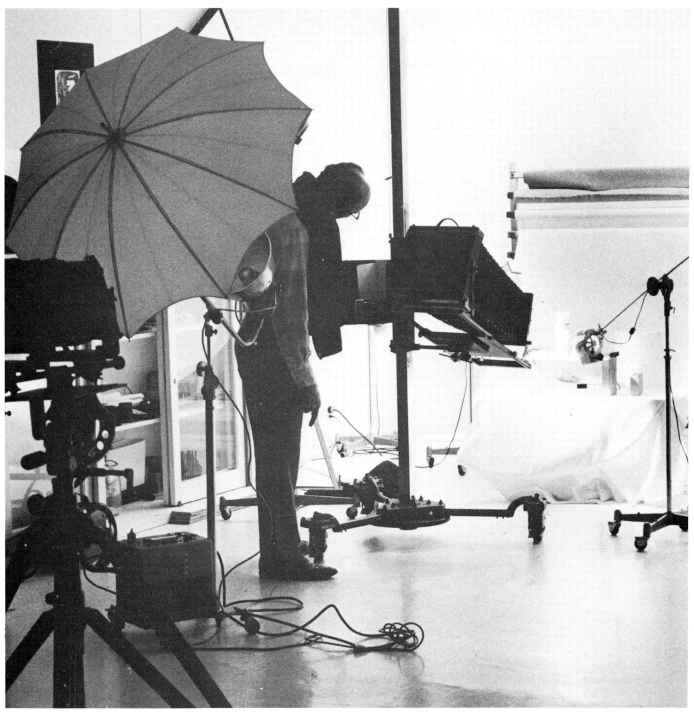

◄
The Louisville newspapers are
careful to distinguish pictures
which illustrate from pictures
photographed to report a
happening. The candid pictures
on the preceding page were
made specifically as illustrations
to go with a written story about
what first grade children want
for Christmas.

▲
An advertising photographer—a
specialist trained to do this type
of work—is shown taking
pictures of small items in an
advertising studio.

# Kentucky Derby

The Kentucky Derby lasts two minutes. But our planning for photographing the Derby requires three weeks. Fifty-eight photographers using 70 cameras and 400 rolls of film are used to record the event.

For the *Courier-Journal & Times* photographic staff, the Kentucky Derby is the busiest day of each year and the most extensively covered event.

It all starts a year in advance when we critique our work of the Derby just photographed and make changes and plans for the next year.

Two different sets of photographs are taken at the Derby. One group is made up of those photographs that change very little from year to year. These include standard coverage photographs like "around the track," which is a series of photographs taken at specific places showing the horses at various times of the race. Another is an overall of the finish. We also have photographers stationed so that we can cover the entire track in case a jockey is thrown or a horse falls.

These pictures are critiqued each year for importance, impact, camera position, sharpness, and lens coverage. If any one of these can be improved, even if it means moving just 10 feet or changing from a 28 mm to a 24 mm lens, we will make the change for next year.

In the other type of coverage we try for the unusual photograph such as a photograph that tells the story of this particular Derby or a photographic angle that has never been seen before. Each year we try very hard to produce different photographs. But after 103 runnings of the Derby, it becomes harder and harder.

Picture stories and specific people stories are planned for the human aspect of the race.

After conferences with the staff photographers, each person is assigned particular subjects to photograph. Often the photographer will make tests with his lens and position days before the race. Assignments covered before the race include features such as celebrities, jockies, and spectators.

During the race each photographer does a specific job. For example: six photographers photograph the start, each from a different angle for a specific reason. One year the finish was photo-graphed by thirteen photographers using twenty-one cameras.

Specific owners, trainers, and jockies also were photographed during the race. Each photographer shoots with a particular picture or story in mind, and each is trying to out photograph the other photographers.

After the race the coverage includes the winners circle, jockey, trophy presentation, bettors, winning horse, and much more.

What makes each Derby exciting and challenging to us is that none of the races are ever the same. No matter how much planning goes into the preparation for photographic coverage, one never knows how a race will be run. One year the winning horse may finish far in front of the other horses. The next year the horses may finish close together or the horses may run wide on the track. Each type of race should be photographed differently, so we have to be prepared to have good photographs whichever way it is run.

Staff photographers are asked for specific ideas weeks before the Derby and are usually given the opportunity to photograph their ideas. These can be picture stories or specific Derby race pictures. This gives the photographer the opportunity to photograph what he wants and gives the paper the advantage of their thinking as journalists. By following this procedure, we have a better opportunity to produce that different picture each year and a fresh look at the race. Competition among the staff photographers is great and produces some fine results.

In addition to the photographers who come up with their own ideas, we have roving photographers whose assignment is to photograph Derby Day as they see it. They have no specific assignment before the race so they are free to be creative photojournalists.

The entire photographic staff works Derby Day, and in addition we hire freelance photographers to cover specific jobs. Staff photographers have helpers who carry cameras, record cutline information, and occasionally trip remote cameras.

The final planning takes place Derby Week, and changes continue with the developments of the news of the Derby.

But by the day before the race each photographer knows exactly what he will be doing, where he will be standing, and exactly what lens he will use.

Pictures are coordinated with stories from the city desk and the picture editors, so specific stories often are covered by reporter as well as by photographer.

For unexpected happenings we rely upon the professional judgment of the photographers for the coverage. We have never been let down.

As much planning and work is done with the photographic laboratory personnel for Derby Day as is done with the photographers.

Our laboratory staff develops more than 400 rolls of film and makes around 350 prints on Derby Day. So developing, editing, printing, and proper identification procedures must be perfect.

Each roll of film coming to the laboratory is identified with the photographer's name and roll number and is accompanied with cutline material in specially marked packages. The film is delivered to the laboratory on scheduled runs throughout the day. All film is rated at the same American Standards Association (ASA) exposure index so that developing in the automatic processing machines can be standardized.

Some photographs such as the around-the-track photographs are printed a designated size, but most are printed 8 × 10 inches with the best being printed 11 × 14 inches. After a picture editor makes initial selections, the photographers may print additional photographs if they think something has been missed.

The photographs are published in a special derby section of the papers in which photographs are used extensively.

# Color Reproduction

The *Courier-Journal & Times* has been using color photography since the 1930s. In the early days, color photographs were taken on a camera that would separate the color on three different plates. From these plates a carbro print was made, which was then reproduced by rotogravure in the magazine.

Today rotogravure reproduction is still used at the *Courier-Journal & Times*. Standard Gravure—a rotogravure printing plant owned by the same family that owns the newspapers—prints twenty-two Sunday magazines for newspapers around the country, as well as *Parade Magazine*. Spectacolor, a trade name for rotogravure color in the daily newspapers, is also produced at Standard Gravure.

Because of this printing capability and the feeling that newspapers must have good color reproduction to compete with color television and the specialty magazines, the Louisville papers use rotogravure color.

Spectacolor is used for news and feature pictures on the front page and for picture pages. The cover of *Scene,* the Saturday tabloid entertainment magazine, uses color, and the *Sunday Magazine* uses color throughout.

# The Laboratory

Since photography is changing so rapidly, the *Courier-Journal & Times* designed its photographic laboratory to allow for change. What is effective today may be completely obsolete tomorrow because of silverless image-capturing heat processing, automatic daylight enlarging, laser transmission, electronic visual signals with high reproductive qualities—or by processes at the moment undreamed of.

So the Louisville papers built for the future by preparing for their own destruction. All of our internal walls are easily movable. All permanent fixtures like plumbing are restricted to outside walls. The newspapers are ready to move in whatever direction photography moves. We could quickly dispose of all wet processing. We could pull down walls and install machines of almost any conceivable size. We have the space and the flexibility for change. But for the present the laboratory is very efficient. It works in this manner.

# The 99th:
# A Derby
# of records

Secretariat
sets a new mark
... and so do
the bettors
and the crowd

Secretariat, left, and Sham dual in the stretch/Staff Photo by Bill Strode

### By BOB ADAIR
Courier-Journal & Times Staff Writer

Records are made to be broken, the saying goes, and it was only fitting that on Secretariat's day of redemption—Kentucky Derby Day, 1973—the biggest record of all was shattered by the sleek champion himself.

Secretariat's time of 1 minute, 59 2/5 seconds for the grueling mile and a quarter of the world's most famous horse race eclipsed the mark of 2 minutes flat, set by Northern Dancer in 1964.

Whatever the superlatives bestowed on the striking Meadow Stable champion beforehand, none could do justice to the heart-pounding performance to which Secretariat and jockey Ron Turcotte treated the multitudes in the 99th Run for the Roses yesterday at Churchill Downs.

Charging from last to earn the $155,050 plum from the $198,000 purse in the richest Derby ever, the favored chestnut son of the late champion sire Bold Ruler vindicated himself—at the direct expense of Sham—for his only loss of the season.

The latter, pegged as his main contender, led into the long homestretch, known as "Heartbreak Highway," only to fall victim to the fastest final quarter in the classic's history.

Aided by a bright, sunshiny day that still managed to be comfortably cool, the Derby attracted a record crowd of 134,476—as millions more watched on television. The betting also set a record, the fans pouring $3,284,962 into the Derby's pari-mutuel pool and wagering $7,627,965 for the day.

The embattled top pair left others among the 13 starters far behind as they dueled to the wire. Third-place Our Native finished eight additional lengths back, a half-length in front of fourth-place Forego.

Secretariat, breezing under the wire with a 2½-length margin, ran the last quarter in .23 1/5. Only two previous winners—Whirlaway, with .23 1/5 in 1941 and Proud Clarion, with a clocking of .22 4/5 in 1967—had ever negotiated the concluding quarter of a mile in less than 24 seconds.

Unique in having become the only juvenile ever to be acclaimed Horse of the Year, in 1972, then syndicated for a future stud career at a record value of $6.08 million, Secretariat did exactly what the Canadian team of trainer Lucien Laurin and jockey Turcotte predicted he would do.

That was to follow in the victorious footsteps of last year's winner, Riva Ridge, also from the Meadow Stable of Mrs. John Tweedy, and to do so faster and in a more convincing manner. Not since Iron Liege triumphed in 1957 and Tim Tam won in 1958 for Calumet Farm had any stable managed to put together consecutive Derby victories. And never before had the same owner, trainer and jockey won two in a row.

The entry of Secretariat and Angle Light, sent off at odds of exactly 3-2, returned $5, $3.20 and $3 across the board. Sham, with regular jockey Laffit Pincay Jr. restored to the saddle, was the 5-2 second choice. He paid $3.20 to place and $3 to show. Our Native, piloted by Kentuckian Don Brumfield, was the 10-1 fifth choice and rewarded his show backers with $4.20.

The race was run almost precisely to a pattern many experts had anticipated. Possible the main exception was that Angle Light, who led all the way to beat Sham by a head and Secretariat by four additional lengths in the Wood Memorial two weeks ago, was never a contender.

The role of pacemaker, as most predicted, was played by the fleet Shecky Greene, winner of the seven-furlong Stepping Stone Purse at the Downs a week earlier. The colt named for the TV and night-club comedian took the field the first three-quarters before giving up the lead to Sham, then held on better than some expected and wound up sixth.

Restless Jet was fifth, and after Shecky Greene, in order, came Navajo, Royal and Regal, My Gallant, Angle Light, Gold Bag, Twice a Prince and Warbucks.

Shecky Greene and My Gallant also formed an entry—for trainer Lou Goldfine. They were rated as the crowd's third choice at 5-1 and the disappointing Warbucks as the fourth most popular contestant at 9-1.

All carried the Derby weight of 126 pounds.

Secretariat, praised by some observers as potentially the greatest thoroughbred runner since the immortal Man o' War, undoubtedly will go from the Derby to the Preakness Stakes at Pimlico on May 19 in pursuit of the Triple Crown, last won by Citation in 1948. The concluding step, the 1 1/2-mile Belmont Stakes, will be contested June 9 at Belmont Park.

Last year, it was the 1 3/16-mile Preakness that spoiled the bid of Riva Ridge to become only the ninth Triple Crown champion in racing history. After failing there, he won the Belmont Stakes.

"There are two races to go," said Turcotte, referring to Laurin's announced schedule which calls for Secretariat to run in the Preakness and Belmont and then take a break before contesting other important events in late summer. "I'll take them one at a time."

Turcotte said he went to the whip twice in the Derby—once leaving the far turn, when Secretariat raced strongly to the leaders, and in the upper stretch, where the winner briefly lost a little of his momentum.

From there to the wire, Turcotte merely flashed his whip at Secretariat from the left side and the champion responded willingly.

At the start, only Warbucks and Twice a...

See SECRETARIAT
Back page, col. 1, this section

Jockey Ron Turcotte kisses Secretariat's owner, Mrs. John Tweedy, while shaking hands with trainer Lucien Laurin. Mrs. Tweedy's sister, Mrs. Margaret Carmichael, and her brother, Hollis Chenery, look on.
Staff Photo by Robert Steinau

## Derby Day Index

### This Section:
The color of Derby Day . . . A day to dress up, see the celebrities and rub elbows with the masses, picnic and play in the greenness of Churchill Downs infield, gamble on the long shots, limp home in traffic jams and drown your sorrows — or celebrate — in a round of parties.

### Sports Section:
Nuts and bolts of a Derby victory . . . How the winning jockey and trainer saw the race—Section C.

### Today's Living:
Who's who in the boxes . . . A picture page of the notable guests who give a special flavor to the Derby mix—Section G.

### General News:
The regular news and features sections of The Courier-Journal & Times follow this special Derby section.

◄The Kentucky Derby is very important in Louisville, and the newspapers go all out to cover the event. *Left,* cameramen get ready to photograph the finish of the race. A 4 × 5 camera and two motorized Nikons were used at this station.

## General Concept

The photo area is divided into four zones: (1) a fast zone, (2) a supporting zone, (3) a slow zone, and (4) an administrative zone.

### Fast Zone

This zone is where everything happens. This is the hub of the operation. It is closest to the entry doors. It has contact with the news department and the picture editors, who remain on the news floor. It is from this zone that photographers start out on assignments and where they return. This is the point from which contact is made with radio-equipped cars. It is where developing, film inspection, information recording, and printing are done.

### Supporting Zone

This area supplements the fast area. Here are a copy room, print mounting room, special hand-developing rooms, a room for making large prints, and a chemical mix room. If the fast zone is the center of the operation, the supporting zone geographically surrounds the fast core.

### Slow Zone

This zone is off to the side, away from the rush. It includes an area for color and magazine photography, a no-rush darkroom and print room, a camera repair shop, and a studio.

### Administrative Zone

This zone includes administrative offices, a negative file room, storage space, and a photographers' ready room which has cabinets for photographers' personal equipment and cameras, a cabinet of specialized camera equipment, color television receivers, coatracks, reading material, and typewriters. The idea is to keep staff members out of the rush area unless they are needed there. In actual practice, the staff has little time to spend in the ready room. But it provides a point of departure.

## The Way It Works

Just inside the entrance door to the fast zone is the control desk manned by a "veteran" who is in actual charge of dispatching photographers to assignments. He also deals with picture editors and has radio control of cars that are out.

Pneumatic tubes nearby put him in almost instant contact with the picture desk on the news floors below. Through these tubes move the orders for pictures from the two photo desks, and back through the tubes go the finished prints at the end of assignments. An intercommunication system puts the control desk operator in instant touch with photographers who may be inside the department but out of his line of sight.

The control operator deals out assignments as they come in from the news floor, and sees photographers when they return from assignments.

Once past this control man, the work flow goes in a great circle that ultimately leads back to this position. Photographers who bring in film have a choice of two processing machines reached through a revolving door light trap. One machine is used for Tri-X film rated up to 800. The other machine develops film rated to 1,600. Well above 90 percent of our developing is done through these machines, though individual darkrooms are available for special hand developing. These rooms have available to them Acufine, UFG, DK-50, and D-76 developers.

Hand developing is extremely rare in our operation. The key to the success of machine developing—which does produce consistent, predictable, high-caliber negatives—is constant care and maintenance. A man who divides his duties between regular laboratory work and care of the machines is the reason it does work for us . . . and well.

While the machines are developing, fixing, and drying negatives, photographers prepare envelopes for permanent filing of the negatives. Print File Negative Preservers are marked with the date, nature of assignment, and photographer's name. When the negatives emerge from the machines, they are sleeved in the plastic preservers and contact printed on a printer that has rheostat, timer, and special balanced poly-contrast filters. The paper used is

▶
The *Courier-Journal & Times Magazine* is produced by rotogravure, a process which the administrators believe to be best for the reproduction of color. As a result, the Louisville daily papers use only Spectacolor, which is printed by Standard Gravure. It is not unusual to see a page on the Derby or a feature page such as "Country Life" (*right*) produced by the Spectacolor system and run in a regular edition.

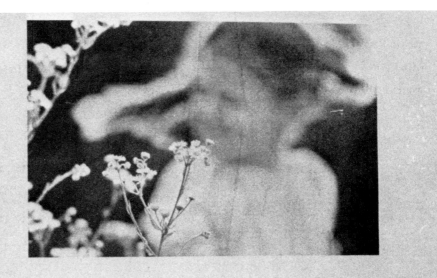

# Country Life

On a visit to her grandparents' home in Austin, Ky., Karen Grabinski takes time out for a late afternoon swing.

Turning the ground over on his farm near Glasgow, Ky. is James Bunch of Barren County.

STAFF SPECTACOLOR BY BILL LUSTER

## Rural Reverie

Life in the country has a charm and grace all its own. Though there is always plenty of hard work to go around, there is time too, to enjoy the simple pleasures and the easy moods of country life.

Greg Smith, 6, and his grandfather, Charlie Brooks, of Cave City, enjoy a leisurely afternoon fishing.

8 ½ × 11 inch Ektamatic, accommodating six negative strips. Two such contact sheets are made, one for the picture desk and the other for the permanent archives. Cutline information is also prepared during this period. This information is typed by the photographer onto a mimeograph sheet which is transferred to the back of each contact sheet and each print that results from the assignment.

Directly adjacent to the place where this information processing goes on is the entrance to the master print room which at present is geared for traditional wet processing. It is possible to bypass wet printing with Ektamatic paper for instant processing, but this procedure is reserved for extreme emergencies. (We have timed it at 13 minutes from photographer's entrance to finished print.) The normal run of printing does not require that speed, and wet printing still accords a higher degree of quality control.

The master print room is 17 by 24 feet. It contains five enlarging booths and two double-sided, temperature-controlled, stainless steel sinks which "work" toward the middle of the room. There, a central sluice transports finished prints through the outer wall to a washer adjacent to the control desk and the pneumatic tubes that will carry them down to the picture desks.

Each enlarging booth is equipped with either a 4 × 5-inch variable condenser Omega enlarger or a 35 mm Leitz enlarger with extralong uprights. The booths were specially designed with light viewers, rheostats, timers, air hoses for blowing dust from negatives, paper bins that hold 8 × 10-inch and 11 × 14-inch paper in five grades, a drawer for exposed paper, and a space for easels, magnifiers, rulers, and miscellaneous equipment. Each lens on each enlarger has been tested and marked for its own particular optimum aperture.

The master print room also contains other equipment one might expect: a contact printer, cabinet for stock paper storage, and sodium vapor safelights which permit an atmosphere not very different from dim daylight.

The printing chemicals—Ethol, LPD, and Kodak Rapid Fix—are mixed in a remote location and gravity fed to faucets at the central developing sinks.

Over each hypo (sodium thiosulfate) tray there is a pinpoint white ceiling light actuated by a floor switch so printers can inspect their work.

Lest men working in the dim confines of the master print room for hours at a time get the feeling they are isolated from the outside, a 2½ × 6-foot window, covered by red safety material, permits them to see what is going on outside around the control desk.

The sluice leads back outside to the control area where everything began. Here there is a 3½-foot circular washer and four old-style flatbed dryers, used because they dry prints faster than anything else we know of. Here, too, are a print straightener, typewriters, cutline information blanks, and the pneumatic tubes.

The entire area—all zones—is under slight, positive air pressure so that when doors are opened air—and dust—flows out, not in.

Since most of our work is 35 mm, cleanliness is imperative. Aside from the outward-flowing air, we fight dirt by forbidding all smoking anywhere except in the lounge and the administrative offices, by a regular cleaning schedule, and by vigilance to avoid pile-up of junk on the floors. There is no flak from any of our laboratory technicians or photographers and administrators. They all recognize an imperative when they see one.

The way things operate now, photographers are expected to develop and print their own assignments unless another assignment presses them. In that case, the work can be turned over to laboratory technicians for processing. Laboratory technicians also regularly process film from stringers, bureaus, and reporters and make special prints.

This procedure could be altered. The place is set up so as to operate as a complete lab system where photographers photograph only.

We have a central stockroom for seldom used materials, but paper stocks are kept near each printing station.

## The Supportive Process

Much of what goes on in the other three zones is self-explanatory. Some of it needs amplification. For instance:

► On the *Courier-Journal* and *Louisville Times* the control center just inside the lab is a veritable beehive. Here the control operator gives out assignments as they come in from the news floor. He also deals with picture editors and has radio contact with photographers in the field. The control operator, a veteran in the business, is an important link in the Louisville newspaper photo operation.

Washed prints *(right)* are being put on a flatbed dryer. Versamat and Pako developing machines are in the background. Light tables used for the selection of negatives can also be seen.

Master print room *(above)* is 17 by 24 feet. It contains five enlarging booths, two double-sided, temperature-controlled stainless steel sinks. A central sluice transports prints through the outer wall to a print washer adjacent to the control desk and the pneumatic tubes which will carry them to the picture desk.

Each enlarging booth (*above*) is equipped with either a 4-by-5-inch variable condenser Omega enlarger or a 35mm Leitz with extra long uprights. The booths are designed with light viewers, rheostats, timers, air hoses for blowing dust from negatives, paper bins, and the like.

## Studios

The main studio is a 25 × 38-foot room with an 18-foot ceiling. Walls, ceiling, and floors are white. Fluorescent lights in the ceiling are color balanced for daylight shooting. Supplementing them is an Ascor sky bank strobe and Ascor umbrella strobes. A collapsing door makes it possible to divide the studio into one large studio and one smaller one for simultaneous shooting. There is a small adjoining dressing room for models and an overhead balcony for high-vantage-point shooting, plus flats and background paper.

The second studio is located by the food department's kitchen where the food to be photographed is prepared. This is primarily for color, using 3,200 Kelvin lights. It, too, is white, except for one end where floors, ceiling, and walls are painted a flat black. This studio has dimensions of 29 × 54 feet and 18-foot ceilings.

## Copying

One small room is devoted to copying and to dry mounting. Equipment here includes a special horizontal copy stand, 4 × 5 Calumet camera and process copy lens. Either 4 × 5 Polaroid film is used, or 4 × 5 Ektapan is developed in the Versamat.

## Camera Repair

Camera repairs can be costly, and shipment to the factory for repairs can result in many lost weeks of equipment use. With 128 cameras and 312 lenses we cannot afford such losses. So we have established our own factory authorized repair station with all the necessary testing machines, calibrators, tools, and spare parts needed. One man operates this shop, as well as help administer our camera amortization program. This program lets the photographer, if he wants to participate, own his own equipment, with the company paying him for its use at a percentage of its value each year. The photographer can obtain all the necessary equipment needed to accomplish his job and can also keep up with the new models and changes in camera equipment.

## Color Laboratory

The color laboratory is equipped with a transparency-processing line and with color enlargers capable of making reproduction or large display prints from 35 mm up to 8 × 10-inch negatives. The majority of the newspapers' color reproduction is from transparencies, but sometimes color prints are used.

▼
The Louisville papers save time and money by maintaining their own factory-authorized repair station. Because of a crew which uses 128 cameras and 312 lenses, they cannot afford the time usually needed to ship equipment to a factory for repairs.

# Archives

The *Courier-Journal* and the *Louisville Times* have under development—and in the final testing stage—a news-clipping recall system using linked microfilm and computers that will summon from the past an image of any printed story that has appeared in the paper. The system is equally applicable to the recall of photographic images. Contact sheets and their accompanying cutline information from each current assignment are now being test fed into the computers. Later, this system will be extended to our file of negatives from past years. Ultimately, any image shot in the past and still in existence, whether it was used or not, will be brought within reach.

# New Areas of Material Use

For years we have felt that it was wasteful that the material presented to our newspaper readers was usually thrown away each day. There is a need to preserve much of the material for use in schools and libraries and for use by individuals for reference material or for nostalgic remembrances.

The newspapers are filed, of course, but we felt the need to present the material in a more permanent form for longer retention, so we started a book division. Several of the books published have been photographic books.

In the future a more extensive use of books, magazines, and filmstrips is planned, all on a regional basis.

Soon the public will be able to use computers for information retrieval of stories and pictures that have been published in the papers.

Nationally, we are operating a syndication service called Pegasus for Sunday magazines and are publishing an abstract quarterly magazine on specialized information.

All of these areas are designed to provide additional material for our readers, which helps achieve the goal of the *Courier-Journal* and the *Louisville Times,* the goal of serving the public.

In newspapers, photographers have the opportunity to introduce man to his fellow man. By appealing to human compassion they can help in the search for a more meaningful world.

If photographers are to be known as photojournalists, they must portray what is going on with trust and integrity; must see a situation as no one else can see it; must photograph it and come back with understanding, awareness, and information that can be communicated only with a camera. I hope all newspaper photographers will accept the challenge, for serving the public is the greatest responsibility and privilege in the world.

# Student Participation

1. Lewis Hine, who photographed in the early 1900s, said "Photography could light up darkness and expose ignorance." Bring to class three pictures from local newspapers which in your opinion do this very thing.
2. Explain the following statement: "Newspaper photographers must be responsible journalists who follow the advice of Carl Mydans: 'Take your pictures with your mind, heart, and a camera.' "
3. Discuss the enterprise system described in the chapter and define a freestanding picture.
4. Discuss the part ethics plays in the Louisville *Courier-Journal* and *Louisville Times* photographic program.
5. Tell what you think Mr. Strode means when he says, "Far too many Sunday magazines have been forever gentle, unprovocative, and sweetly amiable." Bring to class at least one example that upholds the statement.

▲
One of the extracurricular
activities of the Louisville
newspapers is book publishing.
Author, editor, printer, and art
director discuss the printing
quality as the Barney Cowherd
book comes off the press.

# 19

# An Introduction to Color

For many years before it was practical, color reproduction was the goal of the printing industry. Although Currier successfully used the chromolithograph process in the 1840s, the process was slow and expensive, requiring a separate lithograph stone for each of the colors in an illustration. Because of this, most of the color lithographs turned out by Currier & Ives were hand painted. For a number of years, too, fashion plates in *Godey's Lady's Book* and in Peterson's *Ladies' National Magazine* were hand colored in an assembly-line operation. One person painted the blue parts of the steel engraving; another the red feather in the perky little hat; and so forth. This method produced very attractive illustrations, but production was slow and, even with the low cost of labor, expensive.

A system was needed which would permit application of color during a regular press run. Because of this need, spot color, a method still used, was developed. Spot color permits the printing of various colored headlines and illustrations in articles and/or advertisements.

If a sheetfed press is used to do the printing, the page must be run through the press as many times as there are colors. Only one color is run at a time. Occasionally the use of spot color calls for good presswork and close register of the various colors used. For example, if the picture were of a three-colored clown, the red used for the bulbous nose must not completely obscure the tan used for the skin. Color printing requires that each color be kept under control. The job of registration is even more critical in the printing of halftone color.

French Impressionist painters developed realism in color in the 1860s–1880s. Some of the Impressionists used tiny dots of color put down with a finely pointed brush, and in so doing they provided a lesson in color reproduction which is still valid and in use today. Pressmen use the halftone to lay down complementary colors much as the Impressionists had done. Photo-offset and photogravure have added to the quality of many color pictures in present-day newspapers and magazines.

**Printing in color and especially "full color" has always been an expensive process. Researchers have proved, however, that in spite of the additional cost, it is a paying investment.**

# Process Color Printing

Color copy, the copy from which the color illustration is made, can be either a negative color film or a positive print or transparency. Regardless of the form in which a picture is turned in for reproduction, separation negatives must be made. Whether a negative or a positive print or transparency is used, the process is the same. The proper filters are used to separate the copy into the complementary colors. Each color is printed in black and white on special paper. From these black-and-white separations are shot the screened negatives from which eventually come the color plates: the magenta or red plate, the yellow plate, and blue plate. Some newspapers require an additional black plate as a stabilizer.

To emphasize: Newspaper color pictures may be shot on either negative or positive color film. Regardless of how it is shot and regardless of whether one uses a positive color print or a color transparency—or for that matter the color negative—the first requirement is a color separation job. If the copy is a print, it may be color separated, using the proper filters, on a process or copying camera. The negative and positive color transparencies are placed in enlarging machines (now often computerized). Here the various colors are printed in black and white on a special nonshrink, nonstretch sensitized paper. These prints, representing the various separation colors, are screened on the process camera. The negatives so produced are converted into color printing plates, all of which are printed in close register to produce the final color reproduction for the newspaper or magazine. The whole process is almost a miracle. To watch the red, yellow, and blue plates, with perhaps a black plate, turn into pretty, colorful pictures is a pleasure, indeed.

The separation process—the system that breaks the copy into its complementary colors—is one part of the color-printing process which for many years delayed full, complete acceptance of color reproduction. Another factor that hindered wide use of color engravings was the cost. Three or four black-and-white pages can be produced in the same press space required to produce one color picture. Color requires considerable extra work, and it is far more expensive than black and white. Why, then, is color used at all?

# Importance of Color

Surveys have proved that color pages are more popular, that editorial and advertising matter bolstered by color illustrations has far greater readership than pages which offer only black-and-white pictures.

An advertisement in the *Monroe City* *News,* a Missouri weekly newspaper, recently pointed out that "surveys, like the one conducted by the *Independent Press-Telegram,* Long Beach, California, have shown 50 percent, 70 percent, and 80 percent greater dollar sales for a color ad over the same ad in black."[1]

# Run-of-Press Color

Color in a newspaper that is produced by the publication itself is usually referred to as ROP or run-of-press color. Sometimes in an effort to give its readers more and better color, publications use a process known as preprinting. Spectacolor and Hi-Fi are trade names used to identify the products of two business concerns which produce halftone color preprints.

When ordering preprint material, the customer submits pictures and/or transparencies properly scaled, and an accurate layout is submitted with the picture

---

1. *Monroe City News,* May 2, 1974, p. 14.

material to show exactly how it is to run. Type matter can also be provided for use with the color plate. The printer carefully follows instructions. Part of the color side of the sheet and all of the opposite side are left blank, permitting the customer to use type or halftones to fill in with local and timely material.

After the color pictures have been printed, the paper is rerolled and shipped to the user. The roll with the color pictures in place (the preprint), is then printed by the customer who inserts it in his publication for distribution to his readers. The page is marked in the margin outside the printed surface. On the customer's press an electric eye scans this mark which thus acts as a cutoff and adds to the accuracy of the register as the page goes through the press.

# Student Participation

1. Color television produces a wide range of colors by blending the three primary colors: red, green, and blue. Use an encyclopedia to find what is meant by color by addition or subtraction. Be prepared to explain your findings.

2. Why must a painting or a color photograph go through a process of separation before it can be printed in a newspaper or magazine?

# 20

# National Geographic
## The Magazine That Taught Us How to Use Pictures . . . and Color

*W.E. Garrett*

As it has done for ninety years, the little magazine with the yellow-bordered cover still moves quietly and politely through the publishing world—creating little fuss as it gathers records for endurance and popularity.

Nearly one of every five Americans sees the *National Geographic* magazine every month; yet it can be found on no newsstand. And, furthermore, you don't subscribe, you join the National Geographic Society and receive its journal.

The Society, chartered under the laws of the District of Columbia in January 1888 "to increase and diffuse Geographic knowledge" began the irregular publication of its journal in late 1888.

In the two decades between 1885 and 1905 more than 7,500 magazines began publication in the United States. Today only seven of any significance remain: *Vogue, McCalls, Ladies Home Journal, Cosmopolitan, Argosy, The Journal of the American Medical Association,* and the *National Geographic.* Like the dog wagged by its tail the Society became the world's largest membership educational organization. As a result of the magazine's success, the Society yearly grants more than one million dollars for research and exploration.

The only consistent complaint from faithful members who annually renew,

at a near ninety percent rate, concerns problems of storage. Rare is the member so callous as to throw away a single copy. If he does a collector may be waiting to grab it. Edwin Buxbaum's 390-page book, *Collector's Guide to the National Geographic Magazine* serves as a handbook to thousands who collect the magazine as a hobby.

In nearly a thousand issues to date the magazine has published an unparalleled photographic chronicle of our universe—indexed and available to hundreds of millions of people through libraries and sagging home bookshelves worldwide. Like wine of a good vintage its paper, ink, binding, and contents age well. Browsing through old issues distracts many a person bent on cleaning the attic.

The *Geographic* has scored hundreds of journalistic firsts and collected more photojournalism prizes in media competition than any other publication. Yet it makes no pretense to being a news magazine.

Throughout the world the yellow-bordered cover ranks as an institution with the wasp-waisted Coca-Cola bottle. Apropos of such shapes, the magazine has earned a certain notoriety for publishing photographs of bare-breasted women beginning with an 1896 wed-

The magazine that taught us how to use pictures . . . and color, by W.E. (Bill) Garrett, Associate Editor.

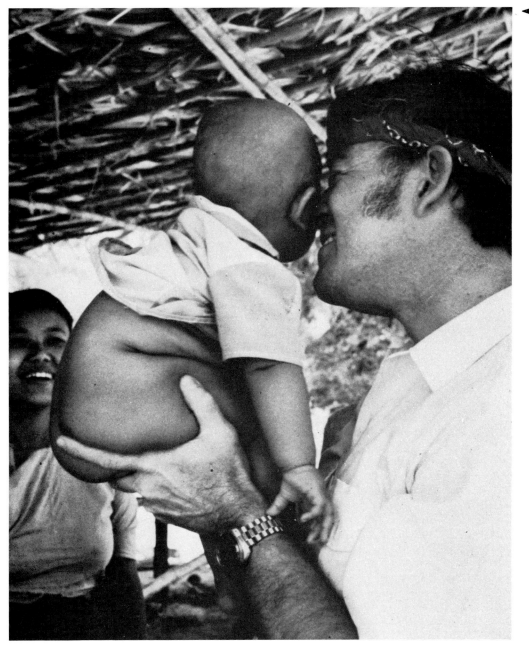

◄ W.E. (Bill) Garrett is Associate Editor of *National Geographic* magazine in charge of illustrations. In addition, he is responsible for planning future articles and for the writing and photography of many special articles on his own. He has contributed chapters to several of the Society's books, and was coproducer-narrator for the television special *Alaska!* which earned the 1967 Ciné Golden Eagle Award. While he has used "words and pictures," to produce articles from Canada, Alaska, and Mexico, his chief interest is in Southeast Asia where he has covered eleven major assignments.

Much in demand as a lecturer, Mr. Garrett has appeared at seminars and special journalism programs at the universities of Alaska, Boston, Harvard, Maryland, Miami, Minnesota, Missouri, North Carolina, Southern Illinois, and Syracuse. He also has lectured to the Cosmos Club in Washington, D.C., and to the Asia Society of New York. A frequent staff member of the University of Missouri Photo Workshop, Garrett was also a staff member of the National Press Photographers flying short course in 1966, 1972, and 1973.

Among the many honors he has received is the Magazine Photographer of the Year award in 1969; co-recipient of the Overseas Press Club's award for Best Photographic Reporting from Abroad, 1976; University of Missouri Honor Award for Distinguished Service in Journalism, 1978.

As a result of his world travels Garrett has friends in many remote areas of the globe. In this photograph *(left)*, taken in 1973, Garrett says hello to a youngster in Pagan, Burma. He had visited the baby's parents in 1971, and they were proud indeed to introduce Bill to their new offspring. (Original picture in color.)

ding picture of a Zulu bride and bridegroom. Yet the *Geographic* has seldom been accused of vulgarity or sensationalism and is generally considered a family magazine.

Partly because of the lack of newsstand sales, the small format, and its universal popularity, it not-so-happily ranks as the most stolen magazine in history. Postal clerks worldwide seem to be the first to spot a story on their area. Occasionally members receive their copies—after they have been well read.

As other magazines weakened and died, frenziedly competing for circulation and advertising, the *National Geographic* has continued to enjoy a steady five-to-eight percent growth rate. In 1978 circulation passed ten million. One month's issue would form an impressive—if unwieldy—stack forty-five miles high; equal to eight Mt. Everests.

This phenomenal success must be credited largely to the early, extensive, and continuing publication of the best in color photography. As a bee and his

flowers enjoy a profitable relationship, the *Geographic* and color photography developed together in a symbiotic dependence nearly as inseparable as nectar and honey. From the first pale stone engravings of views of Nicaragua published in its fourth issue in May 1889, the magazine's pioneer utilization of color illustrations expanded until 1961 when high-speed web presses made possible excellent color reproduction on every page.

In addition, the *Geographic* contributed to the present success and popularity of color. Its photographers and technicians made significant contributions to equipment and techniques basic to color photography.

The first underwater color photograph of a coral reef fish was made in 1924 with equipment built by the *Geographic*. Today Bob Sisson shoots action candids of microscopic creatures on equipment he designed that gives a 25-diameter magnification.

But the magazine's most important contribution may have been its continuing development of a public awareness of color aided by the practice of crediting on every color picture published not only the photographer, but also the type of film he used. From the first Lumière Autochrome of a flower garden in Ghent, Belgium, published in 1914, through Finlay Color, Dufaycolor, Agfacolor, etc., these by-lines traced the development and use of new emulsions.

In the Autochrome process, developed in France in 1907, tiny particles of potato starch dyed red, green, and violet blue were spread on a glass plate and coated with a sensitive photographic emulsion. The plate was exposed with its uncoated side facing the camera lens so that light passed through the colored grains before reaching the emulsion. Developing the plate in reverse produced a positive color transparency.

Autochrome was used by *National Geographic* until the early 1930s, but at one time and another the magazine also used most of the other early color processes.

The Finlay color screen mosaic plate of the 1920s had 175 lines to the inch and was a refinement of the earlier Paget plates. A panchromatic glass plate was exposed in the camera behind a so-called taking screen, then processed to a negative and contacted onto a high-contrast emulsion. After further processing, this was registered with the viewing screen to produce a color transparency.

The Finlay system required special holders, and was not quite as fine-grained as the Autochrome plates, but it was faster, permitting photography of people moving though not too quickly.

Agfacolor, a German process, substituted dyed resin for the dyed potato starch used in Autochrome plates, and permitted photographers to record action at twice the speed of Finlay plates.

Dufaycolor, developed in the early 1930s, was the first to use film instead of glass plates. The mosaic screen on Dufay film had parallel lines of blue and green crossed with lines of red and gave excellent color rendition.

The big breakthrough in color photography came with the introduction of Kodachrome in the 1930s. Film packs were smaller and lighter than glass mosaic plates and had the virtue of not breaking when jounced for hours along backwoods trails or down river rapids.

Beginning in 1938 the monotonous regularity with which photographic credit lines started with the words "Kodachrome by . . ." made Eastman's remarkable roll film a household word and speeded acceptance of 35 mm color photography by professionals and amateurs. Film credits were discontinued in the January 1972 issue, but the magazine still receives letters pleading, sometimes demanding, that they be reinstated.

Throughout its history the *Geographic* has been subject to praise, criticism, and spoofing.

Frank Luther Mott in his Pulitzer Prizewinning *History of American Magazines* (1957) was complimentary:

There is really nothing like it in the world. For more than half a century the *National Geographic* has not published a single monthly number that has not been interesting and informative, with some measure of permanent value. If it has seemed to some critics too much of a picture book, even they have to admit that in this it is in harmony with its times, and that its pictures are educational in a high degree. By the middle of the twentieth century it had attained the largest monthly circulation in the world at its price, and it had an assured position among the top ten monthly circulations at any price. This is

a fabulous record of success, especially since the magazine is founded upon the editorial conviction that rates the intelligence of the popular audience fairly high. The NGM has long represented an achievement in editorship and management outstanding in the history of periodicals.[1]

"More sophisticated" publications enjoy painting a pith-helmet-and-puttee image of the *Geographic*, while they marvel at its mystifying success. The magazine treats the occasional condescending satire with the disdain of a St. Bernard for the yapping of a toy poodle. One of the most ingenious and amusing lampoons appeared in the September 1958 issue of *Mad* magazine. The spoof was titled "The National Osographic Magazine," and it aped the archaic, gingerbread makeup and, with devastating effect, mocked the ingenuous titles then in vogue. It featured articles on "Shooting Mau Maus for Fun and Profit" by Trigger Castalni and "Hootchie-Koo Women Don't Wear Clothes" by Lemuel T. Lecher. So brilliantly did the picture captions mirror *Geographic* text style that the editor considered hiring the author.

In February of 1973 NBC's "Today" show devoted five valuable minutes to a complimentary discussion of the *National Geographic* magazine on its seventy-fifth birthday. Fortunately, or unfortunately, they had not checked their copy with the *Geographic's* meticulous research department. NBC missed the birthday by ten years.

In the third edition (1971) of *Collector's Guide to the National Geographic Magazine*, Edwin Buxbaum, a friend and unabashed admirer of the magazine, felt obliged to note, "Others have been critical. They complain about the text . . . the style has been described, by them, as old-fashioned, archaic, Pollyannaish, or 'Dear Aunt Sally.' "

Traditionally, the magazine has attempted to be accurate and objective, but in recent years under the editorship of Gilbert M. Grosvenor the rose-colored glasses have come off, occasionally to the displeasure of politicians and pressure groups. In the April 1974 issue, for example, an article on Damascus stirred the Syrians to temporarily ban the *Geographic* from their country. The same article prompted the American Jewish Congress to picket Society offices in Washington, D.C., claiming the magazine had been unfair to Syrian Jewry. Editor Grosvenor remarked, "Today there's no middle ground in the Middle East."

*Geographic* members still look to their magazine for vicarious, even escapist, experiences with the world. But as events and controversies of the past two decades stripped away much of the American public's naiveté, they have demanded and received objectively and accurately more of the unsweetened facts of life.

Possibly with some exaggeration for effect, President Harry S Truman once said, "The only thing new is the history we don't know." To understand the success of today's *Geographic* we must consider its history.

A distinguished group of thirty-three men formed the National Geographic Society in January 1888 and began publication of its journal in October. Gardiner Green Hubbard served as first president and was succeeded by his son-in-law, Alexander Graham Bell, in 1898. Ten years later, the one thousand-member Society verged on bankruptcy.

Bell hired, at his own expense, a young man who had just graduated *magna cum laude* from Amherst and who happened to be courting his daughter, to try to save the journal.

This first full-time employee of the magazine, Gilbert Hovey Grosvenor, reported for duty as an assistant editor on April Fools Day, 1899, and the *Geographic* success began to unfold. Although only twenty-three years old, the young man immediately exercised strong leadership. He overshadowed and eventually abolished the awkward committee that had guided the affairs of the fledgling publication. Within the year he rejected all the suggestions of the Society's consultant, the famous publisher S.S. McClure, that "the magazine move to New York, change its name, go to newsstand circulation, and never again mention the Society because people disliked geography." Also, Gilbert Grosvenor married Bell's daughter.

1. Frank L. Mott, *History of American Magazines* (Cambridge, Mass.: Harvard University Press, 1957).

By 1886 Frederick Ives had developed the halftone method for reproducing photographs, but steel engravings were still in vogue. The magazine had already published a few halftones when Grosvenor arrived, but they were generally considered vulgar and less desirable than steel engravings. The young editor found them much cheaper and more satisfying than line engravings. Soon, he was using them liberally in *National Geographic*. To obtain photographs he scoured government agencies and telephoned and wrote indefatigably to explorers and travelers. Soon, spending a month's pay to acquire a bulky, 4-A folding Kodak, he began taking pictures himself.

In 1903 he borrowed photoengravings from the Bureau of Education to illustrate an article on reindeer in Alaska. The following year a Russian explorer sent him fifty photographs of the mysterious Tibetan capital of Lhasa: Dr. Grosvenor ran them across eleven pages.

The magazine became a vigorous advocate of the camera, publishing photographs in unprecedented numbers. In 1906 Congressman George Shiras III—a pioneer in the techniques of hunting animals with a camera instead of with a gun—offered *National Geographic* a box filled with unusual flash pictures of wild animals. The magazine ran seventy-four of these photos. Two members of the editorial board resigned in a huff, charging that Dr. Grosvenor was "turning the magazine into a picture book."

Backed firmly by his father-in-law, Bell, young Grosvenor survived not only this crisis, but also several subsequent attacks. His spirit of innovation led to a spectacular sixty-seven-year career as a giant in publishing history.

Possibly Gilbert H. Grosvenor was the United States' first professional picture editor: certainly he was its most successful. His genius made the magazine a success and the magazine made him famous. He edited it for more than half a century while simultaneously serving as president of the Society. In 1954 he resigned these titles to become chairman of the board.

The Hearstian sensationalism and intense muckraking so prevalent throughout the early twentieth century in American journalism apparently never tempted him to nudge the magazine from its conservative course. In developing his editing format he imposed his own cultured background, thoughtful personality, and Victorian courtesy to create a different, but highly successful, form of journalism.

His seven guiding principles in editing were:

1. Insist on absolute accuracy.
2. Use an abundance of instructive and beautiful illustrations.
3. Everything must have permanent value.
4. Avoid trivialities and material of a personal nature.
5. Use nothing partisan or controversial.
6. Use only what is of a kindly nature: nothing unduly critical.
7. Plan each number for maximum timeliness.

How Dr. Grosvenor applied this unique and unlikely policy was best summarized in a eulogy by his longtime associate, Frederick G. Vosburgh:

Fortunately some of these points, notably numbers five and six, had a certain built-in elasticity and the Editor determined the amount of stretch. There was never any doubt about this, or about his editorial courage. . . . This mild-seeming gentleman of courtly manners had the soul and heart of a fighter. Those who challenged his plans and principles struck steel beneath the velvet. . . . The Chief, or GHG, as we called him (although nothing but Dr. Grosvenor to his face) was not the kind of editor who would ask writers to conform to his preconceived ideas. "Just make it interesting," he would say to a staff man setting out on an assignment. Two or three generations of *Geographic* men and women owe to him our traditional freedom to report the world as we find it. Our only limitation was summed up in his seven guiding principles.[2]

2. Frederick G. Vosburgh, "To Gilbert Grosvenor: A Monthly Monument 25 Miles High," *National Geographic Magazine* (October 1966) 130:445-87.

▶
Marking the twenty-third anniversary of the atom bombing of Japan, South Vietnamese children pray for peace on an island in the Mekong River. The photograph (*right*) by W.E. Garrett appeared on the cover of the December 1968 issue of *National Geographic* magazine.

134, NO. 6    DECEMBER, 1968

# NATIONAL GEOGRAPHIC

SEE "REPTILES AND AMPHIBIANS," TUESDAY, DEC. 3, ON CBS TV (page 875A)

OFFICIAL JOURNAL OF THE NATIONAL GEOGRAPHIC SOCIETY WASHINGTON, D.C.

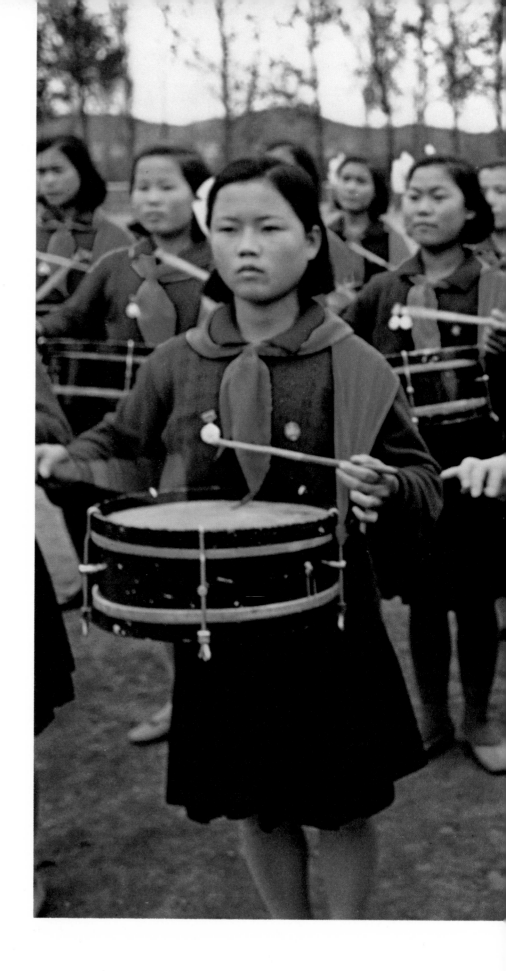

**A Rare Look at North Korea** by
H. Edward Kim. Vast changes
have come to China and North
Korea in two decades; yet
political barriers have kept
Americans from getting the
facts firsthand. When
restrictions eased in 1972,
*National Geographic* began efforts
to send in staff members.
Finally, North Korean officials
agreed to admit *Geographic's*
layout editor, H. Edward Kim,
the first American
photojournalist allowed inside
Korea in twenty-five years. His
word-and-picture report
appeared in the August 1974
issue of the *Geographic* and won
an Overseas Press Club award
in 1975. The picture portrays
children of a new order. The
red neckerchiefs identify them
as members of the Young
Pioneers, a Communist Youth
Corps. The group wear
achievement medals and badges
portraying North Korean
President Kim Il Sung.
(Photograph by H. Edward Kim
© National Geographic Society.)

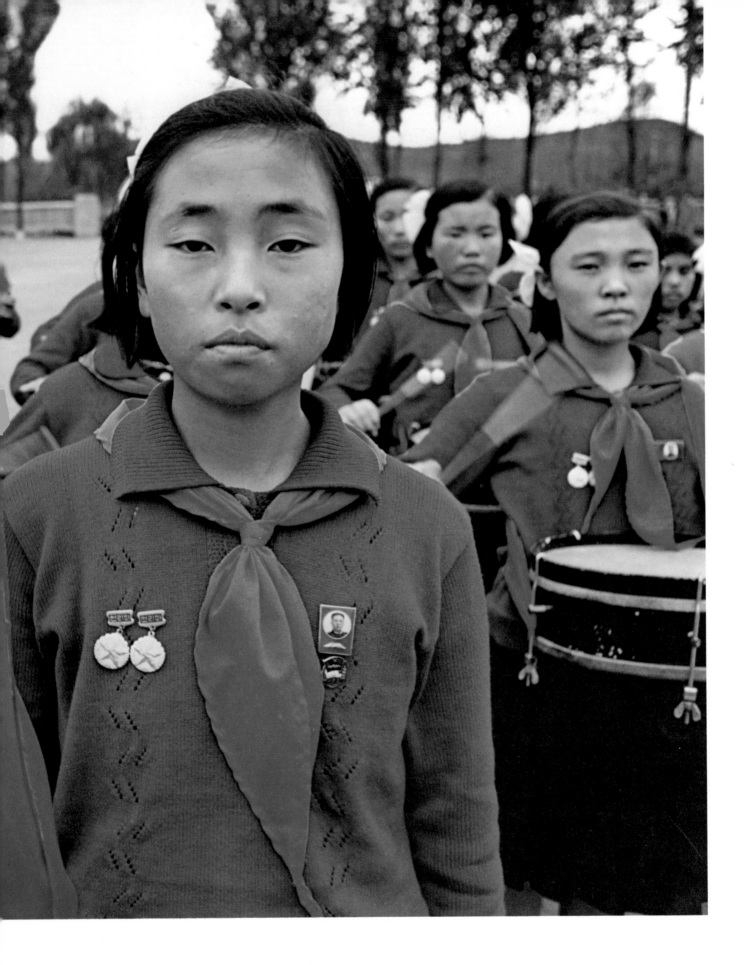

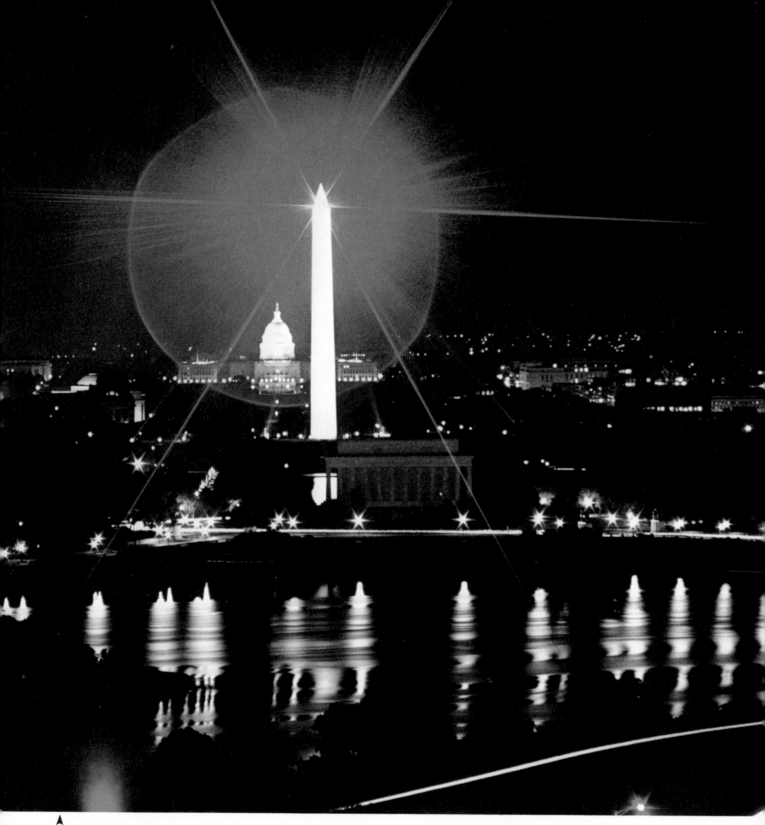

Asked to produce a laser beam photograph for an article to appear in a *School Bulletin*, a *National Geographic* photo crew headed by Arlan Wiker took the assignment in stride. The brief

caption for the cover picture (*above*) of the *National Geographic School Bulletin* read: "Highly concentrated laser beam flashes across the Potomac River from the Washington Monument."

Laser is an acronym formed from the first letters of *light amplification by stimulated emission of radiation* (see chapter 23, p. 288).

In 1970, Mr. Garrett did a story on Mexico for *National Geographic* magazine. These children *(above)* were some of the friends he met at that time. (Original picture in color.)

Mr. Vosburgh applied the principles in his own very successful manner. Under his editorship from 1967 to 1970 the membership grew another million.

Over the years many awards have accrued to the *Geographic* and its editors, but perhaps none so influenced the present magazine as the University of Missouri's School of Journalism Distinguished Service (to journalism) Medal presented to Dr. Gilbert H. Grosvenor in 1954. In accepting the Medal the editor said, "For fifty years I've practiced honesty in photography, and today I met a group of young people dedicated to the integrity of the published photograph."

His fascination with techniques and principles taught by the school led to a continuing interaction with the school and its annual one-week Photojournalism Workshop. Over the next decade this special relationship led to the hiring of many graduates of this university. "Too damn many," complained some of the staff. But the Midwest journalism background provided ideal training for maintaining the honest, unpretentious, and unsophisticated photographic tradition of the magazine.

A flood of young talent soon became a necessity to keep pace with the driving, aggressive leadership of the new editor, Melville Bell Grosvenor. After working for thirty-seven years in the long shadow of his father and his immediate predecessor, John Oliver La Gorce, in 1957 he took over a magazine that had grown stodgy toward the end of their patriarchal reign. MBG, as the staff knew him, burst over the scene like a cluster of Fourth of July rockets on a quiet night. In one decade, with a revitalized magazine as its core, he more than doubled membership from 2,175,000 to 5,500,000, and transformed the Society into a multimedia publishing giant.

*Geographic* books became the most lavishly illustrated bargains in the history of publishing. He launched an atlas and globe program and initiated a television series that immediately set records for both documentary integrity and audience response. Network officials, with the same foresight exhibited by publisher McClure sixty years earlier, had insisted that there was no place in their dynamic new medium for the little geography magazine with the yellow-bordered cover. One wrote of a *Geographic* presentation that surpassed all previous audience ratings for documentaries . . . "It was a fluke, don't expect it to ever happen again." But it did, repeatedly.

In 1963 MBG moved the Society and its magazine into new headquarters, a ten-story building designed by Edward Durrell Stone that stands as an outstanding example of functional modern architecture in Washington, D.C. A similar building twice as large now houses computers, business offices, and correspondence sections required to handle the Society's business.

One of Dr. Grosvenor's first acts as president was to order new high-speed web presses designed and built to replace the sheetfed presses that had become a sentimental luxury.

When he called the staff together to announce that we would drop black-and-white photography and go to all color immediately, a member of the business department moaned, "We'll go broke."

Instead, the membership responded to this daring innovation, and the revitalized annual growth rate of nearly ten percent more than covered all costs.

This year Dr. Grosvenor explained, "If I hadn't made the move, we probably would have folded. We went from sixteen small presses to four large ones. Our paper costs dropped twenty percent immediately with the big rolls instead of the sheets. The quality of the magazine improved dramatically. In publishing, you simply cannot stand still."

More important than any equipment, Melville Grosvenor brought a receptivity, a hunger for new ideas and approaches that stimulated his staff. He edited and led with an enthusiasm described by some as brilliant, by others as childlike and uncontrolled.

At the outset, he formed a planning council to advise him.

"I wanted to hear what all of them had to say—not just the big guy, not just the guy who talked the loudest, but the little guy over in the corner, too. They weren't a committee but a council. I listened to their advice, then went in my office, thought it over, and made the decision myself. You can't run a magazine by committee."

Typical of his faith in color photography is his attitude toward *Life* magazine.

"It was such a great magazine. What a shame they had to fold. You know, I think if they had used more color they might have made it."

At the heart of his system—like the core of a nuclear reactor—he enshrined the magical little 1 × 1½-inch color slide. Engravers had been encouraged, trained, and assisted in making plates from 35 mm film for the *Geographic* when most publishers and printers wouldn't touch the "toy" film.

Custom equipment made possible efficient processing, labeling, editing, and filing of masses of the little slides. Every editor and writer concerned with photographs is furnished with light tables and background projection equipment. A layout machine projects transparencies to page size, and black-and-white prints on nonstretch paper are produced and pasted into a master dummy. Copies go to all editors, writers, engravers, and printers involved in the story.

Inevitably at the end of every assignment loomed the dummy approval or projection session. For some staff members these meetings offered all the charm of rowing into a hurricane in a leaky rowboat.

In a carpeted and paneled room the editor, dummy makeup in his lap, sat before a rear-projection screen which resembled a television console. All staff members concerned with the story gathered behind him. Equipment, custom-built to his specifications, permitted the editor to change, focus, enlarge, and reduce and crop 35 mm slides exactly as he wanted.

As room lights dimmed, all other concerns faded and the editor became part of the story with an enthusiasm that usually kept him on the edge of his chair. His love affair with life was contagious. "Would you look at that," he would marvel. Often he touched the screen as if the act would waft him into the exotic scene before him. Dozens of questions flowed as fast as answers could be found among the staff present. Crops and placements on the page were challenged. His knowledge of geography and astonishing expertise in 35 mm photography could cower a photographer or picture editor not rock-sure of his story. He loved his photographers, but there was a saying around the office that "you're only as good as your last story." No one wanted his last story to be a bad one.

Every session had its lectures. "I'm sick and tired of goggle-eyed flash pictures." "Can't we use available light?" "We don't have space in our magazine for pictures that don't help tell the story."

The side stitching or stapling essential to make a permanent binding creates a tight, awkward gutter. It bothered him more than anyone. "Keep the pictures out of the gutter," was a recurring order from MBG.

A generous number of rejects were provided for his scrutiny. God help the picture editor if too many were better than the selects. Occasionally he took exception to the story approach and ordered the dummy scrapped or revised.

But a story he liked provoked an effusively scribbled "Congratulations" on the dummy cover—usually addressed to no one in particular, but savored by all who had worked on it.

A picture editor who survived a few years of projection sessions had learned the *Geographic* system. He could look to promotions and a long career in a variety of areas within the organization.

Among the old grads are: Barry Bishop, member of the Society's Committee for Research and Exploration; Robert L. Breeden, Senior Assistant Editor and Chief of the Special Publications and Filmstrip Divisions; Donald Crump, Special Publications Illustrations Editor; Robert Gilka, Director of Photography; Leonard Grant, Editorial Assistant to the President; Joanne Hess, Chief of the Lectures Division; Bryan Hodgson, Senior Editorial Staff; H. Edward Kim, Layout and Production Editor; Michael Long, Editorial Staff; O. Louis Mazzatenta, Senior Assistant Editor; Thomas R. Smith, Illustrations Editor; Herbert S. Wilburn, Director, Control Center, and most important, the present editor, Gilbert Melville Grosvenor.

Another assignment of Bill
Garrett's for his magazine was a
story on Alaska. In 1966 he co-
produced a National Geographic
television special on Alaska.

I have been promoted, too, but after twenty-four years I still have not graduated. As Associate Editor responsible for selection and layout of illustrations, I'm still facing the sessions; only now we average six or seven stories a month instead of five, as a few years ago. There have been two new editors since Melville Bell Grosvenor moved to Chairman of the Board in 1967, but projection sessions still determine the fate of every story.

Under editor Gilbert M. Grosvenor, a young, dynamic staff now produces the finest magazine in the Society's ninety-year history. In addition the Society produces five illustrated books a year, a four-title set of children's books, six public service books and an atlas with a total sales to date of some 34,000,000 copies. A print order of half a million copies of Geographic titles is not uncommon. National Geographic World, a children's magazine, has grown to 1.6 million circulation since its inception in September, 1975. Filmstrip series use more color photographs than the magazine.

The magazine originates more color assignments (45,000 rolls shot in 1977) and publishes more color photographs (over 5,000 in 1977) than any other publication in the world.

Prophets of doom would have us believe the day of the still photograph somehow is over—that it died when Life folded. Just as Mark Twain responded to a report of his death by quipping, "The reports of my death are greatly exaggerated," so photography can respond by showing more markets today than ever before. And even Life has been raised from the dead.

After the mirror, the still camera ranks as man's favorite tool of visual communication. This "mirror with a memory" is still a fledgling—it has countless places to go and people to see and events to record—perhaps even in worlds undiscovered. The little magazine with the yellow-bordered cover will be around to publish the best of what is photographed.

# A Story from Genesis to Revelation

The germ of a Geographic story idea may emanate from the myriad sources available to any publication—editors, readers, field men, and so forth. Most funnel through the Editorial Planning Council to the editor. Upon approval, photographer, writer, and picture editor are assigned. A story conference with the editor precedes field travel. Once on location, the photographer and writer work together or separately, but regularly compare experiences and trade ideas.

With thorough captions, film shipments are made as often as possible. A technical staff reviews all processed film for possible camera trouble before it goes to the picture editor.

He will try to keep in close contact with the photographer, detailing story progress by telephone, cable, or letter. Upon completion of field work, the photographer, picture editor, and layout editor (and the writer when possible) work up a layout taking into consideration any artwork or maps required.

The editor, at his projection session, approves, alters, or kills the package. If approved—a high percentage are—the original transparencies go to the engravers. An elaborate quality control system traces them through production and onto the presses. In 1977 the Geographic converted from letterpress and offset printing to high speed gravure. The W.F. Hall Company built a new printing facility in Corinth, Mississippi, where they print and bind the 10 million monthly copies. Computer-produced tapes of addresses are sent from Washington by bus. They are within hours of being up-to-date with address changes. Over 9,000,000 pounds of magazines fill 225 Post Office semitrailers per month and begin the journey to coffee tables of the world.

This capsule story trip compresses to its utmost simplicity the work of dozens of people which may stretch over months or even years.

# The Geographic Photographer

Because he travels far, well, and adventurously, the *Geographic* photographer holds one of the few jobs left in the world that evokes the romantic Richard Halliburton image. In truth, he goes places that would stir a green envy in Halliburton. One of Barry Bishop's assignments took him to the top of Mt. Everest. Tom Abercrombie crossed the Arabian deserts with Moslem pilgrims to the heart of forbidden Mecca. Five years earlier he was the first journalist to reach the South Pole. Dean Conger crossed Inner Mongolia and wintered in Siberia. Luis Marden discovered and photographed the remains of Captain Bligh's H.M.S. *Bounty* off the shores of remote Pitcairn Island.

Today the average *Geographic* staff or free-lance photographer is in his thirties, speaks several languages, has a sensitive eye, and a delicate ego. He must be physically, emotionally, technically, and creatively competent to handle any assignment on short notice anywhere Director of Photography Robert Gilka needs him.

He must be well educated although not necessarily in a formal, degree-oriented system. Once he is hired, the world becomes his campus, and serendipitously the job provides an education no school can match.

Because of their talent, their unique adventures, the demands for thorough research, and on-the-job training that

comes from working closely with staff writers and editors, *Geographic* photographers often become writers themselves. A few years ago five of the top ten articles in the annual readership survey were by photographers or were picture essays.

But successful *Geographic* stories and ego-balming adventures exact their tribute. Extended and lonely absences generate a high divorce rate for staff families. Even when wives travel with the photographers, problems arise. A romantic Arab sheik offered Tom Abercrombie fifty camels for his attractive wife.

A photographer must have a taste for exotic food and the guts to digest it. But even the most travel-toughened stomach falls victim to the countless intestinal germs that seem to lurk in every pot. One man quit because his stomach could not handle the job.

I have eaten rat and deadly jungle snakes and sucked the brains from chicken heads as an honored guest. I have drunk the bile of a cobra mixed with Chinese wine, thought by my host to be an aphrodisiac. I have sorted bugs and vermin from cold rice with Asian armies. But by actual count I have suffered more stomach misery from hotel food than from any primitive fare.

At the same time the bugs you swallow work inside, you may be literally eaten alive from the outside by mosquitos, black flies, bloodsucking leeches, or plain bedbugs.

Every field man carries his bottle of pills marked "For Fevers of Undetermined Origin." Still, malaria, hepatitis, and diseases yet unnamed slip past the best defenses.

Insensitivity to a custom official's desire for a bribe can cause hours or days of sweltering and exasperating delays. Aluminum camera cases hold a magnetic attraction for thieves and con men.

While photographing a fire-walking ceremony in Burma—the entranced crowd pushing and jostling—I felt the weight of a spare camera go slack on my shoulder. I spun and grabbed in time to retrieve my departing Leica, its strap neatly sliced through.

To an unruly crowd of two or more a photographer offers an easy target for their anger. Loren McIntyre received an unprovoked beating and kicking in Peru recently at the hands and feet of a mob of gringo haters. Loren keeps in shape by running ten miles a day, so was able to save himself by executing a very hasty retreat—without his cameras.

Melville Bell Grosvenor's helicopter crashed and burned in Australia in 1969. He leapt clear, but his cameras and lenses became molten exhibits for an insurance claim.

Many of us have been shot at, but only two have been hit. Dickey Chapelle, a free-lance journalist, died in Viet Nam while on patrol with the Marines. Although Dickey was not on a *Geographic* assignment at the time, she photographed and wrote often for the *Geographic* and was part of the family.

Emory Kristof received a mortar wound in the right eye while doing a story on the United States Army in Viet Nam. Fortunately, he recovered the use of the eye.

Particularly on nonhazardous jobs where the good photographs come hard, the photographer is often up before dawn breaks. Days have no end and weeks have no Sundays.

Competition for space toughens every year. Excellent photographers continually appear at Bob Gilka's door, some bringing fully developed stories. Yet the number of pages available remains fixed at about 146. Approximately one-fourth of the stories flow in from adventurers, scientists, naturalists, and laymen with stories to tell.

Every astronaut to go to the moon became a *Geographic* photographer, and three provided articles. David Scott wrote the only article ever published on what it is really like to walk on the moon.

Japanese adventurer, Naomi Uemura, recorded his solo journey to the North Pole for an exclusive *Geographic* article.

Many of the magazine's great bird photographs of the past decade have come from Frederick K. Truslow, a former businessman who has spent a large part of his retirement years zipped into a sweltering blind.

Since Gilbert H. Grosvenor served as the first staff photographer and staff writer as well as editor, field work (writing, photography, and often both) has been the rule rather than the exception for *Geographic* editors.

"You've got to shove people out of the office," insisted Melville Bell Grosvenor. "How else will they learn about the world. We don't edit from some ivory tower."

Frigid lather of the Antarctic rimes the beard of *Geographic* staffer Thomas J. Abercrombie. When his one-hour visit to the South Pole lengthened into three weeks—his plane blew a gasket—Abercrombie volunteered to help dig a snow mine for water and glacial study. Here his face shows the result. (Original in color.)

The handsome headquarters of the National Geographic Society (*above*) rises ten stories above the heart of Washington, D.C., six blocks from the White House. Since 1963 it has served as home base for the Society's executives, editors, and roving staff men. Designed by renowned architect Edward Durrell Stone, the building is lauded as one of the most beautiful in the nation's capital. (Original in color.)

# F8 and Be There

Although I have not been privileged to be on the prestigious photographic staff, I have often worked as a photographer and writer because of this policy of "shoving" editors out of the office.

As a photographer you hope viewers will appreciate and dwell on your photographs' content, but all too often, perhaps for lack of anything else to say, they will ask, "What f-stop did you use?" Such a question is comparable to asking a writer what ribbon he used to type a story. For a while my stock answer to the how-did-you-make-that-picture? type of question, was, "F8 and be there." The answer may seem snide or secretive, but it was not meant to be. Seldom do I remember what f-stop I used, or the shutter speed for that matter. Technique varies as writers' styles vary, but basically there are no secrets in either profession.

Every imaginable photographic device from the electron microscope to Skylab's orbiting solar telescope may be used to make *Geographic* pictures, but basic

equipment for assignments remains the ubiquitous and versatile 35 mm camera, both range finder and reflex types available to every amateur.

Thorough knowledge of photographic technique compares to a writer's need for good grammar. Among professionals both must be taken for granted. But, to follow the simile: straightforward technique without gimmicks compares to simple declarative sentences as the surest way to communicate with a reader or viewer. Naturally, how creatively basic technique is applied determines a photographer's professional competence.

I do not demean technical skill, but today learning basic camera technique is easier than learning to type. It should not be necessary to deal with it in a university curriculum. For teaching advanced skills photographic schools are generally better equipped and staffed than an academic institution. Also, a good apprenticeship offers excellent training.

▲
Actively engaged in a projection session about West Australia, photographed by James Stanfield *(lower right)* and written by the late Kenneth MacLeish, senior assistant editor *(second from left)*, is this group of National Geographic editors. In the center, holding a layout and looking at the screen is Gilbert M. Grosvenor, editor. Behind him is Bill Garrett and next to Garrett is H. Edward Kim, layout editor. At Garrett's left is Robert E. Gilka, director of photography. (Photo by Joseph J. Scherschel, original in color.)

Despite my foregoing protests: just a word on technique. In addition to two cameras and several lenses, my gadget bag always contains a small electronic flash, a penlight, and a tabletop tripod that can be braced against any firm support or used as a chest pod. With this equipment most of the photographic problems I have encountered can be handled. Certainly when more elaborate equipment becomes necessary and is available, it should be mastered and used. But too much equipment can hobble a photographer as much as too little. When a picture situation becomes a production, the pictures can slip away amid all the confusion.

As for the "be there" part of my answer, for the photojournalist there can be no substitute. Portraits cannot be shot by telephone—yet. Wars cannot be covered from bar stools safely away from the action. To photograph a walk on the moon you must be there.

There are different qualities of "being there." Some aspiring photographers would not see a picture if it jumped up and exposed itself. Others seem always to be instinctively into a situation. Like a puppy following its mother, good luck follows photographers who research their assignment and are prepared intellectually and physically to work hard, quickly, and to the point.

No matter how simple the equipment or smooth the photographer, his presence seldom goes unnoticed today. Truly candid photography is rare.

Rapport with the subject may be the single most essential condition to a successful job, yet it becomes increasingly difficult as the power of the camera becomes better recognized. It does not just document and educate—it can also hurt, humiliate, and anger.

A Mexican butcher once chased me through a market waving his cleaver because I "grabbed" a photograph of him at work. I didn't stay to find out why he did not want his picture taken.

Many of us have surrendered our film and occasionally had a camera smashed by self-appointed censors in sensitive areas. George Mobley once fled for his life across rooftops in Beirut while the *Geographic* writer blended with the mob which chased him. According to George the writer joined in screaming "get the photographer."

▼
At a dummy approval session W.E. Garrett, Associate Editor, responsible for all graphics which appear in the *National Geographic* magazine, identifies a marine mammal. This projector is designed to view 35 mm transparencies of photographs which appear in a dummy. The transparencies can be enlarged or reduced on the screen to determine size shots will appear in the magazine. Directly behind Mr. Garrett are O. Louis Mazzatenta, Sr. Assist. Editor, layout and production, Constance Phelps, Production Assistant. Front row of staff, L. to R. are William Curtsinger, photographer; W.A. Royce, Assistant Chief Illustrations; G.M. Grosvenor, Editor. Back row: Carolyn Bennett Patterson, Sr. Asst. Editor, Legends; Joseph W. Judge, Associate Editor in charge of text. (Photograph by Joseph H. Bailey.)

All of us occasionally, if not regularly, invade the privacy of our subjects to some extent—whether we be photographing a peasant woman hoeing a roadside field or young lovers along the banks of the Seine.

As professionals when we aim a camera at somebody, we want something for our own selfish reasons. One colorful tribal lady in Laos told me of going to town and finding her picture being sold on postcards without her permission. At the very least she felt entitled to some payment. This situation differs little from possible magazine or book use·of her picture.

A friendly, open, honest approach to a subject almost always beats the *paparazzi* or grab-shot technique except in a fast-breaking event. Too often we justify our "right" to photograph the world and its people with the same self-righteousness of a missionary in China fifty years ago converting "heathens." Today neither missionaries nor candid photographers find a welcome there. In China as in many other countries photographing a person without his permission is not done. All too soon we may encounter this attitude everywhere.

During demonstrations in the United States crowds suspect us of FBI or police connections. Recently the freedom of all of us to work suffered when it became public knowledge that many accredited journalists—none *Geographic*—worked for the CIA full or part-time.

The Soviet daily *Pravda* once accused the National Geographic Society of being a spy organization. It is an easy assumption for a suspicious government to make since *Geographic* fieldwork must be thorough and painstaking.

In fact, we do gather intelligence or information but only for our readers. In striving for honest reporting we must be painstakingly thorough whether as photographers or as writers. On any assignment representatives of special interests hassle and cajole. Truth rarely enjoys the benefit of a public relations agent. And seldom is there a truly non-controversial subject.

It is impossible to fully comprehend the impact of our work on the public.

Bruce Dale expressed the fear that his nostalgic pictures of isolated mountain life in the United States will contribute to the destruction of that way of life, which he came to love and respect. Their appeal will incite tourism and its commercial caterers.

In a way Dale's concern symbolizes all *Geographic* photographers' awesome sense of responsibility, knowing that their work reaches fifty million people each month. Where else today can a photographer operate with so much freedom and entertain, educate, and influence so many people?

# Color Versus Black and White

The all-time champion for boring bull sessions must be the perpetual sophomoric hassle over whether the camera lies. But for me one other old chestnut-ridden session rankles even more. That is when a bunch of the good old boys and photographic "artists" get together and pontificate on how black and white is more "creative" than color, how you cannot "communicate" as well in color as in black and white, how everything looks too pretty in color, how you can't express yourself as well in color. What nonsense!

If color is so bad, why did nature use so much so well? If it is so limiting creatively, why have all the great painters used and continue to use it? If it is so bad, we should wear deep-blue glasses to enhance our pleasure at watching a cardinal in the snow or a sunrise over a misty mountain lake or in viewing a Paul Klee painting.

For the first half-century or so of illustrated publications there were very real problems with color—both the film and the means of reproduction were expensive and bad. Presses were not designed for the close tolerances needed for three- or four-plate registration. Some paper soaked up inks like used blotters, then stretched, shrunk, and wobbled through the press until the reproduction looked like a color-blind test card. Color had a bad name, and you cannot blame photographers for avoiding it.

Low film speed of early emulsions and slow lenses combined to make color photography slower than cave painting—and more cumbersome. Volkmar

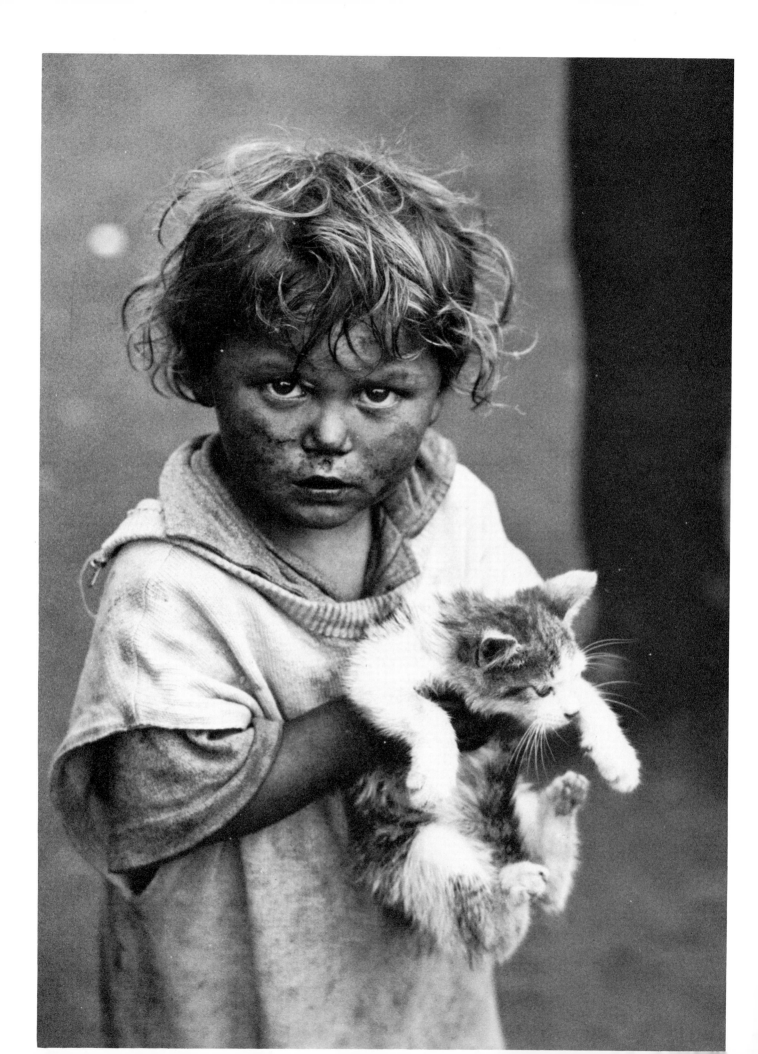

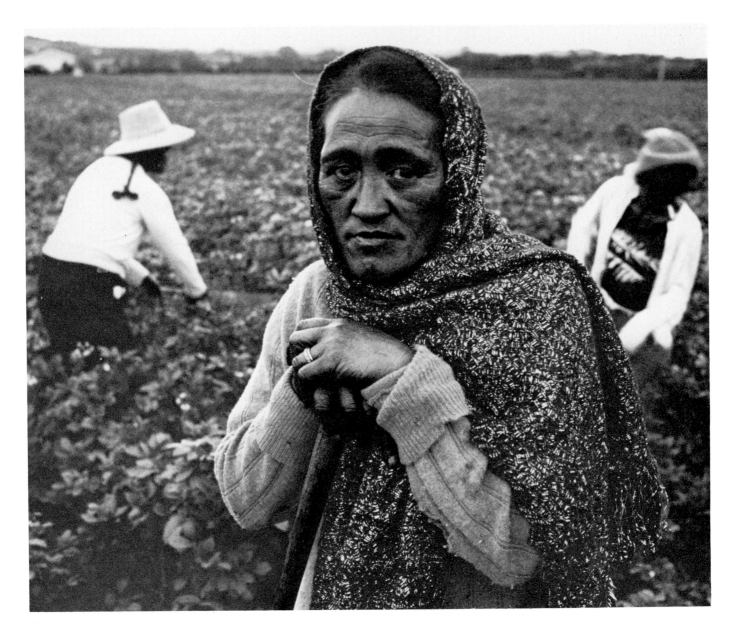

Wentzel of the *Geographic* staff began his career carrying hundreds of pounds of glass plates on overseas assignments that lasted months. Today he can put the equivalent number of 35 mm exposures in his pocket for a day's shooting.

Until after World War II, most lenses were not apochromatic or "color corrected." That is, they focused different colors at different distances from the lens—just as now infrared must be focused differently than the visible light.

Because of the novelty and expense of early color procedures, editors demanded and photographers shot "color" pictures, not necessarily good pictures. The "red shirt" school of photography developed. Film manufacturers hyped up the colors past any reality. Engravers were either unwilling or unable to produce subtle tints. The gaudy results were the same as turning a bunch of hungry kids loose in a candy factory—sickening.

Then why the continuing push for color? Primarily because, unless you are color-blind, the world is in color. Its beauty and its ugliness come equally in color. At the *Geographic* our primary use for photography has always been documentary: to show this universe and its wonders to our readers, to educate and inform.

▲ This informal portrait of a Maori woman hoeing potatoes with other laborers was taken by Gordon Gahan near Pukekohe, New Zealand. (Original in color.)

◄ This picture was taken by Bruce Dale, *National Geographic* photographer who twice won the Magazine Photographer of the Year Award (in 1968 and 1973). Portrayed is a Hungarian child and kitten outside the youngster's shantytown home on the edge of Esztergom, Hungary. (Original picture in color.)

Nearly 250,000 Moslems jam
Haram Mosque in the holy city
of Mecca to pay homage to
Allah. Those in the center
(blurred in this time exposure)
circle the black-draped Kaba,
the most sacred of Islamic
shrines. Five times each day the
world's 456,000,000 Moslems
turn toward Mecca to pray. This
photograph was taken by
Thomas J. Abercrombie, *National
Geographic* Senior Writer.
(Original picture in color.)

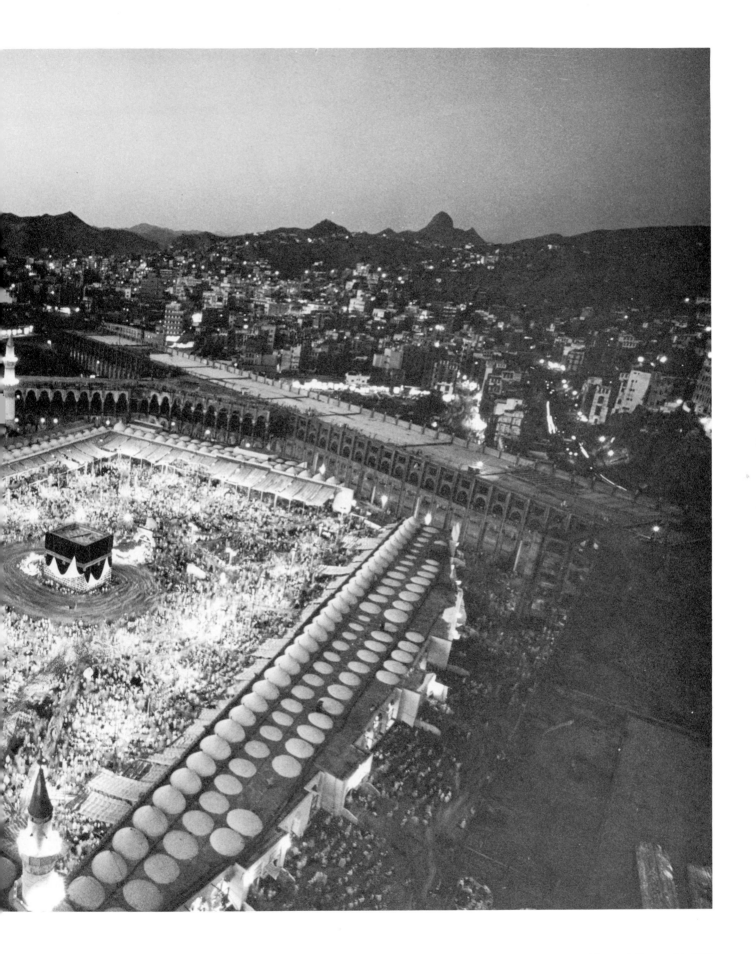

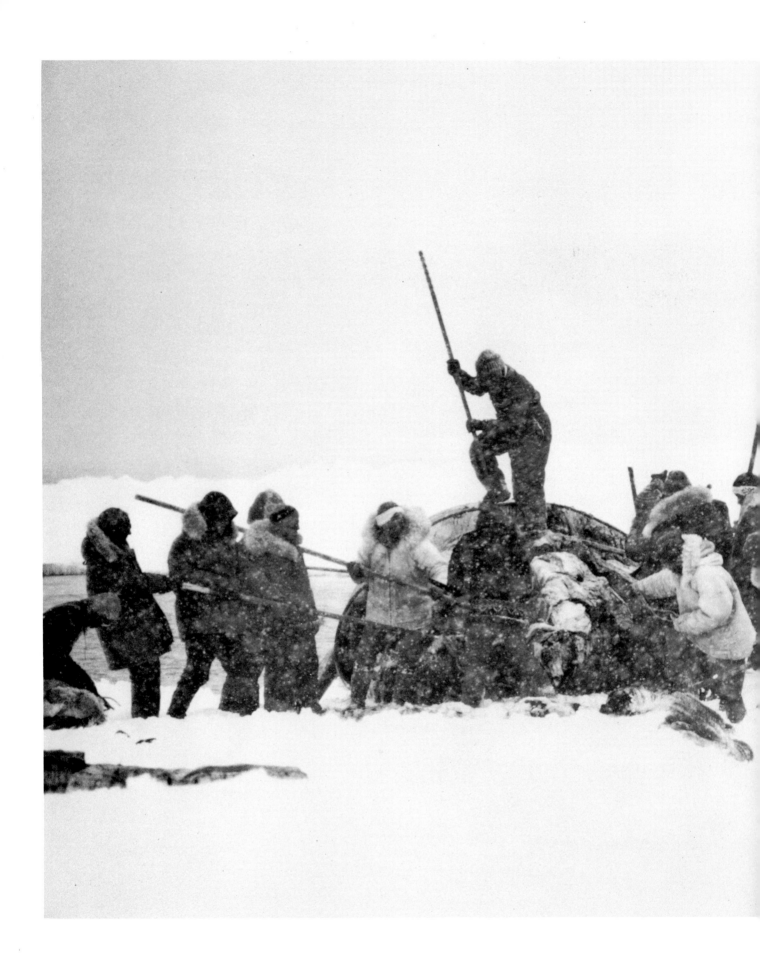

◄ Once alerted to the capture of a whale, dozens of Barrow, Alaska, residents dash out to help butcher it. The *Geographic* legend writer colorfully describes the scene: "Falling snow mutes the cries of pleasure and softens the bloody scene as the men quickly slice into the carcass." With the help of their women, who pull away the foot-thick blubber with long-handled hooks, they often reduce an eight-ton whale to a spot in the snow in five to six hours. This photograph was taken by Emory Kristof, of the *National Geographic* photo staff. (Original picture in color.)

As far as Dr. Melville Grosvenor was concerned, the only reason for not using color was money and quality. "The people wanted it, and as soon as we could afford to do it right, we gave it to them," he has said.

The present editor says simply, "I take color for granted." But he demands increasingly more interpretive and innovative use of it.

With tougher standards and more freedom to shoot subjectively, *Geographic* photographers find the full chromatic palette as much a necessity as a variety of lenses. Brilliant colors still appear, but the expression "monochromatic" no longer denotes black and white. It may mean blue and black or blue and blue or green and green, but used with taste to better communicate.

The skill with which they now use color speaks for itself. Eight of the last ten University of Missouri-National Press Photographers Association Magazine Photographer of the Year Awards went to *Geographic* photographers. In the same period they have collected ninety-five awards in the White House News Photographers Association competition and several Overseas Press Club Awards.

As concern for ecology became not only fashionable but also profitable, color portrayals of scenes and creatures, once almost the sole domain of the *Geographic*, proliferated everywhere—from *Audubon* magazine's superslick crusading to corporate me-too-advertising.

We have seen that documentation in color of pollution and poverty conveys the full, disgusting reality of these blights; that the impact of the great Weston and Ansel Adams scenics can be matched in color; that war pictures with their red blood and green slime nauseate and repel powerfully—as they should; that color properly used does not romanticize or glorify war, but degrades it. The ills of society as well as the beauty of nature can be communicated more powerfully and creatively in color than in black and white.

Fast, stable emulsions now make exposing color comparable to black and white. Speed and quality of printing no longer mitigate against color. President Nixon returned from China on a Monday night. By Friday morning a 164-page book with 64 pages of color covering his entire trip was being sold in bookstores and on newsstands.

Of course color is harder to handle. Some photographers still do not know how, and it frightens them. But so is a spaceship harder to handle than an automobile, and a four-minute mile is harder to run than a five-minute mile.

Obviously, black and white will continue to be both a creative and a practical tool. Its stark simplicity makes it an important and artistic and communicative medium. Most situations calling for speed and economy can still be handled best in black and white. Where paper and press cannot handle color well, it is better to trust to a good black-and-white reproduction than risk the unintentional abstractions created by horrible register and haphazard ink flow.

But, as communicators we must be concerned with "how and when," not with "if," color can be used professionally. We must utilize the technology available, press for better tools, and be prepared to experiment and gamble.

As older photographers fade away, their passionate arguments against color photography will go with them. New generations come on relentlessly like waves on a beach. They will be comfortable with color—whether in publications or exhibits, on television, on the videotape unit, or in mediums not yet envisioned. And naturally they will learn to use it more creatively, profitably, and fearlessly to communicate events and ideas.

# Student Participation

No publication has had a greater influence on photojournalism and on the use of color photography as a means of communication than has the *National Geographic* magazine. It is probable, too, that no publication has earned such an honored place on the shelves of private and public libraries than this magazine.

It should be an easy matter to borrow a dozen or so copies of *National Geographic* to bring to class. If your selections of magazines are spread out over a period of twenty years, you will be surprised at the transitions the *Geographic* has made in its philosophy of photojournalism.

# 21

# The Free-Lancer and the Picture Syndicate

*Howard Chapnick*

The vision evoked by the word *syndicate* is that of a "Mafia" of the picture business sitting in concert making decisions which affect the world's free-lance photographers. In fact, there is no more chaotic, undisciplined, and unstructured group of individual entrepreneurs than "picture agencies," those purveyors of pictures and photographic talent without whom the growth of photographic journalism would have been impeded.

Only the Associated Press (AP) and United Press International (UPI), among worldwide distributors of journalistic material, qualify under the definition of "syndicates" producing, purchasing, and distributing photographs for simultaneous publication in a number of newspapers and periodicals in different localities. Their impact is all-pervasive. Their news-gathering facilities are overwhelming, their offices and photographers ubiquitous, their knowledge of events taking place unmatchable, and their means of transmission via wirephoto and radiophoto unbeatable. Added to their own substantial resources, their contracts with individual newspapers throughout the United States enable Associated Press and United Press International to distribute worldwide the photographic production of the staff photographers who work for

these newspapers. Withal, both of these giants of journalistic photography are compelled to use the services of free-lance photographers to supplement the barrage of images which inundate their central offices from the far corners of the world. Contact with either the central photographic offices or local bureaus of Associated Press or United Press International will elicit for the free-lance photographer answers to questions of when they assign photographers, how much they pay for assignments, what rights they procure, and all the other pragmatic bread-and-butter questions that relate to any business relationship.

I come from a different photographic world than the high-powered press services. My world is the world of the comparatively small picture agencies whose contributions to the development of photojournalism have been overwhelming. It has been the picture agencies which have been the traditional home for many of the great free-lance photographers and source of the most powerful and creative photographic essays of our time. It was to the picture agencies that the early photojournalistic mass media publications turned for photographic talent when the game was just beginning back in the late thirties. So it is indeed relevant and important that any book on photojour-

Howard Chapnick, president of Black Star — a large picture agency in New York — talks about the free-lance photographer and the picture agencies.

◄Howard Chapnick *(left)* is president of Black Star Publishing Company, one of the leading photographic agencies in the world. His association with Black Star for over thirty years has involved him in every aspect of photojournalism.

He has participated for the past dozen years as a staffer with the University of Missouri Photo Workshop. He currently teaches an Urban Photojournalistic Workshop course at the New School for Social Research. He often is a guest lecturer before various professional groups.

Mr. Chapnick has produced many books that combine photography with poetry or prose—among them *The Illustrated Leaves of Grass* and *The Illustrated World of Thoreau.* (Photo by Leo Choplin, Black Star.)

nalism should examine the contemporary role of the picture agencies and their relations to the many thousands of free-lance photographers who have developed in the short history of the profession. As in many other fields, the educational institutions in photography are turning out enthusiastic, creative, committed photographers who have something to say about the world, without real insight into how they can most intelligently achieve their ends with a minimum of pain and disenchantment. Perhaps becoming a great artist or a great anything requires pain, difficulty, and suffering. This chapter will hopefully be a practical guide for those free-lancers who want to take the picture agency route.

# The Picture Agent—Man in the Middle

A picture agent is a man surrounded by millions of pictures, dozens of photographers, countless editors, researchers, art directors, and users of photographs clamoring for just the right images. His is a business fraught with overwhelming detail. He is caught between the legendary "limited budgets" of potential clients and the rising expectations of photographers. He is required to be businessman, negotiator, and creative innovator. His mom-and-pop-candy-store approach is one of the last of the small, highly personalized businesses to survive in this technological, highly computerized age. His business resists computerization by virtue of limited capital and anachronistic pricing which has not kept pace with rising costs. He is responsible to the photographer for the successful placement of his material, responsible to the editor to satisfy his needs for honest imagery, and responsible to the public as another communications arm in their search for information and truth. He lives by his wits (as does the free-lance photographer) in one of the toughest businesses man has yet devised. He has no secret markets. The success he has is in direct proportion to the amount of hard work and creativity he brings to his work. He sometimes succeeds with mediocre photographers and fails with gifted artistic photographers. He responds to and anticipates the news.

# Meeting the Picture Agent

I have often been accused of being tough on the work of photographers who come to see me. There is no closed-door policy. I try to see every photographer that comes up the pike, not because I am a nice guy, but because the future of the agency is dependent on the replenishment of talent and the enhancement of our picture files. You never know which appointment is going to produce a salable set of photographs.

We shake hands. The photographer pulls out his portfolio, and I look at his pictures. I then ask if the photographer has come to see me for my charm or for the straight dope regarding his work and its applicability to the field as I understand it. If it's the straight dope he wants, it's the straight dope he gets, painful as it might be. I consider it a disservice to any creative person to give less than a constructive, honest evaluation of his work. It is, after all, only a personal opinion which may be wrong, but my thirty-seven years in the business have produced some wisdom in evaluating the type of work that photographers bring to me.

A portfolio should be ruthlessly edited. It should tolerate nothing but the best images. It is the free-lancer's creative calling card. It is your opening shot to say to the guy behind the desk that you are a great photographer. He knows that every picture you take is not on that level, but if he sees only the best, he also knows that you make no compromise with quality. Never dilute the impact of the portfolio by including too many photographs. Diversity enhances it. So give that portfolio the tender loving care it deserves and use it to knock out the viewer who may be an agent or an art director who has the power of life and death over who gets what assignment.

# A Photographer's View of the Picture Agency

Harry Redl is a free-lance photographer currently working out of Phoenix, Arizona. He has been a free-lancer in San Francisco, Hong Kong, and Vienna. What follows is his personal view of the picture agency.

It is important to one who is working thousands of miles from the main markets for photography. The picture agencies benefit the photographer particularly in the preservation of subsidiary reproduction rights which may in turn generate large amounts of money in the future.

To a busy free-lance photographer, an agency can mean the difference between success and failure.

Most important is choosing the right agency for one's own needs. If distribution worldwide is your problem, find an agency that specializes in that area.

Some photographers are incapable of functioning without the ministrations of an agency to sell their pictures, handle their finances, soothe their egos, and find them work.

Laymen shudder at the high cost of representation picture agencies charge the photographer and sometimes they are right.

However, an agent often will negotiate a level of pay the photographer would never have dared to propose. The agent will insist on conditions that benefit the photographer, and when reproduction rights are involved, it can mean large amounts of money for the photographer he would otherwise not have received.

For the photographer who has difficulty facing clients or haggling over money or who just lives too far away from the markets, an agent is an absolute necessity.

Perhaps most important, an agent makes it possible for a photographer to spend his time on photography rather than on selling his product.

# An Interview with a Picture Agent

If I were a free-lancer in search of information, I would put some questions to Howard Chapnick which I would evaluate with a jaundiced eye because he is a picture agent who has an axe to grind in behalf of the picture agency business. So, for the purpose of gaining as much information as possible, let us conduct a mythical interview between Howard Chapnick, mythical free-lancer, and Howard Chapnick, picture agent of more than thirty years experience.

Question: Is an agent indispensable to the success of the photographic free-lancer?

Answer: No. Many free-lancers have been more successful without agents. Others have found agents very valuable, particularly in the early years of trying to get established. There are no absolutes to "making it" since we are all unique individuals with varying degrees of aggressiveness, different levels of creativity, and diverse needs to operate alone or as part of an organization. There is, I suggest, no substitute for personal contact and the direct articulation of ideas and presentation of your work. Who knows your work better than yourself? No one! Can a third person digest and regurgitate your ideas better than you can present them yourself? Obviously not.

Question: If a free-lancer does not need an agent, why go on with the chapter? Is there any justification for his existence?

Answer: An agent can be of tremendous help to a free-lancer, opening doors and providing access to clients who might otherwise not be receptive to seeing the work of the photographer. This is particularly true when the photographer is unknown. If the agent is reputable and is known for "not pushing a dead horse," the entrée the agent provides is invaluable. He can also be helpful in portfolio development, in stimulation of editorial ideas, and particularly for "stock agencies" can serve as a repository for file material and generation of other than assignment income.

Question: Do agents exploit photographers?

Answer: Probably no more often than photographers exploit agents. I would like to think that human beings never exploit other human beings. But that is not realistic. Instead of *exploitation*, perhaps we should discuss the relative roles of the ideal principal-agent relationship

where each party can achieve some measure of creative satisfaction and financial benefit. Some agents serve as editorial sounding boards, bringing vast experience to what makes for a viable and salable editorial idea. Some agents are financial counselors, financial backers, marriage counselors, psychiatrists, psychologists, casting directors, equipment carriers, and general assistants.

Question: How did the role of the picture agency change with the demise of the big picture magazines?

Answer: I cannot speak for all picture agencies, but at Black Star the loss of first *Collier's* in the early fifties and subsequently the *Saturday Evening Post*, *Look*, and *Life* in quick succession forced us to reevaluate many facets of our operation. The greatest impact, psychologically and financially, for the free-lancer and the assignment picture agencies came from the loss of *Life* magazine. *Look* and *Post*, even though important markets, depended strongly on their respective photographic staffs to fill the majority of their picture pages. *Life*, during the golden era of the mass magazine circulation race, served as the major source of income for the editorially committed free-lancer. Many photographers could count on contracts, page rates, or free-lance day rate assignments from *Life* which were sufficient to maintain them without additional work. Publication in these magazines provided instant prestige, access to work for advertising agencies and industrial companies, development of a valuable file of residual images for future stock sales, procurement of material which had secondary sales possibilities in foreign countries, and perhaps equally important ego and creative satisfactions. Free-lancers and agencies, faced with the reality of the disappearance of *Life*, were suddenly forced to come to grips with a new set of economics and the search for replacement markets. The Black Star staff, which once numbered twenty-five photographers, has been reduced forty percent by attrition, placing a greater reliance on stringers. All of us, photographers and agencies alike, are forced to work harder, be more energetic in the generation of ideas and markets. The loss of *Life*, *Look*, and *Post* may ultimately prove to be one of the greatest boons to photojournalism in transition and the new economics of

magazine publishing in which the advertising tail does not wag the editorial dog. It is now recognized that a magazine is predicated on whether the consumer is willing to plunk down his money at the newsstand for the publication. Advertising revenues are important but peripheral to the magazines' financial health. The economically unsound madness of selling magazines at a subscription rate loss in ever higher numbers was recognized when advertisers turned to television as the medium providing "bigger bang for the advertising buck." Even as this chapter is being prepared, *Life* and *Look* magazines are enjoying a rebirth. The new *Life* will be a monthly magazine and *Look* plans to be weekly or bi-weekly. Both will sell subscriptions at full newsstand price, fulfilling the prophecies I presented four or five years ago. This philosophical change in magazine publishing can ultimately serve to bring greater stability to the future of photojournalistic publications and consequently to the free-lance photographers and agencies with whom they deal.

Question: Why do photographer-agency relationships go sour?

Answer: Probably for the same reasons that any relationship between human beings declines. But there are very special elements to the photographer-agency relationship. For one thing, the agent is dealing with a creative individual, whose process of creative maturation and values is constantly changing. The picture agent realizes that losing a photographer is a natural hazard of the business—that often the needs the agency has served in the past have been outlived. The photographer may have evolved a new philosophy about his work, or his financial needs may have increased to a point where he reevaluates the relationship. His financial requirements may have diminished by virtue of new alternative life-style philosophies, or any number of human factors may dictate new options to be explored. From the agency viewpoint, the interest is to maintain relationships for long periods to compensate the agency during the photographer's most productive years for the time, energy, and money invested during the lean development years. The agent should, therefore, try to be responsive to the changing financial and ego needs of the

photographer within the context of good business policies.

Keeping the lines of communication clear is of optimum importance. The photographer must articulate his changing attitudes and assure agency responsiveness in order for the relationship to endure.

It is perhaps too obvious to suggest that some relationships fall apart because the agent does not work hard enough in representing the photographer, the photographer gets lazy and does not stimulate the agent with ideas, the photographer develops personal problems which distort all his relationships, the agent may get slipshod in accounting procedures or the photographer unprofessional in rendering of accounts, or the photographer overstates expense accounts or begins to turn in work for which the agent has to apologize. The free-lancer is only as good as the last job he has done and cannot afford a letdown in quality on any assignment.

Question: What factors are most important in selecting an agent?

Answer: Choosing an agent is like choosing a wife or husband. Except for the question of sexual compatibility, which might also be a consideration in some cases, the factors of temperament, mutual goals in photography, efficiency, and reputation take second place to the most important factor of all—how do you, the photographer, relate to the agent who may represent you? Is this the person you will be proud to have working in your behalf? Does he have the understanding to discuss your work, and if he has the understanding, does he have the articulation to express what you are trying to communicate? Does the agent, despite his good intentions (the road to hell is plastered with good intentions), have the time to represent you as fully as you would like?

Putting aside the question of temperamental compatibility, one must come to grips with the mutual interests of the photographer as they relate to those of the agency. A photographer interested in annual report assignments should not associate with an agency with magazine photojournalistic predilections. Although such roles are not always easily defined, an effort should be made to find the closest accommodation for your personalized needs.

# The Picture Agency—Types and Specialties

Each photographic agency is unique in its operation. Some are purely "stock agencies" or photographic libraries. Some handle only color transparencies; some, a combination of black-and-white photographs and color transparencies. Some are photojournalistically oriented—others lean to industrial or public relations photography. Some syndicate picture stories and single pictures in the United States—others distribute material in foreign countries. For the sake of logic and organization, we will attempt to categorize the kinds of agencies that exist and the general methods of operation.

## Assignment Agencies

These agencies are the photographer's representatives or agents who try to generate assignment work from magazines, industrial companies (annual reports, brochures, company magazines,

internal and external), advertising agencies, and other users of photography. At Black Star, we represent two categories of photographers—staffers and stringers. The staff photographers are those who work and bill exclusively through Black Star. Stringers are generally hinterland photographers in geographically diversified areas who do occasional assignments to supplement their work from locally developed clients.

Individual personalized representation is obviously most desirable, but at an agency such as Black Star, it is impossible. The economics of the business do not allow it; the photographer cannot expect it. He is entitled to efficient, conscientious handling of his material and ideas, but he should dispel the idea that he is the *only* photographer to whom the agency is obligated.

Assignment agencies are limited in number, but are constantly on the lookout for new talent. All except Magnum Photos are privately owned. Magnum

is a cooperative agency owned and supervised by the photographer members. In recent years, Magnum has opened its doors to nonmembers, but rarely do assignments go to other than members or close "associates." Lee Jones, project supervisor at Magnum, has this to say about the development of relations with new photographers: "We are delighted to look at the work of any photographer. . . often the more 'hinterlands' the better, providing: he or she has something to say, he or she is not coming to us to learn how to make money, he or she is prepared to wait for an answer, and perhaps a not very comforting one. And providing he or she has already decided to be a photographer and has spent a good deal of time producing visible proof of that decision. I, for one, am not interested in talking to people who are in the process of making 'life-style decisions.' I am interested in seeing the results of a lot of introspective hard work."

Agencies want to see the work of photographers, for photographers are the lifeblood of agencies. Dilettantes and people uncommitted to hard work need not apply. Nor should anyone approach an agency without full realization that picture agencies are not charitable institutions, that agency services cost money.

## Stock Agencies

By far the largest category among picture agencies is the stock agency. New York is the heart of the stock picture business. There you will find small personalized agencies, specialized agencies, and large repositories of color and black-and-white images. A definite listing of stock agencies can be found in the yellow pages of telephone directories in larger communications centers like New York, Chicago and Boston.

There is no pot of gold at the end of the stock picture rainbow. Conversely, pictures stagnating in a photographer's collection in Albuquerque, New Mexico, have no value or prospect of generating income for the free-lancer. Stock picture files for the free-lancer are like buying equities. It is an investment for the future which can continue to pay dividends for years to come. In the case of many Black Star photographers, the residual sales from material originally shot on assignments have generated revenues many times the fee received for the original assignment. Never in the short history of photojournalism have the opportunities for sale of existing material been more salutary. Why?

1. The simplicity and immediacy of visual communication has increased the use of photographs in a multiplicity of media.

2. Users of photographs have found that in lieu of costly assignments, it is often possible to find just the right image to satisfy their needs.

3. Contemporary graphic sophistication has forced publishers to revise and update existing volumes to compete for the visual attention of the reader. This is particularly true in educational books for young people who have been weaned on the visual and respond to visual stimuli as opposed to linear word constructions.

4. There is a greater understanding by communicators of the special consciousness and power of the still image with its concomitant isolation of the moment and enhancement of meaning and impact.

5. The advent of color photography and the sale of color transparencies have generated at least three times the per-picture price of black-and-white photographs.

Most stock agencies work on a consignment basis. They do not purchase photographs outright from contributing photographers. The prevailing split is on a fifty-fifty percent basis, payment being made to the photographer on payment by the client. Some agencies insist on large-format transparencies, 4 by 5 inches or larger. Recent years have seen greater acceptance of 35 mm transparencies, and the large-format transparency requirement is much less evident.

No stock agency can anticipate salable subject matter. The requests are infinite in their diversity. Scenics, sports, industry, animals, family life, science, agriculture, construction, traffic—these are a few of the categories in constant demand. A photographer with a large number of photographs reflecting the life, customs, industry, agriculture, and people of countries of the world must enjoy stock picture success over the long haul. The photographer should recognize that this is a business for the long haul—that patience is the name of the

game. Today's dormant picture is tomorrow's sale.

Discussions and correspondence with some of the leading stock picture agencies have elicited tips for more effective dealing with the agencies and handling of material. Dave Wilson of Globe Photos says, "The sole reason for the existence of the agency is to take the sale burden from the photographer's shoulders and therefore the nitty-gritty aspects of sales are the exclusive business of the agency. The incipient photojournalist when he first approaches an agency should realize that he is not going to get free information about the sale of photos."

The agencies are in constant need of photographs—black-and-white prints and color transparencies. They are not doing you a favor by dealing with you. They are only as good as the photographs they have, and they require a constantly expanding file of relevant and outstanding images.

## Captions

Captions are a necessity! Agents, picture researchers, and editors are constantly frustrated by the sloppy unprofessionalism of some photographers. Captionless pictures are useless unless they are symbolic and nonspecific. Simple good sense dictates that sales should not be lost for lack of caption information.

## Releases

The highest payments for photographs are those sold to advertising agencies. No release, no sale! Then answer your own question as to whether releases are required for successful stock sales. For editorial noncommercial purposes releases are not generally required unless the individual in the photograph is being held up to ridicule or otherwise being defamed. If the opportunity presents itself in any situation to procure a model release, get it. The release expands the potential horizon for that particular image.

## Rights

The pictures belong to the photographer. Most agencies will not accept responsibility or liability for loss or damage to transparencies, prints, and negatives. Many agencies require that prints and transparencies remain on file for minimum periods. Those minimum periods vary. A. Devaney, Inc., requires a minimum of three years; Globe Photos, Inc., five years.

Simplistic but true is that good pictures sell better than mediocre pictures.

The much maligned editors and art directors are professionals. They know their jobs and can generally be counted on to select the best photograph technically and compositionally with the greatest content. When you send pictures to an agency, remember that your pictures are competing with those produced by some of the best image makers of the world. So do not settle for second best when you make the photograph. Take that extra time for the elements to be in the right place, for the light to be moody and dramatic, to use foreground, middle ground, and background most effectively in the frame, and to make sure that the message of the picture is direct and unconfused.

# Ideas

The successful photojournalist, like the successful salesman, like the successful writer, like the successful anything, must be a person with ideas. Anyone can learn to use a camera, but an empty head can't do a damn thing with a camera. A free-lance photographer, working with or without an agency, must be a well-rounded individual with more than superficial interest in every aspect of the world in which he lives. A college education is not a prerequisite, but thorough training in the arts, philosophy, history, literature, and the other disciplines that make for a perceptive mind should be encouraged. The image of the cigar-chomping, rough-hewn, aggressive, insensitive photographer of yesteryear has been replaced by the picture of thoughtful chroniclers of the times

using the camera to make more penetrating and sensitive photographs interpreting events in more meaningful terms. Those whose formal education or self-education has been neglected will find that they cannot be equally at home with kings, scientists, and beggars and therefore are not capable of relating to the subjects with the depth that is required.

There are those who will argue that the question of *ideas* may range far afield from a discussion of free-lance photographers and picture agencies. I disagree. At the heart of the relationship is the quotient of idea productivity. Some photographers will never have an idea—others will walk ten feet and have ten ideas. The most valuable photojournalist to the picture agencies is the person who can give the agencies the tools with which to work—*ideas*. There is no dearth of great image makers among the photographers of America. But there certainly is no great plethora of photographers who have something to say about the world or have the capability of refining their ideas into cohesive well-articulated subjects.

The young photographer seems to have an excessive fear of the possible theft of his ideas. I am sure there are many instances where a magazine or agency has appropriated ideas for their own benefit without respect for the inherent rights of the originator of the idea. After many years of dealing with ideas, my experience has been that most people in this creative business recognize that ideas are a commodity—the most important commodity the free-lancer has in his arsenal of assets. The ethics are on the highest level. There are few comparable businesses where transactions are negotiated on trust, commitments made without written purchase orders, obligations fulfilled on the basis of a telephone call or a handshake.

Photojournalism may be dead for those who refuse to think. I would guess that more than half of the so-called photojournalists, free-lance or otherwise, have nothing to say. Saying nothing with a camera is as negative as saying nothing in conversation, in the written word, in art, sculpture, and architecture, or in any field of creative endeavor. For that category of photographer, the best advice this chapter can render is to suggest giving up photojournalism as a career. For the others, read on!

Where do photographic ideas come from? From reading newspapers, from watching television, from living and observing people, from anger and rage that one wants to express about inequities in society, from the desire to celebrate what is beautiful in people and in nature. From curiosity and caring and restlessness and adventure and getting involved and the desire to peel off the skin of our mores and culture and have a visual look at the reality. From not taking things at face value and giving yourself the opportunity to find out that things are not what they seem, that preconceptions and stereotypes do not prove out. From simple everyday existence. The one great controvertible myth in the photojournalistic business is that to be a salable, palatable, acceptable idea for publication requires that it be bizarre and unusual. The only requirement, I suggest, is that it be visual and well defined. The simplest idea photographed with understanding, compassion, and love can sometimes prove to be the most compelling. Think back to some of the great photographic essays in the short life of photojournalism and contemplate the simplicity of the ideas. Ideas are there for the taking. It was Brian Brake who recognized that "Monsoon" was indigenous to and had great impact on the lives of hundreds of millions of people. It was W. Eugene Smith who found a "Nurse Midwife" to reflect her personal affirmation of life or a "Spanish Village" to show some of the eternal truths of man's existence. It was the sheer force and power of the David Douglas Duncan personality and intellect which enabled him to convince Picasso to allow the camera to present every aspect of his humanity and artistry. The Pulitzer-Prize-winning photographic essay by Brian Lanker then staff photographer of the *Topeka Capital-Journal* on the birth of a child (see page 110) was related to the most commonplace of all events—birth. Nothing cataclysmic, nothing spectacular, not the biggest, the smallest, or the most beautiful—just the most real, the most honest, and the most straightforward.

Each community is a microcosm of the world containing people, albeit of different ethnicity, values, attitudes, and

cultures. Where there are people, there are ideas for stories to be written about and photographed—stories related to the gut issues of life—work, survival, emotions (happiness, sadness, love, hate, etc.). It matters not if the photojournalist is working for a general interest or special interest magazine or for an industrial publication. The criteria and opportunities are the same; the issues and concerns are the same. The variables lie in the special approaches of the journalist to the subject, the selectivity of the idea, the perceptiveness of the photographer, the depth with which he treats it, and the bias and point of view he brings to the subject.

There is one nonsense which we should dispel immediately. Photographers sometimes say that they should be given the opportunity to go to the more exotic corners of the earth because their home bases do not produce stories or ideas. It may be that a change of scenery would be a temporary stimulant, but the probability exists that equal sterility will accompany the photographer in Shangri-La.

Locale is no detriment just as it is no panacea to success. I recall the days of Cal Bernstein who mined the territories of the West Coast, Denver, New York, and Salt Lake City for their photojournalistic lodes. Everybody said that Salt Lake was a dead end for a photographer, that nobody could generate work in such a sterile area. But it was in Ogden, Utah, that Cal Bernstein found a "High School Married Couple" that became an extensive essay for *Cosmopolitan* magazine or "The Rebirth of Loren Peck," a *Pageant* magazine essay which told of the rehabilitation of an automobile accident victim.

To give substance and specifics to how ideas are developed, we might perhaps play what I call the Idea Game. Take any subject in which you have an abiding interest. Old Age? Industry? Sports? Weather? Then try to develop as many editorial visually translatable ideas within the limitations of the subject as your mind can generate. I have selected the general subject of Winter for the purpose of this exercise and have come up with the following partial list of story possibilities:

Winter on the farm
Winter nights
Aftermath of a blizzard
Winter in the city
Winter sports
The abstract beauty of winter
The joys of winter (for children)
Winter in Yellowstone or other national park
Life at 40 below
Winter holidays
Ice
Snow removal
Zoo in winter
Winter carnivals
Winter on the beach
Winter folklore
Winter transportation
Maine winter

These are only points of departure for your fertile mind. See how many you can add.

I leave this subject with a special plea to photographers to open their collective eyes, break the stereotypes, develop a style of personalized photojournalism, and suggest ideas you care about and want to do. You will find that the success of your relationship with the picture agency will be enhanced by your active stimulation of ideas with which the agency can work in your behalf.

During the heyday of *Life, Look,* and *Post,* they were the principal backers for interesting long-term expensive depth photojournalistic projects. As this resource declined, some agencies undertook to fill the void. The history of Black Star is replete with instances where the financial and creative resources of the agency have helped photojournalists realize well-conceived projects. At the height of the civil rights struggle in the United States, Black Star underwrote a "Southern Documentary Project" by a group of committed photojournalists intent on bringing their personalized perspectives of the struggle to the magazines of the world. These involvements are not always altruistic—the agency recognized that its greatest resource is in the quality of the journalistic material it develops.

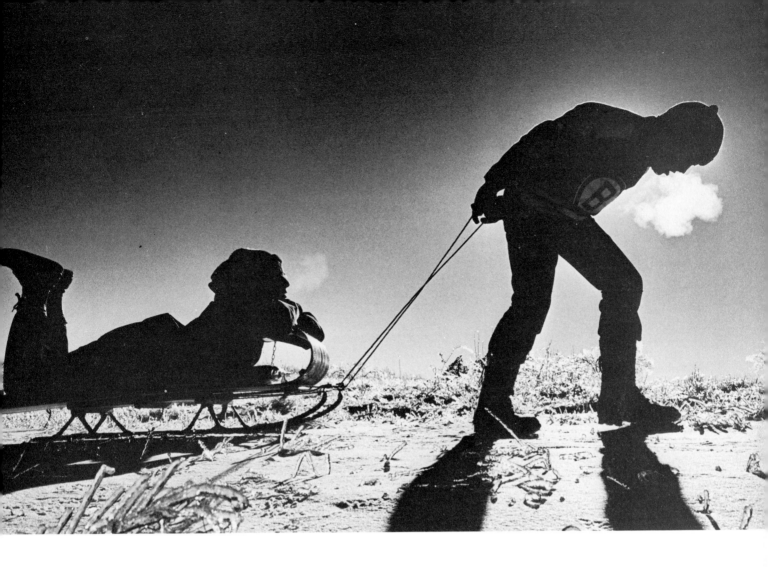

# How Agencies Generate New Uses for Old Material

Pictures have perpetual value. The value of any individual image is impossible to ascertain. Its value is determined by being in the right place at the right time for the right use. Residual sales are primarily based on fortuitous accident, but either the free-lancer alone or in concert with the agency can generate sales by thoughtful, intelligent handling of existing material. The late Charles Rado of Rapho Guillumette may hold the world's record for getting the most mileage out of a photographer's work. Besides sales of Ylla's famous photographs of animals to magazines, book publishers, encyclopedias, advertising agencies, and the like, he also systematically put together a series of children's photo books on many of the wild animals she photographed.

As the diversity of media uses of photography have expanded, the dynamic picture agency has been forced to consider peripheral uses of the material even as the photography is being accomplished for primary use. The agency becomes more than a picture peddler, but rather creative packagers of concepts designed to get maximum financial return from the material. A classic example of a free-lance photographer who has endeavored to exploit this principle in combination with Black Star is Flip Schulke, Miami-based specialist in underwater photography. The Tektite project was a combined effort of the Department of Interior and the National Aeronautics and Space Administration (NASA) to allow scientist-aquanauts to live in underwater habitats for longer periods of time while performing sci-

**Homeward Bound,** by Talmadge Morgan of the Palm Beach, Florida, Post. This silhouette, from a feature point of view, illustrates the chill experienced in 1973 by the people of Rye, New York, during the worst ice storm in a decade. (Photo courtesy of Talmadge Morgan.)

entific experiments. After completing magazine commitments for United States and foreign magazines, Schulke led the final Tektite scientific expedition in an evaluation of films, cameras, and lenses under underwater conditions. A half-hour documentary film resulted from that effort. The still pictures have been incorporated in a trade book on Tektite for the adult market, as part of a *Man in the Sea* series for the young people's book market, for use in a contemplated filmstrip series on man's exploration of inner space, and for subsidiary illustrative purposes in educational books, encyclopedia, advertising, and magazine illustrations. Every editorial idea does not lend itself to this saturation treatment. The thinking free-lancer can enhance his income and satisfactions by trying to generate ideas which allow for this approach.

Some years ago, I had the opportunity to be involved in preparing an idea for a magazine in which the photographer was asked to illustrate poetry passages from Walt Whitman's *Leaves of Grass*. Some years later we were able to produce a book completely with existing pictures from stock files on the same subject. Without the catalyst of the book idea, those pictures would have continued to sit in the files gathering dust instead of generating income. The use of photography in audiovisual and electronic media, greeting cards, posters, record covers, annual reports, house organs, brochures, and myriad other outlets provide creative opportunities for new uses of picture material never contemplated in the early days of journalistic illustrative photography.

## Foreign Markets

The world of photojournalism does not begin and end with the magazines of the United States. There is a great big wonderful world out there in Germany, France, England, Scandinavia, Spain, Japan, Brazil, Italy, and other countries whose price structures are on the rise. It is possible to put together simulta-

neous assignments on the same subject through careful exploration and exploitation of those markets. The picture agency is uniquely qualified to bring these markets to photographers through direct contacts and subagents. It sure beats not reaching them at all.

## The Free-Lancer, the Picture Agency, and the Future

The market for photography has never been better. Think back a short forty years when *Life* and *Look* came into existence and recall how few markets for creative photography existed. We are using the camera less and less for the documentary photo essay and more and more for commercial purposes. The competition is keener, there are more photographers scrounging for every job, and the times are changing. Photojournalism and the photojournalist will adapt and change with contemporary needs. The limitations of the printed page will be replaced by the use of hundreds of still images telling cohesive stories on television, in filmstrips, in

motion-picture theaters, and for home viewing through the medium of cassettes. Already we are seeing photojournalists adapting the picture essay form in combination with text to produce meaningful full-length books. Photojournalism does not need journals to disseminate its message. It needs dedicated creative people who do not sit around whining about their condition and the loss of what once existed. It needs people who face up to today and who are responsive to the needs of today. The role of the picture agency in this chaotic period of change is to bridge the gap between the creative free-lancer and the new markets.

▶ Many times commonplace subjects make interesting pictures. This pattern photograph of a lunar moth on a screen door, taken by the then 13-year-old Teri Smith of Alexandria, Virginia, was a first place winner in a nationwide contest sponsored by Scholastic Magazines, Inc., and Eastman Kodak Company. Courtesy of Teri Smith, 1967 Scholastic/ Kodak Photography Awards.

# Student Participation

Like many other chapters in this book, chapter 21 is comprehensive. To get full benefit from it requires that students refer to it time and again. A once-over lightly is unfair to the photographs, to the student, and to the author who has worked hard to provide new insights into the free-lance business and into picture syndicates.

The first thing which comes to mind in studying this chapter is that the successful free-lancer is a special type of person. He is a business man, an artist, an illustrator, a reporter. Many are writers as well as photographers, and further, more times than not, they are as much at home with movie or videotape equipment as they are with a battery of lights and still cameras.

This situation points up the complexity of our times and emphasizes the numerous demands placed upon present-day photojournalists.

1. Elaborate on this statement by Howard Chapnick: "Only the Associated Press and United Press International, among worldwide distributors of journalistic material, qualify under the definition of 'syndicates' producing, purchasing, and distributing photographs for simultaneous publication in a number of newspapers and periodicals in different localities."

2. Describe the duties and responsibilities of the picture agent—the man in the middle.

3. What single event caused the greatest impact, psychologically and financially, for the free-lancer and the assignment picture agencies?

4. What is the difference between an assignment agency and a stock agency?

5. How has the advent of color photography and the sale of color transparencies affected the price of black-and-white photographs?

6. Write a paragraph explaining the importance of each of the following subjects touched on by Mr. Chapnick:
(a) captions, (b) releases, (c) rights.

7. Do you agree with the following statement of Mr. Chapnick? " . . . more than half of the so-called photojournalists, free-lance or otherwise have nothing to say."

8. List at least five sources of profitable photographic ideas.

9. Does Mr. Chapnick believe that in photojournalism "to be a salable, palatable, acceptable idea for publication requires that a [picture or pictures] be bizarre and unusual?"

10. Write a paragraph explaining how an agency can generate new uses for old material.

# 22

# Careers in Photojournalism

**M**any persons reading this book intend to be photojournalists. With this thought in mind, let us take a closer look at the field which challenges us.

An interesting book by Arville Schaleben, for many years managing editor of the *Milwaukee Journal*, provides some valuable information. Schaleben opened the chapter on "The Picture Field" by pointing out, "Photojournalists are in strong demand. . . . People who take pictures or people who handle pictures are in a fast-growing and exciting field."[1]

With the rebirth of *Life* and *Look,* opportunities seem a bit better than they were a comparatively short time ago. But aside from the great magazines, and the great newspapers, there still are many jobs for the picture specialist. Probably more pictures are being used today than at any time in history. Trade journals, small weekly and daily publications—among these and other groups one can find many organizations need the help of photojournalists; organizations which believe wholeheartedly in the words-pictures team. Each day they seek the services of picture experts, and they do not discriminate against race, creed, or sex.

**A good camera reporter, well trained in his profession, is capable of holding a job on a magazine or newspaper, or for that matter on television. This chapter helps him evaluate himself before applying for a job.**

## Qualifications

In Schaleben's book James Godbold, publisher of a Texas weekly newspaper, had some thoughts about photojournalists. Mr. Godbold was for many years chairman of the educational program of the National Press Photographers Association and at one time was director of photography at *National Geographic* magazine. A frequent staff member of the University of Missouri annual Photo

Workshop, Godbold's experience gives him much authority to comment on photo reportage. "A photographer," he said, "must have the same background and qualifications as any other reporter. I refuse to recognize the man who uses a notebook and typewriter as a reporter and the man with a camera as a photographer. I call them both reporters—both newsmen."[2] Another important bit of

---

1. Arville Schaleben, *A Definitive Study of Your Future in Journalism* (New York: Richards Rosen Press, Inc., 1961).

2. Schaleben, *Definitive Study.*

information from that same book is the report by Earl Seubert, chief photographer of the *Minneapolis Tribune*. Seubert, like Godbold, has extensive experience and the credentials to back up his opinions. Frequently a staff member of Missouri Photo Workshops, Seubert has earned the national Newspaper Photographer of the Year award—has, in fact, earned the title several times. Consider these words of his:

. . . One thing that helps me is that I think pictures all the time. I shoot a lot of pictures. I even "shoot pictures" when I don't have a camera in my hand, wherever I see people responding to life—anywhere, everywhere, on my way to work, in the backyard, going to and from assignments. Spring, summer, fall, winter, inside, outside . . . wherever I find people responding to the people around them, I find pictures.[3]

Thus far in this chapter, we have touched upon two important precepts, two factors which should constantly be part of the thinking of budding photojournalists:

## Precept 1
A good photographer is dependable and responsible. He is intelligent and alert. *The news photographer is also a reporter,* just as much as any word reporter.

## Precept 2
The photojournalist is a complex person. Knowledgeable about what's going on—and fully abreast of the times. In addition, *he knows and likes people.*

As Earl Seubert discovered early in his career, and as many other great photographers before him had learned, "where people are interacting, there one finds material—great material—for one's camera."

"News is of the essence," Frank Luther Mott often expounded for the benefit of his students. And so it is. Any news photographer worth his salt will be on hand to cover spot news events: fires, wrecks, tornadoes, and the like. It is necessary that such occurrences be recorded. But, thankfully, hard news is only a portion of the matter which eventually finds its way into print, and since photographing the obvious is only a small part of the work done by a news photographer, it is imperative that he or she be trained to do much more. Let the photographer learn that "photography is a language," as pointed out long ago by John Whiting.[4] Let photographers master the sentence structure, the syntax, the compositional elements of the language of pictures; let them learn that in visual communication, just as in verbal communication, one must follow the rules of unity, conciseness, and coherence. Above all, let the cameraman (or woman) never forget that *picture content is, or should be, one's first consideration.*

As a young person studies to become a photojournalist, let that person learn how to research a story and how to write it. Let that person, too, learn something about the humanities, something of political science, and something of philosophy—of aesthetics and ethics. All of these disciplines will help him (or her) to become a more understanding, more perceptive person.

Once the budding photojournalist has completed his college education, he faces the awesome task of getting a job. Just where will he go? And what will he do to get that first job? All photographers do not begin work on a large newspaper, magazine, or television station. One might break in as a photographer writer-picture editor and jack-of-all-trades on a house organ, a trade journal, a community newspaper or some specialized publication. In fact, some veteran photojournalists recommend this kind of start, not only because there are not enough *National Geographics* and Louisville *Courier-Journals* to utilize all the help which is available, but also because one usually can learn more and develop faster on a smaller publication.

3. Ibid.

4. John R. Whitnig, *Photography Is a Language* (Chicago: Ziff-Davis Publishing Co., 1946).

# Assembling a Portfolio

At this juncture, if he has not already done so, logic dictates that a prospective photojournalist carefully study his or her negatives, prints, and contact sheets and that he or she work hard and conscientiously to print up his best possible portfolio. We suggest that the pictures in your portfolio be carefully mounted. They need not all be full 16 × 20 inches or even 11 × 14 inch prints. An occasional change of size can be helpful. Bleed some pictures, that is, make them flush on all sides with the mounting boards. This arrangement provides a welcome change of pace and suggests a bit of professionalism. A portfolio representing the best pictures you have ever made will do much to tell a prospective employer about the kind of photographer you are now and the kind you will be ten years hence.

Your portfolio should have (1) good picture content and (2) craftsmanship beyond reproach. Your pictures should have more than passing interest to the observer. While an employer does not select members of his staff solely on the revelation of a handful of photographs, a reasonable number of good pictures properly presented can be of great value to the job seeker.

In making up a portfolio, be sure it has variety and that it represents the full range of your versatility. It would be foolish, indeed, if your portfolio consisted only of pretty pictures, or only of portraits, or only of one type of camera work. Among other things, your portfolio should give proof of your all-around ability. It should honestly portray examples of your best camera work, your best cropping, your best craftsmanship.

## Divisions in Picture Competitions

To help you decide the types of pictures your portfolio should contain, check the divisions featured in current newspaper and/or magazine photographic contests. In the Pictures of the Year[5] competition, one of the oldest and largest of its kind, you will find the following divisions:

### Spot news

These pictures, because of their spontaneity, prohibit advance planning. Spot news pictures are usually grab shots and sometimes they can be attributed to luck. "The photographer was in the right place at the right time." True, luck sometimes plays a part in the making of a great picture. More times than not, however, the winning picture is the result of years of experience, self-discipline, and well-trained reflexes.

### General news and documentary

The term *documentary* is included in Pictures of the Year rules as a concession to non-news magazines which, although they do not cover hard news as do newspapers and television, they do produce a number of documentary pictures which closely parallel what has come to be known as general news. The general news picture, unlike the spot news photograph, may be planned. Knowing the route of a parade, for example, a photographer can place his camera on a tripod to photograph the mayor in the reviewing stand. Should a dignitary in the parade be assassinated by a sniper, however, that would provide a spot news picture. No photographer could prepare himself for that contingency. It, like most spot news pictures, would have been a "shot from the hip," a "grab shot." If the resulting pictures were reportorially and technically good, a portion of that goodness could be attributed to luck and a portion to experience—quick seeing and quick responses.

### Feature picture

A feature picture is a human interest shot which presents an unusual situation. The feature shot often is humorous but too many times feature pictures are trite and contrived. A seven-foot basketball player being guarded by a midget five-footer might make a sports feature. To avoid boredom on the part of the reader, and to help refute the charges that basketball pictures are "all alike," the person photographing a basketball game should work hard to come

5. The Pictures of the Year competition, held annually since 1943, is jointly sponsored by the School of Journalism, University of Missouri, National Press Photographers Association, and Nikon, Inc.

up with something unusual. A good sports feature picture, like a sports news picture, generally speaking, presents something different from the norm.

## Sports picture

The sports news picture, as a rule, presents no classification problem. But the photographer who plans to have one or more sports pictures in his portfolio should make sure that he avoids cliches and stereotypes. Some of the best sports pictures are those taken of spectators, showing audience reaction to a particular situation. Jubilation and/or tears at the end of a hard-fought game are typical examples.

## Pictorial picture

The pictorial picture is a pretty picture, one that a person likes because of its aesthetic appeal. It may be an abstract, a texture, or a pattern picture. On the other hand, it can be a portrayal of something as common as a sunset and still fall within the pictorial picture class.

## Portrait/personality picture

This type of picture indicates much more than the photograph often referred to as a "mug shot." The portrait/personality picture should be of fine technical quality and should be an interpretation of the character of the subject.

**Y.A. Tittle Topples** by Morris Berman of the *Pittsburgh Post-Gazette.* This picture earned first place, sports category, in the 23rd Pictures of the Year competition. It is emotional and story-telling; the kind of picture sports editors welcome. (Courtesy of Morris Berman and *Pittsburgh Post-Gazette.*)

### Home and family interest pictures

This classification was created to release women's pages from the tyranny of fashion and society pictures. While the latter may still be found on women's pages in prizewinning publications, they seldom are placed there to the exclusion of all others. Present-day women are interested in politics, science, and many other subjects. Pictures which portray the broad variety of women's activities and interests are fair game for this division.

### Other Picture Divisions

All successful pictures communicate. The single picture makes a statement. Many pictures, properly organized and properly displayed, usually tell a more complete story. The picture series, in its strictest definition, is a story in cinematic style. The picture series or sequence, as it sometimes is called, shows progressive action—the passing of time or the changing of space.

*News picture stories, feature picture stories,* and *sports picture stories* are all found in the Pictures of the Year competition. Usually they follow the traditional format and have a beginning, a middle, and an end.

Some picture groups are merely collections of pictures, although they may be loosely bound together with a common subject. Pictures of women's hats would not have a beginning, a middle, and an end, nor would they have much in common with a picture series or sequence shot on a racetrack taken with a motor-driven camera.

### Picture essay

The last form of layout is the picture essay. More sophisticated than the others, the essay makes no attempt to have a beginning, a middle, and an end, nor does it necessarily show a series of progressive action. The pictures in a photo essay have a considerably deeper purpose. Words are usually important also, and each photo makes a point, reporting one facet of the entire word-and-picture combination. At its beginning *Life* magazine featured traditional picture stories. Later, when the magazine became more sophisticated, many picture essays were featured, not a few of which were brilliantly done.

# Beginning a Photojournalism Career

The young college graduate fully prepared to enter photojournalism and/or allied fields has many opportunities for employment.

He can, of course, be a free-lance photographer and work for himself. He can, if he chooses, start his career as a photographer or as a combination photographer-reporter on a weekly or small daily publication or house organ. The pay on small publications is surprisingly good, and the experience is broad. Many professional journalists advise this type of start, and some consider it to be the real market, the real opportunity for today's budding photojournalists.

If one's first try is with a big, long-established publication, the going may be tough. Even here, however, an internship or beginning job is not an impossibility. Internships are important during one's college days. The National Press Photographers Association, in conjunction with many schools of journalism, and many cooperating publications sponsors intern programs each year. Through its intern chairman, the photographers' association makes a big effort to place college-trained personnel in summer jobs. The program helps newspapers and television stations fill the gaps during vacation months, and lets students have a firsthand taste of what it's like "in the real world."

Television networks and local stations need still and motion-picture photographers. They must turn out an untold number of prints for publicity releases to newspapers, shoppers, and the like.

◀**The Coming of Spring.** Some of the honors this picture has won for Talmadge (Red) Morgan are first-place feature and best-print-of-show, 1973 New York State Associated Press competition. The picture, taken for the Westchester-Rockland Newspapers, New York, could also have qualified in the "pictorial" class.

The television station also needs transparencies and/or stills for newscasts and commercials.

A research specialist, the person whose job it is to find the right man or woman for a given position, once told me that photographers generally speaking, are not interested in administrative work. After naming a person as art director on a large daily newspaper, the specialist complained that photojournalists prefer to shoot pictures rather than to train for the more lucrative positions of picture editor, art director, director of graphics, or what have you. The jobs he mentioned are important, good paying, and influential. Student photographers should accept a staff job if that is what they want. They should, however, look to the future and to the time when covering fires, and wrecks will have lost much of their appeal.

Do not overlook the picture networks, Associated Press and United Press International nor agencies such as Magnum Photos, Pix Inc., Black Star, etc. A director of an agency once told me that "not nearly enough young people are learning the agency business." He believes an agency can provide a much higher income and as much satisfaction as shooting pictures if given the chance.

To learn how some young people have launched careers in photojournalism, let's examine the work of Randy and Joany Cox, and the words of H. Michael Sell, and James R. Holland in the pages which follow.

➤ **Home Run Slugger** by Joany Carlin Cox.

◄ **Fishin' and Smokin'** by Randy Cox.

▼ **Social Security Case** by Joany Carlin Cox.

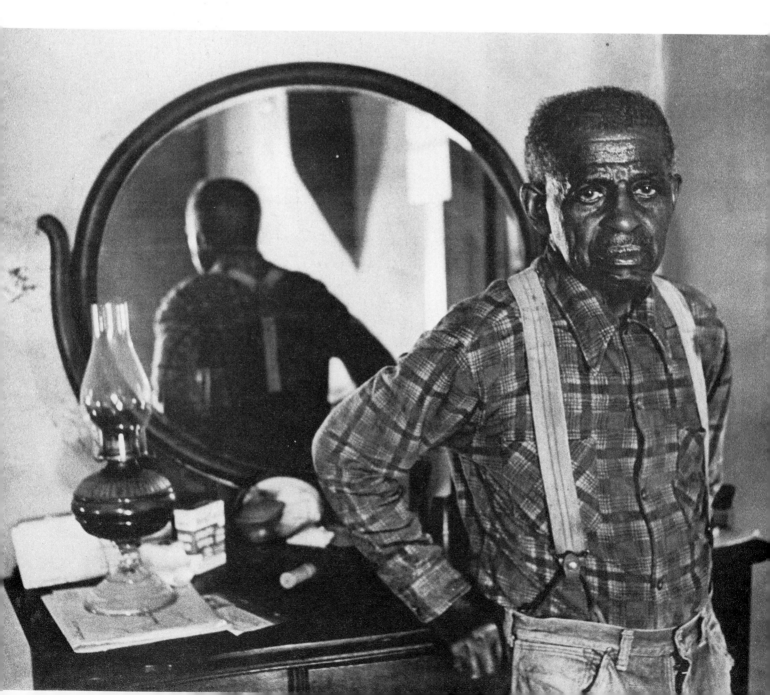

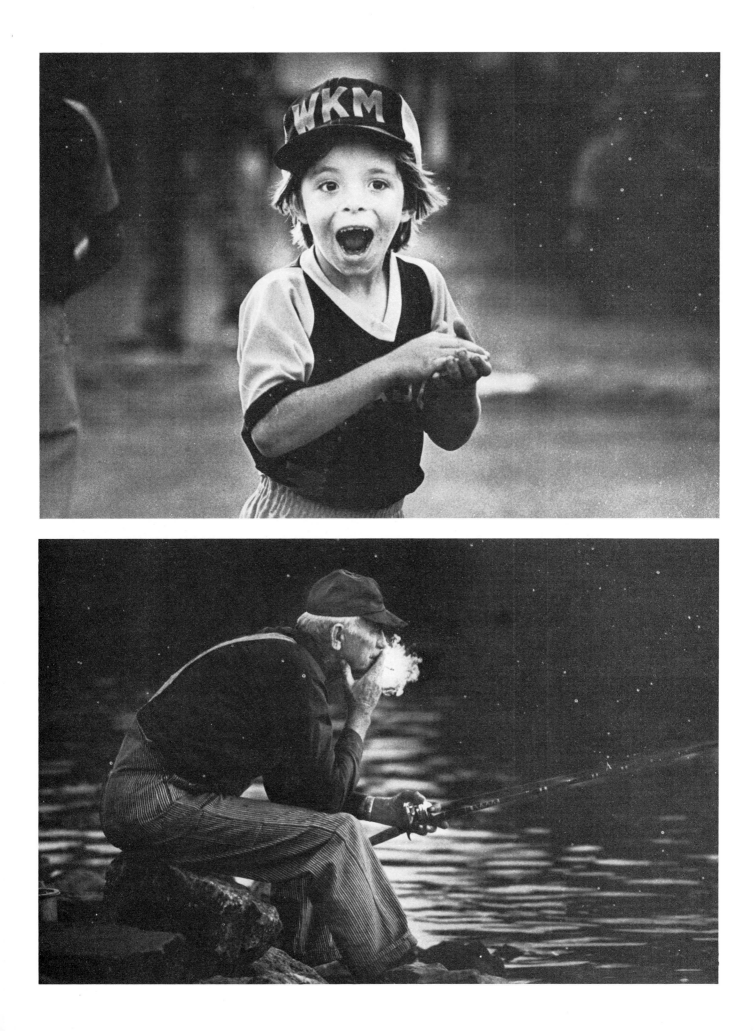

Any dog off the street can walk in to Diane's Grooming Parlor
and in two hours the transition will be complete.

# From Beast To Beauty

Photos and story by Joany Carlin

**On the Cover:**
After the complete treatment,
Lisa waits for her owners,
the Floyd Gilmans,
705 S. Cheyenne St.

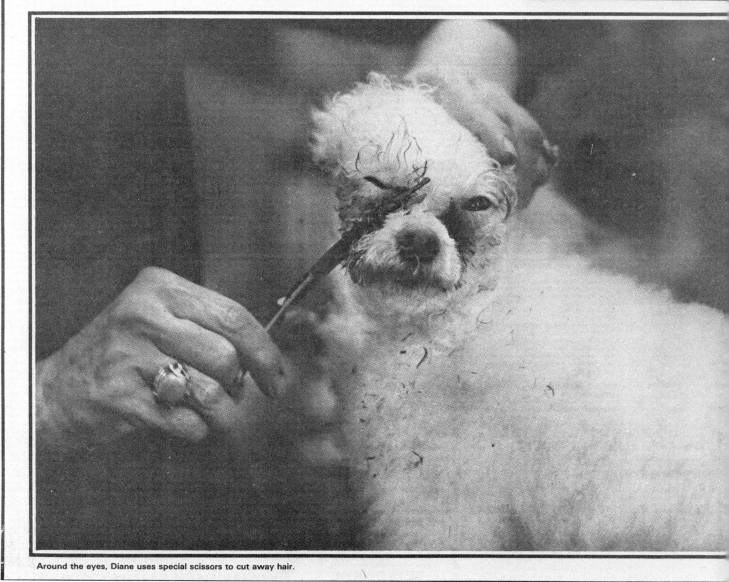

Around the eyes, Diane uses special scissors to cut away hair.

rush season at Diane's Grooming Parlor.
. mainly poodles, but also cockers, Old English
dogs, Pekinese, Scottish terriers, Pomeranians
hih Tzus, need their thick winter coats trim-
away: a spring cleaning of sorts.

d during her spare time between chores as
r of Lakeview Kennels, Diane Blumenstein is
ped, grooming about a dozen dogs per week.

two-hour groom includes brushing out matted
bathing with protein shampoo, fluff drying,
tioning fur and skin, clipping nails, cutting and
ng hair, plucking ear hairs, tying yarn bows
d the ears and, if requested, painting toenails.
h over 10 years experience in primping dogs,
knows how to keep her subjects calm while
re on the grooming table. She uses the radio to
e the dog and talks continually as she clips,
t's a good girl. Oh, so pretty.''

st dogs, except those nervous young ones in for
first clip, stand calm and obediently while
groomed, Diane says. New puppies are
ly trouble. "It's the noise of those clippers. I
vs tell people it would be like putting a
ozer in our face.

ne usually grooms poodles according to a basic
nel clip.''

this clip, the dog's hair is trimmed very close
toes and paws and about an inch up the leg.
is shaved and clipped from the face, formed
V-shape down the neck. The poodle's topknot
mmed and rounded so hair doesn't fall in the
eyes. The base of the tail is clipped, leaving a
f hair at the tip of the tail. Body hair is cut
, "like a lamb," says Diane, and brushed
rd for the "powder puff look."

sides the kennel clip, there are pattern clips for
es. The body can be clipped in 51 different
, the face in 16. A chart in the grooming parlor
ays all the variations and different trimming
rns for the body, legs, tail, ears, topknot,
tache and neck.

ne can cut them all but, she says, "I prefer the
clips because you can make boo-boos on the
rns.''

st customers prefer their poodles to have a
tache even though "poodles are really sup-
ed to have that slender nose look," Diane says.
Diane sees the usefulness of the moustache: It
uflages bad bites and "makes them look
er.''

ooming paraphernalia fills a table catty-corner
grooming table: special clippers, brushes,
rs, scissors, spray conditioners, detanglers,
rizers, various colors of yarn, fingernail
, protein shampoo, and even a "Mr. Groom
al of Health and Beauty for Dogs" brochure.

(Continued on page 8)

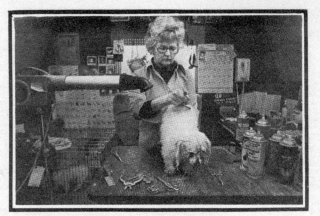

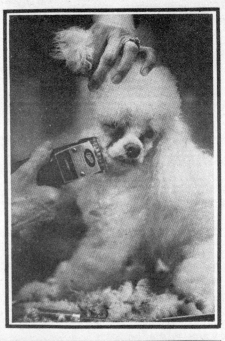

Above, having bathed the Poodle, Diane brushed the dog's fur under the hot air of a blow dryer. She uses a spray detangler and a wire brush to untangle the matted fur. At left, a shaver is used to trim around the dogs nose. Below, Diane clips toenails. Occasionally she gets a request to paint a dog's nails, which she does — in hot pink.

# Shoot-Out
## in Chanute

Law enforcement officers, highway patrolmen and security officers from all over southeast Kansas came to Chanute to spend hours shooting off hundreds of rounds of ammunition at paper targets.

STORY BY
GERALD EWING

PHOTOS BY
RANDY COX

At left, Officer Merrill Stevenson crouches and takes aim at the target during the combat part of the competition. Below, Officer Jerry Hoover checks his target accuracy after the bull's eye competition.

...offeyville Police Officer Jerry ...er, a well-built man with a slight ...stache adorning his lip, patted his ...aliber service revolver and pulled ...m the holster on his hip.

...'s an insurance policy,'' he says, ...l the trophies, plaques and desk of ...e Chief Jerry Smith's office in ... Hall. "I feel more confident that ... the day comes and I have to ..., I can use it. You never know in ...business. I might be talking to you ...three minutes later get called to a ...r store or a grocery store robbery. ...ve to be able to use it.''

...e pistol, championed by some as ...nly alternative to violence in ...rica and abhorred by others who ...n it perpetuates violence, is the ...eman's best friend in a sticky ...ation. It makes the odds a little ... equal when a dangerous situation ...es.

...at's the reason, Hoover says, the ...eyville Police Department has a ...l shooting team, one of the better ... in the state of Kansas.

..."s something you don't do today ...go out six months later and do it ...n,'' Hoover says of pistol shooting. ...u have to keep on top of it. That's ...we have a team.''

...over, a balding man, is the cap-...of the Coffeyville team that ...peted last week in the Southeast ...sas Police Officers Pistol Shoot, ...sored by the Kansas Peace Of-...s Association, a statewide law ...rcement organization.

...was a chilly, windy day Tuesday ...e Kansas Highway Patrol shooting ...e west of Chanute. The wind, ...er contended along with the other ...members, Det. Glenn Welsh and

Officers Merrill Stevenson and Ken Collins, kept the scores down to an unreasonable level.

The pistol shoot, which attracted about 50 law enforcement officers from highway patrolmen to part-time security officers, is sort of a social event as well. The day also featured golf and bowling tournaments, a riot gun shoot and an evening dinner.

Hoover, looking like a modern-day gunfighter in matching brown jeans and jean jacket, black cowboys boots and a wide-brimmed straw hat, gives his men their final instructions below the tall patrol radio tower swaying noticeably in the wind.

The shoot is broken down into two parts. The first part is bull's eye target shooting. It involves accuracy in a 10 minute time period, and accuracy in two shorter time periods. The second part is combat or silhouette shooting at the silhouette figure of a man. It involves a quick draw, speed, accuracy and the ability to shoot with either hand.

The first part of the compeition is slow fire target shooting. Each contestant must shoot 10 rounds in 10 minutes from 25 yards away.

"Approach the firing line, load five rounds and holster your weapon," the voice of the range master crackles over the public address system in a patrol cruiser. "Ready on the right, ready on the left, ready on the firing line.''

A whistle follows the commands and sporadic firing from the .38 and .45 caliber automatics rattles across the barren farmland adjacent to the range.

(Continued on page 12)

Joany and Randy Cox (her professional name is Joany Carlin), are the photography department of *The Coffeyville,* Ks., *Journal.* Randy, photo editor, went to *The Journal* in March 1977; Joany, staff photographer, has worked with the paper more than a year. They photograph, write, and design picture pages on a daily basis, and are responsible for local feature and news pictures. Randy's job also includes editing local and wire service pictures. He decides which pictures to use, and where and what size to use them.

Prior to moving to Coffeyville, Randy worked on the Jackson, Miss., *Clarion Ledger,* after graduating from the University of Missouri School of Journalism in December, 1975.

Joany worked a year as staff photographer on the Hattiesburg, Miss., *American,* after attending MU. Randy and Joany, who met at the university, were married in May, 1978.

◄
A little girl sells her pet lamb at the County Fair. (Photo by Joany Carlin Cox.)

# The Book-Length Picture Story

*James Holland*

With only a handful of newspapers and magazines publishing the classic picture story (a la *LIFE* Magazine), many serious photojournalists have ventured into the one really important new outlet: the book-length picture story.

While producing books may have a limited market, it "is" a market and "that market is growing." For the young photojournalist, this particular form of publication can be very important. Not so much because it is lucrative, (many times it isn't) but because a photo book is perhaps the ultimate portfolio piece. It's about the only place where a photographer has the space necessary to make a complete statement about even the most complex subject.

Another advantage of the photo essay book is its relative "permanence." With the exception of *National Geographic* magazine, and perhaps a few others which everyone saves, most picture story vehicles, newspapers, magazines, catalogs, etc., end up in the trash barrel a few hours after their printing and distribution. A nicely done photo book, on the other hand, usually finds its way on someone's coffee table or into various private and public libraries.

From a monetary standpoint, book-length stories, usually called picture books (as opposed to books illustrated with photos) don't generally make the photographer a great deal of money. The amount of time expended, plus costs of travel, film, and prints, may mean the photographer is working for less than the minimum wage. But the published book does provide him (or her) with some much deserved professional recognition, and a portfolio item which allows prospective clients to distinguish him from the 500 other photographers whose work they've seen that month ("Oh, yes, you're the guy who did the photo essay on Arthur Fiedler"). True, stock picture sales (the sale of color slides and photographs taken in connection with shooting the Fiedler book, *MR. POPS*, made more money for the photographer, than all the book's royalties). Even so, the satisfaction that came from completing the book, was worth more than money. Some people might call this a "photographer's ego trip," but it's more than that. It provides

"soul food" for that much frustrated artist who is buried deep inside every good photojournalist. Book-length picture books fulfill a creative need. They nurture the spirit.

OK! How does one go about doing a picture book? There are many ways, of course, but generally book-length photo essays evolve from one idea. The photographer takes one picture or a series of pictures which are interesting enough to challenge him. This picture or these pictures fairly shout "Hey, now that's a story that should be made into a picture book."

So the photographer spends more time shooting and mulling the project over in his mind until he either decides "it really is a good book idea," or he dismisses the whole thing because it will not "jell" or because it is too much work. If he does decide to pursue the subject, however, he has several possible courses of action to follow. He can proceed right on until the entire book is shot; he can shoot part of it; or he can immediately put his idea into words and start looking for a possible publisher.

Sooner or later, the idea will have to be crystalized so that it can be properly presented to prospective publishers. Usually referred to as a "query letter" a brief explanation (and/or short presentation of the book idea) is sent to various publishers to see if they are interested in publishing the book. In addition to a clear statement of the story's theme, it is helpful to enclose a sample picture dummy, complete with actual photos, sample text, and layout—together with an outline of the entire story. This presentation can and should be kept brief. Above all, it should be professional. The more professional the book idea, the easier it is for a photographer to convince the publisher that the author knows what he is doing; that he will be able to meet publishing deadlines; will be able to deliver a finished book on time.

Many book length stories are too involved or too expensive to complete without assurance that the end product will be published. In such cases, the photographer might seek a fellowship grant or an advance from a publisher. If he prefers, the photographer-author

James Holland, a successful young freelance photographer, already has three books to his credit and looks forward to many others. It's one project he recommends.

In the search for a publisher, the professionalism of the initial contact with a publisher is critical. A brief, well-thought-out presentation can go a long way toward convincing an editor that the would-be photojournalist knows what he is doing.

This particular package of material is part of a query currently being sent to publishers. It includes some sample photos, a published article on the same subject using some of the same pictures and text, and a one page summary of the book idea.

"Classic Life Magazine style layout" from a story published in the United States Information Agency Magazine *Al Majal.* The story, "Flora Azar, Tax Assessor" was about a successful Lebanese-American woman active in Arab-American affairs, director of an Arab Oriental dance studio, and tax assessor for the city of New Bedford, Massachusetts. It was a fun story for the photographer to shoot and write.

Such stories are often covered by the USIA for over-seas distribution and their magazines are usually beautifully done. This particular story, published in Arabic reads from right to left. The entire magazine is designed from back to front, but good layout is good layout no matter from which way it is viewed.

فلوراعازار: مخمّنة ضرائب

[Arabic body text in columns]

# TANGLEWOOD

By James R. Holland  Foreword by Michael Tilson Thomas

▲►
The importance of design and layout control cannot be over-emphasized. With the book *Mr. Pops,* the photographer chose the cover. In the case of *Tanglewood* the publishers designed the jacket. Most people agree that the *Pops* cover is much more effective than the *Tanglewood* cover and when displayed side-by-side at book dealers, the Arthur Fiedler cover was infinitely more eye catching. And as trite as it may sound, "People do judge (and buy) a book by its cover."

$4.95

# MR. POPS

## By James R. Holland

can use the most common approach. He can sell the idea to some magazine, and thus get the magazine publisher to pay a portion of the shooting expenses. Not only does this help defray the costs of doing a picture book, but a finished magazine article helps convince most publishers that his book idea is saleable. The importance of this latter point can't be overstated. "Saleability" is the secret word as far as a publisher is concerned.

Ideas for picture books often come from magazine stories. In the case of THE AMAZON,[6] much of the original shooting was done on a free-lance assignment for *National Geographic*. As is always the case with a *Geographic* coverage, there were hundreds of pictures in the rejects which, in the writer's mind, were as good or better than those published by the Society. *THE AMAZON*, incidentally, was one of those books which came about chiefly because of a lack of material on the subject. Actually, it is several geographically related picture stories—each separate in itself, but joined together between the covers of a book. The whole adds up to the story of one man's youthful adventures on the world's mightiest and most mysterious river. The publisher felt the void of material on the general subject justified the rather unorthodox format.

Photographers, or writers, working on their first book, have very little control over the end product. First-time authors, have very little leverage unless their story is truly unique and such a book can't be done by someone else. The photojournalist in this pleasant situation should get a good literary agent. For the rest of us, the best advice for negotiating with a publisher, once one has expressed an interest in the project, is to remember that the standard book contract is intended for writers. Because this is so, several special steps should be taken to clarify the rights in regards to photographs. The photographer should retain copyrights, and should keep stock sales rights to his illustrations (as photos are usually called in book contracts). He should also keep as much control over the printing as possible—which for first-time authors usually isn't very much. The American Society of Magazine Photographers[7] has a booklet (guide) to business practices. This guide should be consulted before signing anything. The booklet contains some very valuable information on picture book contracts.

Among the points that are usually reserved strictly for the publisher to decide, but which should be spelled out in the contract, are items like the projected publication price. In the case of *THE AMAZON*, it was originally planned to be released in hardback at a retail price of less than ten dollars. When it finally appeared, the price was more than double the projected figure. That hurt sales, especially since the photographer had previously consented to several cuts in quality (i.e., less color, poorer paper stock, and loss of layout control) in order to keep the price as low as possible. But—no matter how much control the photographer has on his picture books, there will always be things which he would do differently if given the opportunity to do it over. That's life, but try to have as much say in the quality control, and in the design and production of the book as possible.

Most book publishers complain that the ideas submitted to them for book length photo essays are either too narrow in scope (to attract a market) or too unrelated in subject matter.

For the would-be picture story author, persistence will have its rewards. Don't be discouraged by a rejection slip. Keep sending query letters to new publishers as soon as possible after the idea is rejected by earlier potential publishing firms. Many photojournalists refuse to compromise quality (or a good idea) and publish their own book-length picture stories. While some of these picture books are beautifully printed, most are costly and many are never seen by the general public. Private publishers usually don't have the finances or know-how to work out a successful marketing and/or distribution system.

Fortunately, the market for book-length picture stories and photo essays is expanding. Before *FAMILY OF MAN*[8] was published, there were few paperback picture essays. Now, more photo essays are released as paperbacks than as hardbacks.

If you've got a good idea for a book-length picture story, just think of that artist buried deep down inside you and get to work. Who knows, you may come up with a real winner.

---

6. *The Amazon*—a book done by Holland in 1971.

7. See Photographic organizations in appendix.

8. See bibliography.

# Newspaper Ownership Promises Profitable Career

*H. Michael Sell*

It was a trying time in 1971. Jobs were scarce and I had a wife and three children to support. Interviews in New York with *Time, Life,* and *Medical Economics* magazines, as well as with Champion Papers and Gannett Newspapers were disappointing. No one was hiring. It was a tight employment situation, indeed, for new journalism "grads."

And so I became editor and publisher of a weekly newspaper—and found an exciting outlet for my photojournalism education.

The weekly newspaper is a microcosm of the many facets of journalism, writing, reporting, editing, makeup and photography, each one a separate entity, but a part of the whole.

I had a preconceived notion that pictures used by weeklies were taken with antiquated equipment using stereotyped "hand-shaking and check-passing" themes. In some respects this is true, but since I entered the field, photojournalism and photographic ideas have improved tremendously. In Missouri I feel that the photography concept instituted at the *News* has played at least a small part in that change for a better use of pictures in the community weekly newspaper.

I was a novice as a publisher when I entered the community newspaper field. Not realizing how broad a journalistic background I had received at the University, I believed that I was trained only for photojournalism.

Because of this, I started off thinking pictures—big pictures—often using one picture and a cutline for half of the front page.

It was an exciting time.

The community had not seen local pictures played like this—nor had the readers of surrounding weeklies and dailies.

The use of big pictures in the *News* became an "in press" joke. Once I was introduced at a press convention as "the only editor whose front page consists of one-half page picture and one-half page news."

Later, as other Missouri newspapers realized the impact on readership and advertising that big pictures bring to a publication, a general increase in picture size became apparent.

Those first years of "newspapering" provided a learning process for the editor and staff of the *News* and for the community.

Those weeks when we were short of type we discovered we could fill space with pictures and please our readers.

In my case, I found it was not a matter of fighting with picture editors about the size and what pictures would run—I was the picture editor. Most new college graduates do not have this option. They "punch a clock," and do only what the boss says to do.

Those early years as editor and publisher were a time of innovation—of introducing magazine style picture pages to the area. Many editors then felt—and a few still do—that a picture page was twelve to fifteen $2 \times 3$ inch pictures on a page. This, in my opinion, was a page of pictures, not a picture page. There's a big difference.

Our efforts in Monroe City brought about a new category in the annual Missouri Press Contest. It was called, "Best Picture Page." Incidentally the *News* won top award the first year in the statewide competition.

Drawing on my experience and training at the University of Missouri School of Journalism and copying an idea from the author of this book, a Lifestyle section based on the now defunct *Columbia Missourian* magazine, was started on a monthly basis. The eight to twelve page Lifestyle section made up entirely of pictures and words was designed in a magazine format.

The *News* stressed features as an important facet—features with strong and big pictures. We (by now the rest of the staff was as picture oriented as I am) felt that every good set of words needs strong pictures and every strong picture deserves a good set of words.

Many times a picture drew unexpected response. Once a staff writer did a story titled "Pirates on the Mississippi." It was a story that involved a large family and we ran one picture, the family portrait one-half page. While the story was strong, and the title was a grabber, we felt it was the picture that

"There is a whole new challenge in the field of photojournalism for the right person on the small community newspaper," says H. Michael Sell, publisher and editor of the *Monroe City News,* a weekly newspaper in Monroe City, Missouri.

Sell graduated from the University of Missouri with a major in photojournalism in May 1971 and that month became editor of the *News*.

## SPECIAL SESSION

Council will decide fate of water line

The Monroe City Council will hold a special session tonight at 7:30 p.m. in city hall to consider a number of items. They will include a discussion of a water line from the city tower east to County Line Road, and an update on the sale of the old electric engine. Bids are to be opened on a truck for the street department and gas line liability insurance, and the council will determine what bids to accept on a snow plow. A representative of the state highway department will talk with the council about the proposed stop sign at Main and Second Streets. The minutes of the regular meeting September 7 will be read and approved, and the council will discuss meritorious awards for city employees.

# The Monroe City News

Volume 103  No. 37          Good Morning, It's Thursday, September 21, 1978          24 Pages  Two Sections  25 Cents

## Central telephone expands with purchase of Murray building

Expansion of the Central Telephone Co.'s northern Missouri district office in Monroe City is underway, with the purchase of the Murray building, located adjacent to the telephone building.

Possession of the 4,611 square feet building will end cramped conditions in Centel's office, according to Leon Thompson, manager customer services.

"However, we can't occupy the building until the remodeling is completed," he said. "As of now we expect it to be remodeled and fully operational by January, 1979."

The one-story cement block building, which formerly housed the Murray Grocer Co., will be occupied by the centralized service center, district office and centralized warehousing. A 4,686 square foot tract of land next to the building will be used as a cable and pole yard.

"Presently the business office, service center and district office are in one building," he said. "With the additional space we can be more productive."

Only the business office will remain in the present location.

In the past, Centel leased two buildings and another parcel of land for equipment storage.

Centel purchased the building from Sam and Charlotte Murray.

## Weather

# Rain may be late, but welcome

Welcome rain fell over the Midwest during the past week, and while it was too late to much good for most crops, late-planted beans were probably given a boost by the moisture. Pastures were of course helped by the 1.08 inch of rain that fell locally.

Along with the rain, temperatures in the 90s created the humidity for which Missouri is unhappily noted. As the News went to press, the weatherman was promising a break in the latest heat wave of the summer.

Joe R. (Buck) Thompson, at Conway Lumber Co., reports the following weather for the past week:

|              | High | Low |
|--------------|------|-----|
| September 13 | 85   | 70  |
| September 14 | 86   | 65  |
| September 15 | 85   | 59  |
| September 16 | 90   | 65  |
| September 17 | 91   | 72  |
| September 18 | 93   | 66  |
| September 19 | 94   | 71  |

The following amounts of precipitation were recorded: September 14, .14; September 16, .49; September 17, .40; September 18, .05; and September 19, .05. for a total of 1.13 in.

# Over $77,000 to be collected in taxes

Gary Osbourne, Monroe City Clerk, has completed the city tax bill for 1978, and has charged the city collector, Chris Buckman, with a total of $77,261.82 in taxes to be collected.

The city's total valuation is $4,661,794. The tax charged for sinking and interest is $25,645.57 at a tax rate of 55 cents. The general revenue rate is 95 cents, and will produce $44,292.74. The library tax is 20 cents, and should produce $9,323.51.

In addition, a total of $4,653.46 in street assessments will be sent to property owners. Osbourne pointed out that these assessments, at 25 cents per running foot, pay for a minute part of the street improvements. The city's share of street improvements this year amounted to $78,000.

Individual tax bills will be prepared in October, and are scheduled to be mailed out November 1, Osbourne said.

KEEPING THEIR FEET on the ground is not for Gary Fishback and John Freeman, as they head skyward in Freeman's balloon. The hot air ascent drew a number of spectators recently when Freeman, otherwise known as Kaptn Krash, brought his balloon to Monroe City. For a picture story of the lighter-than-air craft known as General Confusion, see page 13A.—PHOTO BY NELLIE ANN LANHAM

## Up we go......

# Happy Birthday

September 21—Terry Gibbs, Greg Maher, Mrs. Dee Wilmoth, Kevin Crowe, Shane Taylor, Bob Maddox, Frances Edwards.

September 22--Mrs. Eugene Castanier, Lois Mayfield, Lori Portwood.

September 23—Vicki McAdams, Dick McAdams, Marilyn Drebes, Donna Tanzey.

September 24—Kelani Smith, Jeff Ogle, Mrs. Bessie Hills, Miss Hazel MaGee, Louise Chisham, Steven Borrowman, Catherine Tonsor, Jeffrey Bryan Ogle II.

September 25—Larry Greeves, Glenn Guffey, Mrs. Alice M. Porter, Eva Lena Moyers, Debbie Allen, Pat Hood, Mrs. Leslie Long, Judy Lehenbauer, Alfred Sorrell, Mark Adams, Curt Lehenbauer.

September 26--Mrs. Marguerite L. Jones, Steve Carroll, Sid Buckman, Eugene Dietzel, Frank Berlin, Cindy Whitehall.

September 27—Shawn Hays, Mrs. Paul H. Knies, Cindy Hays, Mildred Watson, Michael Cookson, Gary Bohrer, Iva Powell, Ray DeLaporte, Darren Brooke.

# Punt, Pass and kick is the name of the game

Youngsters in this area may now register for participation in the 18th annual punt, pass and kick contest. Boys and girls ages eight through 13 can sign up at Monroe City Ford through September 29. They must be accompanied by a parent or guardian when registering.

The local contest will be held Saturday, September 30 at 1 p.m. at Lankford Field. Scoring is based on distance and accuracy in punting, passing and place-kicking.

More than 15 million youngsters have taken part in this event in the last 17 years. The program began in 1961, and is sponsored by the Ford dealers of America in cooperation with the National Football League. Local winners can advance to the district, state and national contests.

# THE GENTLE SPORT

Although ballooning is one of the oldest and most elemental forms of flight known to man, the recent popularity of hot air ballooning is partly due to new technology. Until the 1950s, hydrogen or helium had to be used to fuel the balloons, and the cost of these gases was prohibitive. When the U.S. Navy recognized the potential of balloons for scientific research, it pioneered studies in flameproof nylon and polyester used to make the balloon envelopes (the inflatable portion of the balloon), and in the propane burners used to heat the air inside. These inventions made hot air ballooning safe and practical.

Balloonists are attracted to the sport for a variety of reasons. Ballooning is carefree and romantic. It is adventurous because the pilots are never sure where the wind will carry them. It is a social sport that always attracts crowds of curious people. It is also a solitary sport, offering peace and solitude to the pilot who gets up and away from it all.

It is indeed a gentle sport. Ballooning is a neat kind of silence. Kind of a swoosh. You're in the wind...a part of it. And occasionally the silence is broken by the deafening blast of the propane burner...for a few seconds...and then the silence again.

And the cost of ballooning as a sport is not that bad either. Balloons range in price from $4,000 to $12,000. And after the initial investment the cost goes down. Insurance runs about $100 a year and the cost of filling the propane tanks ranges from $8 to $12. Each propane tank will yield about four hours of flight time.

There is something about a balloon that draws a crowd and turns eyes skyward, whether it's at a football game while serenely floating over the stadium or a farmers field at 7 a.m. in the morning.

It wasn't always this way...at one time balloons drew angry crowds. In the early 18th century Europe, angry or frightened farmers stabbed the balloons with pitchforks. For this reason the custom developed of carrying a bottle of champagne in the balloon as a gesture of good will to the landowner. The custom is still adhered to today, although balloonists may stray from it somewhat and pass around beer or wine after the flight instead of champagne.

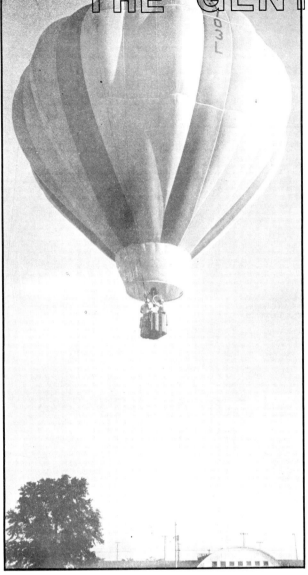

THE ENVELOPE, or balloon, which weighs 300 pounds, is filled with hot air from the blast of a propane heater. Danny Freeman, Gary Fishback, and Jeff Fishback assist John Freeman (third from left) as he fills his balloon (below). Freeman and Fishback climb into the basket as Ren Potterfield and Danny Freeman hold things steady (above, right). And finally, the balloonists take off, (above, left) to drift away through the early morning sky.

Freeman, of Flint, Mich., and his wife, the former Peggy Fishback, visited here recently with his wife's parents, Mr. and Mrs. Albert Fishback, and other relatives. Freeman is a licensed balloonist. Gary Fishback, who has taken up the highly popular sport of ballooning, picked up some hours toward his license while Freeman was here.

The balloon could be flown only in the early morning hours or late evening. As the outside air grew hotter in mid-day, the inside temperature had to be raised to an unsafe degree to take the balloon up. At 300 degrees the balloon melts.

A crash crew follows each flight of the craft, and helps to ''pick up the pieces.'' Since there is little way to guide the balloon except by climbing higher to catch different air currents, landing can be an exciting experience. This particular flight ended in some trees at the edge of a creek, and the crash crew waded through some very down-to-earth mud to pull the balloon in.

**PHOTOGRAPHED BY NELLIE ANN LANHAM**

**TEXT BY H. MICHAEL SELL**

# the Byliner

Vol. 6, No. 3
April, 1974

a magazine for community press writers, editors, photographers

## Writing the obituary

A reporter on a midwest newspaper had a habit that was disconcerting to prominent residents.

The reporter would call them and request an interview, but not for the purpose of writing an immediate story about them. The reporter was gathering data for their obituaries.

The article he wrote and any pictures he took were filed in the newspaper's library. When a prominent person died, the reporter pulled the file and updated an already written obituary.

**OBITUARY WRITING** on a small newspaper usually is assigned to beginning reporters. The beginners get the regular obituaries and the assignment of calling local funeral parlors and taking down the routine details. But when a prominent person dies, the seasoned writer, usually gets the assignment of writing the obituary.

The New York Times, for example, sends its reporter who writes nothing but major obituaries all over the world to interview prominent people. When a prominent person dies, the Times carries two or three paragraphs on the cause of death, circumstances, if unusual, and the age of the deceased. This is followed by an already-written feature article on the person's life.

The obituary is an important part of the newspaper's coverage. Readership studies repeatedly show that obituaries are among the best read items in a newspaper. They enjoy high readership from both men and women.

Most people rarely get their names in newspapers, unless they do something wrong or something particularly outstanding, until they die. So the writer should feel an obligation to do the deceased justice.

**THERE ARE BASIC** facts to be included in an obituary - details of the
(Continued on page two)

**Special treatment**

"We treated the death of a Catholic priest who had ministered to this small town in a most unusual manner," said H. Michael Sell, editor of the Monroe City (Mo.) News.

"This was done after much discussion, soul searching and all staff members offering ideas pro and con. We felt the man had had such an impact on the community that it warranted an unusual treatment. We did not know what the reaction would be, although a little less than half the townspeople are Catholic.

"The reaction was far beyond our wildest expectations," Sell continued. "The tremendous response from Catholic, non-Catholic, local people and people who had lived here was tremendous. We sold over the counter and through requests via mail around 350 extra copies. We even had requests from as far away as Ireland ... We felt our doing the unusual was the right choice."

drew the response. We sold over 250 extra papers as a result of that particular feature.

Another venture with a different use of pictures came about when a Catholic Monsignor died. He had been almost an institution in Monroe City for over 60 years. We ran the entire front page in black using a large picture of the priest taken when he became a monsignor. Across the bottom of the page was a picture of his funeral, taken from the choir loft. It was done only after much soul-searching on the part of the entire staff. Reader response assured us we had chosen wisely and had done the feature on Monsignor Connolly in good taste.

We do not confine our use of pictures to the paper. Borrowing an idea developed by Ed Lehr, picture editor at the Jackson, Mich., *Citizen Patriot*, the *News* made a thirty-minute slide-tape presentation using the phase-dissolve unit. This audio-visual program was called "The Birth of the *News*." With words and pictures it told the story of how our weekly started from scratch and ended with the final saleable product. This show was presented at the Missouri Press, and Missouri Press Women's annual conventions, Businessmen's meeting and, after updating—was shown at the local schools.

Taking the helm of a weekly newspaper was not all smooth sailing. I greeted a staff experienced only in taking "instant" pictures.

A brief training session converted my writers to the 35mm cameras. For them it was a struggle. Little things a trained photojournalist takes for granted became monumental tasks. Slowly, however,

they learned to meter, change lenses, what shutter speed and depth of field meant, how to load film—and yes—to be sure to have film in the camera. I stayed with Tri-X film for both indoor and outdoor shooting.

Together we tackled the picture problems. Since then, several of my writers and I have won state and national awards for our photography.

At times readers did not agree with our picture policies. For many years an auto accident was a main event in Monroe City and it always resulted in a front page picture. I felt then, and still feel that when the first two model T's Henry Ford built smashed into each other it was newsworthy. But I could not accept pictures of fender-bender car wrecks over and over. If you've seen one dented fender, you've seen them all.

Yes, in many instances we had to re-educate our readers. A big tomato, a squash or a ruptured cabbage are not front page news. Generally, they are no news at all. If on occasion we use them, they are relegated to the garden page. Today, we do not look at an overgrown vegetable as we once did.

If one of those jobs I sought after graduation had materialized, things would have been much different.

Had I gone to a large magazine or newspaper, I would have used only my knowledge of photojournalism. Even though I arrived as editor of a community weekly newspaper almost through the back door, the unorthodoxy of it all has enhanced the pleasure of being part of the exciting total world of the Fourth Estate.

It is a joy worth sharing.

◀ The *Byliner (left)*, a national magazine for community press writers, editors, and photographers, commends the young publisher for "special treatment" given Monsignor by the weekly *Monroe City News*.

# Student Participation

1. Write a letter to a friend who, like yourself, has been studying for a career in photojournalism. In your letter submit an outline telling your friend how and where he should apply for his first job.

2. From all the pictures you have taken and enlarged, carefully select five (for a class display) which you believe provide an effective nucleus for your portfolio.

3. Would you recommend that the friend in ex. 1 try first for a job on: (a) a large daily newspaper? (b) a large magazine? (c) a weekly newspaper or small journal? (d) a specialized trade journal? Give reasons for your answer in each instance.

4. Carefully weigh the recommendations made (or implied) by Joany and Randy Cox, James Holland and H. Michael Sell. Which course of action most appeals to you?

First Award, General News
Class, in the 30th Annual
Pictures of the Year
competition, this shocker titled
**Cease Fire** was made by Mike
Zerby of the *Minneapolis Tribune.*
(Photo courtesy of Mike Zerby.)

# 23

# A Look at the Future

With the demise of *Life* and *Look* a few years ago, photojournalism did not go into a slump, as many predicted it would. Newspapers and magazines closed ranks and gained what they could from the situation. Even though the picture giants were no longer with us, each passing year has seen an increasing demand for photographic reportage.

And now that the great picture publications are with us once again, will they once more lead us to a bigger and better photojournalism? Only time will tell.

In the reincarnation it is interesting to note that the roles of *Life* and *Look*, at first seemed to have been reversed. Although it was predicted that *Life* might eventually become a twice a month publication, it began as a monthly. On the other hand, *Look*, the former twice a month magazine, in the preliminary stages, was rumored as a weekly and later on as a twice-a-month publication. Its appearance in 1979 was expected to reveal, not the entertainment magazine of former years, but a hard-hitting publication with a sharp focus on news.

Things did not turn out exactly that way. Although a monthly, *Life* soon took on an aura of its former self. Excellent articles and excellent pictures by well-known photographers brought back pleasant memories of the picture magazine.

◄First cover of *Life* magazine as a weekly—November 23, 1936. Cover photo of Fort Peck (Mont.) Dam by Margaret Bourke-White. (Photo from *Life* "Press Information" release. Sept. 24, 1978.)

◄First cover of *Life* magazine as a monthly—October 1978. Cover photo of hot air balloons in Indianola, Iowa by David Deahl. (Photo from *Life* "Press Information" release. Sept. 24, 1978).

The November 1978 cover of *News Photographer*, official publication of the National Press Photographers Association, Inc., featured a portrait of then managing editor John Durniak holding a "pilot issue" of the new *Look*.

Durniak's portrait (original in color) was taken by Joseph Cannata, Jr., of the Hartford (Conn.) *Courant*. *Look's* cover picture also in color, was taken by Eddie Adams. Black and white copy supplied through the courtesy of Jim Gordon,

editor of *News Photographer*. In late spring of 1979, *Look* magazine was changed from twice-a-month publication to a monthly. At that time, too, Jann Wenner, editor of *Rolling Stone*, became the editor of *Look*.

A Look at the Future/289

On the other hand, *Look* did not get off to such a smooth start. In the July 4, 1979, issue of the *Washington Post*, Tom Zito wrote: "*Look* magazine yesterday severed its two-month-old management with *Rolling Stone* by dismissing editor, Jann Wenner (Durniak's successor), and 'dissolving' its editorial staff, thus throwing the future of the beleaguered monthly into doubt."

Echoing this statement, *Editor & Publisher*, publishing trade journal, in its July 14 issue, reported: "*Look* magazine's future was left in doubt following the dismissal of editor Jann Wenner and the editorial staff last week. The publication began publishing again in February. Daniel Fillipacchi is board chairman and publisher of *Paris Match*. Assistant publisher, Didier Guerin, was quoted as saying that 'the magazine will continue to come out.'"

Leaving it up to our readers to pursue the story of the two picture publications, let us continue our "Look at the Future."

Many persons believe the *National Geographic* magazine, the new *Life* and perhaps *Look* as well as *Geo,* the monthly magazine which promises "a new view of our world," and other publications not yet on the drawing board, will have great influence on photojournalism and photojournalists of the future. We are certain that the careers of picture publications the world over will be watched anxiously and carefully.

Technically, as well as editorially, photojournalism has undergone many changes. We've seen faster, more sensitive, better quality film and more versatile equipment upgrade photography and photo reporting. Among the many important changes through the years was the shift from 5 × 7 inch and 4 × 5 inch press cameras to the 2¼ × 2¼ twin-lens reflex and then to 35 mm cameras. These changes were only the beginning.

Motivated by threats of a silver shortage, and by the spectacular success of the 35 mm camera in the 1930s, some persons today are considering the use of film about half the size of the 35 mm frame such as Eastman's 110.

With better lenses and better equipment, a few authorities believe the day is close at hand when the news camera will be a subminiature loaded with film closely akin to videotape. If and when that happens, completely new technology will also be needed. Photojournalists, must keep their fingers on the pulse of a changing photojournalism.

Before we know what has happened, ecological demands and technological changes can force newspapers and magazines to adopt completely different formats. Conceivably, tomorrow's newspaper could be delivered on a closed-circuit television network.

Film manufacturers, however, do not fear the future. Anthony Frothingham, an Eastman Kodak specialist writes: "In a society which is turned on by the prospects of technological advance and tuned in to the notion of rapid obsolescence, the impression created in some people's minds is that film has outlived its usefulness, that nothing new can happen in film, that there is room for only one visual medium in the days ahead. In short, that film is dead."[1]

Taking issue with that opinion, Mr. Frothingham expresses belief that "the emergence of video technologies has already stimulated the film industry to look for new ways to improve its own capabilities. The end result of this cross-fertilization will be to make film and tape more than alternative agents for communications . . . it will make them compatible partners in getting the job done."[2]

Using the Super 8 camera as the cornerstone, Kodak has recently introduced a practical sound system. A cartridge similar to the standard silent Super 8, is used, and the film has a sound track which is automatically recorded in the camera during the filming. After processing, the film is shown on any standard Super 8 sound projector or on a tape deck projector, also a Kodak product.

The Eastman Company offers a video player for Super 8 film. Primarily intended for educational use, the player may soon be adaptable to any closed-cir-

1. Anthony Frothingham, "Film Industry: That Is the Future," *Audio Visual Communication* 7, no. 1 (December 1973): p. 24.

2. Ibid., p. 24.

cuit television system. The big advantage here, is that one day Super 8 cameras may generally replace more bulky television equipment. Such an arrangement would be more versatile and less expensive. In addition, a broad utilization of the subminiature system would permit the use of vast libraries of existing Super 8 educational film.

Polaroid, too is looking to the future. Only recently this company has come up with "Polavision," a combination "movie camera" and "processing-showing box." This combination enables one to take, process and show moving pictures all in the matter of a few minutes.

Norman D. Lang, of Massachusetts Institute of Technology in a recent article writes:

The time has come when almost anyone can produce a video program from the beginning to the end without a room full of sophisticated instruments, a degree in electronics, and a refresher course in calculus.

Portable video taping in particular has come a long way. Today you can grab a deck or two; can shoot a program in the morning and have a completely edited tape by late afternoon . . . incorporating different camera angles of two Portapack tapes.[3]

# The Laser Beam and Picture Production

To explore another facet of tomorrow's photojournalism, let us take a look at the laser beam: a dictionary defines laser (or lazer) as "*l*ight *a*mplification by *s*timulated *e*mission of *r*adiation. A device, usually containing a crystal such as a synthetic ruby in which atoms, when stimulated by focused light waves, then emit them in a narrow, very intense beam; also called an optical maser."[4]

A *National Geographic School Bulletin* some time ago described the laser beam in more romantic terms:

Unlike the turban-wearing giant that puffs from Aladdin's lamp, the laser's genie bursts forth in the shape of the sharpest, purest, most intense light ever seen by man . . . when focused it is billions of times brighter than sunlight. . . .[5]

Invented in 1960, the laser "has just begun to shed light on its many uses." In essence Geographic's writer said:

Laser light (one wavelength, one color) is coherent. The waves are "in phase," and each step reinforces the other, producing a strong, concentrated beam which can travel for long distances without "fanning out and growing weak." It is this coherence on the part of the laser beam which enables it to perform such miracles.[6]

Discovery of the laser beam has had and will continue to have great impact on mankind. It has made possible bloodless surgery. In the field of communication, as in medicine and other sciences, it has created miracles. Important in televising man's first step on the moon, the laser first gained attention in photography when it was used (in the hologram) to experiment in the production of three-dimensional pictures. Another laser beam breakthrough in photography occurred in 1966 when Arlan Wiker, assisted by other members of the *National Geographic* staff, took a magnificent night-time color picture in Washington, D.C. (See p. 226d)

In a 1973 brochure, the Associated Press (AP), said, among other things that:

Improvements have been made in Wirephoto over the past 38 years, but with more than 800 members moving into offset and improved printing processes, it was apparent higher quality wire pictures were needed than were possible by electrolytic or electrostatic processes.

The laser beam, used to penetrate outer space, now is harnessed by Massachusetts Institute of Technology scientists and AP's Research and Development team to propel

---

3. Norman D. Lang, "Videography—Portapack World . . . It's Getting Better All the Time," *Industrial Photography 23*, no. 8 (August 1974): pp. 32–33.

4. *Webster's New World Dictionary*, College Edition, 1957 s.v. "laser," p. 824.

5. National Geographic School Bulletin 46, no. 7 (23 October 1967), p. 98.

6. Ibid, p.

AP members into a new era of photojournalism.

Laserphoto's application of modern electronics and new principles of photo reproduction and photo transmission offer a quantum leap forward for AP members! Pure photographic quality for outstanding reproduction.

*The Achievement:* Picture editors at AP papers will receive at their elbows individually cut and stacked glossy photographs—not facsimiles—of unmatched sharpness and clarity, all done automatically.

*The Next Step:* The "electronic darkroom" with computer editing and transmission of AP photos.[7]

The three-phase timetable, as revealed in the brochure, was a busy one, indeed. The brochure concluded:

*Phase I*—In 1974 AP begins an approximately 24-month program of replacing all photo receivers and transmitters. Photofax and Automatic Wirephoto receivers are replaced as new Laserphoto machines become available.

*Phase II*—With all new receivers and transmitters in place, improvement in picture quality is accomplished by an overnight change in the AP system's "scanning structure," producing a picture closer in quality to the original.

*Phase III*—As AT&T expands digital transmission lines connecting larger cities, AP gradually introduces computer handling of pictures on regional desks, offering high-speed, high-quality service to members in cities served by digital facilities.

At its hubs, AP stores network picture transmissions in computers. AP edits pictures on video screens and selects pictures for relay on state networks.

This phase will probably be completed by the end of the 1970s.[8]

The Associated Press is right on schedule with its timetable. Let's read the following updated report.

---

7. Wesley Gallagher, Associated Press brochure, 1973.

8. Ibid.

The equipment to send and receive pictures by wire is considerably improved over that in service twenty years ago. The illustration *(op. pg.)* shows the Associated Press Laserphoto machine. "It is here," says Robert Gilka, photo director of *National Geographic* magazine, "that the laser beam is being used to best advantage." (Photo courtesy of Associated Press.)

*Below,* Unifax II, United Press International receiver. *Left,* we see the minute detail which can be obtained from Unifax II. The device through which the laboratory technician looks is part of an infrared sensor assembly to be used in a Skylab space vehicle. (Photo courtesy of United Press International.)

# The Electronic Darkroom

*Herb Hemming, The Associated Press*

The Electronic Darkroom mentioned in the 1973 brochure, is now referred to as E-D. Not too many years ago it was a dream. In 1978 it became a reality. The Associated Press (AP) then began using the E-D at its headquarters in New York.

It started in the early 1970s when the AP announced a revolutionary photo system called "Laserphoto." Developed by the AP research team and the Massachusetts Institute of Technology (MIT), modern electronics were put to work to provide outstanding quality for outstanding reproduction. Facsimiles are gone and picture editors at AP member papers receive individually cut and stacked glossy photographs of great sharpness and clarity.

In Phase I of the program, AP replaced Photofax and Automatic Wirephoto receivers and Wirephoto transmitters with Laserphoto transmitters and receivers. There are approximately 800 Laserphoto receivers and 600 transmitters in the United States.

Phase II will be an overnight changeover. By replacing an electronic card in all Laserphoto equipment, the number of scanning lines will be increased from 111 to 166 per inch. The result: a picture of higher quality. Putting it another way, it means that a picture that is now a mosaic of about 800,000 tiny tiles or picture elements will be transmitted in the new mode at a more detailed 2,000,000 per picture.

Describing the whole program technically would take pages. But the objective is simple: reception of a picture as close to the quality of the original as possible, with retransmission of the picture to provide the best reproduction.

Phase III is the Electronic Darkroom. The basic ingredients of the E-D are a digital PDP-11 computer with a large disc for storage of pictures, a television monitor and a video terminal with a keyboard much like a typewriter. The E-D receives pictures just like the Laserphoto network. Instead of exposing a sheet of paper, however, it stores the picture information. As each picture moves through the E-D, it receives an identification number. The editor then has that picture under his control—he can route the picture where he wants on the AP's international network, he can

store the picture and transmit it later, he can store the picture and delete it later. He can also tell the computer to skip a given picture on a particular leg of the AP network.

What the editor can do with a picture once it's in the computer is almost mind-boggling. He can crop it, enlarge it, darken it, lighten it, sharpen it, give it more contrast, give it less contrast, tone it, rewrite the caption. This can all be done by giving the computer simple commands on the video terminal.

Yes, it's almost mind-boggling, but that's just the start. The AP is also working on a positive input direct from negatives—at high speed (possibly 30 seconds per picture) and high resolution. Thus AP will transmit not from prints, but from photographic negatives as they move deeper into the electronic darkroom applications.

One of the most fascinating capabilities of the system is a combination of functions which results in a kind of electronic air brush for retouching. On the MIT development model of the E-D, selective portions of the picture can be deleted to improve composition, or entirely new elements can be added. This kind of electronic "plastic surgery" is not a feature of the operational model as yet.

The ethics of retouching by the computer is sure to cause much discussion in the future. It's really no different, however, than the "human" artist who retouches pictures now. It will be a human who gives the computer the retouching instructions, and if that retouching is used to mislead, we should vent our anger at the human and not condemn the computer.

The day will come when the system will work in color as well as black and white.

It's all very new in the world of photojournalism. But we must not let the "excitement" of the computer sidetrack us from our prime objective. The photojournalist is still here to accurately capture history, to provide the public with information, to record reality. The Electronic Darkroom is a tool to help the photojournalist better accomplish this objective.

▶ *Right,* AP editors use the electronic darkroom at headquarters in New York. Commands are given on the keyboard (much like a typewriter). Picture appears on TV screen at top.

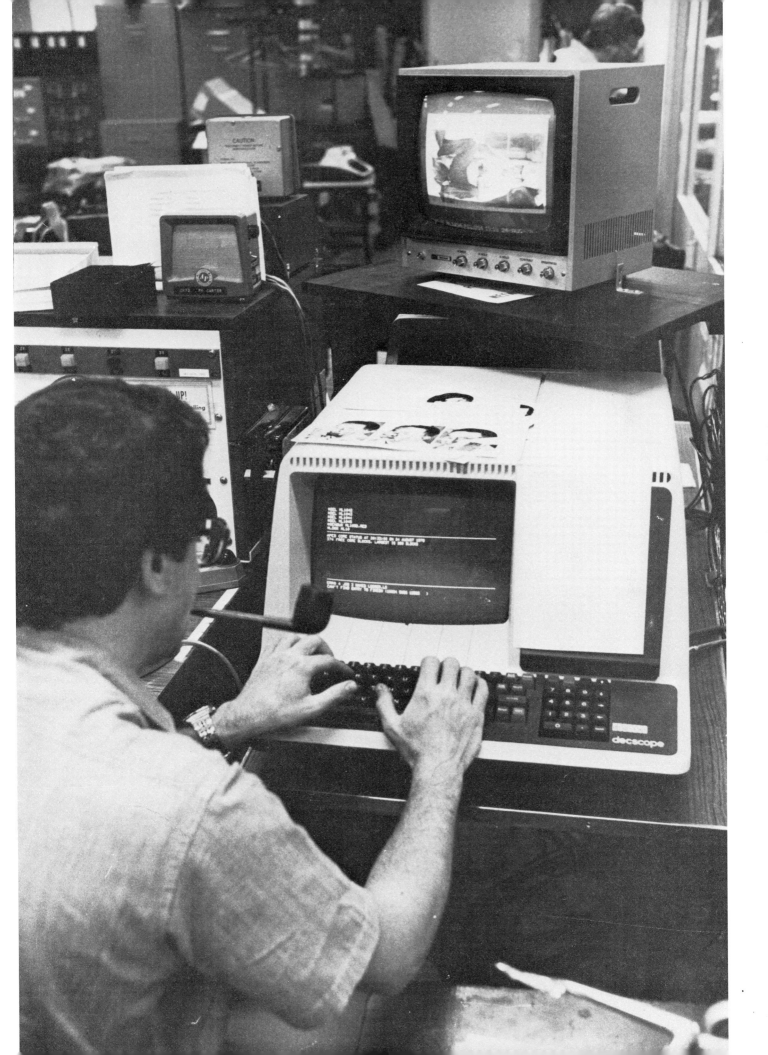

United Press International's portable 16-S Transmitter, *(right)* is a popular piece of communication equipment. A recent UPI brochure says, "its solid-state electronic components, and sturdy light-weight chassis parts solved the size, weight, and reliability problems of a few years ago." More than 300 16-S D/F's have been leased or sold to individual newspapers and national agencies. In 1978 the 16-S was in use in nearly thirty countries.

◄ Each picture that goes through the AP computer is given an identification number *(left)*.

◄ *Left,* a neat, easily readable caption is put on the picture by use of the keyboard. When the picture is transmitted the appropriate caption is automatically queued to the AP picture.

# Computerized Photography

Pictures by wire, which did so much to stimulate wider use of photojournalism in the 1930s, will continue to contribute greatly. In a letter from Jerry Umehara, a foreign picture editor for United Press International (UPI) in New York, we learn something of the function of UPI's "scan-converter."

"The computer," he wrote, "can, upon command, convert a picture being sent on the United States domestic network into either the European mode [network] or the South American mode [network] . . . a picture coming from South America or Europe can also be converted into the United States mode. When it is not convenient to transmit from one network to another, the pictures are stored on tape and played later."[9]

F.W. Lyon, United Press International vice-president for newspictures, elaborates on Umehara's information: "The computer [scan-converter] has [as of February, 1974] been in service for nearly eighteen months. It allows us to convert the domestic network to the international net, or vice versa, on a near real-time basis, with no attendant loss of quality. Instructions are given to the computer by typing a message on a teletype machine. The computer responds by telling the operator what it is doing."[10]

Pleased as he is with the scan-converter, Mr. Lyon is equally enthusiastic about Unifax II, UPI's picture receiver introduced in 1974. Unifax II uses an electrostatic recording process and has the following advantages over existing (1974) electrolytic systems:

*Dimensional stability:* The paper remains dry throughout the process. There is no stretching or shrinking . . . no problem in maintaining register on color separations.

*Permanence:* Unifax II electrostatic copies are archival in quality . . . as permanent as the paper base itself.

*Definition:* Unifax II improves definition and gives a picture of unusual sharpness and clarity.[11]

In a letter updating his report, Mr. Lyon writes:

Unifax II is proving fantastically successful since its introduction. More than 600 units are in use around the world now, and we are beginning to deploy units into areas outside the newspictures field. Applications include high quality weather map reception, and various types of civilian and military photo transmission requirements. Modified units can be used by law enforcement agencies for the transmission of fingerprints and other data concerning suspected criminals.

On the drawing board now is an ambitious project to greatly expand the use of the computer (scan-converter discussed in your first edition) for the processing of photos.

We envision a system which would connect New York with our own headquarter bureaus in Asia and Europe, and through those bureaus to headquarter bureaus of virtually all of the national news agencies in those areas.

Not only would the computers allow direct interfacing of our networks with those of our agency partners, this system envisioned would also allow for video terminal display of photographs, storage of up to 200 photos at any one time with instant retrieval and playback, electronic cropping, enhancement, and recaptioning, if necessary.

The system would allow for magnetic taping of stored pictures, thereby taking a giant step toward an electronically controlled photographic library.

---

9. Jerry Umehara: personal communication, January, 1974 (paraphrased in this text).

10. F. W. Lyon (1974): personal communication.

11. F. W. Lyon (1974): personal communication.

# Summing Up

In the future, newspaper color will be of better quality and will be commonplace. Thanks to sensitive, computerized color-separation machines, newspapers and other publications will photograph fast-breaking news stories in the morning and have color layouts in afternoon issues. Film will continue to increase in quality and sensitivity and may eventually disappear in favor of processes which will enable the cameraman, with the click of a shutter, to record the scene and immediately transmit pictures to the newsroom or picture desk. Here they will be edited. With captions attached, they will be sent to the layout department to be prepared for immediate printing, or will be stored in complex retrieval systems for future use.

Yes, we are living in an exciting age, and more exciting times are just around the corner. No scientific contrivance, however, and no invention in the foreseeable future will eliminate the need for alert, perceptive human beings.

One important influence on photojournalism of tomorrow are the people who depend upon words and pictures for their news, information, and entertainment. Born in a visual age and nurtured on television and on picture newspapers and magazines, they are demanding. Not satisfied with just any "click of the shutter," they demand much of today's photojournalist and in the future will demand even more. Photojournalism of the future must be perceptive and must continue to have integrity and believability.

Does photocommunication conform to the new journalism? That question leads to another: What is this thing called the new journalism?

In a published monograph James Murphy pointed out that, though Truman Capote disagreed, critics hailed his book *In Cold Blood* as a "classical example of the new journalism."[12]

In their approach, today's photojournalist and the photojournalist of the future are not unlike Capote. Both are sensitive and honest. Both are subjective rather than objective.

Tomorrow's photojournalist will be a special type of person. An artist at heart, he will have all of the earmarks of a well-trained reporter. Most young men and women who enter the field will be college graduates. Many will be specialists. Present-day newspaper and magazine readers are more critical, more demanding than ever before. Many are college trained, and the product they buy must be good.

In review, tomorrow's photojournalist will have mastered the ABCs of visual communication. He will know the sentence structure and the syntax of photography. He will know layout and design and its many ramifications. Tomorrow's photojournalist will know how to select pictures, how to crop pictures, and how to present the single picture and know how to combine it with other single pictures and picture strips to produce a picture layout or picture story. Yes, the photojournalist of tomorrow will be an expert in research and will know how to write display lines, captions, and, if need be, the word story, itself. The photojournalist of the future is a person who believes in pictures and the picture language. Above all, he must remember the precept learned early in his schooling: It is not a matter of words versus pictures or of pictures versus words. Rather, it is a matter of words *and* pictures. Tomorrow's photojournalist will contribute his full part to a winning partnership.

# Final Thoughts

As Mr. Schaleben said, "People who take pictures or people who handle pictures are in a fast-growing and exciting field." If you are or will be one of those to enter photojournalism, here's wishing you the best of luck in your chosen field.

Clifton C. Edom

---

12. James Murphy, "The New Journalism: A Critical Perspective," *AEJ Monograph*, May 1974.

# Student Participation

1. Why are some people thinking of changing to subminiature cameras—about half the size of 35 mm to produce pictures for publications?
2. What is your reaction to the suggestion that conceivably tomorrow's newspaper will be delivered on a closed-circuit television network?
3. What influence do you think the laser beam will have on photojournalism of the future? Use information from this chapter and from an encyclopedia to answer this question.
4. The Associated Press and United Press International both have a program for production of better photographs for newspapers, magazines, and television. List some of the steps they have taken to keep up with modern trends.
5. As they become better educated, people demand more precise reporting and more precise communications media. What effect will these factors have on the newspapers, magazines, and television programs of tomorrow?

# Appendix
## Principles of Selection of News Pictures

*William Stephenson*

William Stephenson, "Principles of Selection of News Pictures," *Journalism Quarterly* 37 (1960): pp. 61–68. Reprinted by permission.

News pictures are the daily butter, if not the bread, of newspapers and magazines. The photojournalist is as essential as the reporter. As part of the observance of the 50th anniversary of the University of Missouri School of Journalism, a committee was invited to select 50 memorable news pictures of the past half century (1908–1958), the exhibition of which would constitute a recognition of journalism's pride in the photojournalist's art. The need for suitable principles of selection arose, of course, during the long process of getting together an acceptable panel of judges and worthy pictures for them to judge. The collection of 50 memorable pictures was made under the auspices of the School of Journalism, University of Missouri, the National Press Photographers Association, and Encyclopaedia Britannica.

The problems involved seem, at first glance, to be formidable. Expert judgment, rather than popular voting, was indicated. Looking back over 50 years presents its own difficulties of perspective. Principles of selection are little understood, apart from majority rule. It may be of general interest, therefore, to report what was achieved in the circumstances.

## Selection Conditions

The photographs were limited to those given currency in this country, whether taken here or not, whether by an American citizen or not. Discussion at the outset raised questions, naturally, as to the criteria to be employed: Is a significant news picture to be a literal portrayal of a great historical event, or more a picture of great human interest? Must it show originality and be technically perfect? What is the relative significance of spot news photographs—the unplanned, unexpected happening, caught magically in an instant—and general news, where events are currently in the news or are previously announced? How to judge, too, the literal as distinct from the symbolic?

Faced with similar problems in the selection of *fine art* photographs, a committee responsible for selecting the *Saturday Review* "Portfolio of Great Photographs" (*Saturday Review*, May 16, 1959) decided that it was not necessary to establish for its twelve expert judges any specific criteria for selection. Each judge voted according to his own conception of what was a significant photograph, and the photographs gaining the most *pro* votes were selected. The

**Is there a defensible and preferable alternative to majority rule, when judges are used to select a roster of outstanding photographs? The research specialist who developed Q-methodology in factor analysis proposes an alternative selection procedure and describes its rationale and use.**

---

The author wishes to express his warm thanks to Prof. C. C. Edom, without whom little of the above could have been accomplished.

selection, accordingly, was a "representative choice by majority vote."

The procedure seems fair, and up to a point it is probably sound. Clearly, even if it is nowhere made explicit, in the case of the judges for the 50 memorable *news pictures*, it must be assumed that all the judges would have in mind a kind of general journalism creed that significant photographs are in some sense a true report of what is going on in the country. The photographs would be of interest, presumably, to the nation as a whole. They would be in some way educative, but mainly entertaining, and also a reflection, in some degree, of the charter that all journalists are supposed to have, to "admonish and inform the public."

However, little might be gained by making such factors the bases for selection in any formal or systematic sense, and we conclude, therefore, as was done for the *Saturday Review* jury, that the judges should be left to their own devices. Even so, the procedure of majority voting, so widely employed, is weak from a methodological standpoint. The opportunity is not grasped in such a gross vote to learn how far the judges are alike or different in their selections. No one expects experts to be in complete or even close agreement, but one would like to know the facts of the matter. Some judges may be alike in their selections; others, admittedly, may be idiosyncratic.

Considerations of this kind lead, of course, to voting methods of a more sophisticated kind than that of majority rule. They might lead, indeed, to sound reasons for ignoring, more or less, all but one of several judges, whose selection (for sound reasons) might be far superior to those of all the others put together.

One further point requires consideration. It does not seem sufficient to say, and to leave it at that, that each judge will have his own particular criterion for judging photographs. No doubt some have made up their minds, before they see photographs to be judged, about what they believe to be sound criteria for judging photographs. Thus

Frank Baker, Senior Art Director of McCann-Erickson, and one of the judges of the *Saturday Review* "Portfolio," maintains that "wearability" is important in a photograph: the ability of the photograph "to endure, to fascinate and refascinate generations of minds" is held to be essential in any creative art. No doubt Mr. Baker would evaluate photographs in some such terms.

But more usually, the photographs themselves, either by repute or in the mass as the judge looks at them, are likely to set a frame of reference for their evaluation. Thus, another of the "Portfolio" judges, A. Frankfurter, tells us that he did not begin his selection with any particular doctrine in mind, but *after* the selection he wondered why he had chosen some photographs rather than others, and concluded that he had chosen those which not only seemed best composed and technically the best, but also, above all else, those which "made an instant *live*," that is, they were all "moments which somehow have been made to stay." He knew what he liked most, but only afterwards, upon reflection, was he able to say why he liked them.

It may well be that Mr. Frankfurter's is the more general case, and that only after an expert has made his selections will it be profitable for him, or for others, to consider the reasons for the selections being what they are. Something might be gained, therefore, by examining possible criteria *after* evaluations have been made, rather than the reverse. Discussion after making the selections might make it possible, at least, to consider more pertinent selections than those based on majority rule alone.

These considerations lead to methods which have already been developed to provide additional information about the evaluations of judges, and which require no *a priori* or explicit criteria upon which to base evaluations. Some aspects of the methods are described generally in the work of Cronbach and Glesner[1] and, more particularly, in Stephenson.[2] In the study now to be reported, use was made of Stephenson's methods.

1. L. J. Cronbach and G. C. Glesner, "Assessing Similarity Between Profiles," *Psychological Bulletin*, 50 (1953): 456–473.

2. William Stephenson. *The Study of Behavior: Q-technique and Its Methodology* (Chicago: University of Chicago Press, 1953).

## Preliminary Screening

Many hundreds of news photographs were collected, first, under James Colvin's auspices, and then by Professor Edom. The latter searched books, periodicals such as *Editor and Publisher*, and contest material in general. He also had available the photographs of sixteen years of contest sponsorship of the School of Journalism at the University of Missouri. All committeemen were involved in forwarding suggestions. The result was a pool of some 300 pictures. After preliminaries, these were reduced to 165, the eliminations stemming from duplication, non-American photographs, and the like.

Professor Edom now prepared sufficient 3 × 5-inch photographic copies of the 165 to give a complete set to each member of the committee. Each judged the news photos independently. First he looked through all 165, and was asked to add any other news photos that he thought should be included. From his set of 165 plus the additions so introduced, he was invited to select 60 that, in his opinion, were best (by whatever criteria he wished to use). The preferred 60 were returned to Professor Edom, who composed from these a set of 159 news photos which four or more judges had included in their selections. The procedure, clearly, was not materially reducing the number of news photographs—nearly all of them were receiving support from at least four judges.

## Preliminary Factoring

The more detailed evaluations now began, using factor methods (Stephenson). These consist, basically, of requiring each judge to score each picture; the judges are correlated with one another; their correlations are then factor analyzed. If all are judging on the same basis, with the same criteria, the analysis should provide only one factor. If no judge sees eye to eye with another, there should be no factors. If some see things one way and others another, there would be two or more factors, Such is the rationale of factor analysis. It serves to show what the judges are doing systematically (whatever they may say they are doing). The 159 photographs were divided randomly into three sets of 53 photographs each (designated A, B, C, respectively). The writer visited each judge in turn and gave instructions in how to score on an 11-point scale, from 0 to 10, from least to most memorable, according to the judge's own criteria or viewpoint. Using the sets of 53 facilitated the scoring and made it possible to measure the consistency of the judges as they judged first one set and then the others. They were judged in order A, B, C.

The results of the three sets were in fact similar, showing that the judges were consistent from set to set. Hence it is sufficient to discuss data for set A, to indicate the results.

Table 1 provides the data for set A, for 9 judges (plus one, No. 8, who took part temporarily in this phase of the selecting). All correlate, although in low amounts. The highest correlation is +.63 between judges 2 and 6, and the lowest is—.02 between judges 5 and 7. The low correlations are not to be explained by the unreliability of the judges, however, so much as by the difficulties in discriminating between pictures of such high caliber, all excellent. The judges were consistent in their selections, as their results from set to set proved.

The factor analysis indicates that the judges differ basically. The analysis (centroid method—Thurstone[3]) yields two factors.

It is one of the virtues of factor analysis that it frequently brings new facts to light that one might have suspected, perhaps, but could not otherwise prove. In the present case, there is an interesting discovery of this kind. When the factor loadings in Table 1 are plotted in graphic form (fig. 1), judges 1, 7, and 9 appear at the extreme left of the graph. These men are photojournalists whose daily work is on a newspaper or magazine. Judges 3, 5, and 6, at the other extreme, are wire-service or photo-service men. The judges in between are the historians and public relations officials, none of whom is directly involved in producing the news. The same result appears in sets B and C. Obviously a rather important fact is at issue: The practicing newspaper or magazine men

---

3. L. L. Thurstone, *Multiple Factor Analysis* (Chicago: University of Chicago Press, 1947).

# Table 1

Correlation Coefficients and Factor Saturation for 10 Judges:
News Photographs, Set A

| | | | | Judges | | | | | | | Centroid Factors | | Rotated | |
|---|---|---|---|---|---|---|---|---|---|---|---|---|---|---|
| | *1* | *2* | *3* | *4* | *5* | *6* | *7* | *8* | *9* | *10* | $f_1$ | $f_2$ | *I* | *II* |
| 1 | — | .22 | .01 | .23 | .01 | .18 | .34 | .25 | .31 | .29 | .39 | −.39 | .55 | .02 |
| 2 | | — | .53 | .45 | .20 | .63 | .24 | .50 | .20 | .32 | .72 | .20 | .35 | .65 |
| 3 | | | — | .32 | .40 | .46 | .13 | .26 | .15 | .17 | .51 | .46 | .02 | .68 |
| 4 | | | | — | .38 | .37 | .13 | .41 | .54 | .28 | .69 | −.05 | .50 | .47 |
| 5 | | | | | — | .42 | .02 | .17 | .17 | .16 | .40 | .26 | .09 | .47 |
| 6 | | | | | | — | .15 | .29 | .21 | .39 | .67 | .39 | .18 | .75 |
| 7 | | | | | | | — | .18 | .32 | .13 | .32 | −.20 | .38 | .06 |
| 8 | | | | | | | | — | .42 | .37 | .60 | −.14 | .52 | .34 |
| 9 | | | | | | | | | — | .22 | .53 | −.43 | .67 | .08 |
| 10 | | | | | | | | | | — | .49 | −.05 | .37 | .32 |

**Fig. 1** (From data of Table 1)

are in some respect poles apart from the picture- or wire-service men. They do not see the pictures in the same way.

Rotation of the axes in fig. 1 to the position indicated by the dotted lines brings this little discovery into better focus. We shall call the new axes Factors I and II. Factor I thus represents (theoretically, if one likes) how the local newsman thinks about pictures, and Factor II represents how the more hectic wire-service men think of them. All are dealing, of course, with news photographs, all of which are of the highest

caliber, all well-known in photojournalism.

The factors need not be taken too literally. They merely indicate that there are systematic differences between different groups of judges. They are congruent, however, with the respective broad functions of the judges. Nor will it matter whether *all* community or local photojournalists fall into line with Factor I, and *all* wire-service men in line with Factor II, and everyone else somewhere else or in between.

# Table 2

Correlation Coefficients and Factor Saturations for 10 Judges:
Final Set of 64 News Photographs

| | | | | Judges | | | | | | Factor Loadings | | | | | |
| | | | | | | | | | | Centroid Factors | | | Rotated | | |
| 1 | 2 | 3 | 4 | 5 | 6 | 7 | 9 | 10 | 11 | $f_1$ | $f_2$ | $f_3$ | I | II | III |
|---|---|---|---|---|---|---|---|---|---|---|---|---|---|---|---|
| 1 — | -.08 | -.08 | .27 | -.10 | .03 | .37 | .45 | .15 | .36 | .34 | -.48 | .17 | .60 | .03 | -.08 |
| 2 | — | .50 | .32 | .26 | .48 | -.07 | .08 | .15 | .21 | .47 | .31 | -.18 | -.02 | .49 | .35 |
| 3 | | — | .44 | .23 | .27 | -.09 | .19 | .18 | .23 | .48 | .00 | -.48 | .09 | .67 | -.03 |
| 4 | | | — | .33 | .31 | .16 | .28 | .24 | .41 | .75 | -.17 | -.12 | .52 | .54 | .18 |
| 5 | | | | — | .15 | -.08 | -.19 | .26 | .04 | .22 | .39 | .27 | -.05 | .02 | .53 |
| 6 | | | | | — | .21 | .21 | -.05 | .27 | .48 | .19 | -.29 | .05 | .57 | .22 |
| 7 | | | | | | — | .17 | .01 | .10 | .21 | -.27 | -.14 | .25 | .21 | -.14 |
| 9 | | | | | | | — | .28 | .56 | .53 | -.59 | .08 | .76 | .17 | -.12 |
| 10 | | | | | | | | — | .13 | .34 | .00 | .31 | .32 | .00 | .33 |
| 11 | | | | | | | | | — | .61 | -.25 | .00 | .51 | .37 | .11 |

Theoretically, it is possible that the historians and others in between represent how *most* people in general would judge the photographs. The factors would be what experts do, rather than just anyone. For the present, however, it is sufficient to proceed with the experts in mind. What is important is the evidence that the pictures are being regarded systematically in at least these two uncorrelated ways.

## Final Screening

Interesting consequences now appear. If the majority rule is used to select 50 pictures receiving the highest scores by the judges, the effect would be to cancel out the judges representing Factors I and II, leaving the final selection in effect to the in-between judges. This follows because the factors are uncorrelated, so that there is just as much chance of a picture receiving a high mark from the Factor I judges as for it to receive a low one from Factor II judges. In such a tussle, the in-between judges will tend to win out.

It is precisely such a happening that makes the majority rule so suspect amongst scientists (and so acceptable to democratic politicians). In the present case it seems that if anyone should count, it should be the experts, but by majority rule they would be involved in mutual blackout.

Under these circumstances a selection of pictures can be taken *from each group* of judges, the 10 best from Factor I judges, the 10 best from Factor II judges, and 10 also from the in-between judges. Averaging within such groups is valid; averaging *across* them is merely making a muddle of systematic differences.

Sets B and C were dealt with in the same way. In the present study the yield from this procedure, from sets A, B, C, was 62 photographs, all different, to which the three groupings of the judges had contributed equally.

The judges had not, of course, compared all 159 pictures as a group of pictures, but only within sets of 53 at a time. There might have been more they liked in one set than in the others. However, this was minimized by the random distribution of the pictures into the three sets. It has to be assumed, also, that the average score given to the pictures would be the same for all judges on any absolute scale of values, if any such could exist.

The yield, then, is 62 photographs from which to select the memorable 50. At this point judges could add any other photograph if they so wished, and two did so. There were 64 pictures, therefore, for final evaluation.

## Final Factoring and Selection

At this stage judge 8 dropped out and another, 11, took his place. All 10 were given 3 × 5-inch copies of the 64 photographs, as before, with instructions to score them, again, on an 11-point scale. The data were correlated and factored, as before, with the results shown in Table 2.

The original two factors again appear, defined clearly enough by judges 1 and 9 (and less so by 7) in the case of Factor I, and by judges 3 and 6 as before for Factor II. Judge 5, who had appeared on

Factor II previously, now separated himself into a different factor—there is other evidence that he had changed his ideas at this point in the judging, and this is clearly reflected in the data. The remaining judges who earlier constituted the in-betweens appear in the same position here as well, except that they are differently in-between (so to speak).

To select 50 from 64 does not, at this point, raise too many difficulties. The committee could be guided along lines indicated by the factoring. Factors I and II have been most consistent, and remain the most clearly defined. The judges in the in-between category do not, it seems, contribute anything systematically different from what is taken care of, already, by Factors I and II. The third factor in Table 2 could be discounted on the grounds that the judge is in a minority of one.

If, then, the 50 photographs are taken which gain highest scores on Factor I, and the 50 are taken which gain highest scores on Factor II, the following results:

1. Forty of the 64 photographs appear in both sets of 50.
2. Twenty of the 64 appear only once, in the one set of 50 or the other.
3. Four appear in neither set of 50.

The 40 could be recommended to the committee as acceptable for inclusion in the memorable 50. They give equal weight to Factors I and II, and include many of the photographs scored highly by the in-between judges. The additional 10 photographs can be chosen from the 20 of no. 2 above, by taking those gaining highest scores in either factor. This yielded eight more photographs, leaving two at a doubtful level.

The committee met (as to six members of it) and considered these recommendations. They were quite free, of course, to reject them, or to add any other photographs if it appeared at this point that this should be done. In point of fact a photograph was introduced again (from the earlier sets A, B, C which had been of borderline acceptability at that stage of the screening) because, when the final celebration set was contemplated, it seemed that it should be among them. It was the famous "Lone Flyer" (Charles A. Lindberg in pilot's helmet).

The final 50 were thus agreed upon.

## Discussion

The procedure no doubt seems protracted and difficult to understand except by those familiar with the methods of factor analysis. However, it is essentially straightforward and offers distinct advantages. For the present it is proposed to assume its appropriateness and to look briefly at what it implies.

The factors are arrays of the photographs which are consistently provided by some of the judges. In the present case, two tendencies seem to be quite acceptable, on the grounds that they appear consistently and relate directly to the functions of the judges involved. Thus, in the case of Factor I (for the newspapermen), the judges scored most highly those photographs which valued general news, by way of comment, with the emotions of pity and compassion much in evidence. The other factor (for the photo- and wire-service men) involved spot news more, with the sensational and novel more apparent.

The tendencies in these two directions are quite evident, and in line with what might be expected in the circumstances of the daily work of the respective judges. It is to be supposed that the men getting out the daily newspaper or the magazine feel the need to upgrade their publications by the inclusion of more thought-provoking pictures as well as any more sensational ones. They are more prepared to think of pictures as matters of record and as comment on the community scene.

The wire-service man seems more likely to value the directly entertaining and sensational. His is the more hectic occupation, and he thinks of nationwide popularities rather than of the "good" newspaper in his own community.

It might be thought that the in-between judges should be given the greater weight because they are not so much or so strictly involved in either the one or the other of the two standpoints. However, they are not really as consistent amongst themselves as they should be if we are to suppose that there is a coherent basis for their selections. There is some evidence, indeed, that they represent themselves idiosyncratically—the historian values royalty, and the business editor what is political. The practicing photojournalist is more in touch with the everyday objectives of

newspapers and magazines, and this is clearly reflected in his selections.

This is not to say that one of the above factors is more desirable than the other. T.S. Matthews, in *The Sugar Pill*, indicates cleverly how different newspapers are differently motivated, each appropriate to its needs.[4] The same seems to be true of photojournalism.

## Conclusion

The 50 photographs, by any standards, are great photographs. Without question there are many more as great or greater. But these serve to epitomize the photojournalist's work—they reflect both the wire services' vital emphasis on "spot news" and popularity, and the newspaperman's wider sympathies with more "general news." What the public likes, needs, or wants is another matter.

The method of selection, in general, serves to bring to light systematic differences of the kind here dealt with. The majority rule must always be suspect. And when systematic differences are found, questions of suitable criteria for future judging can be more seriously entertained. A great deal of work, indeed, needs to be done in all areas of art and photograph judging, to determine the motivations at issue besides aesthetic or other principles.

\* \* \*

## Photojournalism Organizations

The National Press Photographers Association (NPPA). For information regarding student and/or professional memberships, etc., write Executive Secretary, P.O. Box 1146, Durham, N.C. 27702

American Society of Magazine Photographers (ASMP). An organization for magazine and free-lance photographers. Devoted to leadership and guidance in pricing practices, business relationships, etc. Room 652, 60 East 42nd St., New York, N.Y. 10017

Kappa Alpha Mu (KAM), an honorary (co-ed) "fraternity" for college photojournalism majors. For information, write National Headquarters, Box 1105, Forsyth, Mo. 65653

## Photojournalism Competitions

Pictures of the Year Competition and Exhibition, an annual contest jointly sponsored by the School of Journalism, University of Missouri, Columbia, National Press Photographers Association, with an educational grant from Nikon, Inc. For information, write Photojournalism Department, School of Journalism, University of Missouri, Columbia, Mo. 65201

Annual contest sponsored for members by Inland Press Association Headquarters, 180 West Monroe St., Chicago, Ill., 60603

Yearly photo contest for Journalism students of AEJ schools of Journalism. William Randolph Hearst Foundation Journalism Awards program. 690 Market St., Suite 502, San Francisco, Calif. 94104

Annual National Collegiate photo competition, jointly sponsored by Kappa Alpha Mu, (honorary photojournalism fraternity) and the National Press Photographers Association, with assistance of the University of Missouri, School of Journalism, Columbia, The Los Angeles Times, and National Geographic Magazine. For particulars write, National Office, KAM, P.O. Box 1105, Forsyth, Mo. 65653

Annual photo contest for college students, sponsored by The Society of Professional Journalists. (Sigma Delta Chi). For information, write 35 East Wacker Dr., Chicago, Ill., 60601

## Prizes and Awards

Robert Capa award for photography. Write Overseas Press Club, Biltmore Hotel, 55 East 43rd St., New York City, New York, 10017

Pulitzer Prizes—one each for feature and news photography. For information, write Pulitzer Prize Committee, 702 Journalism, Columbia University, New York City, N.Y., 10027

World Understanding Award, presented by Nikon, Inc., in connection with the Pictures of the Year Competition and Exhibition. Write Nikon, Inc., Garden City, N.Y. 11530 or Photojournalism Dept., School of Journalism, University of Missouri, Columbia, Missouri 65201.

---

4. T. S. Matthews, *The Sugar Pill* (New York: Simon & Schuster, Inc., 1959).

# Glossary

**Advertising Photograph**
A black-and-white or color photograph made in a studio or elsewhere for the sole purpose of creating greater sales appeal for a product or service. Successful advertising photography requires great technical knowledge. The advertising photographer is an illustrator.

**Air in a Layout**
A page layout in which adequate space between elements on the page creates an uncluttered, "airy" appearance. Picture pages should not be too solid nor too tight. To be inviting a page should, first, have an interesting content; second, it should use white space and air in combination with the illustrations in such a way as to direct the reader in a logical, cohesive manner.

**Airbrush**
A compression device used with watercolor to paint out obnoxious foreground or background or to otherwise increase the reproductive qualities of a photograph.

**Art**
"The embodiment of beautiful thought in sensuous forms as in pictures, statues, music, or speech or the works thus provided" *(Britannica World Language Dictionary)*. Art is also a slang term for any illustrations used in a newspaper or other publication.

**Art Director**
The person responsible for the overall design and layout of a publication. A picture editor, who usually determines the sequence and manner in which pictures are to appear, takes his suggestions, together with the rough layout, to the art director. The latter weighs this material against the word stories, maps, and other illustrative material and finalizes the complete magazine, newspaper, or book layout.

**Available Lighting**
Natural light available for taking pictures. Faster film, faster lenses, and smaller cameras made possible informal, more believable news photography. One of the reasons for the almost overnight popularity of the miniature camera was that it permitted the use of available (natural) light to make exposures. Minimizing the use of flash photography added another degree of believability to pictures.

**Bas Relief**
A photograph which has sculptural qualities. A bas relief is made by placing together a transparent negative and a positive transparency of the same picture and moving them out of register.

| | |
|---|---|
| *Color Preprinting* | A system in which color pictures are printed on a roll of paper. The paper with the pictures is rewound and shipped to the customer who adds the type matter on his own presses. |
| *Color Separation* | Any of many methods used to separate a color print or transparency into its primary colors. The primary colors printed one at a time in close register give the full-color reproduction of the original. |
| *Cover Picture* | The first picture on a thematic type of page. It acts as an *opener* and sets the stage for the story which is to follow. |
| *Crop* | To cut away the unwanted parts of a picture. Cropping enables one to simplify the picture, to increase its impact value and effectiveness. Overcropping, on the other hand, can harm a picture, can detract from its communicative and aesthetic value. |
| *Daguerreotype* | An early type of photograph produced on a glass, silver, or silver-covered copper plate. Named after Louis Daguerre who invented the process in 1839, it is recognized as the world's "first practical photographic process." |
| *Director of Photography* | A person in charge of directing an entire photographic operation. Usually he is among the top echelon of publication administrators. |
| *Documentary Pictures* | Still or motion pictures which record some phase of life or custom. They are "similar to a monograph in literature." Generally speaking, documentary pictures point out social evils and many times help lead the way to reform. |
| *Duotone* | A combination of two color plates made from a black-and-white original which provide a form of color printing. Although not comparable in quality to full-color work requiring three or more plates, the duotone (two-plate, two-color picture) can sometimes be effective. |
| *Ecological Photography* | A type of camera work which focuses on ecological problems such as pollution, conservation, and the like. Documerica, a governmental program, takes an ecological approach. |
| *Ethics* | The principles of professional conduct which govern the actions of reporters and other communicators—photojournalists as well as writers. |
| *Free-lance Photographer* | A person who is not a staff member of a newspaper or magazine, but who sells his pictures to any market which desires to buy them. Operating on speculation and sometimes on contract, a free-lancer is not limited by a weekly, monthly, or yearly salary. To be successful, he must be a self-starter, able to sell himself and his pictures. Above all, he must know how and where to sell the pictures he takes. |
| *Freestanding Picture* | A picture which stands alone. It does not accompany either a word or picture story, but with its overlines and underlines is a complete entity itself. |
| *General Assignment Photographer* | A photographer who covers news, feature, sports, family interest, and all other types of photographs for publication. The general assignment cameraman differs from the specialized photo reporter in that the latter concentrates on a single type of picture such as news, feature, or sports. On larger publications specialists work on the Sunday papers, on the Sunday magazines (roto section), or on fashion photography. |
| *Gingerbread* | A term often used to describe a picture or layout containing nonfunctional borders, odd picture shapes, and the like. Gingerbread layouts were especially popular in the early days of photojournalism, especially in the rotogravure sections of newspapers in the United States. |

| | |
|---|---|
| *Gravure Printing* | The process of printing from an intaglio plate. In this process, the image to be printed lies below the plate surface in ink-filled depressions, in contrast to letterpress printing. *See also* Letterpress Printing; Offset Printing; Photo-offset Printing. |
| *Halftone* | A photoengraving and photo-offset process used for reproduction of continuous-tone copy; also the name given to a photoengraving made from the process. The name implies a tone halfway between white and black. The halftone screen is either a glass screen which is set the proper distance from the film in a process camera or a contact screen which in the camera is placed in immediate contact with the film before a negative is made. Either type of screen breaks the original copy into highlights, middle tones, and shadow dots. The dots, which range in size from coarse to fine, depending upon the number of dots per inch, give the illusion of tone when the halftone plate is printed in a newspaper. |
| *Illuminated Manuscript* | A manuscript decorated with figures and ornamental colored letters. Many authorities consider pre-Biblical illuminated manuscripts to be "the beginning of the illustrated press." |
| *Intaglio* | *See* Gravure Printing. |
| *Juxtaposition of Photographs* | An arrangement of similar or opposite types of pictures in a layout. When properly done, the combination increases the communicative value of each of the pictures used. "The whole is greater than the sum of its parts." |
| *Letterpress (Relief) Printing* | Printing from raised surfaces. In this process, the paper is pressed against the inked surface to produce the impression. *See also* Gravure Printing; Offset Printing; Photo-offset Printing. |
| *Mondrian Layout* | A type of layout inspired by the Dutch artist Piet Mondrian. Illustration designers who use the Mondrian approach believe that white space in the center of a picture layout can be distracting. To avoid this distraction, they put the white space along the edges, as Mondrian did in many of his neoplastic paintings. In addition to working in strict geometric patterns and crowding the white space to the outside, those who favor the Mondrian layout insist on "internal consistency" of space between the illustrations. Even though one does not adopt a pure Mondrian design, white space and cutlines should usually be at the edges of the layout. |
| *Mortise* | An area of a photograph or illustration which is cut out to receive a pictorial insert, a caption, or display type. |
| *Negative* | A photographic image on transparent material used for printing positive pictures. When it is processed after exposure, the film in a camera yields a negative, the exact opposite of a positive. When a negative is printed on sensitized paper, film, metal, and the like, the result is a positive. |
| *Offset Printing* | A printing process in which a page (or other image) is photographically reproduced on a thin flexible metal plate curved to fit the cylinders of an offset printing press. The inked impression is first made on the metal plate and then transferred to a rubber blanket. The type or illustration is offset from the blanket to the paper. *See also* Gravure Printing; Letterpress Printing; Photo-offset Printing. |
| *Overprinting* | *See* Surprinting. |
| *Perspective* | The characteristic of a painting, drawing, or photograph which gives the illusion of receding distance. In photography examples of perspective are narrowing of railroad tracks (linear perspective) and the graying-out of blacks (aerial perspective) as they approach the horizon. |

| | |
|---|---|
| *Photographic Beat* | A specific area of photographic news coverage: police, wildlife, city hall, farming, and so forth. |
| *Photographic Illustrations* | Photographs which illustrate a story idea or point, rather than report a news event. Photographic illustrations should be labeled as such, and should not go under the guise of news photographs. Illustrations allow a photographer the opportunity to create, something news photographs do not. A studio, special lighting effects, rear-screen projection, and setups are all used to produce photographic illustrations. |
| *Photojournalism* | A combination of words and pictures which together form a stronger, easier understood method of communication than either words or pictures alone can produce. |
| *Photo-offset Printing* | A type of offset printing in which a negative print of the copy is used in the photochemical preparation of the printing plates. The process is more economical than other printing processes, a factor contributing greatly to the continuing viability of small suburban newspapers. It is also more versatile, and fidelity of photograph reproduction is greater. *See also* Gravure Printing; Letterpress Printing; Offset Printing. |
| *Pica Rule* | A straightedge divided into pica units as well as into inches used to measure typographic material. With a pica rule a picture editor can measure the size of an original picture and figure the amount of enlargement or reduction needed for the picture to fit a particular space. |
| *Picture Editor* | One who gives picture assignments, selects pictures for publication, and crops and sizes them to increase their storytelling qualities. He (or she) also plans picture layouts, arranging not only the pictures themselves, but also the space and words so that they unite in a pleasing, comprehensible unit. |
| *Picture Page* | A page composed entirely of words and pictures. Picture pages may be planned around a central theme such as Thanksgiving, Christmas, a community, an interesting character, and the like. A picture page may also be a group of pictures without a unifying theme. The most effective picture pages adhere to a theme, although some newspapers feel that a hodgepodge page (with no theme) attracts more people and has greater general interest. When a picture page is being laid out, it is better to use only a few pictures (not more than five) than to use too many. The pictures should vary in size and shape to increase editorial and visual impact. |
| *Picture Strip* | A series of pictures which usually shows a progression of time or action. A how-to-do-it series or sequence is a good example of a picture strip. Here is another example: picture 1, two airplanes collide in the sky; picture 2, the planes swirl downward; picture 3, the planes crash-land. |
| *Proportion Calculator* | A slide rule, wheel, or similar device which permits one to figure the proportionate enlargement or reduction of a line drawing or photograph. |
| *Register* | Alignment of three-color images on a press when natural color reproductions are printed. |
| *ROP Color (run of press color)* | A system of printing which allows color reproductions to be printed on any page or section of a newspaper. |
| *Sketch Artists* | Before invention of the halftone, sketch artists—those who drew pictures of the news event on paper or on wood (reversed)—were the source of most illustrations which appeared in newspapers and magazines. Even now, as in courtrooms and other places where photography is not allowed, the sketch artist very effectively continues to ply his trade. |

| | |
|---|---|
| *Spotting* | Using a pencil or a fine-pointed brush and watercolor to eliminate spots on a print surface before it is displayed to the public or converted to a halftone negative. |
| *Stereoscope* | A device used to project or view two almost similar images to create a third dimension. |
| *Subtractive Color Process* | A process of halftone reproduction of full-color art using one plate for each color, usually magenta, cyan, yellow, and sometimes black. The process is in contrast to the additive process of color printing, which uses red, green, and blue. |
| *Surprinting* | A method whereby something additional is printed over an original picture, and the like. Surprinting is usually done during the plate-making process. A caption, for example, or a display line may be printed (white type in a black area or black type in a light area) on a picture. Surprinting, or overprinting as it is often called, can be effective, but it should not be overdone. |
| *Wire Picture Services* | Commercial enterprises which transmit photographs electronically over telephone wires or other long-distance transmission system. |
| *Wood Engraving* | The art of cutting designs on wood (usually in reverse from left to right) for relief printing. The term *wood engraving* applies to an engraved block or a print. A carry-over from the days of woodcuts is the fact that in England photoengravings even now are referred to as "blocks" and in the United States as "cuts." |

# Bibliography

Like an artist, a lawyer, or a doctor, a photojournalist should begin to build a library early in his study. Although he has a college degree or degrees, he should never stop studying. The minute he does, his career heads downward.

The budding photojournalist should know what great photographers have done and are doing. Through reading books, magazines, and the like, he can know what has taken place and keep abreast of the times. More important, however, is the fact that a thorough knowledge of the past and present will at least give him some idea of what the future holds.

Examine the following bibliography carefully. Some of the older books may not be readily available, but most of these books can be found in public, university, or college libraries. All are interesting and valuable sources of research material.

Agee, James, and Evans, Walker. *Let Us Now Praise Famous Men.* New York: Random House, Ballantine Books, 1966.

Baynes, Ken. *Scoop, Scandal and Strife.* New York: Hastings House, 1971.

Bergin, David F. *Photojournalism Manual: How to Plan, Shoot, Edit and Sell.* New York: Morgan & Morgan, 1967.

Bluem, A. William. *Documentary in American Television.* New York: Hastings House, 1968.

Bourke-White, Margaret. *Shooting the Russian War.* New York: Simon and Schuster, 1942.

———. *Portrait of Myself.* New York: Simon and Schuster, 1963.

Braive, Michel F. *The Photograph: A Social History.* New York: McGraw-Hill Book Co., 1966.

Bresson, Henri Cartier. *The Decisive Moment.* New York: Simon and Schuster, 1952.

Caldwell, Erskine, and Bourke-White, Margaret. *Say, Is This the U.S.A.?* New York: Duell, Sloan & Pearce, 1941.

Callahan, Sean. *The Photographs of Margaret Bourke-White.* New York: New York Graphic Society, 1972.

Capa, Cornell. *The Concerned Photographer.* New York: Grossman Publishers, 1968.

———. *The Concerned Photographer.2.* New York: Grossman Publishers, 1972.

Capa, Robert. *Slightly Out of Focus.* New York: Henry Holt & Co., 1947.

———. *Images of War.* New York: Grossman Publishers, 1964.

Davis, Phil. *Photography,* 2nd ed. Dubuque: Wm. C. Brown Co., Publishers, 1975.

DeCarava, Roy, and Hughes, Langston. *The Sweet Flypaper of Life.* New York: Simon and Schuster, 1955 (an Experimental book since reissued).

Denison, Herbert. *A Treatise on Photogravure*. London: Iliffe and Son., 1892.

Doisneau, Robert. *Paris*. New York: Simon and Schuster, 1956.

Doty, Robert. *Photo Secession: Photography as a Fine Art*. New York: Duell, Sloan & Pearce, 1960, for George Eastman House.

Duncan, David Douglas. *This Is War*. New York: Harper Brothers, 1951.

———. *The Private World of Pablo Picasso*. New York: Ridge Press, 1958.

———. *I Protest*. New York: New American Library, Signet, 1968.

———. *Self Portrait: U.S.A.* New York: Harry N. Abrams, 1969.

———. *War Without Heroes*. New York: Harper & Row, 1970.

Edom, Clifton C. *Careers:* Chicago: The Institute for Research, 1961. "Career as a Newspaper, Magazine and TV News Photographer." Research Number 202.

Eisenstaedt, Alfred. *Witness to Our Time*. New York: Viking Press, 1966.

———. *The Eye of Eisenstaedt*. New York: Viking Press, 1969.

———. *People*. New York: Viking Press, 1973.

Evans, Harold. *Pictures on a Page*. Holt, Rinehart, and Wilson, New York, 1978.

Evans, Walker. *American Photographs*. New York: Museum of Modern Art, 1938.

———. *Message from the Interior*. New York: Eakins Press, 1966.

Fern, Alan, Kaplan, Milton, and the staff of the Prints and Photographs Division, Library of Congress. *Viewpoints.* New York; Arno Press, Reprint of 1975 ed., the Library of Congress.

Frank, Robert. *The Americans*. New York: Grossman Publishers, 1969.

Frank, Waldo, Mumford, Lewis, Norman, Dorothy, Rosenfeld, Paul, and Rugg, Harold. *America and Alfred Steiglitz*. New York: Doubleday, Doran & Co., 1934.

Geraci, Philip C. *Making Pictures for Publication*. Dubuque: Kendall/Hunt Publishing Co., 1973.

Gernsheim, Helmut and Allison. *Roger Fenton, Photographer of the Crimean War*. London: Secker and Warburg, 1954.

———. *The Recording Eye: A Hundred Years of Great Events as Seen by the Camera, 1839–1939*. New York: G.P. Putnam's Sons, 1960.

Hall, Norman. *Press Pictures of a Decade*. London: Photography Magazine, Ltd., 1960.

Hicks, Wilson. *Words and Pictures: An Introduction to Photojournalism*. New York: Harper Brothers, 1952: reprint ed., Arno Press, 1973.

Horan, James D. *Timothy O'Sullivan: America's Forgotten Photographer*. New York: Doubleday & Co., 1966.

Hurley, Jack F. *Portrait of a Decade: Roy Stryker and the Department of Documentary Photography in the Thirties*. Baton Rouge: Louisiana State University Press, 1972.

———. *Russell Lee Photographer*. Morgan & Morgan, Dobbs Ferry, N.Y., 1978.

Jackson, Mason. *The Pictorial Press, Its Origin and Progress*. London: Hurst & Blackett, Publishers, 1885.

Kalish, Stanley E., and Edom, Clifton C., *Picture Editing*. New York: Rinehart & Co., Inc. 1951.

Karsh, Yousuf. *Portraits of Greatness*. New York: Thomas Nelson & Sons, 1959.

Lartigue, J.H., and Lartigue, S.A. *Boyhood Pictures of J.N. Lartigue*. Switzerland: Ami Guichard, Publisher, 1966.

Lieberman, Archie. *Farm Boy*. New York: Harry N. Abrams, Inc., 1974.

Life Library of Photography. *Photojournalism*. New York: Time-Life Books, 1971.

———. *The Best of Life*. New York: Time-Life Books, 1973.

———. *Photography Year 1979*. New York: Time-Life Books, 1979.

Lyons, Nathan. *Photographers on Photography*. Englewood Cliffs, N.J.: Prentice-Hall, 1966, for George Eastman House.

McCall, Floyd H., and Rhode, Robert B. *Introduction to Photography*. New York: Macmillan Co., 1971.

McCombe, Leonard. *You Are My Love*. New York: William Sloane Associates, 1952. (A love story, based on a feature which appeared in *Life*, told in the special idiom of a camera.)

McDougall, Angus, and Hurley, Gerald D. *Visual Impact in Print*. Chicago: American Publishers Press, 1971.

MacDougall, Curtis D. *News Pictures Fit to Print: . . . Or Are They?* Stillwater, Okla.: Journalistic Services, Inc., 1971.

McManigal, J.W. *Farm Town*. Brattleboro, Vt.: Stephen Greene Press, 1974.

Mich, Daniel D., and Eberman, Edwin. *The Technique of the Picture Story*. New York: McGraw-Hill Book., 1945.

Mott, Frank Luther. *A History of American Magazines, 1885–1905*. Cambridge, Mass.: Harvard University Press, 1957.

Mydans, Carl. *More than Meets the Eye*, New York: Harper & Bros. 1959.

National Education Alliance, Inc. *The Complete Photographer, and Encyclopedia of Photography*. New York: Morgan & Morgan, 1942. (Since updated and reprinted.)

Newhall, Beaumont. *Photography, a Short Critical History*. New York: Museum of Modern Art, 1938.

*Photojournalism 76*—An Annual Based on the 33rd Pictures of the Year Competition. National Press Photographers Association, University of Missouri School of Journalism, Columbia. W.E. Garrett, Editor. McLean, Va.: EPM Publications, Inc. 1976.

*Photojournalism 2*—An Annual Based on the 34th Pictures of the Year Competition. National Press Photographers Association, University of Missouri School of Journalism, Columbia, supported by an educational grant from Nikon, Inc., New York: Newsweek Books, 1977.

*Photojournalism 3*—An Annual Based on the 35th Pictures of the Year Competition. National Press Photographers Association, University of Missouri School of Journalism, Columbia, supported by an educational grant from Nikon, Inc., New York: Newsweek Books, 1978.

Pollack, Peter. *The Picture History of Photography*. Revised and enlarged ed. New York: Harry N. Abrams, 1969.

Robinson, Henry Peach. *Pictorial Effect in Photography*. Pawlet, Vt.: Helios Publishing Co., 1971. reprint ed. from 1st ed., 1869.

Rothstein, Arthur. *Photojournalism*. New York: American Photographic Book Publishing Co., 1956.

Rothstein, Arthur, and Saroyan, William. *Look At Us . . .* New York: Cowles Education Corp., 1967.

Salomon, Peter Hunter. *Erich Salomon, Portrait of an Age*. New York: Macmillan Co., 1967.

Schaleben, Arville. *A Definitive Study of Your Future in Journalism*. New York: Richards Rosen Press, 1961.

Schuneman, R. Smith. *Photographic Communication: Principles, Problems and Challenges of Photojournalism*. New York: Hastings House, 1972.

Smith, W. Eugene, Smith, Aileen M., *Minamata*. New York: Holt, Rinehart and Winston, 1975.

Steichen, Edward. *The Family of Man*. New York: Museum of Modern Art, 1955.

Strode, William H. III. *Barney Cowherd, Photographer*. Louisville: Courier-Journal & Times, 1973.

Stryker, Roy Emerson, and Wood, Nancy. *In This Proud Land: America 1935–43, as Seen in FSA Photographs*. Greenwich, Conn.: New York Graphic Society, 1973.

Swedlund, Charles, *Photography*. New York: Holt, Rinehart & Winston, 1973.

Taft, Robert. *Photography and the American Scene*. New York: Macmillan Co., 1938; reprint ed., 1942.

Vitray, Laura, Mills, John, Jr., and Ellard, Roscoe. *Pictorial Journalism*. New York: McGraw-Hill Book Co., 1939.

Weston, Edward. *The Daybooks of Edward Weston*. Mexico, vol. 1. New York: George Wittenborn, 1961, for George Eastman House.

———. *The Daybooks of Edward Weston*. California, vol. 2. New York: Horizon Press (n.d.), for George Eastman House.

Whiting, John R. *Photography Is a Language*. Chicago: Ziff-Davis Publishing Co., 1946.

# Index of Illustrations

318

# Index